Archive Everything

Archive Everything

Mapping the Everyday

Gabriella Giannachi

The MIT Press
Cambridge, Massachusetts
London, England

This book was set in Stone Sans and Stone Serif by Toppan Best-set Premedia Limited. Printed and bound in the United States of America.

Library of Congress Cataloging-in-Publication Data

Names: Giannachi, Gabriella, author.
Title: Archive everything : mapping the everyday / Gabriella Giannachi.
Description: Cambridge, MA : The MIT Press, [2016] | Includes bibliographical references and index.
Identifiers: LCCN 2016015620 | ISBN 9780262035293 (hardcover : alkaline paper)
Subjects: LCSH: Archives--Philosophy. | Archives--History. | Archives--Data processing. |
 Archival materials--Digitization. | Digital preservation. | Art archives.
Classification: LCC CD947 .G53 2016 | DDC 027.001--dc23 LC record available at
 https://lccn.loc.gov/2016015620

10 9 8 7 6 5 4 3 2 1

To Francesca, for everything…

Contents

LIST OF FIGURES

Acknowledgments

This book rests on the support of a number of individuals and organizations. Among the individuals, I would like to thank all my colleagues in the Department of English at the University of Exeter for advice and support throughout the years, and Gary Stringer and his team in the Digital Humanities Unit for support, encouragement, and for making things happen. I would also like to thank Steve Benford, Tom Rodden, Derek McAuley, Laura Carletti, Dominic Price, and Peter Tolmie at University of Nottingham; Henry Lowood and Michael Shanks at Stanford University; Rebecca Sinker at Tate; John Stack at The Science Museum in London; Andy Chapman from 1010 Media; Rick Lawrence at Royal Albert Museum and Art Gallery; Paul Farley, Aidan Hamilton, and Martin Weiler from Exeter City Football Club Supporters Trust, as well as staff working within the Football in the Community and Kick Start programmes, especially Jamie Vittles and Scott Walker, and the Senior Reds at Exeter City Football Club, in particular, Mike and Jen Roach and Phil Bater. A special thank you goes to Giles Ashman for his insightful advice on how to use digital technology in the education context. I would also like to thank my PhD students William Barrett, Acatia Finbow, and Cristina Locatelli with whom I have shared wonderful moments while researching Placeify, The Musée de la Danse, and ArtMaps, respectively.

As an outcome of Horizon Digital Economy research, this book has received extensive support from the EP/G065802/1. Other support was received by REACT (funded by the Arts and Humanities Research Board) and HEIF for the development of Time Trails; 1010 Media for research into the development of Placeify; and the AHRC for research into the documentation for Musée de la Danse's *If Tate Modern was Musée de la Danse?*

I would like to acknowledge the invaluable support of the staff of the following libraries and institutions: the Stanford Libraries Special Collections unit, Palo Alto; the Royal Albert Memorial Museum and Art Gallery, Exeter; the SFMOMA archive; the San Francisco Art Institute archive; the Tate archive, London; the Exeter City Football Club Supporters Trust archive, Exeter. I would also like to thank the numerous private collectors who donated and/or lent their materials to us at Exeter City Football Club for the Grecian Archive.

I am happy to acknowledge that parts of the section in chapter 1 dedicated to Lynn Hershman Leeson's work *Life Squared* (2006) were previously published in Gabriella Giannachi and

Nick Kaye, *Performing Presence* (2011); parts of the section in chapter 3 dedicated to the Jewish Museum in Berlin were previously published in Gabriella Giannachi and Nigel Stewart (eds.) *Performing Nature* (2006) and parts of the section dedicated to CloudPad were published in an article for the journal *Digital Creativity* (2012); parts of the section in chapter 6 dedicated to Lynn Heshman Leeson's work *The Infinity Engine* (2014–) were published in a book chapter in *Performance and Science*, edited by Gianna Bouchard and Alex Mermikides (2016). All these sections have been rewritten and substantially re-contextualized in a new theoretical framework.

The interviews and correspondences extracted and published in this book were recorded and edited by the author and corrected and approved by interviewees for publication. I would like to thank Matt Adams, Henrik Bennetsen, Annet Dekker, Hannah Frost, Thomas Allen Harris, Eduardo Kac, Lynn Hershman Leeson, Chip Lord, Henry Lowood, and Cheo Tyehimba Taylor for their support of my research for this publication.

At a personal level, I need to thank my friends who were there for me when I needed them most: Tania Barton, Barbara Beninato, Ian Brown, Jim Cromwell and Tamsin Ford, Kyriaki Hadjiafxendi and John Plunkett, Leah Hardy, Kate Newey, Carmen Novella, Dalia Oggero, Joanna Robertson, Claudia Romano, and Jude Wright. I would also like to thank Margaret Lowe and John Hore for all their help and for great chats about football and life, and Lorraine and Rob Hafner, and River, for making Francesca happy, and for listening to her. A very special mention goes to my witty and inspiring friend Maria Perosino who died suddenly halfway through the writing of this book and who is profoundly missed: every word I write will always also be for her. My daughter and my mother have been my entire world for the last three years—this book could not have been written without their support. My late beloved father is responsible for my love for interdisciplinary enquiry. I hope he would recognize himself in this book. Last but not least, I would like to extend my profound gratitude to Doug Sery for his interest and belief in this book, and for his patience, advice, and unfailing support.

INTRODUCTION

Over the last fifty years, there has been a remarkable growth of interest in the concept of the archive. Historians, literary critics, philosophers, sociologists, anthropologists, geographers, political scientists, and many others have written about it, mostly staying within the confines of their own disciplines. Etymologically, the word archive has been famously linked to the figure and residence, in the sense of administrative office, of the chief magistrate (Leavitt 1961, 175). However, even in ancient history the five names that were regularly used to designate archives *grapheion, agoranomeion, bibliothēkē, katalogeion,* and *mnēmoneion* (Cockle 1984, 110) point in the direction of the various aspects of archiving that inform the production and dissemination, as well as the recording and preservation, of documents. In fact distinctions between libraries, archives, and museums have always been ambiguous. Thus, for example, Paul Otlet, one of the founders of the documentation movement, already in the 1930s redefined the term "document" to include a wide range of objects and artifacts claiming that documents were simply objects that conveyed information and thus the term could refer to anything collected by archives, museums, or libraries (in Manoff 2004, 10). In this study, I trace the emergence of this diversity of functions of the archive historically, explain the fluidity, and potential interchangeability, between libraries, archives, and museums, illustrate the archive's relationship to technology and industry, and show why the archive has become the apparatus through which we map the everyday.

In talking about the archive as an apparatus I refer to Giorgio Agamben's definition. Agamben draws the term from Michel Foucault (2009, 1) for whom the word, he suggests, is a "heterogeneous set" including "virtually anything" under the same heading: "discourses, institutions, buildings, laws, police measures, philosophical propositions, and so on, precisely because the apparatus is the *network* that is established between these elements" (pp. 1–2; added emphasis). Apparatuses, Agamben points out, produce their subjects (p. 11) and insert them within an *oikonomia,* the Greek term used to indicate the administration of the *oikos* (the home). Thus an apparatus consists of "a set of practices, bodies of knowledge, measures, and institutions that aim to manage, govern, control, and orient—in a way that purports to be useful—the behaviors, gestures, and thoughts of human beings" (p. 12). Apparatuses are therefore not only, "prisons, madhouses, the panopticon, schools, confession,

factories, disciplines, juridical measures, and so forth (whose connection with power is in a certain sense evident), but also the pen, writing, literature, philosophy, agriculture, cigarettes, navigation, computers, cellular telephones and ... language itself" (p. 14). By choosing to define the archive as an apparatus, I therefore suggest that the archive cannot be read in isolation, but rather that it is relational, that it directly affects our behaviors, actions and thoughts, and that it forms an intrinsic part of our economy. I also suggest that we design the archive as the apparatus we want to be produced by. This explains why the archive, more than other form of collection, has evolved in parallel with changing attitudes toward culture, philosophy, politics, and society, and also why there is a direct link between the archive and our *oikos* (home), and the system we use to administer our home, that is our economy.

In his well-known *Archive Fever*, Jacques Derrida suggests that the methods for the transmission of information shape the knowledge that is produced in the archive (1995, 23). I agree with this statement and show how archives evolved and adapted historically, especially, in recent years, to include emergent methods and technologies for the transmission of information. I therefore start by offering an investigation of the evolution of such methods from the earliest archives, created by the Egyptians, Assyrians, Medes, Hebrews, Phoenicians, showing the connections between political systems and their administration in the archive and tracing the development of complex inter-related archives such as the *armari* of the Venetian *Consiglio dei Dieci* and the *Archivio Segreto Vaticano*. I then analyze the introduction of mechanization and digitization of archival databases, looking into the growing popularity and importance of community-generated *live* digital archives such as the September 11 Digital Archive, which aims to collect, preserve, and present the history of September 11, 2001, and its aftermath. Finally, I explore how archives are now often used in the creation of mixed reality environments that augment our experience of the physical spaces we traverse in our everyday lives, and show how we are increasingly likely to encounter them embedded in objects that can literally now tell us their histories.

To show the evolution of the archive over time, I identify significant moments in the development of archival science, focusing, in particular, on the introduction of mechanization, as well as the subsequent implementation of new classification and retrieval technologies, and the use of archives in the design of mixed reality experiences and the augmentation of objects. I show that the archive is not distinct from its administration and so discuss the growing importance of and changing attitudes to the management of the production of increasingly complex administrative systems. Finally, as archives have become more and more hybrid, incorporating elements from other forms of collection, exhibition, display, and broadcast, I analyze how the archive drew from other cultural forms to become an apparatus and trace its growing pervasiveness within our lives. To explain these evolutionary processes, I look at the archive as documents (or objects, artifacts), sites, ordering systems (and administration strategies), but also as installations, cabinets of curiosity, databanks, interfaces, artworks, environments, game-spaces, networks, platforms, mixed reality trails, musical instruments, and motors for the economy.

Foucault showed that the archive operates as "the system of its functioning" (2011, 146) and so cannot be described from within, nor can it be described in its totality as "it emerges in fragments, regions and levels" (p. 147). I agree with this statement and so believe that the analysis of the archive involves the choice of a privileged region. For this reason, this study is organized according to different disciplines. Each of these disciplines operates as a "panoramic" viewpoint from which to observe the various fragments, regions, and levels that form the apparatus of the archive. These include information and museum studies; archeology and feminist theory; memory studies and architecture; postcolonial theory and diasporic studies; aesthetics and media theory; history of science, philosophy, and economics. In adopting different view points, I aim to produce a shift in the reader's attention between the archive as a set of objects (where the archive operates as a noun) and the archive as a knowledge-generating process or lab (where archive is a verb) and draw attention to the growing significance of the user of the archive who more and more often is nowadays also its creator. These different disciplinary lenses, which additionally benefit from the inclusion of original interviews to leading artists, archivists, and theorists operating in the field, are brought together into an interdisciplinary framework that intends to present archives as a fundamental apparatus for mapping the everyday. The study, whose understanding of the word archive reaches beyond conventional notions of the term, looks at how the apparatus of the archive acts as a transformational lens through which we augment our presence, namely our relationship to our environment, and map everything that emerges as a consequence of this augmentation.

In the first chapter, I analyze the historical evolution of the archive throughout the centuries, looking at different archives, archiving methodologies, practices, and technologies. In particular, I show how the archive, traditionally referring to a site and/or a body of documents, evolved through the introduction of different systems of categorization, mechanicalization, preservation, data analysis, and broadcast, to encompass, often concurrently, a broad, but interrelated number of practices and technologies that are traditionally considered separately from the archive. I therefore show how the exponential growth of archives produced a certain fluidity and potential interchangeability between these forms. This means that archives nowadays also often comprise artworks, curiosity cabinets, installations, museums, platforms, and media environments, including ones created through social media, that may be more or less interactive, immersive, and pervasive. These may be interconnected, which means that the archive today often consists of a plurality of technologies, practices, documents, and media. Finally, I show how these interconnected archives offer a multiplicity of viewing platforms to replay or even rewrite the past, capture the present, and so map our presence, as a spectacle for others to view. The historical span is broad, from primitive archives to mixed reality archives, not only to show that archives evolved historically but also to mark how they often retained characteristics deriving from other periods in history. A mixed reality archive may therefore preserve a plurality of features whose provenance may well precede its current appearance and function. In this sense, the archive operates as a set

of interrelated objects and spaces entailing a time-based capacity that implicates its content in its own acts of becoming.

In the second chapter, I show how archeology offers a set of translating and mediating practices that help us build an understanding of the apparatus of the archive as an amalgam of materials that may have been produced at different points in time. To unearth the archive as a site, I introduce an archeological toolkit including elements such as survey; excavation (e.g., deep mapping and cultural stratigraphy); media archeology and remediation. This, I show, is useful to look at how materials are informed by the media (e.g., photography, video, text, box, blog) that document and archive them. I also show how the archive operates as strata, revealing information about the principles of accumulation and conformism that operate in the scriptural economy (de Certeau 1984, 135) and are still crucial in the knowledge and information economies. In particular, I focus on the capacity of the archive to facilitate the production and transmission of our presence, our present, and our identity, showing also how the archive reveals "relations between discursive formations and non-discoursive domains" (Foucault 2011, 179). The case study for this chapter consists of Lynn Hershman Leeson's !R.A.W. project, which in itself is formed by archival materials collected over a prolonged period of time. These materials formed a digital database that was used to produce a film, an installation, a blog, a bibliographic resource, and two archival websites abut a number of feminist artists working in the United States between the 1960s and today whose works had often historically been excluded from the collections and archives of galleries, museums, and universities. By analyzing this project archeologically, I show the interrelatedness of materials and the media used to frame them, therefore unpacking also how archives ought to be read contextually as inter-archives.

In the third chapter, I draw on literature on memory and history to analyze how the archive operates as a memory laboratory facilitating the (re-)creation and transmission of different types of memories, from personal to collective, from primary to secondary. In particular, I focus on how our obsession with memory has led to an "*autonomising* of the present*" (Nora 1996; original emphasis) that, in turn, I show, has led to an obsession with the capture of the subject, or as I will show in the afterword, the object, in the present moment. I also show, by drawing from literature on Embodied Simulation Theory, how archives can give us direct access to the world of others. Crucially, after Agamben (1999), I suggest that after the Second World War, we have become increasingly aware of our roles as witnesses. In this chapter, I introduce a temporal framework based on literature drawn from anthropology, geography, and human computer interaction on mapping and map-making. The framework facilitates the design of mixed reality environments, spanning digital data and physical locations, by using a juxtaposition of cartographic maps and trails. I show how these can be used to create mixed reality memory architectures embedding archival knowledge into places and facilitating the documentation of our own viewpoint or testimony within them. The case studies for this chapter include the work of "memory artists" (Young 2000, 11), Mischa Ullman and Christian Boltanski; The Jewish Museum in Berlin for the way in which it

facilitates our encounter with archival materials so as to implicate its visitors as witnesses to the Holocaust; the archiving tool CloudPad, which is discussed in the context of the creation of a documentation of Blast Theory's archival work *Rider Spoke*; and the trail building tool Placeify used to facilitate remembering and learning among junior and senior fans of Exeter City Football Club.

In the fourth chapter, I draw from studies in geography and anthropology, diasporic and postcolonial studies, to explore the operation of transformation discourse within the archive showing also the importance of the emergence of a hybrid methodology for the presentation of cultural origin, contexts of digital displays and interpretation of archival materials. In particular, I look into the use of participatory forms of appraisal in the context of the creation of community archives showcasing the adaptation of the principles of provenance and ordering to include the use of fluid ontologies as methods for both the creation and preservation of archives (Srinivasan and Hang 2005). I suggest here that it is crucial to capture and preserve individual points of view, first voices, and the practices and contexts from which they emerge through participatory archiving, that would document not only the histories, but also the social lives of artifacts. These kinds of archives show the operation of the multiplication of the transformational and political power of the apparatus of the archive and explore its capacity to prompt societal change. The case studies for this chapter are Thomas Allen Harris's multimedia community engagement archival project *Digital Diaspora Family Reunion* (*DDFR*), consisting of a multimedia roadshow, an online platform, an education pack and archive using interactive media to inspire African-Americans and citizens in other diasporas to re-evaluate their family history; "Creating Collaborative Catalogues," a collaboration between Ramesh Srinivasan at the University of California, Los Angeles, Robin Boast at Cambridge University, and Jim Enote of the A:shiwi A:wan Museum and Heritage Center in Zuni, focusing on the Zuni Community of Zuni Pueblo, New Mexico; and the Museum of the African Diaspora's archival educational projects "Art/Object: Re-Contextualizing African Art," "The Origins of the African Diaspora," and *I've Known Rivers: The MoAD Stories Project*, a first voice archive about people of African descent in the San Francisco Bay area.

In the fifth chapter, I explore how archival methodologies have been used, especially after the 1930s, to generate environmental or process-led artworks and how art has influenced our understanding of what constitutes an archive. I start by looking at practices of accumulation, collection, and curation, focusing in particular on the cabinet of curiosity to show how, among other cultures of collection and exhibition, it acts as a predecessor to archival art. Focusing on the cabinet's capacity to operate as a relational medium, bridging between forms and processes, subjective viewpoints and broader epistemological models, I also show how the cabinet acted as predecessor to how we present, document, and archive ourselves through social media today. Additionally I illustrate how the archive evolved from being a component of the cabinet to operating as an apparatus that incorporates the cabinet. Finally, I show how the apparatus of the archive has become a tool to frame, preserve, disseminate, and aestheticize our lives, showing how we, as citizen archivists, also use the apparatus of

the archive to create exhibitions and performances of the relationships between ourselves and our environment. The case studies for this chapter include works by Michel Duchamp, Robert Morris, Andy Warhol, Ant Farm, and sosolimited, to highlight the roles played by multiplication, performativity, temporality, storage, and spectacularity within the operation of the apparatus of the archive.

In the sixth chapter, I look at the role played by transmission of the archive through the body, drawing from performance studies, bioart, database aesthetics, and history of science to look at what becomes of the archive in the era of genomic experimentation. Drawing on economics, I also establish the role played by the archive within the digital economy showing how the archive evolved for each of the industrial revolutions that occurred since the 18th century. Additionally I look at the role played by the archive in the development of smart objects within the Internet of Things. The case studies for this chapter include the transmission of the archive through the body in the Musée de la Danse's *If Tate Modern was Musée de la Danse?* (2015), and archival database artworks by George Legrady, Natalie Bookchin, Eduardo Kac, and Christine Borland. The chapter concludes with an analysis of Lynn Hershman Leeson's *Infinity Engine,* establishing the connections between economics, medicine, art, and life itself. I show how in *The Infinity Engine* the human being has become its own (a)live archive, one that, through regenerative medicine, can be modified inside out. Finally, I show how the apparatus of the archive nowadays not only consists of a site, a content, a technology, and a communication system but also encompasses life itself captured, increasingly, in its presentness.

Time has passed since Foucault famously suggested that the archive "is the border of time that surrounds our presence, which overhangs it, and which indicates it in its otherness; it is that which outside ourselves, delimits us" (2011, 147). His statement is, however, still crucial to explain why the archive is fundamentally "valid for our diagnosis" (p. 147). Here we see how the still evolving apparatus of the archive enables us "to draw up a table of our distinctive features, and to sketch out in advance the face that we will have in the future," as the archive establishes "that we are difference, that our reason is the difference of discourses, our history the difference of times, our selves the difference of masks" (p. 147). It is these differences that this study has been attempting to bring to light, as it is in these differences, I hope to show, in space and time, in practices and disciplines, roles and places, that the operation of the apparatus of the archive becomes most significant for our diagnosis and, possibly in the future, even for our treatment.

To explain why this is the case, I need to go back again to Agamben's writings about the apparatus. Agamben shows us that the term "archaic" means close to the ἀρχή, that is to say, the origin, or beginning, also from an authoritative point of view, including that of the archive, but the origin "is not only situated in a chronological past: it is contemporary with historical becoming and does nor cease to operate within it" (2009, 50). The present therefore is not only a moment in time, the now that the archive is so keen to capture, but rather it is the "unlived element in everything that is lived. That which impedes access to the present

is precisely the mass of what for some reason (its traumatic character, its excessive nearness) we have not managed to live. The attention to this 'unlived' is the life of the contemporary" (p. 52). This is why the apparatus of the archive is a strategy toward the establishment of our presence, the present, and our identity, toward memory creation and the marking of transformation, a tool for aestheticization, genomic treatment, and even a form of industry. The archive is what determines our ability to "be contemporaries not only of our century and the 'now,' but also of its figures in the texts and documents of the past" (p. 54). The apparatus of the archive is the network of strategies we use to map everything in both space *and* time precisely so that we may find what is as yet unlived in our lives.

1 A Brief History of the Archive

There is no political power without control of the archive, if not memory. Effective democratization can always be measured by this essential criterion: the participation in and access to the archive, its constitution, and its interpretation.

Jacques Derrida (1995, 4, note 1)

According to some scholars, the origins of the archival craze characterizing the late 20th and early 21st century stems from 19th-century Victorian England when imperialism induced a knowledge-gathering mania that aimed at synchronizing and unifying information at a global level. At this time, practices of writing were likened to mapping and colonization, archiving, and information gathering, ultimately leading to the creation of museums, nation states, as well as large national archives (Richards 1993). For others, it stems from the Enlightenment period, and formed part of the then emergent "scriptural economy" (de Certeau 1984, x). There are interesting parallels between these particular historical periods and the 20th and 21st centuries. These have manifested themselves, among other things, in a renewed fascination with archives, albeit nowadays usually digital archives. This chapter, introducing different archiving methodologies and practices stemming even further back in history, adopts Michael Shanks's theorization of Archives 1.0, 2.0, and 3.0 to show how archives evolved historically. Shanks explains that Archive 1.0 shows "bureaucracy in the early state—temple and palace archives—inscription as an instrument of management"; Archive 2.0 indicates a phase of "mechanization and digitization of archival databases, with an aim of fast, easy and open access … associated also with statistical analysis performed upon the data"; while Archive 3.0 consists of "new prosthetic architectures for the production and sharing of archival resources—the animated archive" (2008). The chapter, offering numerous examples of archives for each of these periods, builds on Shanks's model, tentatively introducing also Archive 0.0 and Archive 4.0, the latter, in particular, to show how archives now operate pervasively within the digital economy. The chapter demonstrates how the popularity of archives well precedes the archival craze of the late 20th and 21st centuries, showing, however, how the emergence of what has been described as an archival "impulse" (Foster 2004), or "*mal,*" or, in the English translation, "fever" (Derrida 1995), is in fact a condition, in the

postmodern sense of the word (Lyotard 1985), that is symptomatic of our obsession with the augmentation, documentation, and transmission of our own presence.

Archives 0.0 and 1.0

Both the ancient Greek and Roman empires had archival repositories, though little is known about them, since many had been destroyed during the invasions of the AD 5th, 6th, and 7th centuries (Duchein 1992, 15). In fact, even before that, archives had been assembled by Egyptians, Assyrians, Medes, Hebrews, Phoenicians, among others, though most of them were subsequently lost, probably because they were formed by organic materials like papyrus or paper. Middle Ages archives, in contrast, usually created by churches, royal families, or political leaders and cities, survived, often almost intact, into the present day. There are well-known exceptions, such as Alexander's edict to Priene, which consists of a series of inscriptions, and was described as an "'archive of' connected texts" (Sherwin-White 1985, 69). What is distinctive about this, as well as other archives of the Hellenistic period, is that a community had chosen these inscriptions to make public a particular version of events, suggesting that the history of such an archive had, even in those early days, formed part of the history of the civic community in some respect (p. 74). These initial archives, described by Shanks as archives 1.0, not only, as he suggests, show the bureaucracy of the early state (2008), but also reveal information about transactions by individual traders (Veenhof in Faraguna 2013, 27–63) and often mark the occurrence of salient events in family histories, including those pertaining to women (Jacquert in Faraguna 2013, 63–87). Arguably, a form of pre-archive (Fissore 1994, 344), or, possibly, Archive 0.0, this kind of archive tends to be quite local, focusing on the story, or history, of a given person or community. Interestingly, it is often difficult today to interpret the significance of the various components of these archives. Thus, in excavating ancient archives, it is not always clear whether archeologists are dealing with an archive or, simply, with the remains of some waste. Prussian state archivist Ernst Posner, for example, tells the story that when Berard P. Grenfell, Arthur S. Hunt, and J. Gilbart Smyly discovered the mummies of the "papyrus enriched" holy crocodiles in Egyptian Tebtunis, they included in their publication a "'classification of papyri according to crocodiles,' for papyri in the belly of the same animal might reveal relationships reflecting their administrative provenance and original arrangement" (1972, 5).

The word archive comes from the old Indo-European root APX, which also appears in Sanskrit and other languages (Leavitt 1961, 175). In Athens the archons were the chief magistrates, who were in power and were also the elders (p. 175). The neutral form of the adjective came to be used as a noun and meant "the residence or office of the chief magistrate," "the senate-house," or in small towns, "the town hall." In the plural the word indicated public records kept in the senate house or town hall (p. 175). The Romans tended to use the words *tabulae* to refer to boards, tables, or tablets on which they wrote (p. 176), though, later, they too begun to use the word *archivium* or *archium,* which had been derived from

the Greek *arkheion.* The word archive means both "the place where records are kept and the records themselves" (p. 178). Implicit in archiving is also the practice of preservation in that "only records worthy of being kept" can enter archives (p. 177). It may not be so surprising that already in Roman Egypt the system of state archives became synonymous with its administration. The five names that started to be used regularly to designate archives, *grapheion, agoranomeion, bibliothēkē, katalogeion,* and *mnēmoneion* (Cockle 1984, 110) thus point to different aspects of the bureaucratic machinery at the heart of its administration. So the archive started to designate a site as well as its content (see also Casanova 1928, 11) and was increasingly identified with what could persist over time, including, possibly, as we know from Posner (1972), whatever else was in the archive that also survived through it. This persistence was made possible through processes of inscription, categorization, preservation, and dissemination.

It was Jacques Derrida who pointed out that the archive represents both the *"commencement* and the *commandment"* indicating "there where things *commence*—physical, historical, or ontological principle—but also the principle according to the law, *there* where men and gods *command, there* where authority, social order are exercised, *in this place* from which *order* is given—nomological principle" (1995, 1; original emphasis). This coexistence of the physical, historical, or ontological and the nomological principles is, for Derrida, evident in the origin of the word, the Latin *archivium* or *archium,* which in turn, as we have seen, comes from the Greek *arkheion,* and indicates "a house, a domicile, an address, the residence of the superior magistrates, the *archons,* those who commended" (p. 2). For Derrida this means that "the archive, as printing, writing, prosthesis, or hypomnesic technique in general is not only the place for stocking and for conserving as archivable content of the past," but rather that "the technical structure of the *archiving* archive also determines the structure of the *archivable* content even in its very coming into existence and in its relationship to the future" (pp. 16–17; original emphasis). In other words, the technologies and related processes of what he calls the *"archiving* archive" shape and so determine present and future encounters with archivable materials. For Derrida therefore, "archivisation produces as much as it records the event" (pp. 16–17). Not only is the archive a tool for preservation, and a mechanism for dissemination, it is an ordering system for the production of knowledge. The archive is therefore a site, its content, a medium, and the mechanism, the *"archiving* archive" for its production (pp. 16–17; original emphasis). In this sense, archive is also a verb.

Categorization methods have varied over time and reflect the changing priorities of societies. In fact archives often served different purposes, even within one organization or society. For example, the city of Venice never had just one generic archive; rather each magistrate court could archive its own papers. However, the powerful *Consiglio dei Dieci,* the Council of Ten, one of the main governing bodies of the Republic of Venice between 1310 and 1797 whose actions were often secretive, kept their own archives in the *Segreta,* or Secret Archive, particularly during the 17th and 18th centuries when they were in danger of being mixed with other archives. When an inventory was made of these by Antonio Negri in 1669, he

found that it consisted of 75 *armari* or cases ordered according to the importance of the court that had deliberated. However, over time, these archives became so corrupted that in 1692 Pietro Garzoni drew the attention of the Senate and the *Consiglio dei Dieci* to it (Casanova 1928, 373) and in 1716 old rules were re-applied, which meant nobody could visit without permission and write on any of the papers in the *Segreta*. Despite these measures, it was not too long before old practices were reinstated and in 1783 a "president of the archives" was appointed to make sure a system for preservation was identified and maintained. The history of these archives, their periodic separation and corruption, is indicative of the Venetian structures of government, suggesting that the archive is generally a good *topos* for the study of how individuals or social groups manage their power, whether this is political, administrative, legal, or other.

One of the principal archival collections of all times, and a good example of an archive 1.0, is the Vatican Archives. These were, from their inception, not local, and spun over several hundred years, though, typically, a large percentage of these archives were either destroyed over time or simply disappeared. Like the Venetian Archives, the Vatican Archives do not consist of one physical archive but rather of a set of collections residing under different administrations and reflecting their bureaucratic systems. Thus, for example, there were the separate archives of the Consistory, the *Dataria Apostolica*, the Tribunal of the Rota, the *Secretaria Brevium*, the *Signatura Gratiae*, the Penitentiary, the Master of Ceremonies, the Holy Office, as well as the special repositories of the Sistine Chapel and St Peter's, among others (Haskins 1896, 41). One of the main Vatican Archives is the *Archivio Segreto Vaticano* (Secret Vatican Archive), which hosts the archival holdings of the Holy See, dates back more than a thousand years and spans tens of miles of shelves (Blouin, Yakel, and Coombs 2008, 410–11). The modern archives of the Holy See were established around 1610 by Paul V Borghese, but materials were collected even in apostolic times as part of the *Scrinium Sanctae Romanae Ecclesiae* the Popes took with them as they traveled to their various residences. However, most documents preceding Innocent III were lost because of the fragility of materials and political upheavals. In the 15th century the most important remaining documents were taken to Castel Sant'Angelo and finally, by intervention of Paul V, moved next to the Secret Library were they became known as Vatican Secret Archives. Under Urbanum III, during the 17th century, they were expanded and in the 18th century they were for the first time put in order. Many fonds are still in that order today. In 1810, by order of Napoleon, the archives of the Holy See were taken to Paris, and then brought back to the Vatican between 1815 and 1817. This caused great losses. When the Italian troops conquered Rome in 1870, the archives found outside the Vatican walls were confiscated by the newborn Italian State. They then constituted the core of the new State Archives of the city of Rome. Today, the archives, despite historical depletion, consist of 85 linear kilometers of bookshelves gathered in over 650 different fonds, covering 800 continuous years from 1189 onward (see Archivi Segreti Vaticani).

Traditionally, archives kept evidence of legal and economic transactions to serve particular bureaucratic purposes. For ancient archives this often included papers about the laws of

the land, evidence of administrative action, financial and accounting records, records of the ruler, records about control over people, and notarial records that safeguarded transactions (Posner 1972, 3–4). Such archives tended to be used as instruments of management, legitimization, and consolidation of power. Unsurprisingly then, archivists were often associated with the preservation of this power. Thus, when in 14th-century Ferrara, the citizens, weakened by poverty and aggravated by a series of natural disasters, including famine and the plague, rebelled against the corrupt *Marchese* Niccolò II d'Este (1338–1388), they brutally murdered his archivist Tomasso da Tortona, who was the secretary of the new *cancelleria* or state chancellery at that time, while shouting "long live the *Marchese* and death to secretary Tomasso" (in Brown 1997, 2). The *Marchese*'s strategy, like that of other d'Este princes, had been to distance himself from their own "highly unpopular policies" and, instead, blame the policies on their advisors and appointed communal officials, so Tortona had in fact just been "the first in a long line of sacrificial lambs" (p. 11). Furthermore, at the d'Este court, on three occasions, namely on Good Friday, on the eve of the *Festa di San Giorgio,* St George's Festival, and during the *Festa dei Poveri*, The Paupers' Festival, the destruction of archival record was officially admitted and sanctioned via a ceremony (p. 21). Thus, accompanied by the clergy, cloistered representatives, and courters in attendance, featuring the cathedral altar as a backdrop, the Duke, during a mass, let prisoners go and, at that moment, solemnly destroyed, or at least removed, their records from the archive. Problematic past actions or histories would at that point be erased and new lives could be started.

In this kind of archive, inscription is synonymous with power, though interestingly, the order of such archives, because of frequent institutional changes, was not as significant as it was in subsequent historical periods. However, already by the 13th century there was an awareness that archives played an important role in municipal life and their order and integrity were protected by specific rules and procedures (Bonfiglio-Dosio 2005, 95) even though, as we can see from the example of the Venetian Archives, practices varied widely. At that time archives were described as *loci publici in quibus instrumenta deponentur,* that is, "public places where legal documents are to be deposited" (Duchein 1992, 15; Sandri 1968, 108). Interestingly, and in line with Derrida's presupposition, archival repositories in Hungary were called *loci credibiles*, or "places which give legal credibility to the documents kept within it" (Duchein 1992, 15). This shows how archival sites, rather than their content, had become synonymous with their authority. By being in an established archive, a document gained in credibility and, possibly, believability. At these times archives, of course, were not always public (hence also the Venetian and Vatican archives' reference to secrecy). Until the First World War, and with the exception of France, archives had in fact usually been inaccessible to the majority of the population. Modern archival thinking about archives as a form of *public* heritage can only be traced back to the French Revolution when, in 1790, the French National Archives were created, from various government religious and private records, and made public for the first time. This event marks the beginning of a process of democratization of the archive that, to some extent, is still ongoing.

From the 14th century, archives started to proliferate, acquiring an increasingly promi-
nent role and forming a gradually more significant part of other forms of collection, such
as the cabinet of curiosity whose influence over the way we use social media I will discuss
in chapter 5. By the 18th century, there were known to be, in Paris alone, 405 treasuries of
archives with the overall number in France reaching 10,000 by the end of the ancient régime
(Burr 1902, 656). At this point in time, the most common documents in archival reposito-
ries were still titles of land property and documents of economic significance. Monasteries
were often home to such archives, as were royal chanceries, civil and ecclesiastical courts,
and municipalities (Duchein 1992, 16). From the 16th century onward, archives started to
be handled by specialist staff. One such archive was the Archivio de Simancas in Spain, cre-
ated in 1542, which hosted all the records of the councils, courts, chanceries secretaries,
treasuries of the Castilian Crown. A significant date, in this respect, is 1610, when James I of
England appointed Levinus Monk and Thomas Wilson as "Keepers and Registers of Papers
and Records," thus creating the series of State Papers, which is now the core of the Public
Record Office. That same year, as we have seen, marked the creation of the Vatican Archives
in their modern form. As "administrative monarchies" multiplied over time, the production
of records and their preservation practices, the archival machinery, started to grow in signifi-
cance (p. 16).

For Michael Duchein "an archival science," however, did not emerge till the 17th cen-
tury when, after the work of Baldassare Bonifacio, who in 1632 wrote the first known thesis
on the management of archives, a number of treatises started to appear on the subject in
Italy, France, Germany, and Spain, showing conflicting theories about the best methods for
the arrangement and description of archives (1992, 16). Already at this stage theories about
selection started to emerge, and by 1731, royal instructions were given in the city of Turin
to the archivist of the Royal Archives of Sardinia to destroy "useless paper" (Lodolini 1984,
234). Modern archival principles, however, were only articulated in 19th-century France and
Germany, in the aftermath of the French Revolution, leading to the publication of major
studies by Dutch, English, and Italian archivists, such as the *respect des fonds* principle, and
the *Registraturprinzip* (Rabe Barritt 1993, 43). For Duchein, the modern administration of
archives in Europe begun when it became clear that archives were no longer just historical
repositories but needed to receive continuous updates from administrative centers (1992,
18). One of the most significant studies about archiving, the *Manual for the Arrangement and
Description of Archives,* also was published at this time, in 1898, by the Dutch Samuel Muller,
Johan Feith, and Robert Fruin, and subsequently translated in French, German, English, Ital-
ian, Portuguese, and Chinese, among other languages. This seminal work articulated the
principles concerning the nature and treatment of archives, including the fact that archives
from different creators must not be mixed or based into artificial arrangements dependent
on chronology, geography, or subject, but rather that the arrangement must be based on
the original organization of the collection, which may in turn reflect the organization of

the administrative body that produced it. These rules are now known as the principles of provenance and original order.

The introduction to the 2003 re-edition of the *Manual* notes that while this text is regarded by many as a starting point for archival theory and methodology, it drew substantially from the way the Dutch arranged and described archives in the century before its publication. Whereas, traditionally, archives had served to settle legal disputes and support a particular political entity and its bureaucracy, during the 18th-century Dutch administrators started to consider archives as "a source of knowledge about their cities and thus about the heroic acts of their own forefathers" (Horsman et al. in Muller et al. 2002, v). Hence archives became increasingly significant as collections of historical resources "within which the formal documents, as irrefutable evidence of the historical facts, were considered to be the most important" (p. v). This change in perspective led to the appointment of the first "archivist," Hendrik van Wijn, in 1802, followed by others after 1813, the year of the establishment of the kingdom of the Netherlands. These, in collecting pre-1795 archives decided to "put together, as far as possible, *what belonged together*" (p. vi; original emphasis). Differently from the Middle Ages, when archives were created by religious and secular potentates "to prove their claims to power," after the 16th century the administrative activities of princes, lords, and cities became so extensive that "'other legal deeds apart from the charters had become indispensable as evidence and memory" (p. vi). The principle of original order stems from this identification of an archive with a community (i.e., city, province or state) and the growing belief that "archives held by one community" should not "be amalgamated" with the archives of another (p. viii). However, as communities grew, and new acquisitions were gathered, archivists started to sort materials according to agencies and consider these as separate "fonds" (p. xi).

The *Manual* was crucial for articulating these practices into a framework, suggesting that archives from different record creators should not be merged and that files should not be split or broken up. The *Manual,* however, dismissed the idea of a community archive by stating that archives are created by and located with administrations, not communities (p. xviii). Thus the Principle of Provenance ruled that if one administration ceased to exist, archives would be passed on to those replacing it even though this new group may be in a different location. In 1881 the Principle of Provenance was introduced at the Privy State Archive in Berlin, stipulating that archival files were to be accumulated in the place where they originated before being transferred to the archive. The *Manual* indicated that archives needed to be systematically arranged according to an original order, rather than alphabetically, chronologically, or by keyword. In other words, archival materials were not to be considered as "independent of their original relationship" (p. xix). The Principle of Provenance was also acknowledged as "a system of arrangement of public archives whereby every document is traced to the governmental body, administrative office or institution by which it was issued or received and to the files of which it last belonged when these files were still in the process of natural accretion" (Van Laer in Rabe Barritt 1993, 49).

According to the Principle of Provenance, records cannot be arranged according to subject matter and what is important is their organization, which occurred elsewhere, and at a different point in time. It is therefore clear that the records kept in an archive based on the Principle of Provenance "refer their users back to the conditions under which they emerged (in the other place), the media that helped produce them, the business of which once they were a part, the techniques and technologies that were critical for their emergence" (Spieker 2008, 18). The Principle of Provenance thus reminds us that in an archive, it is never just a question of what is being stored, but rather of "what is being stored *where*" (p. 18; original emphasis). In this sense, archival documents are site and time specific to the archive they are in. Moreover the identification of provenance is telling in relation to the identification of the archive as an ordering system. In this context, the interdependence of archival documents is crucial (p. 18). Documents, in consequence, started to be seen as part of a network of relationships, a broader knowledge economy, within a given environment. The archive as a noun (i.e., as site), and its material content, and archive as a verb (or process), Derrida's "*archiving* archive" (Derrida 1995, 16–17; original emphasis) started to be considered as interdependent. It was stipulated that adherence to the Principle of Provenance would reveal a "preexisting organic 'archive body' showing 'single files and records represent the cells of a living body flooded by a life force [*Lebenskraft*]'" (Brenneke 1953, 22). In this sense, as I will discuss in chapter 6, the archive is not only an ordering system that facilitates the live transmission of knowledge, it is an ordering system that has a "live force," that is *(a)live*.

I have already pointed out that Thomas Richards identifies the origins of the archival impulse in the 19th-century Victorian England, with the establishment of institutions like the Royal Geographic Society, the Royal Photographic Society, the British Museum, and the Colonial Office (1993). Imperial Britain was in fact founded on the production of paper and documents, and the Imperial Archive is characterized by its insatiable desire to gather and share knowledge. This led to a series of changes in the ways that archives operated, primarily to do with power. Thus Richards, for example, draws attention to the change in meaning that occurred at this time of the word classification, which at midcentury meant "ordering information into taxonomies," while, by the end of the century, indicated "knowledge placed under the special jurisdiction of the state" (1993, 6). In imperial mythology, the archive was, for Richards, in fact "less a specific institution than an entire epistemological complex for representing a comprehensive knowledge within the domain of Empire" (p. 15). In other words, in late-Victorian England, as Richards shows, the archive became a function of Empire, taking "the form not of a specific institution but of an ideological construction for projecting the epistemological extension of Britain" (p. 16). Herewith, the archive became synonymous with its owner's ideology. Acting as an instrument not only of local, but of global power, the archive became symptomatic of acts of global political "presencing" (Giannachi and Kaye 2011), necessary for the establishment of connections between a subject and their environment as part of a broader (political, cultural, social, market) economy. To be present globally, to be part of a global circulation, required being present in the archive. The impact of this

change in the way archives were conceived brought on what has been described as an archival "impulse" (Foster 2004) or "fever" (Derrida 1995), to do with the tracing of this presence over time. This shift marked the beginning of a mania that saw Derrida's *"archiving* archive" (16–17; original emphasis) become a primary mechanism for the circulation as well as for the control of ideas pertaining to (cultural, national, individual …) identity. The archive hence became an instrument for the global production, storage, and circulation of knowledge. This led to a substantial proliferation of archives, which in turn brought to light the importance of the role of the representation and self-documentation of the point of view within the archive. The use of technology and the acknowledgment of the role played by the user mark the shift from Archive 1.0 to Archive 2.0.

Archives 2.0

I have shown how, over the centuries, archives started to be considered not only as locations or objects but, increasingly, as media, and communication strategies. As a consequence their processes of storage and transmission became more and more the focus of scholarly attention. For Shanks, Archive 2.0 marks a change in archival practice, pointing to the beginning of a phase of "mechanization and digitization of archival databases, with an aim of fast, easy and open access, based upon efficient dendritic classification and retrieval, associated also with statistical analysis performed upon the data" (2008). Archive 2.0 emerged in response to the success of Archive 1.0, not just as a technology but also as an economic practice whose most significant objective was to manage the expansion of archives, in terms of their size, quantity, and hybrid nature so as to facilitate the global production and circulation of knowledge. A crucial shift occurred during this period that saw the emergence of Archive 2.0, from the industrial and bureaucratic era described by Richards (1993), in which the world witnessed the appearance of steamboats, trains, clocks, statistical thinking, national museums and archives, for example, to a digital economy based on computers and database technologies, contingent on human computer interaction. During this era, profound changes took place in the ways archives were built, accessed and shared. New systems of catalogization substituted old ones, with computer files organized "by multifaceted classifications and with an infinitely reconfigurable past" (Bowker 2005, 136). These changes, as I will discuss in the forthcoming chapters, brought on substantial shifts in the ways that archives are understood in the 21st century. One such change was the understanding that archives could entail and produce different, possibly even contrasting and yet coexisting, systems of value.

It was during this period that two of the most influential works on archival theory and practice were produced by Hilary Jenkinson and Theodore Schellenberg. Both were partly in response to the changes brought on by the shift from the scriptural to the digital economy but also, more broadly, a reflection of the changing role of the archive as a global circulation system of the newest and perhaps most valuable "commodity," namely knowledge. The latter had also been commented on by a number of other theorists. Thus, elaborating on Karl

Marx's writings in the *Grundrisse* (1857–58), Jean-François Lyotard captures one of the most distinctive features of this period. For him, knowledge has become "the principle force of production" and will perhaps be "a major—perhaps *the* major—stake in the worldwide competition for power" (1984, 5; original emphasis). Hence the control over the principles of the "*archiving* archive" (Derrida 1995, 16–17; original emphasis), and the control over the generative power of the archive, became timely, as Schellenberg's work shows. So, for Jenkinson, as well as for Schellenberg, archives should be accumulated rather than collected (Stapleton 1983–84, 77). Both Jenkinson and Schellenberg observed respect *pour les fonds* in the arrangement of archives, the principle of provenance, and broke down archives into manageable units, but whereas Jenkinson thought archives were impartial and authentic, and needed to be preserved for their creator, Schellenberg criticized the control of individual documents and suggested that records had both primary and secondary values and that all these values needed to be fostered. For Schellenberg, primary values reflected the importance of records to their original creator and secondary values to subsequent researchers. Secondary values could be evidential (linked to Jenkinson's sense of archives as evidence) and informational (pp. 77–78), in the sense that they could generate further knowledge and thus turn the archive into a formidable force for the production and circulation of knowledge. This subdivision into primary and secondary values resurfaced in Suzanne Briet's "What Is Documentation" (1951), which distinguishes between the functions played by primary, secondary, and auxiliary documents, all of which are, as we will see in chapter 3, of significance within Archive 3.0. What Jenkinson called "the material evidence" of historical cases (2003, 246–47), was later picked up by Elizabeth Diamond who suggested that "archivists, like forensic scientists, become expert witnesses, testifying to the nature of the documents" (1994, 142). Over time, and as we know from Suzanne Keen (2001), novelists then popularized this distinctive feature of archival practice, and writers such as A. S. Byatt, Peter Ackroyd, Julian Barnes, Penelope Lively, Margaret Drabble, P. D. James, Graham Swift, and Kinglsey Amis, as well as postcolonial novelists Salmon Rushdie, Keri Hulme, Amitov Ghosh, Bharati Mukherjee, and Dan Brown, among others, exploited time and again the *topos* of the archive, as did popular films like *Indiana Jones and the Last Crusade* (1989), *The Mummy* (1999), and *Possession* (2002). The burgeoning featuring of archives in fiction, and, later, film, firmed up their role within our popular cultural imaginary as sites of discovery of hitherto unknown pasts and possible futures often associated with the gaining of some form of wealth (economic, personal, etc.) or value (moral, religious, scholarly, and personal).

One more distinction between Jenkinson and Schellenberg's approaches to archives is worth singling out: whereas in the end Jenkinson departed from the idea of *fonds d'archives* and, instead, talked of "archive groups," containing the entirety of records "from the work of an Administration which was an organic whole" (in Cook 1997, 24), Schellenberg believed that archives were the portion of materials or records received that the archivist had chosen to preserve (pp. 28–29). This is significant in that it presumes that only what has continued to form part of the "*archiving* archive" (Derrida 1995, 16–17; original emphasis), what persisted

over time, almost in Darwinian terms, is what constitutes the archive, whatever the actual values of the content, hence the significance of the "papyrus enriched" holy crocodiles in Egyptian Tebtunis (Posner 1972, 5). During this period, archives grew exponentially in size and the problematics associated with this growth often determined archivists' approach to conservation and preservation. For example, when the National Archives in Washington were created in 1934, they inherited a backlog of about one million meters of federal records, with a growth rate of more than sixty-thousand meters annually. By 1943, that growth rate had reached six-hundred-thousand meters annually. This led to the emergence of the North American records management profession to help agencies deal with what was described as a paper "avalanche" (Cook 1997, 26). The problem of how to deal with the ever-growing quantity and size of archives is perhaps what most clearly describes the consequences of the emergence of Archive 2.0. Jenkinson's idea of "archive groups" and, in particular, as I will discuss in the forthcoming chapters, of interrelated archives, springing, almost organically, out of one another, is a defining characteristic of this phase that is still predominant today.

In the 1970s and early 1980s, debates proliferated over what Terry Cook described as the "first generation" of electronic record archives. There was, in his words, "a strong emphasis on information content over provenancial context, on library cataloguing over archival description, on one-time, one-shot statistical datafiles over continuously and continually altering relational databases and office systems, and on treating electronic datafiles as discrete and isolated items rather than as part of the comprehensive, multimedia information universe of the record creator" (1997, 40). In the mid-1980s, new information technology featuring relational databases became more common, and one of the challenges for archivists became how to translate the old principles into the electronic age. In particular, whereas in the past archival principles were derived from records that originated in "stable, mono-hierarchical institutions," digital records often originated in "unstable institutions," which meant that the focus tended to shift from the individual record to the functions and transactions of the record creator (p. 45). For Cook, this encouraged archivists to stop acting as passive keepers of documents left by creators and become "active shapers of the archival heritage" (p. 46). In the aftermath of this, archivists should perhaps no longer be considered as "custodians of inherited records," but rather, as we will see in chapters 2 and 3, they should be thought of as "active builders of their own houses of memory" (p. 46).

The most significant impediment to the accessibility of electronic records has been technological obsolescence, which means that in some ways the emphasis has shifted from preservation of the information carrier or medium to the facilitation of accessibility over time, something that has been described as "a question of readability, retrievability and intelligibility" (Dollar 1993, 45). Hugh Taylor was an influential analyst of the growing significance of electronic records and the concerns over obsolescence associated with them. For him, electronic records marked "a return to conceptual orality" (in Cook 1997, 34), namely "a return to the medieval framework where words or documents gained meaning only as they were 'closely related to their context and to actions arising from that context.'" For Cook, in

this particular kind of oral tradition, "meaning 'lay not in the records themselves, but [in] the transactions and customs to which they bore witness as *evidences*'" (p. 34). For Taylor too, meaning arose out of the network of contexts, which records capture. This marked a significant change in the way that records and documents were subsequently understood. For Cook, this change showed "a shift away from viewing records as static physical objects," "toward understanding them as dynamic virtual concepts," and a shift away from looking at records as the product of administrative activity and toward considering them as "active agents themselves in the formation of human and organizational memory" (2001, 4). Records, with this, become prompts for stimulating relational thinking, aiding memory formation and facilitating identity reformulation. In turn, archives became the sites where these processes of replay and transformation were seen to be taking place.

We know that archives have always, to some extent, operated as presencing tools. The question then is what exactly did these archives facilitate presencing with. During the phase described as Archive 1.0, archives consisted primarily of papers pertaining to legal and land matters. On the other hand, during the phase described as Archive 2.0, archives became increasingly associated with the archive's role as media, and attention started to be devoted to the role of the archive's creator and, even more important, its interpreter. This change in archival practice is related to the emergence of the information society. As Lyotard noted, with the raking up of grand narratives, people have been increasingly located at "nodal points" of "specific communication circuits," "at a post through which various kinds of message pass" (1984, 15). Archive 2.0 became identified with this network of nodes that could endlessly reconfigure itself, whatever was at the center. Thus Archive 2.0 became a generative tool, capable of programming its own growth and re-position its user within its different configurations. With this, increasingly, Archive 2.0 started to act as a transmitter of more or less subjective knowledge entailing varied and often hybrid documents (primary, secondary, auxiliary) that had different values for different users. Hence Archive 2.0 was no longer necessarily associated with a physical site, nor was it a mark of truthfulness, credibility, or authority, rather it was a database representing an amalgam of materials, of differing, often subjective, values, including, as ever, also obsolete materials and waste, that was capable of somehow augmenting the user's sense of their own presence. It was also the mechanism for its transmission. In fact, increasingly, Archive 2.0 can be described as a plurality of archives that aid the constant flow of knowledge in a global economic market wherein the user is not only a part of, but also, more and more, an instrument in their creation and propagation.

An example of an Archive 2.0 is the September 11 Digital Archive, organized by the American Social History Project at the City University of New York and the Center for History and New Media at George Mason University, now supported by the Library of Congress. The September 11 Digital Archive represents a comprehensive attempt to "collect, preserve and present the history of September 11 attacks" (September 11 Digital Archive). The archive welcomes submissions in multiple and hybrid forms and media, and allows for participation by

anyone who was involved, or was even simply moved by the events of September 11. Users are here positioned as active participants in the unfolding of the history of this day, regardless of their age, nationality, or location on the actual day of the terrorist attacks. Thus the archive consists of firsthand accounts of people directly and variously affected by the events, as well as individual stories of people who do not have any connection to the events but wish to comment on their experience of it. There are, among other things, stories, photos, emails, including individual emails sent and/or received on or shortly after the September 11 event; large collections of emails from institutions, organizations, and other groups such as a collection of over 11,000 emails from the Department of Justice, and from the Madison Area Peace Coalition. There are also posters, letters, cards, brochures, event programs, press releases, announcements, and so forth, collected from the streets of New York; action plans, reports, studies, white papers; newspaper articles (the Independent Press Association collection); various other documents produced by a variety of organizations and journals on a more wide range of topics; and links to other relevant document collections. Additionally, the September 11 Digital Archive gives access to several special collections, like the Ground One: Voices from Post–September 11 Chinatown collection, which preserves interviews with Chinese Americans living and working in the area of Chinatown, the largest residential area affected by the September 11 events; the collection of stories from the National Museum of American History's September 11: Bearing Witness to History exhibition and website; the Here Is New York collection that hosts photographs of the September 11 events by professionals as well as by amateurs; the Sonic Memorial Project collection that holds audio traces of the World Trade Center and its neighborhood collected and submitted by radio and new media producers, artists, historians, and people from all over the world; the Library of Congress Witness and Response exhibition, a collection of stories, images, and emails from the public about the September 11 events and an annotated guide, organized by type and content, to September 11 websites and web resources.

There are differences between the September 11 Digital Archive forms of testimony and more traditional oral or written testimonies. The ones entailed in the September 11 Digital Archive, typically of Archive 2.0, include the fact that their production and dissemination is based on the use of digital and mobile technologies, which means that despite the fact that the original nature of the testimony is personal and private, it underwent "a constant transformation through its exposure and its presentation on the Internet, and it turns out to be collective and public at the same time" (Valatspu 2008, 113). Moreover, in the September 11 Digital Archive, "individual subjects that narrate their stories are simultaneously *producers* and *consumers* of history and the past" (113; added emphasis). No longer are the figures of the archivist and that of the user clearly distinct. The user-archivist generates materials while they are consuming those encountered in the archive. The individual who uses and produces the archive thus starts to experience what has been described as "a feeling of relationality to all the other individuals online, by living a relational digital life" (p. 113). This relationality is a distinctive feature of Archive 2.0 and through this the user not only is able to read

themselves as part of a node in the network but also, increasingly, as part of a history or even community that is present in a multiplicity of archives.

I have already said that the success of Archive 1.0 led to a proliferation of archives. This, alongside technological advances in the period of Archive 2.0, brought on what Hal Foster described as an "archival impulse" that was particularly manifest in the artistic sector, as it emerged in the aftermath of the invention of photography, which made it possible for artists to use archiving as a mode for the organization of the proliferation of images (2004). For Okwui Enwezor, the introduction of photography then generated a world of practices that were often staged directly for the camera (2008, 22). These flattened the distinction between a work and its documentation, or even between an event and its trace in the archive. This is particularly true for performance pieces that consist of their documentation such as works by Ana Mendieta, Lynn Hershman Leeson, Richard Long, among others, "whose activities of inscription were only possible through the medium of photographic representation" (p. 23). For Foster, the "archival impulse" had in fact started "when the repertoire of sources was extended both politically and technologically (e.g., in the photofiles of Alexander Rodchenko and the photomontages of John Heartfield)" (2004, 3). This mode of work then became prevalent in both the 20th and 21st centuries, so that, increasingly, "appropriated images and serial formats" became "common idioms (e.g., in the pinboard aesthetic of the Independent Group, remediated representations from Robert Rauschenberg through Richard Prince, and the informational structures of Conceptual Art, institutional critique, and feminist art)" (p. 3). For Foster, artists engaging with these kinds of archival practices sought to make historical information, that may have been lost or displaced, "physically present" and to this end their practice, as we will see in chapter 5, often privileged, as had been the case for cabinets of curiosity beforehand, the display of "the found image, object, and text," through the installation or exhibition formats (p. 1). Thus Foster notes, for example, how some of these practitioners, such as Douglas Gordon, "gravitate toward 'time readymades,'" that is, "visual narratives that are sampled in image projections, as in his extreme versions of films by Alfred Hitchcock, Martin Scorsese, and others" (p. 2). These sources, he suggests, can be familiar, "drawn from the archives of mass culture," as well as "obscure, retrieved in a gesture of alternative knowledge or counter-memory." Noticeably, these kinds of works, as well as those deliberately blurring the distinction between an occurrence and its documentation, often pushed notions of "originality and authorship to an extreme" (p. 4), leading to the acknowledgment that archives, and their materials, can be repeatedly re-played and, through this process, may acquire further value. In chapter 4 we will see how these practices, no longer object-, but process-oriented, frequently adopted archival strategies to facilitate engagement. With the adoption of archival practices by leading 20th- and 21st-century artists, the archive, already a good *topos* for the study of power and identity creation, and already part of our evolving cultural imaginary, became an established strategy not only to present artifacts found in everyday life, but to refocus the viewer's attention on their act of viewing and the emergent body of knowledge associated with this act. This feature, which was to become

predominant in archive 4.0, transformed the archive, as I will show in chapter 5, into the interface that we, more and more often, use to frame our encounters with everyday life.

The curator Nicolas Bourriaud championed a number of archival art forms under the rubric of "post-production," which drew attention to how artists often facilitated the production of secondary and auxiliary documents, to use Briet's terms (1951), adding further value to original documents "after the event" (Bourriaud 2009). Interestingly, the term also suggests "a changed status in the work of art in an age of digital information, which is said to follow those of industrial production and mass consumption" (Foster 2004, 4). Thus, as I will show in chapter 5, we can speak of artists-as-archivists, artists-as-curators, artists-as-producers, artists-as-collectors and cabinet makers, and so forth (see also Foster 2004, 5). These artists do not only use archival materials as art, they also draw attention to their arrangement through archival logic, often using a matrix of citation and juxtaposition, strings, files, in other words, adopting technologies of order, what Derrida called the "*archiving* archive" (Derrida 1995, 16–17; original emphasis), to present work within "a quasi-archival architecture, a complex of texts and objects (again, platforms, stations, kiosks …)" (Foster 2004, 5). So, as I will discuss in more detail in chapter 5, Marcel Duchamp, for example, famously miniaturized his entire corpus into an edition of reproductions organized and codified as an archival system entitled *Le boîte-en-valise* (1935–41). These artists, we will see, were interested in the archive as a framing mechanism that could include viewers, thereafter often called participants or users, within the work of art.

To conclude, we can see in Archive 2.0 that no longer is the *topos* of the archive merely associated with a physical site or with a particular set of records and their histories, nor is it purely its content's ability to generate future memories, but rather it is the ordering mechanism that is increasingly adopted to shape the way we interface with and document ourselves in the everyday. Archive 2.0, and more so, Archive 3.0 and Archive 4.0, operate by folding everything back within themselves. Crucially then, as we will see in chapters 2 and 4, what is absent from the archive must always enter the ordering mechanism, the "*archiving* archive" (Derrida 1995, 16–17; original emphasis), precisely so as to be part of what could be described as an expanding social memory apparatus comprising the archive, as well as the museum, the library, and, nowadays, the Internet.

Archives 3.0 and 4.0

The use of archives by artists, critics, and curators in performative contexts has changed the way we understand and work with archives. So, for example, archives, as we have seen, are increasingly utilized as production tools (Osthoff 2009, 11) causing what has been described as a "contamination between artwork and documentation" (p. 11), artworks and archives, archives and found objects, archival practices and everyday life. This changing function of the archive has transformed it from "stable and retroactive" to "generative" (p. 12), which means that the user of the archive also plays a productive part in this process. However,

Archive 3.0 not only brings together physical and digital environments, often also consti-tuting, in Shanks's words, an animated (2008) or a mixed reality archive, it also creates the mechanism that facilitates the creation, dissemination and preservation of different types of values within the digital economy. Thus Archive 3.0, and especially Archive 4.0, have become not only a way to experience the place we inhabit but also, increasingly, the frame through which we interact with it, socially, politically, economically, and, as we will see in chapter 6, even from a medical point of view. Archive 4.0 is therefore not only the ordering system we use to design and act out the different roles we play within the digital economy but also, increasingly, the instrument or apparatus through which our bodies are (re-)pro-grammed inside out.

An early "animated" example of an artwork based on Archive 3.0, and in fact the one that prompted Shanks's writings about Archive 3.0, is Lynn Hershman Leeson's *Life Squared* (2007). Developed with funding from the Langlois Foundation by the Stanford Metame-dia Lab, directed by Shanks, Stanford University Libraries, Stanford Humanities Lab, then co-directed by Shanks and Henrik Bennetsen, in collaboration with Linden Lab and Pulse 3D Veepers System, and in conjunction with the AHRC-funded Performing Presence project (2004–2009), *Life Squared* consisted of the "re-production" of two earlier works, the site-spe-cific installation *The Dante Hotel* (1973–74; see figure 1.1) and the performance piece *Roberta Breitmore* (1972–78), in Second Life. This piece, exhibited in 2008 at Montreal Museum of Fine Arts and the San Francisco Museum of Modern Art, re-staged and "re-mediated" these works, investigating how the electronic medium of Second Life may extend and yet depart from the original works. Characteristically of Archive 3.0, the aim of *Life Squared* was to create "an overarching metanarrative and gamespace" within the online world of Second Life, that would integrate real and virtual architectures, character avatars, artifacts, somatic characters, and, in a later phase, situational components such as site tagging and GPS locators. Using content from the Hershman Leeson archive at Stanford Libraries Department of Special Col-lections, such as the *Fragmented Journal* from 1973, in which Hershman Leeson recorded her preparations for *The Dante Hotel* with artist Eleanor Coppola, but also numerous images, receipts, letters, interviews, and notes, fragments of information embedded within the story-line of a crime scene, the team aimed to "reveal layers of clues, each of which [would] propel a search for lost identity." In conception, the *Life Squared* environment was to be based on the "Private I" theme and motif that recurs through Hershman Leeson's work, and that we know is recurrent in archival literature, except that, in this instance, a "missing person" would be "traced through a trail of artifacts and partial or even erased information." Finally, a new "bot" character was to be created to "incorporate deviance" within three works (Shanks et al. 2009).

The early works mentioned above are crucial in the way *Life Squared* was conceived of, so more attention needs to be devoted to them here. In her first site-specific and performance work, *The Dante Hotel* (1973–74), visitors to a "real" run-down hotel in San Francisco encoun-tered "evidence" evoking fictional guests and events in the form of personal belongings

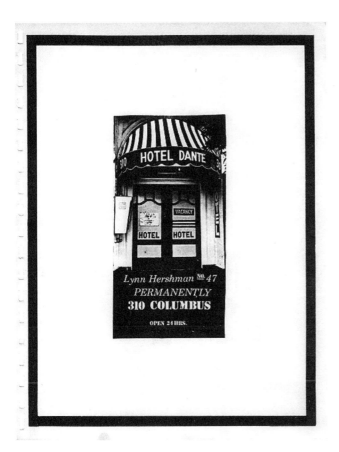

Figure 1.1
Lynn Hershman, *The Dante Hotel* (1973–74). Courtesy Lynn Hershman Leeson.

abandoned in two rooms. Thus *The Dante Hotel* begun on entry to the Hotel Dante, when visitors, Hershman Leeson notes, "signed in at the desk, and received keys," then walked up the stairs to the designated rooms. Through this initial interaction visitors and even residents, unwittingly, "became part of the exhibition" (Tromble and Hershman Leeson 2005, 23) as their "real" activity became the object of *The Dante Hotel*'s installation. For Hershman Leeson the character of Roberta, protagonist of the other work that was significant for *Life Squared*, *Roberta Breitmore*, was "bred out of" or "born" when "she arrived in San Francisco on a Greyhound bus" (Hershman Leeson in Tromble and Hershman Leeson 2005, 25), reputedly checking into the first hotel she saw, the Hotel Dante, because, she reported, "she likes the name" (Roth). This, of course, marks a connection between the two works *The Dante Hotel* and *Roberta Breitmore*. Carrying with her $1,800, her entire life savings, Roberta then

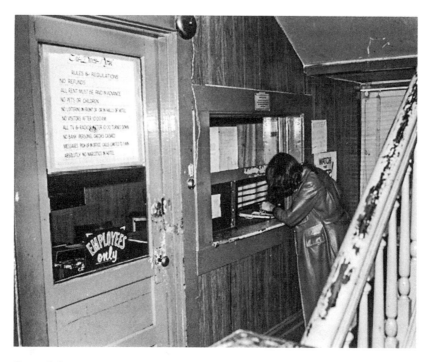

Figure 1.2
Roberta Breitmore at *The Dante Hotel*, San Francisco, November 1973. Courtesy Lynn Hershman Leeson.

became involved in a series of social interactions: she picked up two credit cards, a driver's license, rented an apartment, placed an advert in the *San Francisco Progress* to advertise for a roommate, and met with each respondent to the advert three times in an implicit play between a "proof" and persistence of Roberta's presence to the applicant and the repetition staged by "performance." Meetings were documented photographically and each event was tape-recorded so that the people who replied to the advert became part of her "fiction" (Hershman Leeson 1996, 330). The semi-autobiographical persona of *Roberta Breitmore*, was therefore, subsequently, met primarily in "documentation"; hence Hershman Leeson's largely "unseen" and, arguably, archival performances, conducted and recorded over a six-year period were made available through their documents, namely exhibitions and publication that included correspondences, newspaper announcements, dental records, psychiatric assessments, and receipts of financial transactions.

Life Squared was modeled on the floor plan of Hotel Dante, in a re-staging of the site-specificity and interactivity of Hershman Leeson's "original." Visitors were thus invited to sign in a blue box to enter the project and a red one to enter the room, in which documentations

Figure 1.3
An early demonstration of *Life Squared* (then called *Life to the Second Power*) to the project team and other invited guests. Photo Gabriella Giannachi.

from room 47 at *The Dante Hotel* were reproduced. In place of a clerk, visitors would encounter a bot, named "Dante," who would guide them through a door. They would then climb a staircase and walk down a narrow corridor from which they could enter room 47 (see figure 1.3). Bennetsen points out: "each object had its function. The scrapbook, which was populated with scanned images of the original scrapbook ... was a vehicle for transporting knowledge" (in Giannachi and Kaye 2011, 58). Hershman Leeson describes the resultant piece as "a remix of original photographs from the archive of *The Dante Hotel* with virtual avatars trespassing, changing things, and leaving their trail" (2009, 14). Just as the visitors to the "historical" work, *The Dante Hotel*, frequently left traces of their presence in the rooms, here visitors to Second Life could impact on aspects of the installation. More broadly, too, and typically of Archive 3.0, *Life Squared* consisted of a series of interrelated and in part practiced or even performed sites, including a gallery space, a Roberta bot as well as the re-enactment of *The Dante Hotel*, all in Second Life, and as a whole the piece encompassed a display of virtual representations of materials from the Hershman Leeson archives.

In a further elaboration and multiplication of its sites, when the piece was exhibited at the Montreal Museum of Fine Art and San Francisco Museum of Modern Art in 2008, physical

archival and documentary materials were displayed alongside terminals allowing access to the Second Life installation, while the virtual counterparts of these objects were also displayed in the navigable Second Life environment. Finally, the traces left by the visitors in the virtual installation were captured over time by machinima and as still images. For Hershman Leeson this meant being able to "manipulate time," "looking at the past as a context to reconsider the present," reviving an earlier exploration of space, and "migrating this into a more contemporary form" (Giannachi and Kaye 2011, 54). In its presentation at the Montreal Museum of Fine Art, a two-way mirror was integrated into the work to produce a further multiplication of perspectives and spaces to be traversed by the visitor. For this installation, a large monitor was hung on the wall in both the Museum and in Second Life. The museum monitor permitted a view from the physical space into the contained space in Second Life, and vice versa, the Second Life monitor mediated the physical space into Second Life via a web cam. Visitors could thus explore Hershman Leeson's documentations displayed in the Museum and then re-explore them in their digitized form as displayed in Second Life, potentially being "present," and being able to document their presence, twice, in both sites (see figure 1.4).

Life Squared shows a series of characteristics that are distinctive of Archive 3.0. First, this kind of archive is an object and a process, but often also an artwork, a monument, an

Figure 1.4
Lys Ware (a.k.a. Henrik Bennetsen) taking a photo of Henrik Bennetsen taking a photograph of Lys Ware in *Life Squared*. Photo Henrik Bennetsen.

autobiography, a platform, and so forth. Second, it is often performative, and it could be more or less interactive, immersive, and pervasive. Third, it is not only deriving from (being born out of) another archive, but it is also frequently aware of the problematics of its own documentation. Fourth, the archive offers a multiplicity of viewing platforms to replay or even rewrite the past (sometimes through crowdsourcing), and capture the present through both old and new technologies. In this sense in Archive 3.0 we may have multiple identities, not only as users and producers of knowledge but also as performers or spectators, subjects, or objects. Fifth, as Shanks points out (2008), the Archive 3.0 entails new, often prosthetic, architectures and thus becomes akin to a cybernetic system wherein, in Wolfgang Ernst's words, "the aesthetics of fixed order is being replaced by permanent reconfigurability" (2013, 99), hence the increasing popularity of terms and practices such as reframing or re-loading. This marks the transformation of the archive into an adaptable re-playable set of interrelated platforms that interface with our everyday lives. Sixth, Archive 3.0 is therefore no longer just an "impulse" (Foster 2004) or a "fever" (Derrida 1995), it is the lens or interface through which we perceive, interact, and often extract value from our environment and, increasingly, the apparatus through which the latter can, quite literally, (in)form us.

We have seen that digital archives are often built so as to facilitate regeneration and co-production by users (Ernst 2013, 97). This explains the growing popularity of crowdsourcing, through which users are made directly responsible for producing new knowledge that may be useful to a particular organization. One such example is *ArtMaps,* which was developed as part of an interdisciplinary collaborative project between three departments at Tate (Tate Learning, Tate Online and Tate Research) and researchers in Computer Science (University of Nottingham) and Performance and New Media (University of Exeter), funded by RCUK Horizon Digital Economy (2009–15). Technically, *ArtMaps* consists of a web app optimized for mobile that allows users to explore over 70,000 artworks in the Tate collection through a Google Map interface (see figure 1.5), which facilitates their analysis in relation to the places, sites, landscapes, and environments that informed or led to their geotagging through their association with a specific location. The app can locate their users and bring up works in the Tate collection that are geotagged in relation to places near them.

Users can then look at these works on the map and/or explore them in situ (see figure 1.6), reflecting on how what they see in the works relates to their surroundings. Alternatively, through a search function (by artist and by location), they can explore works in any locality. They may then change the location of an artwork and add a comment reflecting on the reasons behind this change and/or what they think may be the relationship between a place and a work. *ArtMaps* constitutes a typical example of an Archive 4.0, attempting to engage users by bridging between or even overlaying physical and digital spaces, and prompting relational thinking in allowing users to juxtapose one with the other and so perceive one through the other while also producing new knowledge that may be of use for the organization hosting the archive.

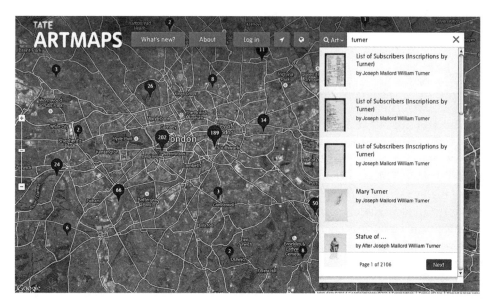

Figure 1.5
ArtMaps interface

Figure 1.6
ArtMaps used at Tate. Photo Ana Escobar. ©Tate Photography 2013.

Distinctively, with such archives, there is, in principle, no more delay between the present and the creation of its memory in the archive but rather the technical option of immediate feedback, particularly visible through the use of social media, turns all present data into instantly accessible archival entries and, vice versa, facilitates the re-interpretation and re-writing of canonic entries by users. In this context, "*streaming media* and storage become increasingly intertwined" and, because of this, Archives 4.0 could be described as "adaptive" and "transitive to their respective media (formats), meta*dating* (temporally, rather than static 'data'), flexible" (Ernst 2013, 98; original emphasis). For Ernst, this marks the "supremacy of selection over storage, addressability over sorting." With this, the archive becomes "a function of *transfer* processes" (p. 98; original emphasis). Archives, Ernst notes, "once online, are no longer separated from the actual infrastructure of Web-based data circulation," rather, they dissolve "into electronic circuits, data flow" (p. 100). Archives 4.0, while maintaining distinctive features of Archives 1.0, 2.0, and 3.0, can no longer be easily told apart from the environments that produce them. In fact Archives 4.0 become our environment.

While the responsibility for creating and sharing Archives 2.0, 3.0, and 4.0 is increasingly resting with users, their preservation remains a problem that is almost exclusively dealt with by organizations. Nowadays, an increasing number of documents are born digital, and thus crucially, archivists have become more and more concerned in defining the documentation, preservation, and archivization of such forms, not only as objects but also increasingly as processes. This includes the documentation of the user experience. Born digital works are ones that are "produced—and in some cases presented—using digital tools" (Dekker 2012, 65). Annet Dekker thus notes that in the case of artworks, it is important to maintain the authenticity and integrity of these works. For example, she points out, converting a text document into another format could introduce changes in the latter, but this does not usually have an effect on the content of the document and is therefore not a problem for an archive. Converting an artwork into another format, however, does have serious consequences for the aesthetics of the work (p. 65). At a symposium organized by her through Virtueel Platform in the Netherlands called *Archiving 2020,* the complexities of preserving born-digital artworks were discussed and different approaches were assessed, including "Jack the Wrapper" which "would involve putting all the software in a box ad describing and documenting the entire artwork so that it could be cloned in the future" (Dekker 2010, 6). Interestingly, this is, increasingly, the approach of a number of libraries to the problem of archiving the everyday (e.g., in Google Street View) or even of archiving the Internet, which means that data pertaining to our lives, including data that we may think may have been permanently deleted, have started to form part of various privately owned archives. To address the fact that not all born digital materials are worth preserving, or can easily be preserved and documented, however, "Darwinistic archiving" was considered, referring again to the "survival of the best documented artworks" (p. 6). Crucially, there was a call to change the term "digital preservation" to "permanent access," drawing attention to the fact that aging formats are likely to cause increasing problems in terms of accessibility (p. 7). Such studies show the burgeoning

importance that the digital is acquiring within cultural, economic, and, as I have shown elsewhere (Giannachi 2007), political contexts. At the same time they draw attention to the vulnerability of digital formats. In this sense digital archives are pervasive and yet porous, cannibalistic and yet fragile.

Caitlin Jones's study, which forms part of Dekker's edited collection, points out the approaches taken to address these problematics by a number of institutions whose practices have shaped the field of archiving digital media and born digital materials thus far. Particularly significant in this context, she notes, have been Matters in Media Art, a large-scale inter-organizational effort by MoMA (New York), SFMOMA (San Francisco), the Tate (London), and the New Art Trust (San Francisco) dedicated to the preservation and documentation of a range of media artworks. Likewise the Variable Media Network, with partners including the Guggenheim Museum, the Berkeley Art Museum/Pacific Film Archives, Rhizome.org, and a number of other smaller independent arts organizations, sought to develop new inter-organizational strategies for preserving works of variable media. In the realm of the Internet, a number of organizations have attempted to document the ephemeral history of Internet art. In 2003, V2_'s Capturing Unstable Media laid out a structure that allowed the DEAF Festival organizers to "capture" details about works of art rather than be obligated to preserve the works themselves. Typically for Archive 3.0, Rhizome.org's ArtBase accepts voluntary contributions to its archive of Internet art, and the Langlois Foundation, the major underwriter of both the Variable Media Network and V2_'s Capturing Unstable Media, proposed in their most recent project DOCAM (Documentation and Conservation of Media Arts Heritage) a wealth of tools and resources. A number of these projects are not only inter-organizational but also decentralized. Richard Rinehart and Jon Ippolito (both founding members of the Variable Media Network) have long suggested that the responsibility for preservation of media art should not be trusted to institutes but should be decentralized and distributed (2014), an approach that, in all likelihood, will be prevailing in the future among diverse organizations. Their proposed concept of The Open Museum is that of a self-archiving archive in which artists deposit their work at a central locale where the source code and files can be copied and downloaded by other users. Similar aims are at the heart of the Gateway to Archives of Media Art (GAMA) project. Based on the library model of "union lists" (which provides access to numerous library collection catalogs from one central access point), GAMA is a consortium of media art archives in Europe allowing access to their distributed and hybrid collections from one central point, thus promoting collaboration between archives with similar collections and mandates (see Jones in Dekker 2010, 41–48). Thus Archive 4.0 shows yet a further distinctive feature in comparison with Archive 3.0, which is that this kind of archive operates as a protective and authoritative gateway linking various types of archives to databases, physical and human environments, often globally, so that they may form an integral part of the digital economy. In fact Archive 4.0 frequently consists of a number interconnected platforms, which, as we will see in the forthcoming chapters, can adapt to different formats and host diverse contents so that they can be at once an exhibition space, a social media

tool, a teaching tool, a lens through which to experience the everyday, a memory theater, a media-archeological dig, a tool for the re-writing of history, an artwork, an object, life itself. Part of a larger, future-oriented social memory apparatus continuously folding the present into the past, and vice versa, reading the present through its past, the archive, the museum, the library, have become increasingly interchangeable.

In conclusion, throughout the ages, we have seen changes in what archives have collected that reflect the different roles played by archives in society (Schwartz and Cook 2002, 6). We have seen how, over time, archives have acted "as dynamic technologies of rule" that "create the histories and social realities they ostensibly only describe" (p. 7). As we know, archives always produce and disseminate the events they record and collect. This is why Joan Schwartz and Terry Cook call for an examination of archives against the backdrop of identity politics (p. 16) and, increasingly, the whole issue of ontology, as we will see in chapter 4, is growing in significance in the context of archiving.

In this excursus, we traveled from one era to another, tracking salient changes in archival practices, technologies, and methodologies. I have used Shanks's distinction for Archive 1.0, Archive 2.0, and Archive 3.0, and expanded it to include Archive 0.0 and Archive 4.0, to explain some of the fundamental changes in archival practice, showing the emergence of different archiving technologies, from the papyrus, to the card index, the typewriter, the database, born digital materials and virtual and mixed reality architectures, to hybrid, interrelated and generative meta-archives that act as portals to the digital economy. We have looked into how and why we have become increasingly obsessed not only with our presence in the archive but also with our ability to record this presence in the now and to fold it within the archive, so much so that our everyday lives have started to be continuously integrated within the archive as part of what we call the digital economy. Through this excursus into the history of archival practices, we have seen that archives have never been just "passive storehouses of old stuff," but rather that they have operated as 'active sites where social power is negotiated, contested, confirmed" (Schwartz and Cook 2002, 1). We have seen how archives, libraries, museums, the Internet, have become more and more interchangeable, forming part of a broader social memory apparatus. Finally, we have seen that archives have always been at the very heart of the way we live. By studying how we build ourselves in the efficacious and pervasive apparatus that is the archive, and so augment our daily life through the archive, and its interchangeable faces (the museum, the library, the Internet), we therefore can learn not only about who we are, how we wish to read our past, and what we hope to be in our future, and then again, how we increasingly use the archive to augment life itself and how therefore we literally re-create ourselves through the archive.

2 Archives as Archaeological Sites

When you are a woman it's hard to tell you are being censored when you are not in a museum to begin with.
Hannah Wike in *!Women Art Revolution*

Nobody who is ignorant will ever make change.
Judi Chicago in *!Women Art Revolution*

In *The Archaeology of Knowledge* (1969) Michael Foucault compares the study of archives to archeological practice. We learn about the past thorough its remains. In this chapter, I argue that archives should be read as "material" archeological sites. Everything that is found within them should be treated as an index of something else. Drawing from literature on media archeology, site specificity, hybrid site curation and orchestration, this chapter discusses a number of archeological methods, such as survey; excavation (including deep mapping and cultural stratigraphy); Michael Shanks's practice of archaeography, the documentation of "the past in the present" (2005); media archeology (Shanks 2007); and the concept of remediation (Bolter and Grusin 2000) to look at how materials are informed by the media (e.g., photography, video, text, box, blog) that document and archive them. The chapter then moves on to conduct an "archeology" of a particular "archival" work by Lynn Hershman Leeson composed by: a film, *!Women Art Revolution* (2010), which chronicles and documents forty years of the feminist movement in the United States recorded at different points in time and through different media; *!W.A.R.*, the archive of the raw footage, including also some transcripts and biographies, located at Stanford University Libraries; an annotated bibliography which forms part of a graphic novel; and the emergent living blog RAW/WAR, a user-generated archive, and an installation. Analyses of the various components of this hybrid work are complemented by original interviews to Hershman Leeson, the new media developer Gian Pablo Villamil, who worked with her on the user-generated archive, and Henry Lowood and Hannah Frost, the curators from Stanford University Libraries who generated the archive of the raw footage.

Digging up the Archive

We saw in chapter 1 that according to some researchers, the origins of the "archival impulse" that characterizes the late 20th and early 21st century stems from 19th-century Victorian England. During this period, imperialism induced a knowledge-gathering mania aiming at synchronizing and unifying information at a global level, which integrated practices of writing with mapping and colonization, archiving and information gathering, leading to the creation of museums and nation states (Richards 1993). For others, it stems further back in time, from the Enlightenment period, when it emerged as part of a "scriptural economy" (de Certeau 1984, 131–53). I showed in chapter 1 that even before the Enlightenment, archives played a substantial role in memorialization, law enforcement, the administration of bureaucracy, and the management and transmission of power. To understand the role currently played by the apparatus of the archive in the digital economy, particularly in terms of its ability to remediate past practices and world views, it is therefore necessary to revisit the strategic functions played by the archive in the scriptural economy.

The two theorists that offer the most influential analyses of the role played by archiving in the scriptural economy are Michael de Certeau and Michel Foucault. De Certeau argues that the scriptural economy operated via two principles that had to do with accumulation and conformism. He states that the scriptural economy "transforms or retains within itself what it receives from its outside and creates internally the mechanisms for an appropriation of the external space," both "*accumulating* the past" *and* "making the alterity of the universe *conform* to its models" (1984, 135; original emphasis). For de Certeau, archival practice satisfies both these operational principles by serving to accumulate "internally" relics from the past *and* to conform what was other from itself. Just as bodies were inscripted—formed—by the laws that ruled over them (p. 139), books became "metaphors of the body" (p. 140), and archives accumulated histories of inscriptions, documenting practices of (in-)formation (see also chapter 6). For de Certeau only revolutions could subvert the dynamics of the scriptural economy in that they addressed "the scriptural problem at the level of an entire society seeking to *constitute itself* as a blank page with respect to the past, to write itself by itself" (p. 135; original emphasis). In de Certeau's view, revolutions represent crucial agents of change encompassing novel, multiple and self-constituted scriptural operations. He states: "the important thing is neither *what was said* (a content), nor the *saying* itself (an act), but rather the *transformation*, and the invention of still unsuspected mechanisms that will allow us to multiply the transformations" (p. 152; original emphasis). In other words, the scriptural economy, for de Certeau, operates by appropriating and absorbing what is other to it. A revolution, in this context, is the constitution of novel "internal" mechanisms that can transform the social sphere and propagate the transformation. The archive thus functions as the *modus operandi* of the scriptural economy but also, as we will see in chapter 4, as the very mechanism that could be used for the subversion of world views and world orders.

If for de Certeau the archive became the tool that satisfied the scriptural economy's operational principles of accumulation and conformism, for Foucault it constitutes its ordering system. We know that archives entail normative features from Foucault's writings about the archive as the "law of what can be said" (2011, 145), or "the system that governs the appearance of statements as unique events" (p. 145). For Foucault the archive is "that which determined that all these things said do not accumulate endlessly in an amorphous mass, nor are they inscribed in an unbroken linearity, nor do they disappear at the mercy of chance external accidents; but they are grouped together in distinct figures, composed together in accordance with multiple relations, maintained or blurred in accordance with specific regularities" (pp. 145–46). His vision of the archive is that of an ordering structure or tool, and the politics and power (as well as biopolitics and biopower) that are a consequence of it. Thus he famously suggests, the archive is *the general system of the formation and transformation of statements*" (p. 146; original emphasis)—a knowledge-generating system, or, more accurately, a system of enunciation (p. 129). In identifying a discrepancy between what he calls "present existence" and the archive, he states: "at once close to us, and different from our present existence, it is the border of time that surrounds our presence, which overhangs it, and which indicates it in its otherness; it is that which outside ourselves, delimits us" (p. 147).

In some ways for Foucault too the archive becomes a presencing tool, although he does not use this term, that is utilized to generate order in that which is other from us, precisely so that our presence may be constructed temporally (i.e., historically) and spatially (i.e., geographically). I have argued elsewhere, with Nick Kaye, that presence always remains in advance of or before itself, "always in emergence" (2011, 237). As what is in front of or before us changes constantly, the construction of presence requires a continuous repositioning (or reframing) of the self in relation to what is other to it. We have seen how for de Certeau the archive can be used to accumulate and conform to what constitutes the scriptural economy. In this sense, the archive is a knowledge-generating apparatus that not only facilitates the understanding of our presence (in the sense of what is before the self), by defining, and hence including within discourse what emerges in front of or before us, but in effect the archive is used to produce our presence. We have also seen that Foucault considers archiving an ordering act. He describes it as a "border of time," surrounding but also overhanging our presence. We know that presence is a network of phenomena rather than a stable entity (Giannachi and Kaye 2011). The archive, which is the tool that is used toward the production of our presence, then must also be emergent, relational, in flux. Hence, on the one hand, while the archive forms order out of chaos, by accumulating and conforming, ordering and informing, on the other, it must subject itself to constant change, precisely so as to redefine our presence from what is other to it. No archive is ever completely stable, closed. Rather, archives, as we saw in chapter 1, are unstable, open to re-interpretation, re-ordering, re-enouncing.

To sum up, the archive is where our presence and identity are generated and transmitted. In this sense, the archive is about the production of our permanence, but to produce this permanence, the archive must remain in a state of unrest. This condition allows it to capture

and transmit the changes that occur around us. How quickly and through what methods societies feel they need to archive themselves, and hence capture the changes that occur around them, and what they do to generate archives that are capable of remaining in a state of unrest, that are capable of changing, is therefore not only a symptom of how societies wish to conceive of and transmit the memory of their "present" over time but also an indicator of how societies deal with their own histories and the possibility of change.

Foucault, Archeological Method, the *Punctum* and the Archive

The Enlightenment's fascination with the past that constituted one of the motors of the scriptural economy prompted the foundation of what is known as contemporary archeology, the discipline that, according to Foucault best "describes discourses as practices specified in the element of the archive" (2011, 148). For Foucault, archeology does not so much refer to a search for a beginning or a method for an excavation (p. 148), but rather "it designates the general theme of a description that questions the already-said at the level of its existence" (p. 148). Archaeology, for Foucault, has a regional field of analysis (p. 175), aiming to uncover "the play of analogies and differences *as they appear* at the level of rules of formation" (p. 178; added emphasis), revealing "relations between discursive formations and non-discursive domains" (p. 179). It is the latter relationship between the discursive and the non-discursive that is most interesting in the context of an analysis of the archive as an archeological site. We are, after all, here engaging with emergence, as archeology deals with articulation rather than hermeneutics (p. 180). For Foucault, "the phenomena of expression, reflexions, and symbolization are for it [archeology] merely the effects of an overall reading in search of formal analogies or translations of meaning" (p. 180). Archaeology, in this sense, constitutes itself as a relational practice, proposing relationships between history, discourse, historicity and "a whole set of various historicities" (p. 182).

Since Foucault wrote *The Archaeology of Knowledge* in 1969, the discipline of archeology underwent a series of substantial changes. From the 1970s, contemporary archeology started considering artifacts no longer as "temporal indices and cultural markers," but "as means to understand past society" (Shanks in Pearson and Shanks 2001, xv). Thus archeologist Michael Shanks points out that new archeological thinking started to draw attention to the fact that "an artifact—a work of art, for example—must be set in the context of the society that produced it, rather than allowed to simply stand on its own and speak for itself" (pp. xv–xvi). Moving away from positioning artifacts on a temporal continuum, outside of discourse, the discipline of archeology started to interpret objects in the context that generated them, understanding temporality not as separate from the past, but "as *actuality*, the return of the past in the present" (p. xvii; original emphasis). While Foucault's theorization is crucial to understanding how the archive operates in discourse, archeological method, as seen below, is fundamental to understand how the archive operates as a material object.

With attention shifting away from understanding the relevance of the object in the past, to its positioning in the present, archeology became a fundamental discipline for the analysis of relationships and processes to do with presence (Giannachi, Kaye, and Shanks 2012), performance (Pearson and Shanks 2001), and transmission. For Shanks, archeology represents "a mediation of past and present rather than a discovery of what happened in the past" (1996, 21), constituting a discipline which is in effect about "*relationships*—between past and present, between archeologist and traces and remains." Thus, he notes, crucially for this study, "archeology is a set of *mediating* practices—working on the remains to translate, to turn them into something sensible—inventory, account, narrative, explanation, whatever" (2009; original emphasis). Archaeologists, he states, "don't discover the past," but rather "set up relationships with what remains" (2004), so that "[t]he tension between the past and the present involves a redescription of past events in the light of subsequent events unknown to the actors themselves; it involves the creation of temporal wholes, historical plots" (1987, 133). Archaeology offers us a set of translating and mediating practices, which help us in understanding the past as actuality, plot, and presence, and the present as a potential future past. For Shanks, since it is not possible to have witnessed the past (p. 133), we must utilize the translating and mediating practices of archeology to look at the past from and in the present. Interpretation of the past is a process, which is in itself never complete because as long as we have a present from which to reinterpret it, new relationships, and plots, between past and present are invariably forged. As Ian Hodder notes, there are no "right" interpretations to be arrived at and we are in "a continuing process of interpretation" (1986, 155).

Archaeology helps us to unfold these relationships, translating and mediating between hypothetical pasts and possible presents, the present and probable future pasts. Using an archeological approach toward an analysis of archival practice is therefore helpful in identifying a given society's relationship to and understanding of its past. This approach does not so much throw light upon the past itself but rather unveils a society's positioning in relation to it, showing, for example, its willingness or capacity to incorporate its past into its present, its relationship with what it calls presence, or its need to use the past and present to project itself into the future. Walter Benjamin's *Angelus Novus* (1940) whose face is contemplating the past, which he sees as one single catastrophe piling wreckage upon wreckage while being flown into the future by the storm of progress, famously captures how Benjamin saw this relationship at a crucial moment in history. Likewise Jorge Luis Borges's "Nostalgia del Presente" (*Nostalgia of the Present*, 2007) in which a man says to himself that he would give everything to be at "your" side in Iceland, sharing "the now" as one shares music or the taste of a fruit, at the precise moment at which he was at "your" side in Iceland, captures our age's problematic relationship with presence, and its inability to possess the present moment and capture it at the instant of its occurrence. The archive, its content, architecture, usability, forms part of this process of organization of the relationship between past, present (or presence), and future. Operating like a frame or lens, archeology shows us how to construct

possible plots in the archive. These plots, or timelines, are what help us to revisit who we *are* in relation to what we *were* and *could be*.

Before I proceed further to use archeological theory in the context of archiving, it is worth noting that, as Shanks suggests, the archeological method generally leads to two paradoxes. First, as the past is physically excavated, it is displaced and thus destroyed in the process of its uncovering (Shanks 1992, 23). Second, because of this, the past is observed and recorded through its traces in the present (p. 22). There are, for him, two seminal images underlying the figure of the archeologist: that of the detective and that of the therapist (1987, 6). The former, akin to Diamond's figure of the forensic scientist (1994, 142), is particularly relevant to our understanding of the operation of archives. Shanks points out, as a detective the archeologist "pieces together clues in order to reconstruct the past" (1987, 7). He suggests, "history is supposedly to be found in the archeological object. The artifact is a *punctum*, a punctual presence, piercing time; it is the marl of history, the historical moment" (p. 9). By drawing attention to the object as *punctum*, Shanks identifies a number of the salient features of the discipline's relationship to objects. Following Roland Barthes, the *punctum* is a "detail" (2000, 43). This has "a power of expansion" (p. 45) in that it "fills the whole picture" (p. 45). It also has a presence that is not metaphorical but rather a "perverse confusion between two concepts: the Real and the Live" (p. 79). In this sense, the *punctum* indicates not so much "what is no longer" but rather "what has been" (p. 85). The emphasis then is not on what the artifact, or the photograph, or the document was in the past, which has invariably gone, but on what it affords on the present. The present perfect continuum tense of *what has been* thus marks the connection between a past occurrence and the present, indicating an action that is continuing into the now, or the consequence of a recently completed action, whose occurrence, however, as in Borges's story, we already experience a nostalgia for. What the *punctum* denotes that *has been,* still is, in some ways, now, either as an action or as an effect of a past action. Just as the artifact is, for the archeologist, a *punctum*, the archive is formed by, I suggest here, *puncta—what have been,* which are no longer but whose trace somehow persists into the present.

For Barthes, "every photograph is a certificate of presence" (p. 87), as well as "an act of catastrophe" that has already occurred (p. 96). The archive is not only a certificate of presence, an identity generator, multiplier and transmitter, but also the trace of the "catastrophe" that marks a past occurrence. To dig up the archive then, is to pursue the traces that unveil *what has been.* The emphasis, again, is on the now, the present, our presence, and on the processes of translation and mediation that an archeology of the archive entails. The user of archives, like a detective, searches not so much for a culprit, as for the transformative potential of that catastrophe that still affects our presence today, and for the processes of transmission between this past, our presence, and possible futures that this will invariably bring about. This is what allows the archive to change. What is as yet absent from the archive constitutes what the archive needs to evolve. To construct our presence, or define our "present," over time we must then always renew the archive and redefine our relationship with it

to include the other both in relation to *what has been*—what is no longer there but has traces that persist into the now—and to that which was originally excluded in order to look into what *might be*—what is as yet potential, emergent, not yet lived, in the future. In this sense, our nostalgia of the present moment informs our perception of the past as well as the future. To look at archives as material archeological sites allows us to capture not only the plots and timelines that link pasts to presents and possible futures but also to understand how societies deal with what is as yet absent from the complex ways in which they construct their presence in history.

Archaeological Toolbox

The relationship between documents, records, artifacts, and their re-location, display, and mediation, in the archive is crucial to understanding how archives operate as material sites. In this section, I analyze how archeological method can disclose important relationships between the different components that form the materiality of the archive.

In a photoblog initiated by Shanks in 2005, which visualizes the convergence of photography and archeology (2009) as an archaeography, he suggests to think of media as "material matters" and remember that the materiality of media "be it the photograph itself, computer screen, negative, paper or transparency, is an integral and material part of engaging with what is pictured. The archeological trowel, spade and surveying instrument sculpt the past into different documentary forms we can comprehend" (2005). Just as the trowel sculpts the past, media literally sculpt the present. The same content, seen through different media, does not only look different but in effect will *be* different. Our interest, obsession even, with the past's influence on the present, with what the past looked like when observed through a different technology, with *what has been,* is crucial to contemporary thinking, so much so that the leading "condition" of our present age (Lyotard 1979), postmodernity, defines our present in relation to our past. As we have seen in our discussion of Derrida's *Archive Fever* (see chapter 1), one of the symptoms of this obsession with the past is, precisely, our *"mal"* (in Derrida's original French)—not so much a fever as the pain, ache, or illness that marks our age. In an attempt to treat the *mal,* and deal with Borges's nostalgia, we strive to understand what our history was. The media we use to this extent, their materiality, play a major role in shaping our treatment to our *mal*. In this sense, media not only inform our present but also our future relationships with our pasts. Here we will see how archives do not only entail media that variously re-shape the same content but do in themselves operate as media.

Shanks, McLucas, and Pearson identify a type of map, the deep map, for symptomatic reading by juxtaposing fact and fiction, data and oral histories. In Shanks's own definition, the deep map consists of the "attempts to record and represent the grain and patina of place through juxtapositions and interpenetrations of the historical and the contemporary, the political and the poetic, the factual and the fictional, the discursive and the sensual; the conflation of oral testimony, anthology, memoir, biography, natural history and everything

you might ever want to say about a place" (in Pearson and Shanks 2001, 64–65). For this defi-
nition of deep mapping, Shanks draws from artistic director of Brith Gof, who was trained
as an architect, Clifford McLucas's list of "things" about deep maps, which includes key
definitions about the use of deep mapping indicating that they have an implicit ambition in
terms of size; they evolve slowly over time; they entail a range of media; they entail a graphic
work, a film or performance and a database; they require an insider and an outsider engage-
ment, bringing together the "amateur and the professional" as well as "the official and the
unofficial, the national and the local"; they form a creative space; give rise to debate and "be
unstable, fragile and temporary" (in Shanks 2010). Deep maps are crucial for the articulation
of difference in both archeology and archiving. Following McLucas and Shanks, I suggest
here that archives act as deep maps, operating as laboratories for the performance of presence
and identity.

If we were, literally, to conduct an archeological excavation of a site, we would be focusing
on its exposure, processing, and recording of the archeological remains found therein. As an
excavation is conducted, stratigraphic boundaries are usually uncovered, and surveys and
records are generated. Geographical surveys are used, particularly in landscape archeology, to
search and map sites, often by walking and mapping, and to collect information about how
humans lived in a geographically contained area. Surveys can be intrusive or nonintrusive,
depending on the level of intervention into a site, and extensive or intensive, depending on
the type of research conducted on the site. Surveys constitute the initial interrogation of a
site that may be at a later point excavated. Tools utilized during surveys include mapping
tools, like GPS, remote sensing tools, and aerial photography, among others. Stratigraphic
studies are sometimes conducted as part of a survey. They usually include information about
artifacts that were found, a literature research (including past surveys), oral histories, and
local knowledge. In this sense, surveys are not so much a method but a conglomerate of
methods that mark the preparatory phase of an excavation. In the context of conceiving of
archives as archeological sites, surveys are useful tools to map the plurality of events com-
prised by the archive and offer possible routes of orientation. In this book I have used the
survey as a method for the interrogation of each archive I discuss as a material site. In the
process of doing so, each survey has uncovered a stratigraphy of materials.

Stratigraphy is a branch of geology that studies rock layers, layering, and stratification.
The origin of stratigraphy stems from Niels Stensen, also known as Nicholas Steno, who
introduced the "law of superposition," "the principle of lateral" or "original continuity," and
the "principle of original horizontality" in 1669 as means to work with the fossilization of
organic remains in layers of sediment. Subsequently, stratigraphy was adopted by William
Smith, who recognized the significance of strata or rock layering in geology. There are a
number of branches, for example, lithologican stratigraphy, or lithostratigraphy, reflecting
the changing environments of deposition known as "facies"; biostratigraphy or paleonto-
logic stratigraphy, which is based on fossil evidence; chronostratigraphy, which looks at the
absolute age of rock strata; magnetostratigraphy, a technique used to date sedimentary and

volcanic sequences; and archeological stratigraphy, which maps the temporality of site and is used to understand how a site became what it is and how the processes that generated it changed over time. More precisely, stratigraphy looks at how relationships between layers form and what this could mean in terms of the context that produced them. One of the values of stratigraphy in archeology is that it allows for the creation of chronology as, according to the law of superposition, it assumed that soils that are deeply buried were laid down before others, and therefore older. Shanks suggests that as "[t]he archeological matrix, sometimes called the archeological record, is considered as an amalgam of layers." For him, "[t]he concept of stratigraphy is used to decode this amalgam. In this decoding, the archeologist digs down to find meaning. But digging stratigraphically is impossible without the concept of horizontal surface interface—edges, moments of discontinuity when one layer becomes another" (Shanks 2009). This way of utilizing stratigraphy is significant for archives in that, by looking at materials both chronologically and in terms of their "horizontal surface interface," we are able to consider materials in their chronology (i.e., temporally) and relationally (i.e., spatially and as media). Shanks points out that the value of stratigraphy is that it "translates variations in space into variations in time" (1987, 119). I suggest here that stratigraphy, in the context of archiving, is a tool for engaging with the instability of the object as it not only discloses information about the archive as palimpsest, as archaeography, but also generates knowledge about the relationality of its contents.

To sum up, there are a number of archeological strategies that are useful in the analysis of the archive as a material site. Deep maps are suitable for the articulation of difference (in Pearson and Shanks 2001, 64–65), excavation through survey and record facilitate orientation, and stratigraphy allows us to look at materials both chronologically and relationally, over time. An archeology of the archive, methodologically speaking, consists in the adoption of a set of strategies that allow us to look at the archive as a multiplicity of *puncta*, or details, that should be treated as indexes marking spatial and temporal relationships between the past and the present, which, in the context of a digital economy, are also shaped by the media that form them. Survey, record, and stratigraphy are among the other tools that facilitate orientation within the cumuli of materials that form the archive, the *puncta*, both spatially and temporally. This is crucial to understand the changing relationships between the components that form the apparatus of the archive and the processes of accumulation and conformism, as well as the production and transmission of our presence and the present, our identity, within it. An archeology of the archive therefore can consist of both the survey of a material site *and* the analysis of the formation of discourse that Foucault and, more recently, scholars in media archeology proposed as a method for understanding the archive as an ordering system. Above all, an archeology of the archive will disclose how we sculpt and re-sculpt the materiality of history. The shovel is also part of the apparatus of social memory creation.

Media Archeology and Remediation

Before proceeding to the analysis of our case study, it is necessary to dedicate some thought to the relationship between media, remediation, and archeology and again to define more precisely the terms of reference used here. Media archeology is an emergent but not uniform field of study. Chris Webmoor notes that the field can be approached from two directions. The first one considers media archeology as "an object-oriented field of media studies" and the second one entails "a concern with media as modes of engagement with the material world" (2007). Whereas the first one, he points out, tends to be concerned with dead media, as is the case of Bruce Sterling's dead media project, and was discussed in studies such as Siegfried Zielinski's *Deep Time of the Media* (2006) and Erkki Huhtamo and Jussi Parikka's *Media Archaeology* (2011), the latter understands media as prostheses mediating archeological practices and experiences (Webmoor 2007). It is this latter understanding of the term that is relevant to this study. In particular, it is media archeology's translational qualities, as I will also discuss in chapter 4, that are relevant in the context of archiving. Interestingly, scholars have approached these translational qualities in different, even diametrically opposite, ways. For example, Zielinski suggests that the media (an)archeologist does "not seek the old in the new, but find[s] something new in the old" (2006, 3), while Shanks points out that media archeology is "the (re)articulation of traces of the past as real-time event" (2004a). Both scholars draw attention to the media archeology's translational qualities and note that it is the relationship between past and present that is at stake.

There are parallels between these translational qualities of media archeology and what has been described by Jay David Bolter and Richard Grusin as remediation. For Bolter and Grusin, remediation is "the representation of one medium in another" (2000, 45) so much so that a medium is defined as "that which remediates" (p. 65). Moreover they note, no single media functions in isolation from other media (p.15), and in the process of remediation, media do not entirely absorb each other, but rather a situation is created whereby the old medium is not completely effaced and the new medium "remains dependent on the older one in acknowledged or unacknowledged ways" (p. 47). Within a media archeological context, this suggests that new technologies often help us see, to put it with Zielinski, the "new in the old" while also, to put it with Shanks, remediate, and thereby re-articulate, the remains of the past in the present.

In discussing the role of remediation, Bolter and Grusin mention the way in which media put the viewer in the same space as the objects viewed as a salient characteristic of this process (p. 11). This suggests that in this translational process, viewers find themselves performing within the timeframes of the remediated processes, seeing the new in the past while also re-performing its remains. It in this context that Bolter and Grusin draw attention to how the logic of remediation compares to Jacques Derrida's account of mimesis in which Derrida states that mimesis is not "the representation of one thing by another, the relation of resemblance or identification between two beings, the reproduction of a product of nature

by a product of art. It is not the relation of two products but of two productions. ... 'True' mimesis is between two producing subjects and not between two produced things" (1981, 9). This suggests that through remediation, and likewise, through the translational processes at stake in media archeology, we do not so much see how products copy or even simulate each other but rather we witness how subjects produce themselves within different histories. The following case study well illustrates this ability of the apparatus of the archive to act as a presencing tool in the generation of historical plots.

!W.A.R. by Lynn Hershman Leeson

Lynn Hershman Leeson's 83-minute feature film, *!Women Art Revolution* (2010; see figure 2.1), which premiered at 2011 Sundance Film Festival, chronicles and documents forty years of the feminist movement in the United States, featuring artists and curators such as Marcia Tucker, Nancy Spero, Silvia Sleigh, Carolee Schneemann, Miriam Schapiro, B. Ruby Rich, Yvonne Rainer, Yoko Ono, Miranda July, The Guerilla Girls, and Judy Chicago, among others. For Hershman Leeson, the film originated as a set of documentaries shot as a "scrapbook of what was going on" in art in the 1960 and 1970s (Hershman Leeson in Turner 2011). The resulting archive, !WAR, available online at http://lib.stanford.edu/women-art-revolution, consists of 200 hours of raw footage, offering first person accounts that trace the evolution of the Feminist Art Movement from its roots in the antiwar and civil rights movements of the 1960s through its major contributions to women's art of the 1970s and 1980s. Additionally

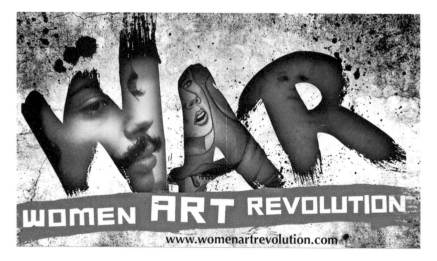

Figure 2.1
WAR_Main_Title.jpg Graphic Animations Justin Barber for Oddball Animation Ryland Jones for Oddball Animation Aaron Moorhead for Oddball Animation. Courtesy Lynn Hershman Leeson.

a living blog RAW/WAR was built to develop, over time, a user-generated archive at http:// rawwar.org/. A separate installation was also created so that visitors could interact with the archive and experience it as a *live* environment. These were complemented by a graphic novel, which was illustrated by Spain Rodriguez, and accompanied by an annotated bibliography with selected highlights of the period (2010). Described as a "seminal documentary" (*Newmedia FIX*) and an example of "transmedia storytelling" (*City Weekly*), the !W.A.R "project" is a complex form of archive, consisting of multiple public interfaces (the film, the installation, the blog, the bibliographic resource, and two archival websites) that incorporate historical documents and new materials which can be experienced in more or less immersive and participatory ways. I now introduce each component before proceeding to conduct an archeologically driven analysis of the project.

!W.A.R. Voices of a Movement

The !Women Art Revolution online archive, called !W.A.R. Voices of a Movement, was curated by staff in the Media Preservation and Special Collections Departments at Stanford University. The archive, hosted by a website built with Drupal CMS, consists of the film's raw footage, which was shot principally by Hershman Leeson between 1990 and 2008, and entails 68 videotapes, their transcripts, and the biographies of the interviewees. The archive also contains a finding aid, which identifies where items in the collection are physically located. The biographies of the artists offer enough information about their lives for users to be able to contextualize the works cited, while the bibliographies facilitate further reading. Interviews vary in length and context, though some questions and themes return, offering invaluable insight into what some of the artists and educators interviewed by Hershman Leeson considered to be milestones in the birth of the feminist movement in the 1970s, as well as the movement's reception and legacy over the subsequent forty years. Among a number of recurrent themes cited by the interviewees are the roles played by personal circumstance and the use of consciousness-raising exercises and performance (captured by the slogan "The personal is political") toward the creation of feminist art and the reclamation of history as one that included women artists within it.

A number of artists interviewed by Hershman Leeson had generated works that aimed at reclaiming the heritage of communities whose lives and works had previously been underrepresented in museums and galleries. One such artist is the muralist Judith Baca (1946–), a Mexican American activist working primarily in Los Angeles, who developed public art with communities to encourage social change, organizing neighborhood gangs to paint California's unknown history (see figure 2.2). In 1976 she founded SPARC, the Social and Public Art Resource Center, which inspired local artists wanting to develop work about women, immigrants, and the economically disadvantaged. Her vision had been "to depict the history of California, with particular emphasis on the part of history that had been left out in

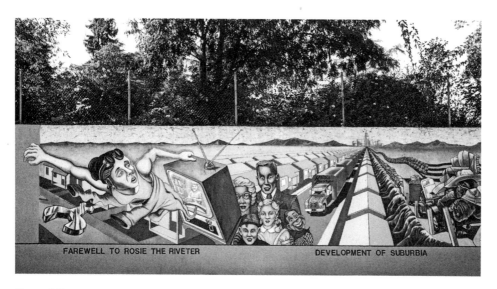

FAREWELL TO ROSIE THE RIVETER DEVELOPMENT OF SUBURBIA

Figure 2.2
Judith F. Baca, "Farewell to Rosie the Riveter and Development of Suburbia" (1983)—A detail from "The Great Wall of Los Angeles." Photo Linda Eber. Courtesy SPARC.

history books" (in !W.A.R., interview with Baca, 1992). Answering the question "How did you become involved in the Feminist Movement?," Baca states:

> I think on a personal level what happened for me was that I sort of got thrust into feminism and into the movimiento and into the whole 60s activism simultaneously. And it occurred because I got divorced, because I got fired, because I sort of stepped forth from the University trying to figure out how, trained as a minimalist painter, I was going to make my work relevant to people I loved and cared about and it was a very interesting time. It was in the very early 70s, late 60s. I stepped out into the world having been married for four years. Had been in the University through 1969 and the moment I sort of emerged from that institutional setting the world was in a sort of tumultuous state. And all around me was perhaps one of the most amazing educational grounds that anybody, or any young artist could hope for. Simultaneously what was happening was, on the east side of Los Angeles the moratorium marches were occurring. (in !W.A.R., interview with Baca, 1992)

Personal circumstances are also mentioned by other artists, particularly in relation to the role played by consciousness-raising groups with respect to identity creation. Thus, in reply to a question about the concepts leading the first feminist art program launched with Judy Chicago and Faith Wilding at Fresno State College (now University) in 1970, Susanne Lacy notes:

> We said that basically a female identity is a created identity, it's a manufactured identity. But, ... but we also believed that there was a true identity and that that was to be found in experience. So, the dilemma was, How do you dig up the experience? And in sharing it and in consciousness raising groups

does that reflect and mirror that experience back in the way that you begin to see who you are? And of course the project was always intensely political because, remember the personal is political. (in !W.A.R., interview with Lacy, 1990).

In fact Fresno art classes were not so much oriented toward developing particular skills but rather toward engaging students with concepts and consciousness raising activities. The Fresno College website, for example, cites program alumna Faith Wilding describing how the curriculum was "learning to contend with manifestations of power: female, male, political, and social," via processes that asked students to

"go around the room" and hear each woman speak from her personal experience about a key topic such as work, money, ambition, sexuality, parents, power, clothing, body image, or violence. As each woman spoke it became apparent that what had seemed to be purely "personal" experiences were actually shared by all the other women; we were discovering a common oppression based on our gender, which was defining our roles and [sense of] identity as women. (in Meyer 2009)

Interestingly, Wilding is cited by Howard Fox, former Curator of Contemporary Art at the Los Angeles County Museum of Art, who curated *Avant-Garde in the Eighties* (1987), with respect to the personal nature of much of the work of the movement. He states:

I remember reading an account by Faith Wilding, who was one of the first students in the first class, first course that Judy Chicago ever offered in feminist art at Fresno State College, and their project was to come back to class a week later having thought about some event that had involved their own personal experiences with respect to sexual harassment. Now that's a pretty broad spectrum. Sexual harassment can be anything from someone whistling at you or making a rude comment as you're walking down the street. Or it might involve incest or rape. She said it was the first time in her experience as an art student that she had ever been asked to do something that reflected a real experience in her life. Prior to that it was pretty much circumscribed out of the studio practice that was being taught in universities. You don't bring your life into it, you don't bring your personal history. The art is its own autonomous entity. (in !W.A.R., interview with Fox, 2004)

The same episode is reported by Judy Chicago, who also explains the choice of using performance as a strategy to work on consciousness, identity and politics:

I remember asking my students how many of them had been raped. And being just totally shocked when like a quarter or half of them raised their hands. ... The thing is that after I lifted the lid, it was like an explosion, it was right there under the surface and really it was being held down by a very thin veneer of repression and suppression and the young women began to just blossom. But I had to teach them everything. They didn't know how to use tools, they didn't have discipline, they didn't know how to work in an extended way, most of them ... they came to build walls wearing sandals with open toed shoes, dropping hammers on their feet.

I had to really work with them in terms of their person, not their talent, their person, their ego structure, their sense of self, and part of that I did through the discovery of their own history and by validated their own experiences as subject matter for art. So we had a year in which we had to work together and we started doing performance, because I discovered that it was easier to get access to

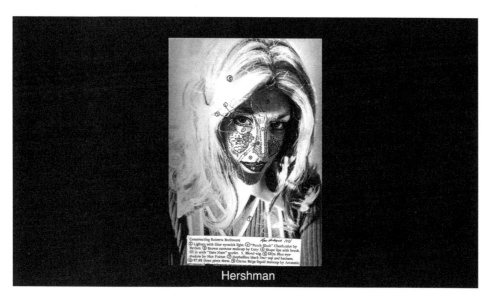

Figure 2.3
Lynn Hershman, "Roberta Breitmore," 1974–78. "External Transformations: Roberta's Construction Chart, No. 1." Dye Transfer print, 40" × 30," 1975. Courtesy Lynn Hershman Leeson.

the subject matter through performance. It was very easy, most women knew how to act out even if they didn't have any experience performing, they were experienced at performing roles in society. And so they could perform. So we started using performance as a way of getting to subject matter. We would come up with an idea we'd all act it out, and we'd begin and that was really how all the feminist performance started. (in !W.A.R., interview with Chicago, 1990)

The use of personal circumstance and performance for the creation of identities and the reclaiming of history brought on a new body politics. Thus art historian Moira Roth (1933–), author of *The Amazing Decade: Women and Performance Art in America 1970–1980* (1983), mentions Eleanor Antin's use of the body in *Carving: A Traditional Sculpture* (1972), in which she photographed herself naked every day as she dieted; Faith Ringgold's *Change* (1986), during which the artist lost weight by dieting for a year, and Lynn Hershman Leeson's creation of a semi-autobiographical character in *Roberta Breitmore* (1974–78; see figure 2.3) in which Hershman Leeson, as we have seen in chapter 1, impersonated a fictional persona for a period of four years. Described as the "private performance of a simulated persona" (Hershman Leeson 1996, 330). Roberta Breitmore was encountered as traces and evidence of incidents and activities in real places at real times, such as a checking account, a driver's license, the psychiatric report, and her credit ratings. For Hershman Leeson,

one of the major difference between Ro- [sic] the Roberta work, as well as the other works that were happening at the time, was endurance. A lot of women were trying to find their histories. They

were … anonymous. There was no history, and in a sense people were feeling that they had to create some sense of who they were and some semblance of creating artwork that would reflect new possibilities for who they were, what they could become, for actual history that … could be envisioned.

[Roberta's] trespass was almost transparent. She really blended into the world.

… it was about everyday life, it was about the psychology of everyday life and … the underpinnings. (in !W.A.R., interview with Hershman Leeson, 2006)

Crucially Hershman Leeson's own work deliberately blurs the boundaries between art and life. The personal becomes political, role becomes social construction, and performance becomes a tool to both comment on and change society.

As part of an attempt to reclaim Art History, through the production and performance of personal histories, many of these artists developed what could be described as "archival" works, that is, works that variously framed personal histories as legacies. One such artist is the author and educator Judy Chicago (1939–), who, in 1972, together with Miriam Schapiro founded the first feminist art program in the United States at the California Institute of the Arts. Chicago's landmark piece *Dinner Party* (1974–79; see figure 2.4) was archival in nature and, as in Hershman Leeson's *Roberta Breitmore,* the references were both real and fictional. The work consisted of an installation depicting place settings for 39 mythical and historical women arranged in groups of 13. Each place setting featured images and symbols of the woman's work, their name, as well as plates, napkins, and various utensils. The white floor of

Figure 2.4
The Dinner Party. Installation view of Wing Two © Judy Chicago, 1979. Elizabeth A. Sackler Center for Feminist Art, Brooklyn Museum. Collection of the Brooklyn Museum, Brooklyn, NY. Photo © Donald Woodman.

triangular luminous porcelain tiles is inscribed with the names of 999 well-known women. The piece, which, as suggested by Amelia Jones, "clearly disrupted modernist value systems" (1996, 150), is riddled with symbolism, with the triangular table being reminiscent of a vulva; the use of porcelain, weaving, sewing, and embroidery reminding us of how women used crafts; and the number thirteen was cited in reference to the Last Supper. Chicago, who herewith offered a glimpse of what it could be "to have a feminist society" (in !W.A.R., interview with Chicago 1990), also draws attention to the use of performance as a tool to develop personal experiences into histories:

> I had to really work with them in terms of their person, not their talent, their person, their ego structure, their sense of self, and part of that I did through the discovery of their own history and by validated their own experiences as subject matter for art. So we had a year in which we had to work together and we started doing performance, because I discovered that it was easier to get access to the subject matter through performance. It was very easy, most women knew how to act out even if they didn't have any experience performing, they were experienced at performing roles in society. And so they could perform. So we started using performance as a way of getting to subject matter. We would come up with an idea we'd all act it out, and we'd begin and that was really how all the feminist performance started. (in !W.A.R., interview with Chicago, 1990)

The attention to craft and other skills associated to women is cited by a number of interviewees who refer, for example, to the importance of stitching, also seen in Chicago's work, as a "connective process"; layering, taking fragments and making them whole, a metaphor "for taking the bits of our life and constructing something new" (in !W.A.R., interview with Hammond, 2008); the belief that "there is no work without a social subtext," which is why process was preferred to product "because you can see social milieu in process" (in !W.A.R., interview to Rosier, 2008), and the role of "performance-based work, temporal work, of sight-specific work, of installations, of collaborative work'" (in !W.A.R., interview to Hershman Leeson by Jan Zivic, 2005).

Unpacking the *puncta* of this particular component of the project, it is interesting to note how Hershman Leeson attempts to capture, through the interviews, descriptions of processes and occurrences rather than, purely, artistic products. In particular, it is important to note how the interviewees talk of their use of crafting, layering, and networking, how they juxtapose art, life and politics, and how they narrate their stories to Hershman Leeson, to each other, and to us, the viewers of this archive. In an attempt to create a rich set of documents of the salient events of the time, Hershman Leeson carefully collects multiple views of some of the same events, with the focus on personal experience in relation to a particular workshop, for example, being cited by three interviewees (Fox, Chicago, and Wielding). However, what may be most interesting about this collection is the fact it occurred over time—interviewees changed, the same stories were told in slightly different ways, and even Hershman Leeson herself is more or less involved, positioning herself neutrally in some interviews and as participant in others.

I have already pointed out that de Certeau stated, in the context of writing about revolution, that "the important thing is neither *what was said* (a content), nor the *saying* itself (an act), but rather the *transformation*, and the invention of still unsuspected mechanisms that will allow us to multiply the transformations" (1984, 152; original emphasis). The transformations (personal and collective) described in these interviews were the mechanisms through which the feminist revolution of the 1970s occurred. This archive not only captures these transformations in the words of those who witnessed them at the time but also, in doing so, facilitates their multiplication at the present time. In particular, the focus on the personal, and hence Hershman Leeson's construction of her archive of the feminist movement in the United States through interviews, is perhaps one of the most significant aspects of this archive, reminding us that these *puncta*, were those of individuals whose thinking about presence, the present, about identity, and life itself, were to radically change the world we live in.

!Women Art Revolution

The film *!Women Art Revolution* was written, directed, and edited by Hershman Leeson, produced with Sarah Peter, by Kyle Stephan with Alexandra Chowaniec and Carla Sacks, as a Hotwire Production in association with Chicken and Egg Pictures, Creative Capital, and Impact Partners. The world premiere took place at the Toronto International Film Festival in September 2010. The film, which draws from the interviews conducted by Hershman Leeson between 1990 and 2008, was also shown at the Berlinale in February 2011 and at the Museum of Modern Art in March 2011.

!Women Art Revolution traces the movement's birth out of the political turmoil and civil rights movements of the 1960s, showcasing a number of works such as Judy Chicago's installation *The Dinner Party* (1974–79), which is juxtaposed with footage from congressmen debating whether to censor the work; the Guerrilla Girls' poster campaigns and the Whitney action; the first feminist art education programs, political organizations and protests, alternative art spaces such as the A.I.R. Gallery and Franklin Furnace in New York and the Los Angeles Women's Building; publications such as *Chrysalis* and *Heresies*, and landmark exhibitions, performances, and installations of public art, concluding with the period's retrospective WACK! Show at MOCA (2007).

The title is a tribute to a coalition formed by women in 1969, Women Artists in Revolution (WAR), which had split off from the Art Workers' Coalition (AWC) because the latter was male-dominated. Narrated by Hershman Leeson herself, the documentations are 'patched together like a quilt' (Hershman Leeson in *!Women Art Revolution*), combining color with black and white footage and a graphic novel by Spain Rodriguez (see figure 2.5), and juxtaposing historical documents with interviews filmed subsequently. In fact the film is organized thematically, through a series of subheadings: "consciousness raising"; "media"; "activism and social protest"; "the body politic"; "identity," which mark different phases in the history of the

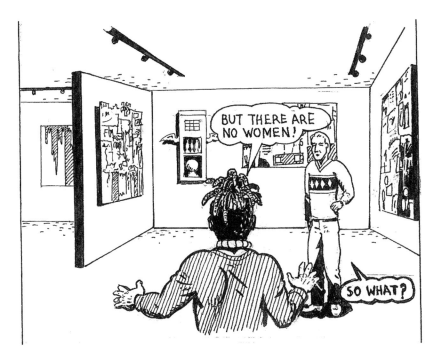

Figure 2.5
SpainGraphicNovel.jpg Graphic Novel by Spain Rodriguez. Courtesy Lynn Hershman Leeson.

movement. The overall aim is, in Hershman Leeson's words, to address a "historic erasure" (in *!Women Art Revolution*), namely that of women's work from museums and galleries. Thus she notes, even in the new millennium people are still not able to name three women artists because of the lack of female artists in museum exhibitions and textbooks. The works shown in the film, we are told, are "relics of resistance" (Hershman Leeson in *!Women Art Revolution*) that were not seen in galleries or taught in art schools or universities.

Chronicling the early years of the feminist movement, the film documents events such as the Whitney protest of 1970 during which the Ad Hoc Women's Art Committee, which included artists Poppy Johnson, Brenda Miller, Faith Ringgold, and critic Lucy Lippard, led a protest against the prevalently male Whitney Annual exhibition by writing to the museum, staging demonstrations, projecting slides outside the museum and even throwing eggs inside. The film then moves on to show how during the period between May and September 1970, and throughout the 1970s, a number of protests occurred throughout the United States that influenced the creation of new galleries and curricula, such as the A.I.R. (Artists in Residence) Gallery created in 1972 as the first run for women in the United States.

Performance is singled out as a key strategy running across all themes. Thus we see Judy Chicago recalling that when she had asked how many of her students had been raped, she

was "totally shocked" when over a quarter of them raised their hands. This, she suggests, made her realize that it was easier to approach the subject through performance. Rachel Rosenthal too recalls that "women were able to enter the art structure through performance" (in *!Women Art Revolution*). This is evident, for example, in footage of Martha Rosler's *Semiotics of the Kitchen* (1975) in which we she her adopting a series of gestures and utensils "as a sign of utilitarian domesticity" and transforming personal gestures into political provocation. Along performance, role playing also played an important function, particularly in identity creation. Thus Hershman Leeson notes, in the context of her seminal piece *Roberta Breitmore*, "we made art in which we created identities. Even fictional histories were better than none at all. The personal became the political and the very personal became art" (in *!Women Art Revolution*).

In the context of an analysis of the body politic, Moira Roth then discusses the role played by gaze in Martha Rosler's *Vital Statistics of a Citizen, Simply Obtained* (1977) in which we see a group of people crudely measuring a woman, suggesting that "it made you think how women are measured ruthlessly" (in *!Women Art Revolution*). Likewise Eleanor *Antin's Carving: a Traditional Sculpture* (1973), Ana Mendieta's *Anima* (1976), and the *Silueta* series (1973–80), showing female silhouettes in nature, Hershman Leeson points out, draw attention to the "temporal nature and frailty," but also "violence" of the female body (in *!Women Art Revolution;* see figure 2.6). Media too were used at the time as forms of self-documentation, literally representing, in Hershman Leeson's words, "private battlefields" (in *!Women Art Revolution*). This, for example, was the case of her own video diary *First Person Plural* (1984) in which she repeatedly blurred the distinction between fact and fiction. To further illustrate the fluidity between art and life, the film then introduces events leading to the foundation of Womanhouse by 21 students in the Feminist Art Programme at Cal Arts under the supervision of Judy Chicago and Miriam Shapiro (January 20–February 28, 1972). Womanhouse transformed a vacant home in Hollywood into a permanent exhibition space, one of the first public exhibition spaces of feminist art. The house was first restored, and then used as a commune in which consciousness-raising activities took place at the same time as training and performance.

The film also chronicles the birth of the Guerrilla Girls in 1984, showing their protest at the Museum of Modern Art opening of the exhibition "An International Survey of Painting and Sculpture," featuring 169 artists, of which very few were women or people of color, but also noting their failure in engaging with the violent death of Ana Mendieta in 1985 (see figure 2.7). The film finally moves on to document how in the 1980s new artists entered the scene, from Cindy Sherman to Barbara Kruger, Jenny Holzer, and Miranda July, who often explicitly acknowledged a continuity with work developed by women artists in the 1970s. Despite the prominence of the movement, Hershman Leeson suggests, there still are very few histories chronicling this period, something this film proposes to address (in *!Women Art Revolution*). The closing shot shows a burning silhouette, an image by Mendieta from the

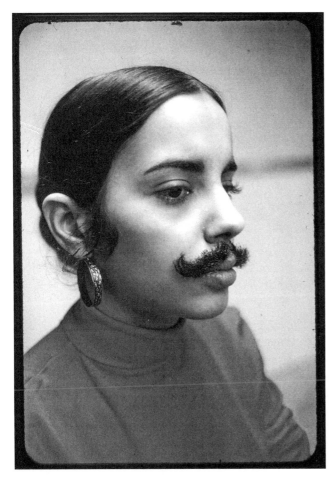

Figure 2.6
Ana Mendieta, "Documentation of an untitled work," 1972 (Intermedia Studio, University of Iowa). 35 mm color slide © The Estate of Ana Mendieta Collection, Courtesy Galerie Lelong, New York.

Silueta series, concluding with the words "a legacy is a gift for the future" (Hershman Leeson in *!Women Art Revolution*).

!Women Art Revolution is a remarkable documentary of the emergence of the feminist movement in the United States in the 1970s, not only because it succeeds in capturing the voices of a number of its protagonists, including, of course, Hershman Leeson's own voice, but also because, like its archive, it does so over time, documenting changes, evolutions, as well as fragmentations within the movement, and at the same time nourishing interest in the legacy and fostering integration with it. Whereas the archive is organized according to

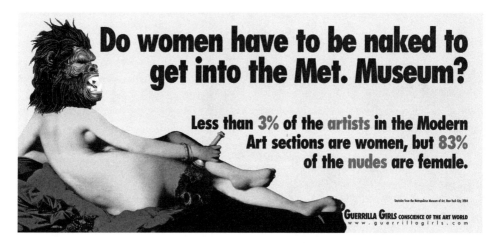

Figure 2.7
Guerrilla_Girls_Poster.jpg Guerrilla Girls, Poster: "Do women have to be naked to get into the Met. Museum." Copyright Guerrilla Girls, courtesy guerillagirls.com.

the name of the artists interviewed, allowing us to focus on the personal accounts offered by the interviewees, the film is organized thematically, through subheadings. These subheadings rearrange the archival materials offering a stratigraphy of the period consisting of the following strata: "consciousness raising," "media," "activism and social protest," "the body politic," and "identity." The reorganization of the materials through strata generates new plots that show how individuals generated collective innovation.

RAW/WAR

To encourage direct participation into the debates captures by some of the subheadings, Hershman Leeson subsequently developed a user-generated archive and installation, whose name mirrors that of the film and its archive at Stanford Libraries. The RAW/WAR interactive archive was built as a "living archive, a community-based information system of this work" (Hershman Leeson in Turner 2011). Whereas the !W.A.R. archive was built by materials shot by Hershman Leeson herself between 1990 and 2008, RAW/WAR is built through user contributions, "with the goal of creating a history defined by the community" or "community curated video archive that provides a forum in which users can come together, share their stories and collaboratively contribute to the history of feminist art and activism" (Hershman Leeson 2011). Aiming to create "one of the most expansive historical documentations ever attempted," this archive was built "as an alter ego" to the film (2011) constituting an "extension of the film into the future" (Hershman Leeson in Savage 2011). For Hershman Leeson, "the retrievability of this information subverts traditional notions of filmmaking"

(in Savage 2011). This is because the archive can be experienced online, as well as an interactive installation.

For Hershman Leeson, the project originated

> from the idea that history is about access and authorship and that we, as a global digital community, can now all participate in its creation and change the way history itself is constructed. Using new technologies, current and future generations can create their own histories, breaking the cycle of omission and erasure. (2010, 94)

The RAW/WAR live, expandable, archive can be searched by keywords, titles, descriptions, and thumbnails. Users can watch but also upload videos, selecting in and out points to create and annotate short clips. The organization of this archive mirrors that of the film, through the use of the subheadings, as well as the Stanford archive, through the use of individual uploads. Additionally the timeline visualization facilitates the identification of salient events during particular decades as the as the generation of historical plots, overarching different decades. While the Stanford archive represents the past of the film (in the sense that the film materials originate from the interviews in the archive), this archive constitutes the future of the film, making it possible for future generations to see how the thematics identified in the film evolved over time.

The interactive installation *RAW/WAR* was developed by Hershman Leeson in collaboration with Alexandra Chowaniec, Brian Chirls, Gian Pablo Villamil, Stacy Duda, and Paul Paradiso, with Paradiso Projects. The installation is integrated with the web-based media database of RAW/WAR, which means that it is updated live with multimedia from the RAW/WAR interactive archive. The vision for the work was to invite "users to 'bring light' to lost or invisible histories of women with virtual flashlight controllers" (in *Newmedia FIX*), as if one was "exploring a dusty attic with a flashlight" (Villamil 2011). To this extent the installation was built as a dark empty room, which can be searched through virtual flashlights (see figure 2.8). When users enter the room they pick up the "wiimote" and point at the room. As they explore the space, text appears on the wall, which the user can illuminate. The text outlines themes and decades. Switching on the themes or decades will make texts appear along the wall. Hovering over each media object displays its metadata. Users can select one or more themes or decades and place them in a player, which detaches from the wall. Multiple playback scenes can be active at once. The more users interact with the wall the more objects appear. Related media can also be displayed.

The media can be filtered by category and decade. Technically the installation was made possible by modifying Wii videogame controllers to become a pointing device, creating the illusion of "casting a virtual spotlight" (Villamil 2011) onto histories that would otherwise remain hidden (see figure 2.9). While it was important that the media were easily accessible, it was also critical that the installation conveyed "a sense of depth, that it was an extension of the space the viewer was in" (Villamil 2011). In the installation users thus "have the opportunity to literally shine a light on that history, pointing Wii-rigged flashlights at

Figure 2.8
Installation shots from Raw/War at Sundance by Lynn Hershman Leeson. Courtesy Lynn Hershman Leeson.

virtual closets to unlock various chapters in the story of feminist art." For Hershman Leeson, it was crucial that this immersive, interactive dimension was added to the project. For her, "by engaging with the project one becomes part of the discussion, and that discussion in turn creates a ripple in the larger wave. Form and content are one, and you can use really advanced technology in order to retrieve history" (Hershman Leeson 2011). Crucially, she points out, "history is fragile and malleable and that becomes part of the piece itself" (2011). The installation, which also has a portable version that is often used to demo the work, is performative in that, in line with the use of the performative by the feminist artists features in the archive and film, it turns the viewer into an "acting" participant, present within the work and the histories it captures. Through this, unexpected juxtapositions are generated, genealogies uncovered, and new histories written. This component of Hershman Leeson's complex transmedia work thus attempts to move beyond Foucault's vision of the archive as a "law of what can be said" (p. 145), by utilizing performance as a means to both experience and generate the archive.

The Curriculum Guide and Graphic Novel

To facilitate research into the history of the movement, Hershman Leeson published a curriculum guide, written by herself with Chowaniec, which includes a graphic novel by Spain

Figure 2.9
Installation shots from Raw/War at Sundance by Lynn Hershman Leeson. Courtesy Lynn Hershman
Leeson.

Rodriguez, a timeline and bibliography for feminist film compiled by Fiona Summer and
an equivalent one for visual arts compiled by Claire Daigle and Krista Geneviève Lynes. In
it, Daigle and Lynes point out that "revolution no longer resides simply in the great battle-
grounds of history, but also in the invisible daily operations of those who seek to overturn
deep-seated forms of inequality, prejudice and oppression in the public and private sphere"
(2010, 37). For them, "the personal is therefore not only political, but also revolutionary" (in
Hershman Leeson, Chowaniec, and Spain 2010, 37). Reminding readers that central to femi-
nism is the question of identity, they also note: "The history of the intersection of women,
art and revolution has worked to challenge this figure, always with the assumption that gen-
der is not only a figure or an image but also a social relation—male/female—that pre-exists
each individual" (in 2010, 37–38). Clearly setting itself the objective to assist researchers to
contextualize the personal as social, as political, the curriculum guide constitutes another
strategy in Hershman Leeson's social project to not only document the history the feminist
movement, but also facilitate its legacy and safeguard its future memory.

The bibliography starts with Betty Friedan's publication of *The Feminine Mystique* in 1963 and sets critical dates in US history against crucial events in the feminist movement and publications, thus literally re-writing feminism into Art History but also proposing to adopt feminist methodologies for the development of future histories. To draw attention to the openness of the process, the curriculum review continues to pose questions as a mode of reflection. Thus, for example, under 1970 we read:

> What are the relationships between aesthetic practice in the public sphere, demonstrations, and "guerrilla tactics" in feminist art practice? During this period feminist strategies are developed to create alternative institutions and an underground feminist press. Instances include the Feminist Art Program, Womanhouse, the New Museum, Franklin Furnace, heresies and Chrysalis, among others. How do these strategies address issues of inclusion and exclusion? Is the category of "woman" fully representative? How does institutionalization affect artistic practice?
>
> Secondary readings:
>
> • Lucy Lippard, *From the Center: Feminist Essays on Women's Art* (New York: Dutton, 1976)
> • Linda Nochlin, "Why Have There Been NO Great Women Artists?" in *Women, Art and Other Essays* (New York: Harper and Row, 1988). (in Hershman Leeson, Chowaniec, and Spain 2010, 43)

The guide ends by saying "of course there is more to this story. You can contribute your history, images, video or story to an ongoing live archive: http://www.rawwar.org" (in 2010, 94). By simultaneously creating documents of the past and facilitating the generation of future records, Hershman Leeson not only developed a set of documents, and archived them, so that the past may be encountered through the material voices and testimonies of those who drove the movement in the 1970s and 1980s, but she also created a deep map, a *live* archival site that turns viewers into active participants, performers even, throwing light into feminist Art History, uncovering old materials while generating new plots, new identities, and so writing our feminist futures.

Toward an Archeology of the !W.A.R. Archive(s)

In an interview with the staff at Stanford who developed the !W.A.R. archive, Henry Lowood, Curator for History of Science and Technology Collections, Germanic Collections, Film and Media Collections at Stanford Libraries, points out how digital archives, unlike traditional archives, have to be rebuilt every five to ten years. Noting that "traditional archives change at a much more glacial pace than digital archives," he reminds us that "traditional archives are very different in everything from the format, to the procedures, to the way the rooms were designed, from digital archives in that everything was very stable for a long period of time and now nothing is really stable" (Lowood 2011). The multiplicity of archival forms at the heart of Hershman Leeson's project may in part also be an attempt to address this instability, offering multiple viewing and generating channels to future users of this particular archive. Interestingly though, archives, including digital archives, while not stable, still have

a tendency to remain. This persistency of archives is captured by Hershman Leeson who in discussing her work Roberta Breitmore, remarks: "I've learned, through the process of an archive, that things never cease to exist. They transform, but you really can't get rid of 'em. I mean, look at landfills, that we, you could find anything" (!*Women Art Revolution*, interview to Hershman Leeson 2006). Thus while digital archives, unlike traditional archives, are inherently unstable, they are also persistent in that, like landfill sites, their objects tend to remain, yet change over time.

Through a stratigraphy of all the works Hershman Leeson built around her original documentation of feminist performance, we can see that these form a number of layers which, in her own words, "spill onto one another" (2011). We have seen how stratigraphies are useful instruments to translate variations of space into variation of time. For Hershman Leeson (2011), the first layer of the work is formed by the unformed materials, which would take months to watch in their entirety. The second layer is formed by the Stanford archive, which hosts these materials on a website. To watch these in their entirety, it would take less than a fortnight. This layer involves a level of organization, which Hannah Frost, Preservation Librarian for Digital and Media Collections at Stanford Libraries describes as follows: "the first step in building !WAR was to form the files into a 'collection' by literally putting them into a different directory, giving them different names so that they could be linked to determinate 'conventions,' and generating a finding aid, so that the materials would become 'cohesive' and could be easily located" (2011). This layer, Villamil notes, is explicitly archival in that "you can look for something specific, like a specific artist, works of a specific period or specific themes" (2011a). The third layer, Hershman Leeson continues (2011) is formed by the film, which lasts 83 minutes. Specific themes were identified for this layer, which operate as "chapters to facilitate navigation" (Hershman Leeson 2011). These chapters could be seen as strata, adding a finer layer within the overall palimpsest generated by the project. The fourth layer is formed by the user-generated archive. This, for Hershman Leeson, is "completely democratic, completely uncensored" (2011). For Villamil, its "dominant metaphor, the flash-light, creates the sense that not everything is laid out for the user. In order to find stuff the user has to explore [and] actively seek things out" (2011a). For him, this archive "is organized according to the same themes that are present in the movie but contains works that are not in the movie." Furthermore the RAW/WAR archive "lets you see a continuity from the themes expressed in the movie into contemporary art practice" (Villamil 2011a). The RAW/WAR installation, which participants have tended to experience in ten minutes slots, though they could take longer if they wanted to, is very much "a tool for discovery" (Villamil 2011a). Villamil draws attention to the fact that it is impossible to easily browse the totality of the archive using only the RAW/WAR installation because it presents "a subset of works that meet criteria that are randomly chosen and as the works are played through it brings up another random set that meets those criteria" (Villamil 2011a). For Villamil, another interesting quality of the installation is that it allows multiple users to interact with it at the same time "so you create juxtapositions of content which can be very interesting

because things seem to shed light on each other" (2011a). Crucially, for Hershman Leeson, the installation is "also a performance, a gestural body performance." For her the piece is about "instant history, so by performing it, you are in it" (2011). As in Jackson Pollock's drip painting, participants use light to create their own performance of the artwork (Hershman Leeson 2011). This performative dimension is crucial in that it allows users to encounter the archive through a different, experientially grounded, approach. The historical documents here become the very tools through which new unexpected juxtapositions can be created. Finally, the last layer is formed by the curriculum guide, which was created "because people said there is no information on this period" (Hershman Leeson 2011). This layer, complemented by the graphic novel that captures the information visually in a synthetic way, offers the possibility for individual exploration of artists, themes, and works, thus acting as a survey and at the same time operating as a stratigraphy for the whole project.

The work as a whole constitutes a deep map of the field, comprising elements of Archives 2.0, 3.0, and even 4.0. It is a plurality of forms; it is performative, born out of another archive, offers multiple viewing platforms, and allows users to produce and consume knowledge. It is large and hybrid in size; it is "slow" in that user-generated component is built to develop over time; it embraces different media (website, film, video, performance, graphic novel), orchestrating materials in a multilayered, stratigraphically recognizable way; it is multimedial because only through the use of a variety of media are different forms of articulation of the work possible; it entails graphic work (the novels in the film and the curriculum guide), time-based work (the performance of the installation, film, and videos), and a number of unfinished databases (the two archives); it engages insiders (historical figures) and outsiders (future users), amateurs and professionals and attempts to create lineage between them; operates as a creative space (the user-generated archive); offers space for debate, acting as a conversation and not, like a deep map as "a statement" (McLucas in Shanks 2010). If we excavate the user-generated archive through the installation, we create unusual narratives which throw new light over the continuity between past and present. This is very much for Hershman Leeson a "living archive," in the sense that "it is constantly changing, and people can add and adapt, move things about and mutate it." For her, "the user-generated archive has a preliminary structure of organization but this is meant to be changed" (2011). This use of deep mapping thus both constituted the means through which the original documentation was collected and curated while also representing a method for the capture of future events. A combination of action painting and deep mapping, ensure that the user-generated archive participant becomes the catalyst, the mechanism for the work to reproduce.

The materials are shaped through the media (e.g., photography, video, text, box, blog) that document and archive them. For Hershman Leeson, the media used here change the story. Thus "one story is more chronological and entertaining, the film, which is a closed narrative; the archives at Stanford are cross-linked and transcribed so you can go way in depth with individuals or link to particular ideas that they are thinking about and then the RAW/WAR archive is more about inputting globally. So they all have different structures but they

are all related." (2011). These different components, as well as the contents of a number of additional accessions, such as one recently submitted to Stanford Libraries (Lowood 2011), constitute, for Hershman Leeson, "one piece," which however is formed by "different layers" that "grow out of each other" and aim at offering "different ways of accessing information" (2011). For Hershman Leeson this multiplicity is crucial. Thus she comments, "in trying to make a narrative I realized how many narratives could be made and how much important information would be left out. … This whole project is about missing histories, missing information, power structures." (2011). For Villamil, additionally, "it's not just the content that is different in each one of those things, it is the process of interaction is different in each one as well" (2011a). This process of interaction is intended as an "empowering" process, revealing "the idea of adding to history. One doesn't have to accept what is traditionally thought of as the definition of a cultural product but actually have a hand in reshaping it" (Hershman Leeson 2011).

We have already seen how the archive acts as a system of enunciation (Foucault 2011, 129), operating as a presencing tool, where presence, the present, and identity are generated and transmitted. This transmedia archive, combining different dynamic components, acts also as a laboratory for the performance of presence and identity. Here users are encouraged not only to learn about the revolution brought on by the past but also add to that past and herewith produce new futures. Hershman Leeson notes: "archeologists are detectives. They search history for the transformation that has come from the core unit and how it shifts everything." In this work too "you go to the root of it and see how it reshapes other things around it." This, for her, "is very archeological" in "how it brings things out" (2011). In this sense, the work operates as landfill site, an archeological repository that allows us to produce ourselves inside a number of possible past and future feminist histories. Users, like archeologists, or detectives, search for the transformative potential of that past feminist work that so much affects who we are today. In searching for it, they disclose new relationships between past and present, the personal and the political. In this sense, the work is archeological, for it offers itself to the user as a set of mediating practices, translating between points in time and bringing about novel mechanisms for the transformation of the social sphere through the performance of ourselves within and because of the apparatus of the archive.

3 Architecture, Memory, and the Archive

Auschwitz has changed the basis for the continuity of the conditions of life within history.
(Habermas 1987, 163)

In his influential "Between Memory and History: *Les lieux de mémoire*" Pierre Nora writes: "Modern memory is, above all, archival." We are delegating to the archive, he suggests, "the responsibility of remembering" (1989, 13). Drawing from literature on memory and remembrance (e.g., Bartlett 1932; Nora 1989; Connerton 2007), research about the operation of mirror neurons (Gallese et al. 1996 and Rizzolatti et al. 1996) and Embodied Simulation Theory (Gallese and Guerra 2012), the role of the witness in holocaust monuments and memorials (e.g., Agamben 1999; Huyssen 1995; Young 1994 and 2000), and the function of mapping and mapmaking in the generation of knowledge (Ingold 2000; Wood 1993), this chapter explores the role played by the use of archives as laboratories for memory production. In particular, the chapter analyzes the functions of individual and collective memory through the lens of anthropology (e.g., Connerton 2007) and memory studies (e.g., Schiffer 2008), introducing the role that different types of memory practices (Hirstein in Nalbanthian et al. 2011) play in the use of the archive. Finally, the chapter looks at how archival materials and practices are increasingly encountered as part of our everyday lives. The case studies for this chapter are the Jewish Museum in Berlin, the CloudPad replay of Blast Theory's hybrid location-based game *Rider Spoke* (2007), and a number of trails built by using archival materials belonging to Exeter City Football Club Supporters Trust.

Memory, History, and the Archive

In chapter 2, I introduced an archeological, spatial framework for the analysis of the processes and layers of accumulation and conformism, and the palimpsestic production and transmission of our presence and identity in the archive. This framework proposed deep mapping as a means to read and build archives. Here I present a temporal framework aimed at generating an understanding of how the archive operates as a memory aid. This framework utilizes mapping and mapmaking. Before I introduce the framework, it is crucial to

understand the changing relationship between the archive, memory, and history. In *Les Lieux de mémoire* Pierre Nora makes a distinction between memory, which he equates to life, and which is "in permanent evolution, open to the dialectic of remembering and forgetting" (1989, 8) and history, which is "the reconstruction, always problematic and incomplete, of what is no longer" (p. 8). While memory for him is "actual," a "bond tying us to the eternal present," history is "a representation of the past" (p. 8), and while memory "takes root in the concrete, in spaces, gestures, images, and objects," history, for him, "binds itself strictly to temporal continuities, to progressions and to relations between things" (p. 9). In chapter 2, I discussed how archives act as archeological repositories that allow us to produce ourselves inside a number of possible past and future histories. Here I adopt Nora's distinction between memory and history, and refer to a number of studies in neuroscience, to analyze the role of the archive in relation to different types of memory.

For Nora the fact that "[m]odern memory is above all archival" means that modern memory is reliant "*entirely* on the materiality of the trace, the immediacy of the recording, the visibility of the image" (1989, 13; added emphasis). This "upsurge in memory" is contingent on the documentation of the signs of the presence of subjects captured in their "permanent evolution" (p. 8), in their relation to their environment over time. As memory is profoundly reliant on traces, recordings, and images, their capture, organization, and preservation in the archive have become indispensible for the operation of memory processes. This shift can be traced back, according to Nora, to the 1970s when "every country, every social, ethnic or family group" underwent "a profound change" in their relationship with the past testified by the increase of "criticism of official versions of history," the "recovery of areas of history previously repressed," and "demands for signs of a past that had been confiscated or suppressed" (1996). I will later show how this phenomenon can be traced further back, to the end of the Second World War. Here I show how our suspicion toward a single canonic History, traceable even further back to the modernist disbelief in the rational structures of temporality (Huyssen 1995), and, more generally, any form of meta-narrative (Lyotard 1984), has proceeded, in Nora's analysis, alongside the "upsurge in memory" (1996) prompting also a rise of worldwide "memorialism" (Nora 1996), aimed, however, not so much at the production of privileged, canonic histories, but rather at the multiplication and (re-)performance of the memory of the self, as well as the (re-)performance of the memories of others, within the archive. This "upsurge in memory," alongside the rise in worldwide "memorialism" (Nora 1996), is a defining characteristic of our age, inextricably linked to our obsession with our presence, its capture, preservation, and replay in the archive.

Nora notes that the "upsurge in memory" (1989, 8) has led to what Daniel Halévy called an "acceleration of history," precipitating a "distance" from the past so that "we no longer inhabit the past, we only commune with it through vestiges" (in Nora 1996). The fact that we can only commune with the past through vestiges shows that we can only reconstruct the past by building sets of relationships with its traces. We construct memories—ours, as well as those of others—through these traces, as if a construction of the present moment

could only occur by relating ourselves to the traces of the past. Memory, hence, is not so much responsible for a recollection of something in the past, as for the construction, or even reconstruction, of the past in the present (i.e., in relation to our presence) and for the capture of the present as something always already passed (i.e., accelerated into history). The growing obsession with self-documentation is a symptom of this phenomenon with the very "task of remembering" forcing us to become the curators, or, in the words of Nora, the historians of our own lives (1989, 15). It is through self-documentation that we capture the effect of our presence on what is around us, producing the traces that facilitate the creation of mnemonic plotlines. These, in turn, locate us within a number of possible histories. The production and reinterpretation of traces is the foundation of future memories.

While there are substantial distinctions between memorial and archival cultures, which I do not have the space to analyze in detail, a brief excursus into the use of architecture in memorial cultures will aid the understanding of the spatiotemporal operation of memory in the 21st century. We know from medievalists like Mary Carruthers that while modern cultures in the West are "documentary," medieval culture is best described as "memorial" (2008, 9). This distinction is visible in the physical configuration of the relationship between memory, documents, architecture, and the archive. Memorial cultures relied heavily on architectural structures as means "to imprint on the memory a series of *loci* or places" (Yates 1972, 3). In fact, the earliest known reference to architecture in relation to memory is in 86–82 BC when an anonymous author introduced in *Rhetorica ad herennium* a memory device based on house names. Carruthers tells us that the backgrounds used here are like "wax tablets (*cerae*)" (2008, 24), an image which is likely to have derived from the seal-in-wax model for cognition as described in Plato's *Theaetetus* (417–369 BC) who in turn probably developed the image from Homer (Carruthers 2008, 24). Carruthers points out how "the arrangement of the images on these backgrounds was meant to be like writing" and that "subsequent delivery is like reading aloud." She also notes that "[t]he backgrounds must be arranged in a series, a certain order" so that one may proceed forward, backward, or start in the middle. To aid the creation of this order, architectural structures were adopted that had to be practiced daily. These architectures, interestingly, included the positioning of the viewing subject. Both the author of *Rhetorica ad herennium* and Cicero in fact talk about *intervallum* meaning "the distance between two points" (Carruthers 2008, 90) or the distance between the viewer and the background, aiming to create what could nowadays be described as a perspectival point of view in which the viewer is positioned in relation to the memories they narrate (p. 91).

While the *Rhetorica ad herennium,* which dominated medieval teaching, had adopted Roman architectural features, the medieval commentator Albertus in his *De bono*, which was heavily reliant on the *Rhetorica ad herennium*, used medieval architectural features (Carruthers 2008, 174ff). In other words, an orator would have moved through the "virtual" building whist speaking (Yates 1972, 3), utilizing architectural features that were "current" to their times as prompts to recall particular memories. The fact that movement through virtual space and engagement with particular architectural features could be used to generate

memories, and thus prompt the production of possible histories, and that memory is spatial, architectural even, and that this architecture needs to be current, or "present," plays an important role in my analysis of archives as laboratories for the production of memories, as I will discuss more specifically in relation to this chapter's case studies. The fact that because the spatial features had to relate to the present time, or one's presence in time, they were contemporary to the viewing subject, also helps in building an understanding of how memory operates within and through the archive.

I have suggested that our changing relationship to history and to the role that memory plays in that relationship is at the heart of our current obsession with archiving. For Nora it was the "upsurge in memory" (1989, 8), and for Halévy the "acceleration of history" (in Nora 1996), that led to the proliferation of institutions and instruments relating to memory and history creation, such as museums, archives, libraries, collections, digitalized inventories, databanks, chronologies, and, I may add, in more recent years, self-documentation through social media such as Facebook, Twitter, and WordPress. This in turn led to "the *autonomising* of the present," which bought on "the emergence of the present as a category for understanding our own lives" (Nora 1996; original emphasis). Recent studies about the relationship between the present and presence (Giannachi and Kaye 2011; Giannachi, Kaye, and Shanks 2012) confirm Nora's view, showing also how the performance and/or production of the present, and our presence in relation to it, its documentation and preservation toward the production of a history, are fundamentally linked to archival practices.

I have suggested that the past can only be read in relation to the present. The archive constitutes the "memory architecture" within which we encounter and re-appropriate what is left of the past in the present and where we preserve the present as a future past. By building new memories in relation to the past, we become the curators of our own lives, constantly producing new traces to re-write our histories in relation to those of others. It is in the archive that our presence is captured and its traces are read relationally in time. It is again in the archive that history can be encountered as subjective memories and that, *vice versa*, subjective memories are shaped as collective histories. This act of presencing, of pacing the *intervallum* of time, produces, like in Samuel Beckett's well-known play *Footfalls* (1975), sets of perspectival viewpoints that affect the act of viewing/performing/generating the archive. Different documents are produced to capture these perspectival changes so as to record what we looked at and/or how we performed within the archive. We can only remember our presence in time by analyzing the traces of this effect of our presence on whom or what is around us through these documents. The archive, hence, is the architecture wherein the documents, capturing the signs of the effect of our presence on others, and *vice versa*, the effect of the signs of the presence of others on us, are encountered, remembered, curated, and historicized. Because of this, the apparatus of the archive, as in the case of Beckett's other renowned play *Krapp's Last Tape* (1958), is where our histories must continuously be replayed, for their "liveness," or our "aliveness," is dependent on our ability to rewrite ourselves within it.

The Plurality of Memory

In the context of writing about the role of memory in the archive, it is crucial to think of memory as plural. Recent scholarship in memory studies suggests that there are different types of memory. Thus the philosopher Willian Hirstein draws attention to the fact that there is an "episodic" or "autobiographical memory," that forms a fragmentary and highly subjective "record of our personal experiences, usually from our point of view." This memory, which, like medieval memory, entails a perspectival view point, is crucial in the construction of identity, so much so that losing it, Hirstein points out, "means losing sense of our self" (in Nalbanthian et al. 2011, 218), something that confirms that processes to do with memory, the archive, presence, and identity affect each other. Other types of memory, Hirstein shows, are "source memory," which tells us where we acquired a specific item of information, and "semantic memory," which is about knowledge of impersonal facts (p. 219). Hirstein thus notes that autobiographical memories aggregate into semantic memories so that, for example, we may forget the occasion we heard about something but still remember the principal fact we heard (p. 219). Additionally to these forms of subjective memories, there are collective memories, or memories shared by groups (Zerubavel 2003, 4). There are also primary memories, which are those of people who have lived through certain events, and secondary memories, which are the "result of critical work on primary memory whether by the person who initially had the relevant experiences, or, more typically, by an analyst, observer, or secondary witness such as the historian" (LaCapra 1998, 20–21). In discussing the function of archives in this context, I argue in this section that memory processes are multiple, in the sense that diverse forms of memory may coexist and prompt each other. This hypothesis is crucial to build an understanding of the role played by archives as a social memory apparatus.

Different types of memory may influence and implicate each other. Sociologist Paul Connerton points out that there are different types of memory claims: personal memory claims, for example, "take as their object one's life history" (2007, 22); cognitive memory claims may imply the remembrance of words or stories and stem from past cognitive or sensory memories of oneself; and habit memory claims allow us to reproduce a certain performance, such as reading or cycling. (p. 23). He shows that the relationship between different types of memories pertaining to oneself remains somewhat fluid, with cognitive memory being able, for example, to affect personal memory (p. 23). Moreover there are collective memories or memories shared by groups, which can be acquired through membership of a social group, and the relationship between individual and social memories also can be fluid (Zerubavel 2003). Ritual too plays a crucial role in this context since images of the past and recollected knowledge of the past are "conveyed and sustained by (more or less) ritual performances" (Halbwachs in Connerton 2007, 38) that are particularly significant for commemorative ceremonies (Connerton 2007, 71), namely ceremonies in which "a community is reminded of its identity as represented by and told in a master narrative" in a kind of "collective autobiography"

(p. 70). Crucially, these studies show not only that there are different types of memories, and that these affect each other, but also that individual memories can affect group memories and produce novel kinds of master narratives through what can be described as performative processes.

Recent studies in neurology suggest that we continuously re-categorize the past so that our memories are never the same (Schiffer 2008, 15) and that remembering is in fact not so much "equivalent to going through a photographic album but rather constitutes a creative process" (p. 4, my translation). In other words, remembering is not so much a recollection of a past event but rather its creation. As different neurons are engaged in the act of remembering over time, memories of an event are not only variable among the different people who witnessed this event, as would be expected, but also, over time, they are different for every one witness, in that the brain categorizes and processes these memories as separate though related events (p. 29). Thus neurologist Davide Schiffer suggests that when we recall an event, new stimuli are created that become integrated into how the lived event was associated with from an emotional point of view. This phenomenon he calls *quale*, denoting the subjective quality of the conscious experience. He argues that "every time there is a recall, its integration modifies the lived experience so that it will never be the same again" (p. 184, my translation)—"these fluctuations," he claims, "are not unlimited but closed within the limits of recognition of one's own identity" (p. 192, my translation). In other words, the recall of a memory does not only regenerate an event but rather, in the course of doing so, it modifies it. Remembering, in this sense, becomes a "creative" process that is invariably tied to identity creation, which, in turn, is related to the establishment of one's presence, or the understanding of one's being in the present—in time. Remembering, of course, also shapes the creation of social memories, which means that the archive forms a crucial part in how societies see and think of themselves.

Mirror neurons tell us even more about how memories may be created of events that we have not personally experienced. In *Descartes's Error* (1994), Antonio Damasio describes the neural substrate of the bodily basis of emotion. Movement, he claimed here, as well as in *The Feeling of What Happens* (1999) and *Looking for Spinoza* (2003), generates emotional awareness so much so that, in David Freedberg's words, in observing the physical and emotional behavior of others our brains "assume the same state they *would have been if* we were engaged in the same actions—or underwent the same emotions—ourselves" (2011, 341; original emphasis). The discovery then, by Giacomo Rizzolatti and others, of mirror neurons became a crucial means to understand our response to art as well as, potentially, visual materials in archives. Mirror neurons, Rizzolatti and his team discovered, are a particular group of visuomotor neurons in the rostral part of the ventral premotor cortex of macaque monkeys. What is interesting about them is that they discharge both when a monkey observes an action and when the monkey executes it (Gallese et al. 1996; Rizzolatti et al. 1996). Researchers also found that when a goal-oriented action is observed, the same parts of the neural network in the premotor cortex become activated that are active during the action's executions. This occurs

whether the monkey imitates the action or simply observes it (Fogassi and Gallese 2002, 13–19). This finding led to the belief that human brains too are capable of reconstructing actions "by merely observing the static graphic outcome of an agent's past action" so that, for example, even in just looking at a painting, there is an activation of the same motor centers required to produce a given graphic sign (Freedberg and Gallese 2007, 202). It is now proved that watching someone conduct an action activates the same cortical regions that are usually activated when executing the same actions so that by means of Embodied Simulation (ES) Theory we have what has been described as "direct access to the world of others" (Gallese and Guerra 2012, 185). By looking at an action in a film, photograph, or painting, or their visual documentation, we (re-)enact that action in our brain. In this context the artwork, its visual documentation, the archive, and museums that host it, all become fundamental architectures to the experience of the embodied simulation of actions, allowing us not only to learn about but, in effect, re-create a past event and herewith appropriate it within our memory.

In conclusion, it is common knowledge that the terms history and story are interrelated. This can be seen by the fact that some languages, like Italian, French, and Spanish, for example, have one word for both these concepts (Zerubavel 2003, 13). History, story, and memory are also interrelated. Thus emplotments, "scriptlike *plotlines*" (p. 13; original emphasis) can be described as "sociomnemonic structures" (p. 14). Through processes that can be seen as forms of "mnemonic pasting," we can mentally convert distant points in time "into seemingly unbroken historical continua" (p. 40). Separate and disparate memories can be organized and structured into complex meta-memories, which are continuously re-enacted, and herewith re-rewritten through new secondary memories generated in the archive. We know that memories have a constructive and reconstructive character: as we forget information over time, we reconstruct this by adding and altering original memories (Bartlett 1932). We also know that memory cements information in the brain in "sequential" fashion with an initial phase in which memories can be easily interfered with and a subsequent phase in which they are more resilient (Silva in Nalbanthian et al. 2011, 41–42). Finally, we know that in watching the actions of others we effectively re-enact them and herewith appropriate them within our own memory. As put by Gallese and Guerra, we literally "map the actions of others onto our own motor representations, as well as others' emotions and sensations onto our own viscero-motor and sensory-motor representations" (2012, 206). In watching the actions of others, a mapping process therefore takes place through which others become present to us, *become us,* as their memories become ours. I have said that the archive is where personal events are forged into communal histories. In fact, the archive is the site where the traces of this act of becoming are produced, stored, and transmitted; it is the "memory architecture" where Halévy's "acceleration of history" (in Nora 1996), or the historicization of the present, and hence the documentation of the making of our future past, occurs. The following three case studies analyze what happens when the apparatus of the archive is juxtaposed with the places we inhabit in our everyday lives.

The Witness and the Archive: Remembering the Holocaust

Since the Second World War there has been a known increase in the number of artists who have been endeavoring to answer the problematic question as to how to remember the Holocaust, so much so that James Young identified them with the name "memory artists" (2000, 11). Their concern with the past brought on a "memorial, or *museal,* sensibility" generating "obsessive self-memorialization" through camcorders and writing (Huyssen in Young 1994, 11; original emphasis). For Young, these artists have had to "acknowledge both the moral obligation to remember and the ethical hazards of doing so in art and literature" (2000, 6). In the actual impossibility of remembering, many of them did not attempt to represent the Holocaust, but rather constructed, in his words, "hypermediated experiences of memory" (p. 1). For them, Huyssen notes, the past "must be articulated to become memory" and thus "the temporal status" of these acts of memory "is always the present" (Huyssen 1995, 3). Their practices, like those of the memory artists described in chapters 1 and 5, are often archival in nature. In this section, I will discuss how these artists' engagement with "hypermediated experiences of memory" (Young 2000, 1) within the context of an overall rise of a "memorial, or *museal,* sensibility" (Huyssen in Young 1994, 11) has affected our relation with and understanding of the role of the archive in relation to architecture.

For Huyssen our obsession with memory has significantly weakened the boundaries between museums, memorials and monuments, rendering them somewhat "fluid" (12) or, as we have seen earlier, interchangeable. An example of a monument-memorial, for instance, is Mischa Ullman's *The Empty Library* (1996), a physical installation portraying the empty white bookshelves of an underground library accompanied by a placard quoting Heinrich Heine: "Where books are burnt, so one day will people be burnt as well"—a reminder of what followed the burning of books at Bebelplatz in Berlin on May 10, 1933. Another well-known example is Christian Boltanski's *Missing House* (1990), which was built in memory of a number of people who lived in 15/16 Grosse Hamburgerstrasse between 1930 and 1945. The building had been destroyed by allied aerial bombardment on February 3, 1945, and while after the war the two buildings next to it were restored, an empty space was left between them, where the memorial was placed. This consisted of a series of twelve black and white plaques indicating the names, dates of birth, death, and occupation of the missing Jews who inhabited the site in approximately the position of the apartments they once occupied. Likewise, work in Boltanski's *Monuments* series (1989–2003), which explores the themes of loss and death while at the same time raising questions about the efficacy or validity of the photographic medium, constitute themselves as monuments and archives. His *Archives* (1965–88), a monumental collection of photographs, letters, and other personal documents of his own life, collected in 646 biscuit tin boxes, also are at once an artwork and archive. As Kai-Uwe Hemken suggests, here the "archive is an exposition of a continual process of sedimentation." Individual references "become traces that lose their singular identity, only to function in mass as an archive of memory. But it is also a place that stimulates memory—memory

understood here as mourning at the presence of the past as past" (in Schaffner and Winzen 1998, 80). Here the archive is both a laboratory for the production of collective memories and a facilitator for the creation of new memories.

This complexity of forms is also at the heart of the architectural and curatorial vision for a number of museums dedicated to the Holocaust. For example, the United States Holocaust Memorial Museum, built in Washington, DC, 1993, was described as a "code," bringing together "a collection of Holocaust symbols that need to be identified and 'read'" (Linenthal 2001, 106). For Edward Linenthal therefore "[t]he curved entranceways leading off the [Hall of Witness] are reminiscent of the shape of the crematoria doors, while the massive brick towers on the north side ... represent chimneys" (p. 106). Yaffa Eliach's tower exhibition of photographs, consisting of 1,032 framed images which have "the warmth of a family album" (Eliach in Linenthal 2001, 184) aims to represent people not yet as victims (Farr in Lilienthal 2001, 185). The viewing of photos such as that of Polish teacher Marian Jurek, taken just a few moments before his execution in 1939, or that of two Hungarian Jewish boys on the ramp at Auschwitz, taken shortly before they were murdered in the gas chambers, turns visitors to the museum into post-event witnesses. Not unsurprisingly, then, Susan Sontag describes her experience of viewing these images as life-changing: "One's first encounter with the photographic inventory of ultimate horrors is a kind of revelation, the prototypically modern revelation: a negative epiphany. ... Indeed, it seems plausible to me to divide my life into two parts, before I saw those photographs ... and after Some limit had been reached, and not only that of horror: I felt irrevocably grieved, wounded, but a part of my feelings started to tighten; something went dead; something is still crying" (1977, 20).

Another such museum is Daniel Libeskind's Jewish Museum in Berlin, which reflects the architect's belief that the Jewish history of Berlin is not separable from the history of modernity, and that a Jewish Museum built in Berlin could not be designed outside of the historical and emotional parameters of the Holocaust (1992; see figure 3.1). Thus Libeskind states: "The Jewish Museum is based on the invisible figures whose traces constitute the geometry of the building" (1999, 17). This follows the design of an invisible broken Star of David connecting individual addresses in Berlin like a contorted angel, a reference to Walter Benjamin's angel of history who is flown backward toward the future, his mouth wide open, his eyes staring at the mounting wreckage of so-called progress (Benjamin 1992, 249). These contortions are described by Libeskind as being "as real as those of all the other deported archangels: Franz Kafka, Walter Benjamin, Primo Levi, Osip Mandelstam, Paul Celan" (1997, 26) that constitute points of intertextual reference for the work.

The outside of the building is covered in zinc. The shiny surface is, like a wound, cut by 365 windows (see figure 3.2), which are, as in Libeskind's words: "the actual topographical lines joining addresses of Germans and Jews immediately around the site and radiating outwards" (1999, 27). Libeskind called the work "Between the Lines" "because it is a project about two lines of thinking, organization and relationship" "one is straight line, but broken into many fragments; the other is a tortuous line, but continuing indefinitely." In their

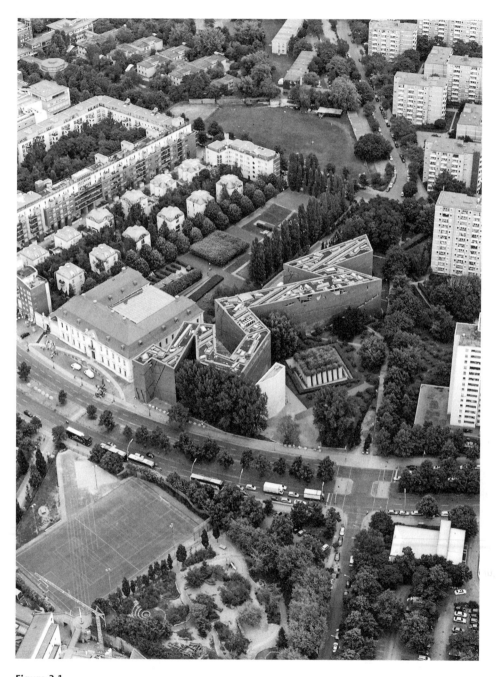

Figure 3.1
Orte/1/0 JMB Außenansicht, Altbau und Neubau Orte/61/0 JMB Akademie, Blumengroßmarkt, Außenansicht (Archiv, Bibliothek), photo Philipp Meuser. © Philippe Meuser.

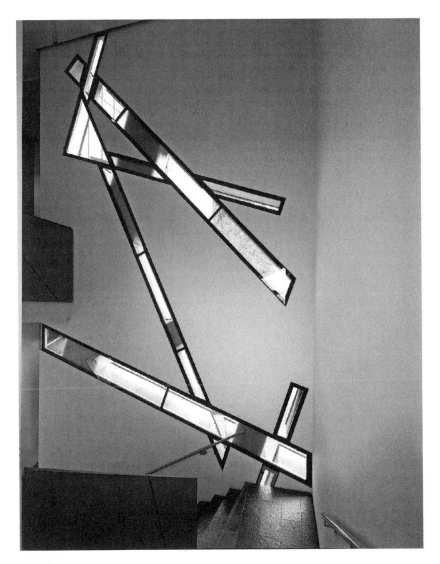

Figure 3.2
Inside view Jewish Museum Berlin, Window in the Libeskind-Bau © Jüdisches Museum Berlin. Photo Jens Ziehe.

"dialogue" "they expose a void that runs through this museum and through architecture, a discontinuous void" (1991, 23). At the heart of the building there are in fact a number of void rooms, six in total, of which only the first two and the last two can be entered. The two in between are inaccessible though they can be looked onto from the upper floors through inside windows also resembling gun slits. At every point of transition black surfaces on the floors and ceilings signal the rectilinear relationship to the voids. There is noncongruence between interior and exterior and the figure in space described by the underground floor is different from the one of the building above. Among the most complex spaces is the Holocaust tower. This is another void space, lit by a shaft of natural light coming from the top of the tower. The sloped floor has a rough finish and creates the sound of scraping sandpaper. Visitors can faintly hear the sounds of the city.

As the building distorts visitors' sense of spatial perception, they are continuously directed to depart from themselves to question their own relationship with, or even place within the building and, more broadly, within the architecture of the city. In the words of Michal Kobialka, "[l]ike a nomad, one walks through this space where the ground constantly changes direction, and the trajectory of movement frustrates a perspectival viewing of the space. There is neither background nor center" (2000, 52). Everything in the Museum is transitory so that the building can be described as being "always on the edge of Becoming—no longer suggestive of a final solution" (Libeskind in Young 2000, 163). As Jürgen Habermas noted, the very basis of the continuity "of the conditions of life within history" (1987, 163) are at stake in the aftermath of the Holocaust. In his work Libeskind, for example, challenges the subject to position her- or himself in relation to the past, as part of a historical continuum. The architecture is such that this positioning, the working out of the *intervallum*, is difficult. The subject often vacillates, her or his physical, and metaphorically, intellectual stability is being put into question. At the heart of this destabilization of the subject is their role as witness.

The explanation as to the significance of the act of witnessing in the aftermath of the Holocaust is given by the philosopher Giorgio Agamben. In analyzing Michel Foucault's suggestion that the archive is "the general system of the formation and transformation of statements" (1972, 130), Agamben suggests that "as a set of rules that define the events of discourse, the archive is situated between langue, as the system of construction of possible sentences—that is of possibilities of speaking—and the corpus that unites the set of what has been said, the things actually uttered or written" (1999, 143–44), constituting the "historical a priori" (p. 4). For him, as we have seen, this means that the archive is "the mass of the non-semantic inscribed in every meaningful discourse as a function of its enunciation," "the dark margin encircling and limiting every concrete act of speech" (p. 144). This "dark margin" is the pure potential of the "matter" of discourse that is stored in the archive.

Agamben suggests that there is an opposition, however, between the archive, indicating "the system of relations between the unsaid and the said" and testimony, indicating "the system of relations between the inside and outside of langue" (p. 145). This is a crucial

distinction that allows us to understand the role of the Holocaust in changing our relation-ship to memory and the archive. To explain this, Agamben shows that there are two words for witness. The first comes from Latin, *testis*, signifying etymologically "the person who, in a trial or lawsuit between two rival parties, is in the position of a third party" (p. 17); the second word, *superstes*, indicates the person "who has lived through something, who has experienced and event from beginning to end and can therefore bear witness to it" (p. 17). For Agamben, "the archive's constitution presupposed the bracketing of the subject, who was reduced to a simple function or an empty position; it was founded on the subject's disappear-ance into the anonymous murmur of statements. In testimony, by contrast, the empty place of the subject becomes the decisive question" (p. 145). This statement marks a fundamental change in the way that archives are often thought of today. As I will show in the next sec-tions, the subject, after the Holocaust, no longer accepts to be flattened into history, but rather feels that she or he can and often must state their position in the archive. Because of this necessity, the archive has become the main lens through which the subject defines her or his role as witness in history.

In the aftermath of the Holocaust, artists, as well as museum curators and architects, have often had to privilege what have been described as "hypermediated experiences of memory" (Young 2000, 1), the remains of history, testimonies by Agamben's *superstes*, as a way to engage new publics with the Holocaust. Thus, for example, in Libeskind's Jewish Museum, we find ourselves positioned as *testis,* not so much of the Holocaust itself but of our encounter with its remains (or, in Libeskind's case, the absence of remains, the Void). Through Embodied Simulation Theory we know that this means that here we do not only learn about the Holocaust but, in bearing witness to it, we map this knowledge into our own memory. As *testis* of legacies left by the *superstes*, we produce our own memories, and write ourselves as part of that history. The "decisive question," in Agamben's words (1999, 145), of the absence of Jewish history from our spaces transforms us into a *testis* charged with re-writing our relationship to that history, so that the memory of the *superstes* may live on. This remarkable building, both an architecture *and* an archive, a laboratory for the production of memories, shows that after the Holocaust the subject can no longer remain neutral; rather they must enter, even in the most uncertain conditions, in "the dark margin" that is the archive, precisely so as to be informed by their position within it.

Replaying Blast Theory's *Rider Spoke*

As playwright Bertold Brecht showed us in the "Street Scene, a Basic Model for an Epic The-ater" in which an eye witness demonstrates their recollection of an accident from a number of perspectives, such as those of the victim and the offender, so that different points of view may be evaluated (1964), acts of witnessing are not neutral but rather reflect culturally and politically biased perspectives over the reporting of an occurrence. In this section, I discuss the significance of the "role of witnessing" within the archive by using as a case study the

Figure 3.3
Rider Spoke interface. Copyright Blast Theory.

CloudPad replay of Blast Theory's *Rider Spoke* (2007–), a location-based game for cyclists, which the company developed in collaboration with the Mixed Reality Laboratory at the University of Nottingham as part of the European research project IPerG. I also discuss how a distinction between different types of documents in the archive can offer insight into why we cannot necessarily consider documents as evidence to the truthfulness of an original event, why documents need to be considered as part of the environment of an occurrence, and, finally, why it is through the juxtaposition of different documents that knowledge is generated in the archive.

In *Rider Spoke* participants cycled through a city to record personal memories in relation to particular locations while listening to statements made by preceding players (see figure 3.3). The piece, which focused on witnessing as a mechanism through which to encounter physical spaces in the city, was structurally archival and each day's recordings were loaded into the system overnight to appear in the work the following day, so that the experience of the piece was always being counterpointed by its historicity (Chamberlain et al. 2010). *Rider Spoke*, whose title hints to the fact the act of speaking always already occurred in the past, lasted approximately one hour. After the first few minutes, music started playing and a narrator, Blast Theory member Ju Row Farr, began giving instructions, the first being to choose a name and describe yourself. Participants would then record their description in sites that appealed to them and were "empty," in the sense that they did not contain another message, since every message in the work had to occupy a distinct location in the city. Further questions asked them to reflect on significant, evocative, or funny moments of their life

while engaging with the city through which they cycled. Typically, they might be told to look for a particular place or identify meaningful locations, which often encouraged them to reveal private details about their own lives. While these kinds of instructions prompted them to use details from the physical world around them to start reflecting about themselves, others turned them into witnesses narrating what they saw. Other questions were designed to elicit intimate, sometimes even confessional, stories, and encouraged riders to seek out locations that might have special meaning to them. When the experience was near its end, participants were given one final task, to make and record a promise, which prompted them to disclose a personal vulnerability. After the promise, they were asked to return to the base where the piece would end.

Each city in which *Rider Spoke* took place became a user-generated archive of ephemeral memories; the performance of the work consisted in the act of self-documenting these "memories" in the spaces that had motivated them. "Meandering" had constituted a significant design goal (Adams et al. 2007, 3) as it was assumed that a spatial meandering would afford a mental meandering, leading participants to move from the present to the past as well as, toward the end of the piece, the future. Unlike in other Blast Theory works, no background scenario or overarching meta-narrative was offered. Rather, this piece exposed a tension between the participants' presence in space and their being in time. Whereas temporally, by asking them to remember, the piece relocated them to the past, spatially, by encouraging them to cycle forward, it projected them toward the future so that their "here and now," their present, was presented to them as being at stake both literally, in the busy traffic, and ontologically, in relation to their presence or even persistence in time.

Rider Spoke was documented in September 2009 by a team comprising staff from the Universities of Exeter and Nottingham, as well as personnel from the Ludwig Boltzmann Institute Media.Art.Research in Linz, Austria. Influenced by hybrid approaches to documentation (Jones and Muller 2008; Depocas et al. 2003; see also chapter 1), the team used a range of equipment to capture the user experience and recorded nine participants' rides by including GPS to record location; in-game audio along with the participants' responses to the game and environmental sounds; and video captured from two key vantage points (see figures 3.4 and 3.5). These vantage points were a "chase cam" mounted on the bicycle of a documenter following the rider, which delivered an over-the-shoulder, third-person perspective, and a "face cam" upwardly mounted on the handlebars of a participant's bicycle, which delivered a head-on perspective of the rider. All nine participants were interviewed after the experience to capture their memories of the work (see also Giannachi et al. 2010). Overall, the team had aimed at collecting hybrid data from participants and gathering further interview materials from the artists and technologists involved in *Rider Spoke* and the development of the archival replay tool CloudPad, which was developed specifically for this project, at a later point.

CloudPad was devised by an international team comprising staff with expertise in Performance Studies and New Media, Information Science, Computer Science and Human Computer Interaction (HCI), in partnership with the UK artist company Blast Theory, the British

Figures 3.4 and 3.5
Participants to the *Rider Spoke* documentation in Linz (2009). Courtesy Horizon Digital Economy research.

Library, Stanford University Libraries, the San Francisco Art Institute, the Ludwig Boltzman Institute Media.Art.Research, and the University of Sheffield. A customizable web-based platform, CloudPad, which only ever existed in Beta, aimed to facilitate the synchronized playback of cloud-based media entities such as YouTube video or audio files with layers of user annotations. It could be used to create documentation and archives of one or more performances, thereby facilitating the creation of legacies of artworks, while also integrating new documentation, annotation, and metadata with existing digital archives (see Giannachi et al. 2010). The vision for this had been that CloudPad should offer a novel technical approach to the archiving and replay of pervasive media experiences by making use of Web 2.0 technologies (DiNucci 1999) rather than grid technologies. CloudPad users were thus empowered to view the repository as a "live" document in which they could leave their own impression of an experience (both of the original event recordings as well as any thematic connections or annotations provided by other visitors and experts). Previous interactive systems designed for the replay of events for analysis had lacked this level of emergent reflection (see Brundell et al. 2008), treating the corpus of recorded material as essentially immutable. To enable this capability, CloudPad made use of server-based storage, which means that media from a wide variety of different sources could be included in a presentation (e.g., YouTube videos synchronized with images from Flickr). This integration was accomplished through the use of HTML5 (see w3.org), an emerging web standard that enables collaborative interactive applications to be structured to run inside a web browser (Murray 2005).

To organize the relationship between the original *Rider Spoke* documentation and information provided by subsequent users in CloudPad, the team adopted Suzanne Briet's distinction between different types of documents. In her seminal "What is Documentation?" (1951), in which documents are presented as signs, challenging the view that they are proofs of a fact and situating "the practice of documentation within a network of social and cultural production" (MacDonald 2009, 59), Briet discusses the use of primary and secondary documents, where by primary documents she refers to initial documents and by secondary documents she means documents that are created from the initial document. Briet then goes further in her analysis between life itself, or "the real," and documentation. She writes: "Is a star a document? Is a pebble rolled by a torrent a document? Is a living animal a document? No. But the photographs and the catalogs of stars, the stones in a museum of mineralogy, and the animals that are cataloged and shown in a zoo, are the documents" (2006, 10). She notes that a document should not be read in isolation. Precisely because documentation is contextual, rather than delivering remains of an isolated event, they form a matrix or network of signs. This, she notes, can lead to creation "through the juxtaposition, selection, and the comparison of documents, and the production of auxiliary documents. The content of documentation is, thus," she concludes, "inter-documentary" (p. 16). A number of conclusions can be drawn from Briet's analysis: first, while documents may constitute what remains, they are not necessarily evidence of an original event; second, documents are generated contextually, as part of the environment of an occurrence; third, it is through the often dialectical

juxtaposition of different documents that knowledge is generated. These distinctions provided the basis for the organization of the *Rider Spoke* documentation thorough the CloudPad archiving tool, which aimed to use documents for the generation of future memories.

All materials in the *Rider Spoke* documentation were tagged "neutrally'" (i.e., offering descriptions only of what could be seen or heard in the archived video captures of participants' experiences). Three possible trajectories were constructed to facilitate navigation through the archive for those who wanted to organize their 'reading' of the documentation from a definite access point: Matt Adams from Blast Theory tagged one rider's journey by annotating how his experience related to the artistic intent of the work and how he felt looking at that particular rider's journey though the work; Nick Tandavanitj from Blast Theory tagged a rider's video to describe what he saw in it, including what the documentation could not capture; I offered an analysis of a rider's journey and explained how this related to the intent of the documentation, also by comparing this to the other documentary materials. Based on Briet's distinctions between different types of documents and on the basis of the team's work on designing trajectories through mixed reality experiences (Benford and Giannachi 2011), the archive was designed as follows: each of the nine participants' experiences of *Rider Spoke* was described as a historic trajectory through the work (constituting, in Briet's terms, a primary document). These individual experiences can be accessed through a number of canonic trajectories, which is to say, through the historic trajectories forming the archive (constituting, in Briet's terms, a secondary document). Finally, users of the *Rider Spoke* CloudPad archive, by further annotating these materials, are expected to create sets of participant trajectories, which were thought of as adding value to the archive over time (constituting, in Briet's terms, auxiliary documents). Typically, whereas the historic trajectory of a participant, for example, shows him cycling down a wealthy part of Linz, the canonic trajectory, which in this case was created by Matt Adams of Blast Theory, comments on the origins of the dramaturgical structure of the piece. While the historic trajectory shows the original documentation only as recorded on site in Linz, the canonic trajectory constitutes an authorial gaze recorded after the event itself, aiming to comment on the work from an aesthetic, academic or technical point of view. Interestingly, the team found that canonic trajectories not only offered those who authored them the possibility of annotating a historic trajectory, but also facilitated reminiscence about their own performance of the work or evoked moments that were cognate with it. Thus for example, while watching a participant reflect about his father in response to the question:

> Please will you tell me about your father. You might want to pick a particular time in your father's life or in your life. Freeze that moment and tell me about your dad: what they looked like, how they spoke and what they meant to you. And while you think about this I want you to find a place in the city that your father would like. Once you've found it stop there and record your message about your father at that moment in time.

"Please will you tell me about your father." A really important question for me. My father worked (and for a few years after my parents divorced, lived) in the City of London. We didn't speak for about a decade but I cycled through the City from London Bridge most days during that period. As we developed Rider Spoke for its premiere at the Barbican I was once again riding through those streets and reflecting on our relationship. For me, he is emblematic of a brooding presence in the city. He imprinted many places in London with a powerful charge of fear and regret.

Figure 3.6
Matt Adams's annotation on CloudPad. Courtesy Horizon Digital Economy research.

Adams starts to reflect about his own father and recalls memories of his own experience of the work at the Barbican in London, as can be seen by the CloudPad recording in figure 3.6.

Just as *Rider Spoke* facilitated spatial and mental meandering, the use of CloudPad encouraged meandering between different documents of the work and associated memories, such as subjective memories (episodic, autobiographical, source, semantic memories), as well as group memories (primary, secondary memories). While at one level the CloudPad facilitated the replay and annotation of primary documents of *Rider Spoke*, at another level the emerging CloudPad archive proved to be an effective medium for replaying secondary documents, generated in this process, and then produce auxiliary documents as a consequence of the latter. We know from Briet, that it is the juxtaposition of documents, their inter-documentary dialogue that allows them to inform the understanding of an event not only at the time when an event may have originally occurred, but also in the aftermath of it. Implicit in this is that the document is much more than the remains of an event. It is the signs of a series of contextual factors that may have mapped aspects of the conception, realization and reception of an event. In this sense the document is not static; it changes over time and according to use. The document must therefore be read as an inter-document, not so much a proof of a past event, but rather a clue to a possible context whose varying interpretation, at any given present moment and over time, may lead to the generation of new types of interpretation and so produce further documents within the archive.

More and more, ephemera kept online, particularly through social media sites, are used as documents to prompt and share memories. This means that, as in the case of *Rider Spoke,* the act of remembering, and witnessing the memories of others, is an ever more public and possibly even performative experience, and that the *act* of remembering through the archive, or creating and re-playing documents in the archive, as in Beckett's play *Krapp's Last Tape,* or as we will see in chapter 5 in the case of sosolimited's work, may constitute a spectacle in its own right. As Geoffrey Batchen had remarked in his essay "The Art of Archiving": "the archive is no longer a matter of discrete objects (files, books, art works, etc.) stored and retrieved in specific places (libraries, museums, etc.). Now the archive is also a continuous stream of data, without geography or container, continuously transmitted and therefore without temporal restriction (always available in the here and now)" (1998, 47). This often live broadcast and sharing of a stream of data, alongside the creation of documents that testify to this occurrence, is at the heart of the ways that memory functions within the apparatus of the archive as a continuous bringing the present into meaning through its relation to past documents.

We have seen that the status of digital archives is ontologically different from what we have, thus far, understood archives to be. No longer purely centers for storage and preservation, digital archives have become the main repositories for the capture, preservation, reinterpretation, sharing, and finally spectacularization not only of the act of remembering, but also of the instant memorialization of our everyday lives. We know, as Derrida noted, that archivization "produces as much as it records the event" (1995, 17) and that archives are architectures for the "production" (Santone 2008, 147), propagation and exchange of future memories. This emphasis on exchange and production, supplementing the notion of an archival repository as site for storage and preservation, and the general trend toward participatory and interactive forms of user engagement, explains the growing interest in repeating, replaying, and re-performing documents as part of our everyday lives. I have already said that we can only reconstruct the past by building sets of relationships with its traces. We can also only grasp the present by interpreting it through the apparatus of the archive. Likewise we can only build future traces by capturing the present as document for the archive. As *Rider Spoke* shows, to become the historians of our own lives, we constantly need to produce and share documentations of our presence in time and space, so that our own histories, our acts of witnessing, may produce further documents for others to replay within the archive. As archiving is increasingly a form of art, generating or performing the archive constitutes, as in the case of *If Tate Modern was Musée de la Danse?* (2015) discussed in chapter 6, a spectacle for others to witness.

The Distributed Archive: Mapping Memories in Everyday Life

I have said that, increasingly, archives are used as a strategy to interpret and document what we do and encounter in everyday life. The trail building web app Time Trails, which was developed by 1010 Media and the University of Exeter in partnership with Royal Albert

Memorial Museum and Art Gallery (RAMM) and Exeter City Football Club Supporters Trust in 2013–14, and which was renamed Placeify in 2014, facilitates the generation of trails linking physical places to digital data.

The web app was originally conceived to offer users the experience of learning about and engaging creatively with RAMM's collection and archival materials through a series of trails that could be experienced both inside and outside the museum. These were called Exeter Time Trails and included, among others, a Tudor trail to coincide with an exhibition on Elizabethan art that took place in October 2013 (see figures 3.7, 3.8, and 3.9). Subsequently a number of trails were built in collaboration with Exeter City Football Club Supporters Trust as part of the research and development for the platform. Following a launch in 2014, users can now also generate their own trails by subscribing to the web app currently hosted by 1010 Media. At the point of writing, this had been adopted by a number of museums and heritage organizations in the southwest of England, including Topsham Museum, Sidmouth Museum, Tiverton Museum, Newton Abbott Museum, Barnstaple Museum, Royal Cornwall Museum, Mevagissey Museum, The Museum of Witchcraft, Wheal Martyn, Padstow Museum, Bodmin Museum, Exeter Civic Society, Fairfield House, Devon Garden Trust, and St Ives Archive. This section focuses on the collaboration with Exeter City Football Club Supporters Trust, which used Time Trails and, subsequently, Placeify to generate encounters with materials based in the Trust's archive so as to facilitate mobile learning among groups disaffected with traditional teaching methods. The archival materials for the trail were also used to prompt memories among its senior members, the "Senior Reds."

A number of predecessors, especially Serendiptor and Dérive apps, played a significant role in shaping our approach as to how a mobile platform could be used to stimulate creative thinking, encourage mobile learning, and prompt memory re-creation. These tended to adopt physical meandering as a performative strategy to change users' perception of places. Among them, Serendiptor, developed by Mark Shepard at V2, combines a rooting service offered through Google Maps with instructions for action and movement. The app prompts performative actions and is inspired by the work of Fluxus, Vito Acconci, and Yoko Ono. In particular, the Serendiptor team believed that the app would help users to "find something by looking for something else" (Serendiptor). Likewise Dérive app, developed by a team led by Eduardo Cachucho, uses Situationist strategies to allow users to explore urban spaces "in a care-free and casual way." Interestingly, the Dérive app team postulated that "active engagement of communities in their urban spaces unleashes in them new understanding of their urban surroundings," hereby allowing users "to see their urban spaces in a different light" (Dérive app). In line with these projects, Placeify aimed to facilitate some level of physical meandering, which was known, through research into Blast Theory's performance-work *Rider Spoke* (2007), to stimulate mental meandering (Benford and Giannachi 2011, 188). The potential to prompt relational thinking in the latter was deemed to be crucial in the context of memory (re-)creation.

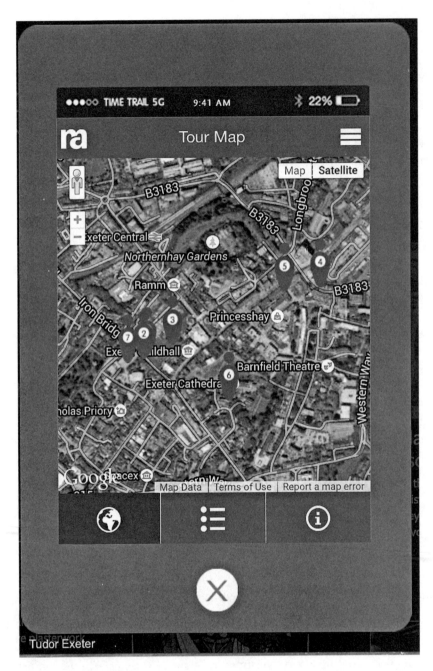

Figures 3.7, 3.8, and 3.9
The RAMM Tudor Time Trail in Exeter. Photo Gabriella Giannachi.

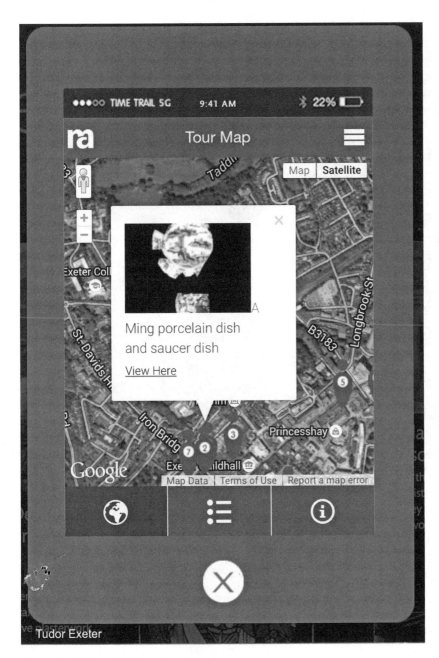

Figures 3.7, 3.8, and 3.9 (continued)

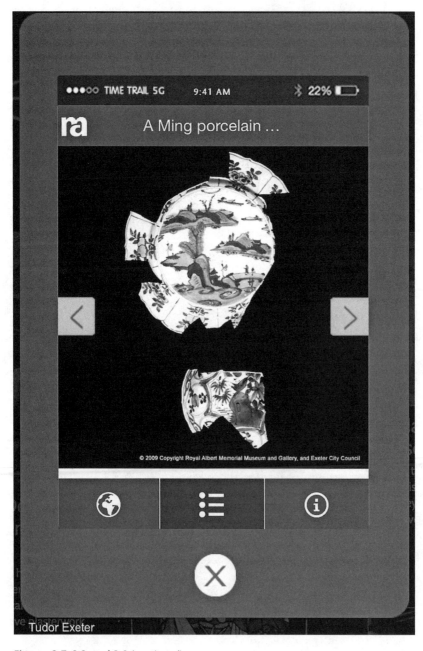

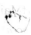

Figures 3.7, 3.8, and 3.9 (continued)

A number of platforms that facilitate trail creation were used to inspire the design for Placeify, such as viewranger, allowing users to generate and share trails primarily to talk about journeys and experiences, and EveryTrail, allowing users to generate trails, and add texts and images to them. Apps that specifically use trails to facilitate the exploration of places through art and history were particularly influential. These included 7 scenes whose project website notes that as "the smartphone is quickly becoming our primary access to cultural information," people increasingly "use apps on their phone to find cultural landmarks, to take tours exploring the city, to learn more during exhibitions and to share experiences" in order to "experience cultural heritage" in novel ways (7 scenes). Tourmaker is another such tool, which allows users to select a genre; produce a story; choose a configuration to determine a tour's time limit; specify localities, dragging and dropping texts, photos, and sounds; and finally publish and share their tour. 1001 Stories about Denmark, likewise, aims to collect knowledge from the Iron Age settlement Sorte Muld ("Black Soil") on Bornholm to the Black Horse Cavern in Copenhagen in the form of trails that can be walked, cycled, or driven by car. The histories underpinning the trails were written by historians and heritage experts, though they could also be annotated by users. Like these platforms, Placeify too was conceived of so as to act as an orientation tool, a search tool, and a publishing tool to connect different kinds of documents with places and the individual stories of those who witnessed these documents in given locations.

Other projects helped shape our understanding of how to encourage users to attach their own memories to places. One such project is Findery, developed by a team in the San Francisco Bay Area, that allows users to leave notes, photos, or videos in commenting on specific destinations. Another is History Pin, developed by We Are What We Do in partnership with Google, which allows users to share stories about places. The History Pin was adopted by a number of organizations that have used it in projects such as Olympic Memories, encouraging the gathering of photos and memories from the Olympics throughout the ages; Year of the Bay, capturing events occurring in the San Francisco Bay Area; and Putting Art on the Map, which facilitates the exploration of Imperial War Museum's collection of artworks on a Google Map. These projects confirmed that pinpointing memories and stories to locations, a tradition inherited from memorial culture, and using maps as a means to prompt the telling of personalized stories in relation to these locations, is, as we have already seen in the case of ArtMaps, an increasingly popular and rewarding strategy to generate engagement with local history in that they can facilitate the creation of a sense of presence (and so also of belonging) within that history among a particular community.

The development of Placeify drew on two bodies of research, bringing together findings in relation to the use of trajectories for the design of mixed reality experiences (Benford and Giannachi 2011) with studies on what constitutes presence in live, mediated, and simulated environments (Giannachi and Kaye 2011; Giannachi in Giannachi, Kaye, and Shanks 2012). Mixed reality experiences, we have seen, are ones that span physical and digital environments (Milgram and Kishino 1994) and often entail forms of interactive, distributed, and

subjective performance (Benford and Giannachi 2011), by which I mean that users of such environments are encouraged to perform actions or embrace some form of role-play to help them relate to the environment they are in. The trajectories framework was developed to provide a means to design and interpret mixed reality experiences (Benford and Giannachi 2011) and has since been utilized in a variety of contexts, including the design of the Cloud-Pad tool discussed above. According to Benford and Giannachi, trajectories define "predicted and actual itineraries through mixed reality experiences" (2011, 15). They are predicted in the sense that they express a desired set of routes participants may follow, and actual in the sense that they can show how participants choose to behave while on the go. Two types of trajectories were deemed to be particularly useful in the context of the design of physical trails entailing a time-driven narrative: trajectories through space, to facilitate the experience of the strata of a given set of places, and trajectories through time, to prompt individual and collective memory creation. As mixed reality environments are hybrid, different spatiotemporal conventions are used, often concurrently. The trajectories framework helps plan how users may behave as they embrace a variety of more or less active roles (spectating, interacting, acting, documenting, doing, etc.) to deal with the shifts necessary in moving from one set of spatiotemporal conventions to the next. In terms of presence research, the team's thinking was influenced by the notion that presence emerges out of a set of relationships with one's environment (Giannachi in Giannachi and Kaye 2012, 50) because integral to an understanding of what constitutes presence is what is before or in front of a subject (Giannachi and Kaye 2011, 4–9). In other words, presence is always contextual to the environment a subject finds him or herself in and, as no environment is ever complete because they are forged by living things (Ingold 2000, 20), they are best described as processes rather than fixed locations, which means that one is only present in so far as one is part a set of environmental processes. As such environments entail traces of past operations of presence, the subject may redefine their presence not only spatially, like in a palimpsest, but also temporally, by looking forward to what is evolving and is not yet present (also in Agamben's sense of the term as discussed in the Introduction to this study), as well as by looking backward toward the traces left by the past in the present. To put it with Edmund Husserl, and as was seen in the case of the operation of Blast Theory's *Rider Spoke,* to construct one's presence in time, we engage with processes of protention (the anticipation of the next moment in time) and retention (not so much a memory as the emergence of the present from the past) (1990), both of which were considered to be strategic. Within a mixed reality context these can be designed by using the trajectories framework.

To facilitate exploration, and in line with other psychogeographical practices (Giannachi et al. 2013) and location-based games like *Rider Spoke,* the team introduced some level of meandering, both physical and mental to the design of the trails. The team also built in some level of performativity to prompt affordances and facilitate the adoption of different, more or less active roles that would encourage users to self-document via social media. To further enable psychogeographical exploration and knowledge generation, and in line with findings

about the role played by the use of contemporary spaces in memorial culture, two distinctive processes, mapping and mapmaking, were utilized concurrently. There are significant differences between these two that informed the design of the experience.

Having been famously described as "graphic representations that facilitate a spatial understanding of things, concepts, conditions, processes or events in the human world" (Harley and Woodward 1987, xvi), maps, as we have also seen in the case of ArtMaps, are powerful orientation tools and facilitate mobile interpretation, encouraging the production of knowledge "on the go." Maps are also instruments of navigation, as well as tools for the establishment of power, authority, presence, and identity. Knowledge about the environment is determined while we are "on the move" within it, which means that "the traveler maps," or put differently, "knows as he goes" (Ingold 2000, 231). Hence a map is a navigational tool, but this tool is in fact generating and facilitating "a social construction of reality," a "system[s] of signs" (Wood 1993, 52).

For Ingold, mapping, the production of knowledge as one goes (2000, 231), is a form of memory or "re-enactment of those movements in inscriptive gestures" (2000, 232), while wayfinding is "the movement of people as they come and go between places" (p. 234). The map, he notes, captures neither, as it remains a representation and it is wrong to assume that the "structure of the map springs directly from the structure of the world" (p. 234). This ultimate "carthographic illusion" (p. 234) has to do with the differences between networks and surfaces. In discussing a number of studies that show that Inuit people perceive their territory as a network of lines and itineraries rather than a surface (Collignon 1996, 98; Aporta 2004, 12), Ingold therefore notes that while the British Royal Navy would follow specific points on route to a destination, moving "across" a surface, the Inuit people moved along "paths" (2007, 75). We have also seen that, in the case of Libeskind's Jewish Museum in Berlin, visitors move along lines. Whereas the map, which constitutes a means to facilitate transportation and assist with orientation, can capture the former, the network of lines and paths formed by the latter remain too complex and subjective to be visualized on a map. In other words, while maps or cartographies show a "bird-eye's view" (Gibson 1979, 198–99), in that they show what claims to be an "objective" reality that may be useful for transportation and orientation, trails show paths, making visible aspects of wayfinding, and the memory of it, allowing for the capture of the "subjective" trajectory through space and time. While maps represent more or less canonic and holistic worldviews, useful for the telling of a history, trails constitute individual memories that are usually invisible within a broader history. Placeify operates by bringing together these two worldviews, respectively associated with memorial and archival culture. Placeify thus offers a map, facilitating the embedding of history in places, that can be used for orientation. It also prompts the exploration of the territory through a trail, facilitating a subjective journey through a given history. Finally, the combination of the two facilitates the creation of memories in a mixed reality architecture bridging physical and digital data.

The trails on Placeify were designed so that users could encounter archival materials through a map interface. This was meant to prompt them to further map a physical location and so create signs through which to perceive this environment. This, in turn, facilitated their placement within both the map and the physical environment. Affordances were then used to prompt the recording of this act onto the map. The latter then facilitated mapmaking, that is, the documentation of the processes through which knowledge is generated while mapping.

The first trail was written for the interested public using a number of locations in Exeter that reflected the history of the club. The second trail was written for the children taking part in the Football in the Community Kick Start program hat supports children who are at risk of disengaging from education by delivering a personalized learning program (see figures 3.10 and 3.11). This particular trail used locations within the Exeter football stadium, St James

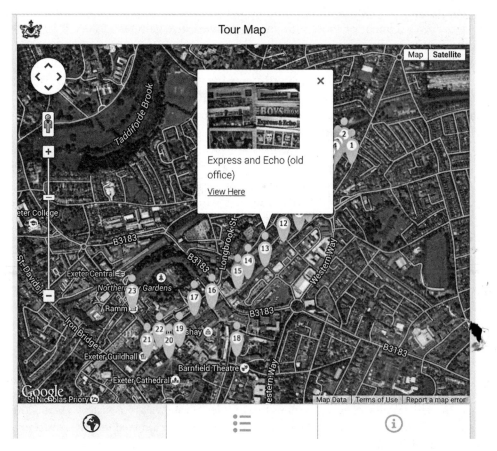

Figures 3.10 and 3.11
Two Exeter City Football Club Supporters Trust Time Trails. Photo Gabriella Giannachi.

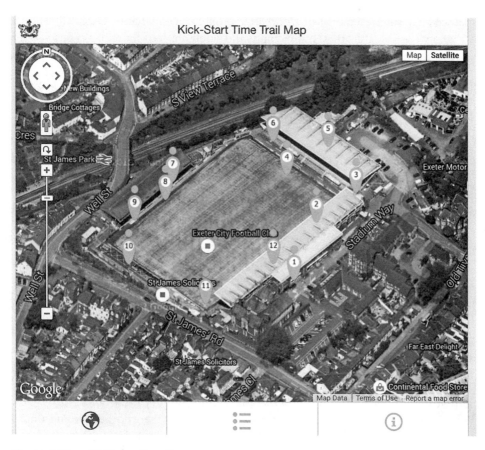

Figures 3.10 and 3.11 (continued)

Park, so as to ensure the safety of the children. The third trail was written in collaboration with the Senior Reds community, as part of the Grecians Remember project awarded to the University of Exeter and Exeter City Football Club Supporters Trust with the aim to stimulate remembering among its senior members. The first two trails were designed by asking stakeholders to identify a set of locations in Exeter and at St James Park, through which one could narrate the history of both the Club and the Trust that owns it. This history was then told by pinning down the lives of well-known players and managers at these particular locations so that users would in the future associate a location with the broader history of the Club and Trust. To ensure the coverage of this history, diverse aspects of the Club and Trust's history had to be utilized in the trail, such as the Club's formation in 1904, a historic match against Brazil played in 1914, the formation of the Trust that, since 2003, owns the club, among others. For the Grecians Remember project, archival materials were designed as a trail and then

used on a screen to spark memories of groups of approximately ten senior citizens (over sixty in total) who were filmed as they individually and often collectively remembered specific events of the history of the Club. The overall length of the texts written for each location of all the trails was about 150 to 200 words, which had been estimated to offer a sufficient level of interpretation for a mobile device. Finally, each entry could be accompanied by one image or video, usually from the archive, so as to create a contrast with the location, and a sound file. These were meant to be subsequently annotated by users who could add further text and images.

The locations selected for the first two trails constituted the physical spaces that would form part of the environments encountered by the users while out and about. The locations not only had to be historically significant, sufficiently diverse, but also relatively safe, accessible, and reachable as part of a walk. Each location was associated with a text that aimed to augment the location by adding knowledge about its significance in the context of the Club. Most locations have changed substantially over the years because a large part of the center of Exeter was destroyed during the Second World War. This means that participants would be asked to look, for example, at a Turkish supermarket while being given information about the Red Lion Inn where in 1904 delegates of Exeter United met with members of another local amateur side, St Sidwell's United, to merge and form the Club. Facts and histories were narrated using the third person; contemporary oral and personal histories were narrated in first person, or using *pluralia majestatis,* and questions were asked at the end of the interpretation text to prompt affordances using second person. These aimed to encourage users to respond by adopting first person to write their own story within the broader history of the Club and Trust so that users, having seen the information text about the past, would progressively become more involved by being addressed through the use of second person and finally become part of that history by using first person, as in the example below:

> Michael John McGahey (b. 1873), whose family has run this tobacconist for four generations, was a local solicitor and Exeter City FC chairman when the club travelled to the continent of South America. It was during this tour that the side became forever known as "Exeter City, da Inglaterra, o primero quadro proffisional que jogou no Brasil" or "Exeter City from England, the first professional team to play in Brazil." During the tour City played the newly formed Seleção of Brazil in a game that ended 2–0 to the South Americans. Yet beyond the result, this fixture gave the fledgling republic a symbol of its identity and gives Exeter the distinction of being the first team ever to have played against the nation that would go on to win the World Cup five times! McGahey sent some reports back to England from the Alcantara on its troubled journey back. Did you watch the friendly fixtures between Exeter and Brazil in May 2004 and will you watch the one in July 2014? Would you like to send us some reports?

The Kick Start trail comprises various stands in the grounds, the players' changing rooms, the media suites from which the press deliver their broadcasts, but also sites where specific fans stood, players displayed their skill, or memorable objects were on display, such as the trophy cabinet or a set of Brazilian flags. When the trail was first tested with the children in

Figure 3.12
Exeter City Football Club Supporters Trust Time Trail users from the Kick Start programme. Photo Gabriella Giannachi.

the Kick Start program, the class was divided in two groups of five to six children, and each group was given an iPad to follow the trail (see figure 3.12). As the children passed each location, they could read up about its history. The task at this stage was for the children to absorb specific knowledge about the Club and Trust, which they would write up on a note pad so that it could be used in the second part of the exercise. A member of the team operated as a guide, linking stories from our tour to an induction tour they had previously received by a member of the Kick Start program, and ensuring they captured the relevant information for the second part of the exercise, while another member of the team documented the event for the Grecian Voices blog. The documentation had been a requirement to show the schools from which the children had come how they engaged with literacy and numeracy while using the Time Trails tool. At the end of the exercise, all children were asked to congregate in the Club's Chairman's Room, where they took on the role of Exeter City staff who had to persuade a foreign player, interpreted by a member of the group, or, with the second group by a volunteer child, to join Exeter City Football Club by boasting about the successes in the history of the Club and Trust over the past hundred years. This allowed the team to test how much content had been remembered and how the tool could be used within an educational context.

Figure 3.13
A Grecians Remember session. Photo Gabriella Giannachi.

Figures 3.14, 3.15, and 3.16
The Grecians Remember Trail and two comments left by users. Photo Gabriella Giannachi.

Materials for a film documenting the Senior Reds workshop were gathered during six sessions in which they were encouraged to look at a series of documents from the Exeter City Football Club archive so as to remember specific moments in the history of the Club and Trust (see figure 3.13). During this workshop a number of primary memories were shared which produced secondary memories among the participants. The trail in turn generated further memories for other participants (see figures 3.14, 3.15, and 3.16).

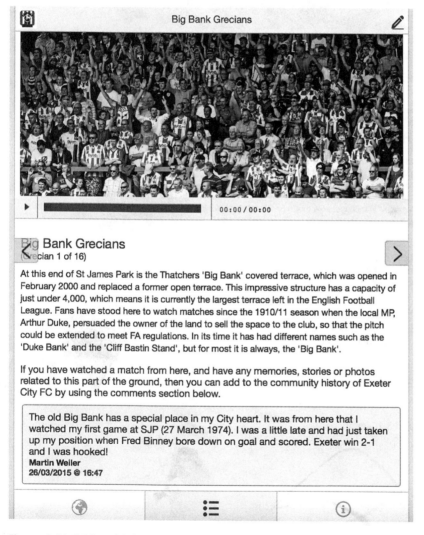

Figures 3.14, 3.15, and 3.16 (continued)

WTS Stand Grecians

▶ ████████████████████████ 00:00 / 00:00

WTS Stand Grecians
(Grecian 3 of 16)

This stand is the newest addition to the ground and was opened in 2001. This smart looking all
seated construction is home to over 2,000 fans in a single tier, with some executive boxes
located in the middle to the rear. It is also home to the Grecian Centre, which does great work
off the pitch, and for a time it hosted the dug out, which led to Alex Inglethorpe and Paul Tisdale
orchestrating a strong period for the club on the pitch. Before the modern stand was erected at
the turn of the millennium, this part of St James Park was known as the 'Cowshed', courtesy of
its corrugated iron clad standing terrace. The main feature of this stand was the raised earth
bank that it sat upon, which had previously led to it being known as the 'Daisy Bank'. You can
hear the audience celebrating in this audio file made on 6 April 2015, when David Wheeler
scored right footed from the right side of the six yard box to the bottom right corner against
Newport County.

If you have watched a match from here, and have any memories, stories or photos
related to this part of the ground, then you can add to the community history of Exeter
City FC by using the comments section below.

> Its predecessor, the "Cowshed", had disadvantages, with partly obstructed views
> and being gloomy. But it was a good viewing point for witnessing the unusual sight
> of an injured goalkeeper, Colin Tinsley, head the winning goal against Workington in
> 1962, the forward Ray Carter becoming our keeper.
> **Alan Ware**
> **06/04/2015 @ 11:41**

Figures 3.14, 3.15, and 3.16 (continued)

The primary documents used to prompt memories led to the production of a number of secondary documents, now available online on The Grecian Archive website. Such documents were useful toward shaping individual into collective and even commemorative memories. The sharing of fragmentary and often highly subjective episodic memories in this "memory architecture" produced an effort toward the creation of what has been described as "collective autobiography" (Connerton 2007, 70). In this context, Exeter City Football Club's archive constituted at once the resource, the frame, *and* the affordance for this communal and indeed the very social act of memory (re-)production. By quite literally asking participants to place memories within specific locations, not only were these brought back to memory, and the as yet unlived became lived, but also they were hereby re-formed in the minds of the workshop participants. This contributed to the collection of a significant volume of intangible heritage in the period April to July 2015.

We have seen how Placeify allows for archival materials to be experienced outside of the institutions that host them, capturing also what occurs during this encounter. We have seen that memorial cultures tend to rely on architectural structures as means "to imprint on the memory a series of *loci* or places" (Yates 1972, 3). Archival cultures, in contrast, tend to rely on documentation. However, the use of mobile technologies now facilitates encounters with archives within the fabric of our everyday lives, which means both architectures and documents are increasingly necessary to generate and preserve what occurs during these encounters. By creating, documenting, and replaying the traces we leave in marking the distance, or *intervallum,* between ourselves and our mixed reality environment, we not only incorporate the memory of others into our own and, in turn, become part of a particular history but also, by mapping and mapmaking, we embed these processes within the physical spaces we encounter as part of our daily lives. These processes of remembering, of bringing *back* to mind, as was clearly the case during the workshops at which materials for the Grecians Remember project and trail were collected, also allow for the re-experience and the re-writing of different types of memory into one another. This generation of a collective memory, and the writing of a communal autobiography, or even a "community autobiography," the taking possession of the as yet unlived, that is associated to particular digital artifacts and physical places, is made possible by the creation of networks of trajectories that are captured through sets of documents, or inter-documents tying, architecturally, physical environments with digitally stored archival knowledge. These constitute novel mixed reality environments, apparatuses, that form, as we will see in chapter 6, powerful agents within the digital economy precisely because they constitute mechanisms for transformation that can ensure the expansion of the knowledge economy in space and time.

The 21st-century archive is no longer a space of neutrality, where the subject is put into parenthesis; rather it is the place where the subject intervenes, speaks up, takes on the act of remembering, often sharing very personal memories, and so changing the way that a given history is recorded or understood. This kind of distributed, often communal (or community-generated), archive is the stage of multiple, individual and collective, often interconnected

memory processes, where inter-documents are continuously produced and shared, and where, as part of that process, new (hi)stories are written that affect how particular moments in time are perceived in the environment we live in. It is in the apparatus of the archive that subjects become the historians of their own lives. It is also here that their performance, their deep mapping of the acts of memory, integral to these processes of historicization, and heritage regeneration, become spectacles, for others to see. Here, digital archives become not only archeological sites showing how knowledge is created through different forms of mediation but also architectures for social memory production, offering possible routes for individual and collective orientation into acts of remembrance of our pasts and yet unlived presents that will affect the creation of our possible futures.

4 Diasporic Archives

We make our tools and our tools make us
(White in Schwartz 1995, 60)

This chapter discusses a number of archives that support and enable access to diverse knowledge communities, both on- and off-line, and analyses the ethics and politics of, often contested, archival representation within migrant, multicultural and transcultural contexts. Inspired by recent research in geography and anthropology (Boast et al. 2007), relevant literature in diaspora and postcolonial studies (e.g., Mitra 2001; Appadurai 2003; Brinkerhoff 2009), and the use of web 2.0 in the context of museums (e.g., Srinivasan and Pyati 2007; Srinivasan, et al. 2008), the chapter shows the operation of transformation discourse within archives and argues for a hybrid methodology toward the presentation of cultural origin, contexts of digital displays and interpretation of archival materials. Analyzing practices based on participatory forms of appraisal, this chapter addresses the adaptation of the principles of provenance and ordering to this new hybrid methodology, building on Ramesh Srinivasan's concept of fluid ontologies (Srinivasan and Huang 2005) as a method for creating and preserving archives. The first case study for this chapter is Thomas Allen Harris's multimedia community engagement archival project *Digital Diaspora Family Reunion (DDFR)*, which consists of a touring multimedia roadshow, an online portal aiming to stimulate a sense of community, and an online archive that uses interactive media to inspire African Americans and citizens in other diasporas to reconsider and, above all, re-valuate their family history. The second case study is "Creating Collaborative Catalogs," a collaboration between Ramesh Srinivasan at the University of California, Los Angeles, Robin Boast at Cambridge University and Jim Enote of the A:shiwi A:wan Museum and Heritage Center in Zuni, focusing on the Zuni Community of Zuni Pueblo, New Mexico, in which hybrid ontologies were adopted in the interpretation of part of the collection. The third case study is the Museum of the African Diaspora in San Francisco, focusing on exhibitions like "Art/Object: Re-Contextualizing African Art" and "The Origins of the African Diaspora," and, especially, the *I've Known Rivers: The MoAD Stories Project,* a first voice archive about people of African descent, based on "origin stories," "movement stories," "adaptation stories," and "transformation stories."

The Transformational Power of Diasporic Archives, Looking at Santu Mofokeng, *The Black Photo Album / Look at Me: 1890–1950*

Increasingly, archivists and theorists from a variety of disciplinary backgrounds have questioned whether the conventional archival concepts that emerged from European bureaucracy, those at the heart of Archive 1.0 discussed in chapter 1, are appropriate for preserving memories of migrant and diasporic communities whose cultures are frequently excluded from traditional archives. Thus in his essay "Archive and Aspiration," Arjun Appadurai notes how migration is often "accompanied by a confusion about what exactly has been lost," which, in turn, creates an uncertainty about what needs to be "recovered or remembered" in the archive. This has led to the questioning of canonic collection and preservation strategies in favor of the development of novel practices, frequently utilizing social computing and web 2.0 and even crowdsourcing to gather, share and preserve oral histories. For Appadurai, this "confusion" brought on "an often deliberate effort to construct a *variety* of archives," ranging from intimate and personal to public and collective ones (in Brouwer and Mulder 2003, 21; original emphasis). Crucially, for him, the diasporic archive becomes "a place to sort out the meeting of memory in relationship to the demands of cultural reproduction" (p. 23). The diasporic archive can therefore operate as a tool for cultural orientation: "For migrants" he notes, "more than for others, the archive is a map. It is a guide to the uncertainties of identity-building under adverse conditions" (p. 23). We know that through maps, we can renew the "system[s] of signs" that allow us to build our "social construction of reality" (Wood, 1993, 52). Hence changes in signs in archival representations can influence the way we construct ourselves culturally, historically, *and* socially. Here, I discuss how the diasporic archive may act transformatively, prompting the rethinking of the role of individuals within historical events, and analyze also how this transformative power of the diasporic archive may influence the way we think of ourselves today.

We know that archival practices are tied to identity creation. We also know from Stuart Hall that "identity is formed at the unstable point where the 'unspeakable' stories of subjectivity meet the narratives of history, of culture" (1987, 44). Finally, we know that the narratives of culture framing the history of the individual frequently marginalize certain communities as "other" and that this, in turn, has often led to their victimization. These communities, as Gayatri Spivak suggests, recurrently have not had the epistemic capital or the political power to have a voice, let alone one in the archive (1988), though sometimes, archives generated by such communities have survived over time. On occasion, archives were imposed upon populations by occupying, often nonnative, forces. There are numerous examples in history of such archives, such as those imposed on the indigenous cultures of Oceania whose oral practices, in the words of Chief Reklai Raphael Ngirmang, the traditional leader of the state of Melekeok in Palau, had previously been "stored in the collective memories of the people of Melekeok" and which had until then been "passed from generation to generation over the centuries" (in Wareham 2002, 194). These archives, which sometimes were used to support a

prevailing economic, legal, and political bureaucracy, and were then frequently hybridized or even destroyed as a consequence of a change in government, constitute, like most archives, sites for the configuration of identity where, even more than in other archives, the matter of whose identity is represented by whom is contested.

The diasporic archive has the potential to transform our reading of such processes of marginalization, making it possible for oppressed cultures to be brought to light and their histories to be rewritten. It is crucial therefore to consider also what is absent from the diasporic archive, and to look into the reasons why we should consider this absence, like in the case of Libeskind's Jewish Museum in Berlin, integral to our identity. The diasporic archive in fact shows that the archive is not merely a site, its content, or ordering system, but that it is also what it is not, what was left out, what was destroyed or hybridized as a consequence of adverse political contexts, and, perhaps so, what has, as yet, to be found, what is still open to interpretation. In other words, the diasporic archive entails essential absences: it is intrinsically unstable, but also unfinished, in progress, potentially able to initiate a knowledge revolution.

One such "archive," displaying an essential absence, is the Anne Frank House in Amsterdam where Anne's own bedroom in the Secret Annex was never, deliberately, fully reconstructed. As Otto Frank put it, in his opening speech on May 3, 1960, "[w]ith the restoration of the building at Prinsengracht 263, the aim was to leave the Secret Annexe in its original state as far as possible. The Secret Annexe is unchanged. ... The wallpaper in the room has been renewed, in the same pattern as before, but the section of the old wallpaper where Anne stuck up the pictures in her room is still there, and the papers with the map of Normandy, as well as the lines that show the growth of the children, are original" (1960). This curatorial choice to display an essential absence, makes the viewer take notice of its *punctum* (Barthes 2000, 47), of the affordance of that absence on the present. This is fundamental, not only to learn about and empathize with this particular archive and the story it tells us but also in relation to the impact of that archive on its present day viewers.

Archives, especially diasporic archives, entail a significant transformational potential. South African history provides a good example of this (Harris 1996, 10–11). Between 1990 and 1994 a systematic destruction of archives occurred in South Africa so as to "keep the apartheid state's darkest secrets hidden" (Harris in Hamilton et al. 2002, 135). Thus in 1993 alone the National Intelligence Service headquarters destroyed 44 tons of paper-based and microfilm records in a six- to eight-month period (TRC report cited in Hamilton et al. 2002, 135n. 3). Apartheid had been supported through a powerful bureaucratic machine, which reached into almost every aspect of people's lives. This generated "a formidable memory resource" though until the 1980s this resource, which included the State Archive Service (SAS), was geared to support only white users or, to be more specific, white academics (Harris in Hamilton 2002, 138). In the aftermath of the end of apartheid, surviving archival materials were revisited and their transformative potential was disclosed. A good example of this is *Holdings: Refiguring the Archive*, curated by Jane Taylor (1998), an exhibition of work by

contemporary South African artists who had explored the activities of documentation and archiving as interpretative processes. The exhibition, entailing "works of retrieval" drawing on "historically ignored materials" (Taylor in Hamilton et al. 2002, 243), was inspired by Christian Boltanski's well-known *Verloren in München* (*Lost in Munich*) (1997), which used an image on the newspaper *Süddeutsche Zeitung* to display small photographs or artifacts that were at that time housed by the city's Lost and Found office, such as teddybears, watches, a guitar, false teeth, a type writer, chocolate bars, among others (Taylor in Hamilton et al. 2002, 246). Likewise, *Holdings: Refiguring the Archive* aimed to exhibit found documents and ephemera to disclose their transformational potential. The *punctum* here directly impacts on the viewer by literally re-forming them within the apparatus of the archive.

One of the artists involved, Santu Mofokeng, exhibited *The Black Photo Album / Look at Me: 1890–1950*. For this work, Mofokeng set about recovering photographic documents of black African families, described as "images that urban black working and middle class families had commissioned, requested or tacitly sanctioned" and yet had been left behind by dead relatives, the sort of picture that may hang "on obscure parlour walls in the townships." While, as the artist points out, in some families these types of pictures "are coveted as treasures, displacing totems in discursive narratives about identity, lineage and personality," in others "they are being destroyed as rubbish during spring-cleans because of interruptions in continuity or disaffection with the encapsulated meanings and the history of the images" (pp. 277–78). For Mofokeng these images constitute "acts of self-representation of Africans that he designates as 'integrationist,' in other words, those who engaged in performances of bourgeois identity that would facilitate their integration into the hegemonic world of white affluent power" (p. 278).

The establishment of the point of view is crucial here. Thus the book collection of *The Black Photo Album / Look at Me: 1890–1950* starts by asking viewers to "look at *me*" (emphasis added). This immediately prompts the viewer to trace, archeologically, the *punctum*, the "what has been" (pp. 2000, 43), and identify its voice as being *present* to them. In the collection, Mofokeng alternates images, descriptions, and texts from a series of personal family archives. Thus, for example, the 1997 black and white slide projection shown above (see figure 4.1) depicts two women, whom we learn, from a subsequent text slide, to be Ouma Maria Letsipa, née van der Merwe, and her daughter Minkie Letsipa. The photograph was taken around 1900. We learn from the text that Maria was born to a family of "inboekselings" in Lindley, Free State, South Africa. From the subsequent text slide, we learn that "inboekselings" indicated "a forced juvenile apprenticeship in agriculture, a euphemism," Mofokeng points out, "for enslavement," Maria was a slave. The image, which shows Minkie affectionately touching her right arm, while with her left hand she holds what looks like a branch of flowers, does not show either woman as a victim. The "gap" between what the image shows and what the text tells us here is "the dark margin" of this archive that the viewer is meant to articulate.

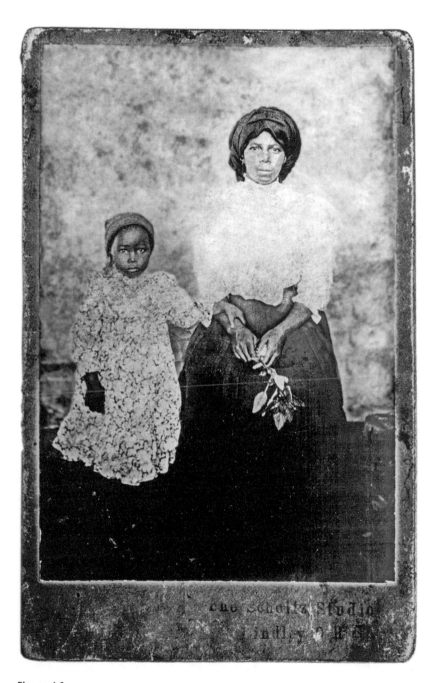

Figure 4.1
Santu Mofokeng, *The Black Photo Album / Look at Me: 1890–1950*. Copyright Santu Mofokeng. Image courtesy Lunetta Bertz, MAKER, Johannesburg.

By exhibiting the very images that black working and middle-class families commissioned in the period 1890–1950, while apartheid was being seeded as an ideology, and thus representing "a place for the performance and contest of identity" (p. 278), Mofokeng shows these families' aspirations and desire for recognition at the time of racial suppression. The family photograph, for Mofokeng, particularly in this context, is therefore "a highly charged canvas, in which the hierarchies of kinship structure are displayed and contested" (p. 278). Such photographic archives constitute maps of behaviors, acting both as "documents of exclusion and monuments to particular configurations of power" (Hamilton et al. 2002, 9). Representing indexes of power relations between cultures, races, and political groups, their value lies precisely in their transformational power over the viewer. Through this process, we may at last recognize the lasting value of individuals who have, thus far, remained largely invisible in world history.

In diasporic archives, as well as in colonial archives, even more than in other kinds of archives, the "point of view" is crucial and often neglected. This may be a reason why Ranajit Guha (1994) and Greg Dening warn us off considering such sources as "springs of *real* meaning" and "fonts of colonial *truth* in themselves" (1995, 54; added emphasis). Thus Nicholas Dirks, for example, observes that early colonial historiographies in British India were dependent on native informants, who were then, however, written out of those histories (1993, 279–313). The point of view, and the role of the witness, in this case that of the native informants, is significant not only because it offers insight into the origin of an archive but also because it could entail knowledge about power relations and even *puncta*, that would otherwise remain invisible, but which are crucial in determining the value of such an archive. Bronislaw Malinowski explains the crucial role played by the point of view in *Argonauts of the Western Pacific* (1932) where he articulated, for the first time, the theory of the participant observer, recognizing the anthropologist's presence in the field and their function as a filter of information. The articulation of the point of view, the preservation of a first voice in the archive, is therefore crucial not only in determining the truthfulness or veracity of the archive but also in ascertaining how the observer's act of witnessing may have shaped the operation of what Derrida called the "*archiving* archive," namely the archive's technical organization that, as we saw in chapter 1, determines the "structure of the *archivable* content even it its very coming into existence and its relationship to the future" (1995, 16–17; original emphasis). Thus knowledge about the point of view, so often hidden from the archive, is fundamental especially in the diasporic archive. In other words, knowing whose map we are using is crucial in determining our ability to operate (rather than be operated by) the apparatus of the archive.

What remains of an archive, any archive, but in particular a diasporic archive, is often the result of destruction or plundering caused by conflict. Operations of appropriation, as we know from Michel de Certeau, are frequently destructive, and yet can at the same time constitute what he describes as a "point of departure" marking a moment of transformation, that could be "the condition of a new history" (1988, 75). Wolfgang Ernst describes two

such moments of high historical importance in terms of how archiving was subsequently to develop in the Western world. The first one occurred in the aftermath of 1794, when French Revolutionary Troops occupied Prussia, and in 1806, at the time of Napoleon, when they proceeded to destroy the network of small archives in the Rhineland states, and each region was given an archival depot where the remains of the surviving archives had to be relocated. This then led to their reorganization and to the development of renewed preservation efforts (1999, 15), which, eventually, prompted an increase in the number of files being deposited in centralized state archives (p. 17). The second one occurred when the historian Lord Acton was visiting Vienna to attend a dinner at which he was to meet Leopold von Ranke who had revolutionized historical science by pioneering the use of archives in the study of diplomatic relations, and "in so doing made archival traces the essence of the modern nation-state" (p. 6). When the news broke out that Italian troops were about to capture Rome, in 1870, Ernst tells us, King Victor Emmanuel prompted Acton to abandon his dinner and set off at once in a carriage "with the unashamed and resolute intention to plunder the Vatican Secret Archives in the confusion" (p. 6). The Vatican Secret Archives' door, apparently, bore a carved inscription threatening excommunication to any unauthorized person passing through (Giles 1996, 6). Among those queuing for entry were Prussian (mostly Protestant) historians, uncaring about the excommunication threat, and "seeking archival ammunition in the *Kulturkampf* between the state and the Catholic Church over the issue of public education" (Ernst 1999, 6).

The histories of marginalized or defeated communities were often appropriated within the archives of dominant civilizations. This frequently led to the creation of "archives *about* rather than *of* the communities," sometimes causing irreparable damage through the application of "arrangements and descriptions of the 'other' to form incomplete and decontextualized representations of cultural groups" (Hagan in Shilton and Srinivasan 2007, 89; original emphasis). This has concurrently not only produced what Ananda Mitra has described as a systematic "disenfranchisement" (2001, 31), but has often also lead to narrative distortions which in turn frequently affected the reading of these cultures' histories (Ketelaar 2002). An example of appropriation is provided by Evelyn Wareham. She describes how archives of the Spanish administration of the Mariana Islands in Guam were taken by the US armed forces and relocated to the Library of Congress while archives from Samoa were relocated to New Zealand (2002, 202). This prompted former Solomon Islands Chief Archivist John Naitoro to note that the relocation of the Western Pacific High Commission Archives led to the fact that "[o]nly foreigners who have access to these records in London [can] interpret Pacific history" (in Wareham 2002, 202). For Katie Shilton and Ramesh Srinivasan, to ensure the collection and preservation of such communities' point of view within the archive, archivists should start to preserve "the articulation of community identity" and facilitate the production of "empowered narratives". In other words, archivists should start to collect, exhibit and preserve the point of view of those who entered the archive through contextual information conveyed by displaying "records and histories spoken directly by traditionally marginalized

communities, embedded within the local experience, practice and knowledge of that community" (2007, 90). Crucially this point also marks a recognition of the growing significance and value of intangible heritage in the context of all heritage collection displays.

Diasporic archives are to be considered not only as sites, or contents, but technologies and practices preserving individual points of view, or first voices, and the contexts from which they emerge, which are both, as yet, still frequently absent from the archive. This has meant that diasporic archives, or even, nowadays, archives more broadly, have frequently had to adopt innovative methods for the capture, preservation, and exhibition of individual points of view including contextual information about their emergence. As Ann Laura Stoler suggests, such archives should be thought of as "epistemological experiments rather than sources." Colonial archives in particular, though arguably we could extend this definition to diasporic archives, in fact constitute for her "cross-sections of contested knowledge," "both transparencies on which power relations were inscribed and intricate technologies of rule in themselves" (2002, 87). For Stoler the "[c]olonial ontologies of racial kinds" that we encounter in the archive are therefore "not fixed," but rather should be "subject to reformulation again and again" (2010, 4). With colonial agents continuously utilizing new ways to secure their social status, the resulting archives must be seen as unstable "records of uncertainty and doubt in how people imagined they could and might make the rubrics of rule correspond to a changing imperial world" (Stoler 2010, 4).

In conclusion, diasporic archives, like colonial archives, constitute records of uncertainty and loss. They are ontologically and epistemologically fragile. Despite, and perhaps even because of their status, they do, to use Appadurai's term (in Brouwer and Mulder 2003, 23), operate as maps, only that the maps offer a view of *what has been that has changed*. Transformation occurs as part of the processes we must put into place to continuously re-orient ourselves through such archives in our lives. For the diasporic archive is where we form whom we are in relation to where we come from. It is where we re-evaluate our present in view of and in light of our past. For these reasons the diasporic archive can reveal diversity and inequality, and act as a catalyst to promote change. To operate effectively, the diasporic archive has therefore had to, and increasingly so, adopt experimental tools to capture changes in the subjects' points of view, map their transformed contexts, and form them into trails and histories that link the object of the archive to its user, bridging between the past and the present. These tools are, as White indicates (in Schwartz 1995, 60), not only what we use to form the archive but also what we use to re-form ourselves, socially and politically, within the archive.

Diaspora and the Archive, the Case of *Digital Diaspora Family Reunion* (*DDFR*) by Thomas Allen Harris

We already discussed, in chapter 3, how our growing obsession with presence has led to a significant fascination with the capture of the present moment, which in turn, as Frederic

Jameson suggested, has led to a "nostalgia for the present" (1989). We also know how for many of us, to put it with Arjun Appadurai, the past "is another country" (1996, 31). Here, we suggest that the diasporic archive not only constitutes a laboratory for the study of inclusion and the representation of diversity in the archive, and so represents a formidable transformational tool, politically, socially, and artistically, but also that it constitutes a platform for the study of personal identity, revealing information about who we think we are, who we aspire to be, and how others see us at different points in time and space through different cultural and political perspectives. Because of this capacity to show change, the diasporic archive is the site where the (re-)evaluation of the point of view of the observer, and their as yet unlived present, may lead to sociopolitical changes.

A diaspora is not only a community dispersed from homeland, which means that the identification of the point of view as well as the point of origin is crucial, but also it is "a globally mobile category of identification" and the context of diaspora constitutes what has been described as "a process productive of disparate temporalities (anteriorities, presents, futurities), displacements, and subjects" (Axel 2004, 27). Thus a diaspora is a community as well as its history. The diasporic archive, to reflect the implications of the passing of time and the changes in place for diasporic communities, must take not only the present but also the past, and indeed even the future into account, and it must not identify the archive with one and only location, or one and only stratigraphy, but rather be able to comprise and possibly exhibit these processes of change.

In modern times, a diaspora has been described as consisting of ethnic minority groups of migrant origins residing in host countries, but frequently maintaining sentimental and material links with their countries of origin (Sheffer 1986, 3). The term is applied to groups as different as "expatriates, expellees, political refugees, alien residents, immigrants and ethnic and racial minorities tout court" (Safran 1991, 83), comprising also individuals in the third, fourth, and fifth generations of assimilation (Brinkerhoff 2009, 31). For all of them, usually the country of origin has some level of significance. For Jennifer Brinkerhoff, these considerations mean that diasporas are migrant groups that share

1. dispersion, whether voluntary or involuntary, across sociocultural boundaries and at least one political (i.e., nation state) border;
2. a collective memory and myth about the homeland, created and recreated across distances and generations;
3. a commitment to keeping the homeland—imagined or otherwise—alive through symbolic and purposive expression in the hostland and/or in the homeland;
4. the presence of the issue of return, though not necessarily a commitment to do so. The idea of return may be explored, discussed, and debated with or without specific intention of physical return; and
5. a diasporic consciousness and associated identity hybridity, expressed, in part, through the creation of diaspora associations or organizations (p. 31).

Broadly speaking, diasporic groups are dispersed, displaced, and their hybrid identity can be the result of a synthesis or a blending (p. 32). Unlike in the case of other groups, the issue of one's relationship with the homeland is critical toward building an understanding of how diasporic groups view themselves, and how they are viewed by others in society.

In recent years we have witnessed the growing significance of the phenomenon known as digital diaspora, or e-diaspora, or virtual diaspora. These terms indicate an electronic migrant community who interact through social media (Axel 2004; Brinkerhoff 2009; Everett 2009), such as Facebook, Twitter, and LinkedIn, to build a sense of community and facilitate integration (Diminescu et al. 2010). For these communities, social networking sites are often seen as a "safe space" for the negotiation of identity (Brinkerhoff 2009) and debate about crucial shared concerns to do with, for example, memory, homeland, consciousness and identity. Digital diasporas have been said to operate within information environments (Srinivasan and Pyati 2007, 1734) where voice, particularly first voice, agency, and debate are increasingly playing a more significant role than reading and reception (Appadurai 2003, 22). Despite being "virtual," e-diasporas are, of course, connected to varied social contexts (Srinivasan and Pyati 2007, 1736), and their actions can have actual social consequences.

Digital Diaspora Family Reunion (DDFR) by Thomas Allen Harris is a good example of how a digital diaspora can be encouraged to document and share its own history through social media. Produced by Chimpanzee Productions, *DDFR* received support from, among others, the Corporation for Public Broadcasting, Rockefeller Foundation New York City Cultural Innovation Fund, Nathan Cummings Foundation, Cross Currents Foundation and National Black Programming Consortium. *DDFR* can be best described as a "multimedia community engagement initiative" encouraging individuals "to explore the rich and revealing historical narratives found within their own family photograph collections" (DDFR) (see figure 4.2). In practice, *DDFR* consists of a touring multimedia roadshow, an online portal aiming to stimulate a sense of community, and an online archive that uses interactive media to inspire African Americans and citizens in other diasporas to reconsider and re-evaluate their family history. The archive is built through user-generated content, primarily family photographs and videos, which are related to their associated stories. The roadshow is a touring event, used to gather materials for the archive, and the portal aims to generate a sense of community and build the presence of the digital diaspora. Both the roadshow and the portal are oriented toward the generation of a repository for images and other media covering approximately 160 years of history showing African various diasporas through the family photo album over time, place, and genre. Users are encouraged to contribute photos, video, text, and audio at the roadshow, or through blogs and social networks, and to comment on, document, and share their family history with others. A participant, Pat Cruz commented: "the history of African Americans has been told by so many people other than ourselves, ... with our family photographs, this opens up some doors as well as some eyes into what we are, on an intimate level" (in Lee 2011).

Figure 4.2
Digital Diaspora Family Reunion (DDFR). Courtesy 1World1Family, LLC.

When showcased at the Sundance Festival in 2014, the archive comprised twenty events run in 13 cities, including Boston, and various New York boroughs, such as Brooklyn, Harlem, and the Bronx, and consisted of over 600 interviews and 6,500 photographs. This has since grown to include 36 engagements in over 25 cities in the United States and Canada. The project thus far involved interviews to over 1,000 participants, gathered over 1,000 hours of video footage, collected over 18,000 participant images, created over 35 digital video modules and over 20 digital photo albums comprised of nearly 3,000 images, receiving also extensive media coverage, from newspapers to television, radio, blogs, and other web-based information outlets, with a combined local reach of 2.7 million people (Maciariello 2014; Harris 2015). Harris had already used his personal family archive in past projects as a means to look at identity and religion in *That's My Face/é Minha Cara* (2001), gay and lesbian issues in *Vintage—Families of Value* (1995), and apartheid in *The Twelve Disciples Of Nelson Mandela* (2005). According to him, only few institutions have been collecting photos of African Americans before the 1960s, and so there has been, and still is, a lack of images of people of African descent (in Krinsky 2009), which means that to generate a repository one needs to persuade people to share their personal family archives (see figure 4.3). Having already explored though his film *Through a Lens Darkly: Black Photographers and the Emergence of*

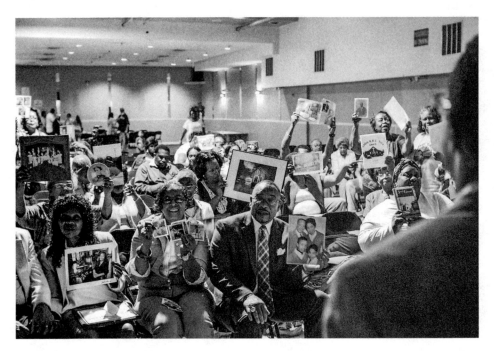

Figure 4.3
Digital Diaspora Family Reunion (DDFR). Photo by Natalie Shmuel for DDFR, LLC. Courtesy 1World1Family, LLC.

a People (2013–14) how various communities use photography "to construct political, aesthetic, and cultural representations of themselves and their world" (Krinsky 2009), and using the camera as a means to promote social change, Harris adopted the strategy of the roadshow in conjunction with the showing of clips from his film to draw attention to his collection process and, at the same time, create a sense that this enterprise was for the benefit of the overall community. Thus, for example, at the roadshow, the clips were often intercut with enlarged photographs and accompanying stories, and audiences were encouraged to help to identify and tell stories about the individuals in the photos. This gave participants the sense that their task to was to resolve a mystery, and herewith facilitate, as the title suggests, a "family reunion" by sharing individual testimonies with others.

Harris aimed to give a face and a voice to "the stories in history books and films about civil rights" (in Lee 2011). In many ways, his work is about tracing, documenting, and especially re-evaluating the history of such diasporic communities: "we take grandma for granted," he says, "[w]e need to understand that instead of looking outside ourselves for value, we can look inside" (2011) (see figure 4.4). One participant, for example, Lana Turner, a 61-year-old real-estate agent who lives in Harlem, brought photographs of her parents to be included in

Figure 4.4
Digital Diaspora Family Reunion (DDFR). Photo Lindsey Seide for DDFR, LCC. Courtesy 1World1Family, LLC.

the project. Her father worked as a chauffeur. We are told: "She spread out images of him posed in front of an elegant, vintage car, and a 1952 photo with a group of natty men in suits who belonged to a chauffeurs' club. Her mother, a chambermaid and a cook, wore a tiara in a photograph in which she and several other women were adorned in elegant white dresses." For Harris, "[t]he Turners were the kinds of unsung heroes who helped move the country forward." This is why, he notes, "[w]e need these stories" so as "to let the next generation know they come from a people who have made it by their bootstraps and made it for everyone around them, regardless of color and race" (2011).

The roadshows varied slightly among each other. Thus in Harlem, for example, in collaboration with Harlem's Schomburg Center for Research in Black Culture, *DDFR* opened the curatorial process to the public, asking local citizens "to nominate people whose contributions to the community help make Harlem unique—unsung heroes, heroines, and ordinary people whose extraordinary presence creates a sense of community" (Maciariello 2014). Nominees ranged in age from 17 to over 60, including a student who created a community garden on her block, "a grandmother who gave tours to Columbia University students to counter the poor image they had of their new neighbors," a community events organizer, and a local

"legend who brought Double-Dutch back to the streets of Harlem" (2014). Among other participants was Dr. Mary Marshall who brought large numbers of family photos and concluded her interview by saying "[i]t's important that we document our history, talk about it, share it with as many people as far as we can" (2014). On Staten Island, *DDFR* chose to focus the roadshow on celebrating 193 years of Staten Island African American history, "a cultural legacy that is generally tucked away in family albums and therefore invisible to the public" (2014). Among the project partners here was the community center of the First Central Baptist Church, one of the oldest historically Black churches on Staten Island that has strong ties to the local community. On this occasion, in addition to asking residents to bring their photographs, *DDFR* encouraged them to bring artifacts based on their photographs, such as the historical quilts made by volunteers at the Sandy Ground Historical Society (2014), which were then used to support the stories told. Finally, in collaboration with the Bronx Museum of Arts, *DDFR* sought to uncover Real Bronx Tales, stories from local residents about what life was and is like for them, their families, their friends and neighbors, and people on their streets. Here, even more than at other roadshows, *DDFR* "truly was a reunion" that made it possible for residents to renew connections they had lost over the years, as was the case of two women who rekindled their friendship after losing touch for 50 years (2014).

One powerful realization, says Don Perry, writer and producer of Chimpanzee Productions for *DDFR*, was an increased understanding and commitment to vernacular narratives: "We learned that vernacular photography is extremely important. What is vernacular today becomes the museum collection of tomorrow." This is why Harris and Perry had asked participants to *DDFR* to put on white gloves when handling their own photos: "At home," they say, "they may just have had a sandwich, and we're asking them to put on gloves All of a sudden, they realize that the thing they are holding is important, precious, and has value. That moment is a real shift as people begin to see the project on another scale. It changes their relationship to their photos" (in Maciariello 2014). For Harris, "illuminating and sharing these archives creates a significant new pathway to community-building" (2014) and from the moment that the photos are no longer private, but public, each image acquires "different registers—history, personal history, and community connections" (2014). In *DDFR* the archive therefore constitutes just the beginning not only of the re-evaluation of the identity and the re-writing of history of individuals from the African diaspora but also the creation of a community and, with this, the possibility that this community may use the transformational power of the archive to seek social and political change. We know from Derrida that "archivization produces and much as it records the event" (1995, 16–17). It is through the creation of diasporic archives like *DDFR* that the history of the African diaspora will acquire persistence and a power.

DDFR's ultimate aim to create a sense of community is probably a reason why at the heart of the project is also an educational objective. Thus the *DDFR* website, which already features interviews with a number of scholars, offers news about family reunions, and showcases images by black photographers, also entails a significant educational resource that allows

students to create multimedia projects with cameras, phones, and videos, aiming to teach them how to use their family photographs to generate and capture their histories. Students are here encouraged to seek their family's personal connection to historical events by looking at family photographs, interviewing family members, and documenting the process. They are also encouraged to share family stories with their peers and create a historical timeline as seen through the group, expanding their visual and media literacy by critically examining the contents of photographs and other visual representations and "reading" images to understand the intentions behind the taking of these particular photographs. The resulting media projects intend to preserve an important piece of the students' family history, told in their own voices, while also contributing to their collective understanding of American history as reflected in their families' lived everyday experiences. Thus *DDFR* ultimately in not only a live archive, making public stories that were thus far only told by others in history books, or shared within the privacy of a family home, but it is also an educational program, aimed at making these processes part of how we learn about and possibly change who we are in relation to where we come from. Like Lynn Hershman Leeson's *!Women Art Revolution, !W.A.R.* and RAW/WAR, discussed in chapter 2, *Digital Diaspora Family Reunion* is a live transmedia archive entailing a transformative cultural and political program functioning as an apparatus for the rewriting of history.

We have seen in chapter 3 that the archive is the architecture or laboratory where personal histories are forged into communal histories, the "theater" where Élie Halévy "acceleration of history" (in Nora 1996), or the historicization of the present, and hence the documentation of the making of our present, occurs. In *DDFR* we witness this transformational power of the diasporic archive, turning the private into the public, the individual memory into a communal or community memory, the personal story into a history. Here we witness, literally, the making of personal photos into heritage. The "dark margin" of discourse (Agamben 1999, 144) is in this case the site for potential revolutions, where, through the additional inclusion of educational materials, the "invention," to put it again in de Certeau's words, "of still unsuspected mechanisms" makes it possible "to multiply the transformations" entailed in such revolutionary processes (1984, 152). The archive is an apparatus for the rewriting of our history so that what may as yet be unlived becomes part of our present, informing our presence, and herewith re-forming what we think of as ourselves.

Toward a Fluid Ontology: The Case of "Reconceptualizing Digital Objects around Cultural Articulations"

In the museological context, the need to identify archival concepts that could accommodate a plurality of cultural approaches, including those of diasporic communities, has grown in parallel to an increased engagement with the public in general, and, in particular, with indigenous communities through activities like exhibition design, interpretative panels, presentations, and talks (Peers and Brown 2003). Increased engagement with the public has

often implied the creation of participatory and immersive environments, including ones which prompt visitors to make difficult choices, as in the case of the Smithsonian National Museum of American History's Field to Factory exhibition (1987), which required visitors to walk through one of two doors labeled "WHITE" and "COLORED"; the selection of door then framed the way the rest of the exhibition was experienced (Simon 2010, 52). This approach was subsequently adopted by other museums such as the Apartheid Museum in Johannesburg, which frames the visit to the museum by asking visitors to choose between two paths ("whites" and "non-whites"), with a fence separating the two suggesting that "the non-whites are on the inferior side" (p. 52).

James Clifford (1997) applies Mary Louise Prat's (1991) notion of "contact zones" to a museological context to prove that museums can be contentious places of collaborative relations and interactions that introduce the problem of "translation," which was also used by Homi Bhabha (1994, 1) to indicate "moments" or "processes" in the "articulation of cultural differences" within the "movement of meaning" (p. 228). The identification of archival and museological practice as significant in terms of translation and transformation discourse has prompted calls by scholars in various disciplines to broaden the ways that institutions engage with the documentation, preservation, and sharing of archives and collections (Furner et al. 2006; Srinivasan et al. 2008), encouraging the use of social computing, web 2.0 in particular, to represent the multiple and possibly conflicting perspectives entailed in such archives (Boast et al. 2007; Furner et al. 2006; Tapscott and Williams 2007) and make visible the technology facilitating the expression of the point of view and the context of its emergence. Thus the use of social computing increasingly constitutes part of a new museological approach, which puts the museum's educational aims at the forefront (Vergo 1989), alongside research (Macdonald 2006), and community spaces, which are gradually made available online (Srinivasan, et al. 2008), so that information about documents and artifacts hitherto not captured could eventually be shared among diverse distant communities.

We have already touched upon the fact that instead of speaking, dispossessed groups are often spoken for (Mitra 2001, 31), and this means that groups who have been historically denied a space in the archive, or chosen not to be in the archive, have often used alternative forms of transmission, such as oral or ritualistic traditions or even *aide-mémoire* (Clanchy 1980–81, 115). It is also well known that the choice of technology, metadata, and vocabulary are crucial factors in record and document creation. International standards for this practice started to be set in the 1960s (Parry 2007), and are now governed by the need to be able to share data among different and often very diverse organizations. A number of scholars have argued that to give voice to varied communities a more participatory approach is needed, not only at the level of interaction or feedback, but starting from the very "core of how museums organize, record, classify, perform and present their collections" (Srinivasan et al. 2008, 7). Thus Boast, Bravo, and Srinivasan write of the cultural knowledge lost when an Inuit artifact, for example, is imported to a museum exhibit and interpreted by a curator, as there is little understanding of the "richly situated life of objects in their communities and places of

origin" due to "loss of narrative and thick descriptions when transporting them to distant collections" (2007).

Recent research has shown that to reach broader audiences new classification systems are needed. This is because museums and libraries often do not to engage with the fact that indigenous communities tend to hold knowledge that is frequently absent from catalog entries and are passed on through oral "stories, intergenerational communication, and contextualization of cultural objects" (Srinivasan et al. 2008, 8). Embracing diverse "ways of knowing" is therefore "fundamental to experiencing and creating faithful representations of knowledges" (Boast et al. 2007). Each object, each piece of tangible heritage, each associated document, following this view, could in fact become "a gateway to a number of intangible, yet critically connected, practices" (Srinivasan et al. 2008, 8) and only through "multiple ontologies" (Srinivasan and Huang 2005; Boast et al. 2007; Srinivasan 2007), focusing on the preservation of heritage that is both tangible (objects) and intangible (performances, stories, music, events, but also rituals, anecdotes), can the complexity of diverse cultural knowledge be documented, preserved, and transmitted.

Oral histories, rituals, and gestures are all strategic for the transmission of knowledge. What the discipline of performance studies has unveiled about the role of transmission in performance practice is particularly significant in this context. Diana Taylor, for example, distinguishes between what she calls the archive and the repertoire, where, by the former, she means "supposedly enduring materials (i.e., texts, documents, buildings, bones)," whereas by the latter she refers to the "so-called ephemeral repertoire of embodied practice/knowledge (i.e., spoken language, dance, sports, ritual)" (2003, 19). Taylor points out that the archive "sustains power" and that "archival memory works across distance, over time and space" (2003, 19). Because archival memory is separated from "the knower," in time and/or space, it appears to be "immunised against alterity" (de Certeau 1986, 216), while the repertoire consists of "ephemeral, non-reproducible knowledge" (Taylor 2003, 20). For Taylor, ultimately, "the repertoire requires presence" precisely because, as we will see in chapter 6, "people participate in the production and reproduction of knowledge by 'being there,' being part of the transmission" (p. 20) and so while for her the archive is "stable," the repertoire "both keeps and transforms choreographies of meeting" (p. 20). While Taylor's model is useful, the binary opposition does not capture the hybridity that most archives, especially diasporic archives, entail. Amelia Jones rightly points out that in fact the "living body is just as mediated as the 'body' of the archive, itself never fixed in meaning or static," which means that we should avoid the creation of a binary opposition between an "authentic" live body and the "secondary" archive, and instead note that the body, "recovered via remembered movements, conversations, and interviews, is an archive of past works and the archive, filled with bits of things touched, manipulated or otherwise used by performance artists, is a kind of material embodiment, especially as it is mobilized in historical narratives and exhibitions." Thus, crucially for Jones, "neither body nor archive are mutually exclusive; neither transparently renders the truth of the present, the past or the future" (2012, 117) in that

the body becomes "archival"' and the archive should be thought of as "embodied" (p. 118). While I will explore the significance of this contamination between the body and the archive more fully in chapter 6, it is important to note that this factor also plays a fundamental role in the creation of diasporic archives.

These reflections about the role of the repertoire in the transmission of performance practice are crucial to understand what may underpin the transmission of intangible heritage, including traditional forms of cultural expression such as storytelling, rituals and other contexts, which are important components of the diasporic archive. Arguably then, to become more inclusive and representative of diasporic cultures, archives have to adopt diverse strategies for the transmission and even embodiment of context from what could be described as the repertoire, or even the "performances," the work of being, we carry out in our everyday lives. The recognition of the importance of preserving context is in itself not new; thus Hilary Jenkinson (1944) and Theodore Schellenberg (1961) both stressed the significance of the evidential value of records and the importance of developing strategies to preserve contextual narratives. More recently, scholars have pressed for archivists to use participatory processes to "facilitate the preservation of representative, empowered narratives" (Shilton and Srinivasan 2007, 90). This has led to experimentation with participatory forms of archiving (p. 91) grounded in the belief that there may be different understandings of what constitutes a record so that, for example, "for the Yolngu (Aboriginal) peoples of Australia, cultural memory may be created during a performance" (p. 93). This was certainly also the case of Harris's *DDFR* discussed above that made it possible for participants to record, preserve, and experience diverse "ways of knowing" their own history.

It is claimed that provenance should be understood as "a culturally constructed phenomenon," since diverse forms of authorship directly affect provenance decisions. For example, in work conducted by Srinivasan, members of the Kumeyaay, Luiseno, Cupeno, and Cahuilla tribes in San Diego County made decisions about provenance based on "a complicated, inter-tribal network of authorship to shape the organizational structure of the tribal PEACE online communication hub" where notions of authorship embedded in the records' unique ontologies could not have been identified without the participation of the communities (pp. 96–97). In this context, the archival principle of original order, or the "relationship between records and the knowledge architecture in which they were created" is also crucial (p. 97) in that "by performing archival processing in which the record creators participate in 'ordering' records within ontologies of cultural knowledge, archivists ensure that the creator's ordering preserves context and evidential value" (pp. 97–98). Participatory archiving, as we will also discuss in chapter 5, then is a fundamental step forward for archiving, especially for community archiving, precisely in that it "encourages community involvement during the appraisal, arrangement, and description phases of creating an archival record" (p. 98). Crucially ontology is understood here in philosophical terms, as a way of grouping and categorizing entities, so as to generate diverse ways of knowing them.

For Srinivasan, the fact that information systems are ones of cultural imposition (Sassen 1997) means that novel systems should be developed which would be driven by community needs and discourses (2007, 723). For this, he suggests the consideration of multiple ontologies (Srinivasan and Huang 2005; Boast et al. 2007; Srinivasan et al. 2008) and participatory design (Crabtree 2004) grounded in an ethnomethodological approach that argues that knowledge is formed through interactions and embedded within the practices of our everyday lives (Garfinkel 1967; Crabtree 1998; Crabtree et al. 2000). For him, this contributes to the creation of "a dynamic evolving representational structure that allows information to be navigated and accessed on the basis of a community's own acknowledgment of its own activities and discourse" (Srinivasan 2007, 725). The fluidity is not so much responsive to browsing patterns, but rather it privileges "the community's communication and reflections that emerge from in-person meetings" (p. 725). The systems developed in this way would be "created, designed, and integrated within the ethnomethodological framework of recognizing embodied and social practices" (p. 731). Crucially such a method would allow for comparisons between past and present practices, making it possible for us to look at heritage in the context of its use rather than in isolation.

The "Creating Collaborative Catalogues" project, a collaboration between Ramesh Srinivasan at the University of California, Los Angeles, Robin Boast in Archaeology at Cambridge's Museum of Archaeology and Anthropology (MAA), and Jim Enote of the A:shiwi A:wan Museum and Heritage Center in Zuni, focusing on the Zuni Community of Zuni Pueblo, New Mexico, concentrated on information about objects held in Cambridge, UK, from the proto-historic site of Kechiba:wa (Kechipawan) in New Mexico. The project aimed to experiment with the genealogical history of digital archives and the archival traditions that dominate the production of information around digital objects (MAA 2009). The project resulted in the creation of a "collaborative catalog" (Srinivasan et al. 2009) sharing digital objects such as images and associated museum metadata between communities and museums. The objects used in the study were originally excavated from the Kechiba:wa site at Zuni, New Mexico, during the early 1920s, as part of the larger Hendricks–Hodges expedition directed jointly by the National Museum of the American Indian, Heye Foundation, and the National Museum of Natural History at the Smithsonian Institution (Isaac 2005).

The collaboration with the Zuni community at the A:shiwi A:wan Museum and Heritage Center (AAMHC) at Zuni was crucial in determining the selection and interpretation of the objects. Thus a set of objects was selected by the team in 2006, and then vetted by Octavious Seoutewa, a Zuni religious and cultural expert (Boast and Biehl 2012, 144). None of the objects had religious associations because knowledge of religious nature is sensitive for this particular community. For the project, over 100 Zuni participants were interviewed, but some accounts remained the property of the individuals who were interviewed and were not made available to the public. A significant component in the Zuni accounts, which was not reflected in the MAA catalogs, had to do with the stories shared by the Zuni when presented with the objects. Such stories were identified to be "crucial to cultural heritage revitalization

and for eliciting participation in the kinds of emergent cultural heritage systems that integrate and share multiple ontologies" (p. 146). In particular, the authors found that by "[by] focusing on personal experiences with objects, people are able to talk about important aspects of their lives as Zunis and still avoid revealing esoteric areas of knowledge," as was the case of the following comment:

> My mother has a similar one [set of tweezers] that was used in the plaza ceremony with the bear dance and another dancer who had a yucca plant on him, and the bear tries to get them, but it was my mother who had the tweezer and took the fruits. We also used to make our own tweezers while staying at our Nutria farming village. (viewing MAA 24.119, p. 147)

It was clear that the Zuni made connections between how objects were used in the past and how related objects are used in the present, which transformed these into "important catalysts to vitalize contemporary social and political programs in the community" (p. 148) in relation to learning practices that are so fundamental in the museological and archival context (p. 149), which may then have an impact on everyday practices.

At the heart of the project was the assumption that knowledge consists of practices (Srinivasan et al. 2009) and that individuals attach different descriptions to shared phenomena that represent their different ways of knowing these practices (Boast et al. 2007). Each object would therefore need to be considered as a different way of knowing a number of practices that may stem from different periods in time and geographical areas (Srinivasan, et al. 2009). Objects should thus be made sense of in terms of how they have been and are being used. Insight into these practices allows us to attach multiple ontologies to everyday objects, including objects in the archive makes it possible for us to interpret their use over time and in different places and contexts. In this sense, objects can be thought of as having social lives, entailing biographies and associated narratives (Srinivasan et al. 2008). To reflect continuity in time between past, present, and future practices, these could be presented as emergent, mutable and processual (Turnbull 2000). Objects, including both objects in the archive and archives as objects, should thus be thought of as "complex, socially-understood things" (Srinivasan et al. 2008), each associated with the stories told about them, each catalyst for further stories that would help us to capture who we are and what we do that makes us "us." Objects, stories about their use, and the various intra-documents associated with them thus form a powerful transformative knowledge network that is of increasing importance to archives and museums. The broad social memory apparatus linking the archive, the library, the museum, and the Internet is also the story told or as yet untold, and so as yet unlived, about the object and its life, about both tangible and intangible heritage and its interpreters and users, about our presence in the past and the history of what may become a future past in our so-called present.

I've Known Rivers: The Museum of African Diaspora Stories Project

The Museum of the African Diaspora (MoAD) in San Francisco opened in 2005. It is one of the only museums in the world focused exclusively on African diaspora culture to present the work of African people or people of African descent across the globe. The museum grew out of a process of research that started in 2002 and involved scholars and community leaders from the area. Nowadays, the museum hosts both permanent and temporary exhibitions. Among the permanent ones, presented through often immersive and interactive environments, is *The Origins of the African Diaspora*, a kinetic map of the world that offers information about the African diaspora through chronological and geographical illustrations. Four monitors embedded in the map offer information about when the tools were used, culinary traditions, cave art, to end with images of our contemporaries. Another permanent exhibit is *Celebrations: Ritual and Ceremony,* a circular space upon which images and videos are projected so as to give visitors the impression that they are "suddenly wandering into a street fair around an unfamiliar corner" (MoAD 2014). Finally, *Slavery Passages* is a darkened space in which visitors may listen to first-person accounts of enslaved African men and women from the United States, the West Indies, South America, and Sudan, covering three centuries, with a voiceover by Maya Angelou, who provides biographical information while music from the country of origin is playing in the background. In all these exhibitions, archival and collection materials are encountered as part of an experience bringing together different materials, media, communication strategies, and modes of encounter.

Among the temporary exhibitions was "Art/Object: Re-Contextualizing African Art" (2011), which aimed to re-contextualize African art that has been displaced from the context of the communities it is associated with. For the Executive Director of the Museum of African Diaspora, Grace Stanislaus, "the fundamental idea [is] that these objects were made by people who valued them, both as functional items and objects of beauty" (in DeFlorimonte 2011). The exhibition thus examined how these artifacts were originally used within African societies, often to mark important rituals that were part of the day-to-day lives of local communities. For example, we are told that visitors could see "the full regalia and spectacle of the mask along with a vibrant raffia or cloth costume, and envision how they were used to protect the community by appeasing spirits, or to mark life transitions, whether birth, adulthood, womanhood, or death" (2011). The exhibition also included interactive films, videos, and photographs from the archive, so visitors, involved in a multisensory experience, could "hear the drumbeat and the music and see the community watch and participate in the dance" (Stanislaus in deFlorimonte 2011).

"Art/Object: Re-Contextualizing African Art" operated stratigraphically, and the superimposition of different interpretative practices made it possible for visitors to see the changing value of these day-to-day objects across different geographical areas and during different moments in time. The exhibition consisted of five sections. Section 1 introduced viewers to a sculpture of the Fang people colonized by the French in Gabon, offering an example of

114 Chapter 4

how such displaced items would end up in Parisian shops on their way to be "aestheticized" by the art markets in Europe. Section 2 examined objects that showed how West African religious beliefs reached across the Atlantic. Section 3 looked at performers in masquerade, focusing on the value of ritual and other embodied practices. Section 4 showed the Komo headdress in the context of how its blacksmith creators were key to the well-being of the Bamana peoples of Mali. Finally, section 5 explored ritualized play in the context of initiation ceremonies, fertility, and ideals of beauty from the Ibibio in Nigeria to the Fali in Cameroon. The exhibition concluded by looking at how traditional rituals have been adapted in time but are still practiced in contemporary Africa (deFlorimonte 2011). The Museum has also been running an educational program including "Behind the Lens: Girls of Color," which allows girls of color to explore the origins of images, sounds, and words they encounter in their daily lives. The Summer program for 2014, for example, focused on women living in the Bay Area and encouraged participants to capture individual voices, in the Museum's words: "the experience of our mothers, aunts, sisters and grandmothers" who are considered to be "the mothers of the African Diaspora" so that we could "see what their eyes have seen and feel what their hearts have felt" (MoAD 2014) and herewith turn episodic into communal memories. All stories, documented though digital photography, then lead to the creation of a film accompanied by various articles written by participants in the project.

The *I've Known Rivers (IKR): The MoAD Stories Project* (2005-), curated by Cheo Tyehimba Taylor, draws its title from Langston Hughes's poem "The Negro Speaks of Rivers," which the poet allegedly wrote while crossing the Mississippi River by train in 1920, at the age of 17, and using the *topos* of water to define African identity. The project, which has since expanded into a substantial digital repository, comprising, in 2014, four volumes of archived materials, aims to collect, document, publish, and share first-voice digital narratives about people of African descent in the San Francisco community as well as around the world, including, thus far, countries such as Bosnia, Brazil, Haiti, the United States, and South Africa. The project partnered other organizations to collaborate with particular communities. Thus, for example, in 2007 the project collaborated with StoryCorps Griot, a major story-collecting enterprise that had been launched across the country to capture and broadcast the voices of African Americans on National Public Radio (NPR). Together, the Museum of the African Diaspora (MoAD) and StoryCorps Griot recorded the stories of African Americans living in Northern California. With additional funding from Cal Humanities, *I've Known Rivers: The MoAD Stories Project* also curated Bayview Hunters Point Oral History Project, which aimed at generating a multi-format digital story collection of oral histories of long-time residents of San Francisco's Bayview Hunters Point neighborhood, offering a glimpse of the pioneering African American residents who built their lives in the neighborhood during the early 1940s. These included skilled workers, educators, entrepreneurs, politicians, among others, who witnessed transformative events like the Jim Crow segregation, the end of World War II, the emergence of a Black middle class, integration, the Civil Rights and Black Power Move-

ments in the Bay Area, the decline of the Black community due to drugs and violence, and gentrification (2013, press release).

The project is a testament to the transformative journey of African Americans during the 20th century. A number of workshops were offered as part of the project, such as "Images Speak Words," which resulted in a major youth-created digital photography and audio-recorded exhibition that was on display at the African American Arts and Culture Complex (AAACC), a well-known San Francisco African American community center. For these, each participant received a free digital camera and was taught how to write and record stories based on a single digital image. Working with the national StoryCorpsGriot Team, I've Known Rivers youth also partnered with senior citizens and interviewed them about their life experiences. These interviews were then recorded onto a broadcast-quality audio CD, and copies were sent to the American Folklife Center at the Library of Congress and to the National Museum of African American History and Culture at the Smithsonian. Tyehimba Taylor noted: "As an institution, we are honored to record, share, and archive these rare, compelling stories of African American elders from the Bayview Hunters Point neighborhood. … These histories can help transform and improve the community today" (2013, press release). The stories, as well as a number of offline panel discussions on oral history, were subsequently presented to the general public at the San Francisco Public Library Bayview Branch during Black History Month in 2014.

I've Known Rivers: The MoAD Stories Project also played a significant role the documenting the experiences of those who survived Hurricane Katrina. To commemorate the lives lost and the enduring spirit of adaptation of Hurricane Katrina, the project presented the I've Known Rivers Salon on August 20, 2006, which consisted of a live spoken-word performance by poets and musicians, including Bay Area poet Devorah Majo and New Orleans performance artist and poet Michael Molina, hip hop theater artist and poet Aya de Leon, with testimonies from former New Orleans residents who survived the hurricane. Many speakers made analogies between Katrina and slavery: "I feel like a slave," said Carmen Evans, an employee of Continental Airlines, who relocated to the Bay Area with her mother and son, "I don't have anything behind me." It's "[t]he biggest migration of black people since the Civil War. We lost more than our homes, we lost our culture, and we're trying to get it back" (Harmanci 2006). Another speaker, Diane Evans, noted: "The levees didn't break, they were blown." For her, it was a "strange coincidence" that Jefferson Parish, a white section of town that was very close to the flooded Ninth Ward, remained dry: "How does it only break in this way," she said, "in the black community? Does it make sense the water would only flow in one direction?" Recalling her personal experience, from her initial decision to stay in New Orleans, to the first signs that the levees had been breached, to the arduous trips from her neighbor's roof to the buses, to the treatment she and her family received from every governmental presence along the way, up to her arrival at the Houston Astrodome (in Harmanci 2006). Finally, we are told, she broke down: "It's 2005—two thousand and five—the age of silicon, IT, computers, everything, and people were standing there with signs, handwritten signs, because they

didn't know where their people were. People were reduced to holding signs. And then I saw this woman holding one that said, 'Little Mikey Jones, 3 years old'" (2006). In the 2006 press release for the Salon, Senator Bill Bradley, StoryCorpsGriot, Managing Director, Allen & Company LLC, noted that Hurricane Katrina created a new diaspora in America and that the Museum of African Diaspora was attempting to bring the spirit and culture of New Orleans to life in the museum and to connect communities both locally and globally around this event. Denise Bradley, Executive Director of the Museum of the African Diaspora, also noted on the project website: "Hurricane Katrina has produced one of the largest migrations of people of African descent since the civil war. ... Their stories and their voices deserve to be documented and preserved. And MoAD, as a first voice institution, is best-suited to capture and contextualize these stories unlike any other museum in the nation." The project published all stories, including first-person essays, fiction and poetry, digital still photography, audio interviews, and streaming video of lesser known voices from those who survived the hurricane (2006).

As part of *I've Known Rivers (IKR): The MoAD Stories Project*, Tyehimba Taylor ran a number of workshops, including one with ten 11-years-old who were given free cameras to create, in his words, a "kids'-eye-view on their lives" (in Harmanci 2007). Inspired by the oral histories recorded by the WPA Federal Writers' Project in the late 1930s, Tyehimba Taylor wanted lead a similar "first-voices" initiative. The name of this volume was "Images Speak Words," and the project was carried out in conjunction with the Museum of African Diaspora. As was mentioned above, the previous two volumes collected the stories of people of African descent from around the world and those of Hurricane Katrina survivors. This time, Tyehimba Taylor worked with African American children in the San Francisco Bay Area. The project website states that instead of "taking photos" children were taught how to "make photos" and use their eyes to "see what others don't see." The course comprised four weeks of photography instruction and four weeks of writing. As part of the course, the Western Addition youths received a master class from two internationally renowned photographers, Akinbode Akinbiyi from Nigeria, who lives in Berlin, and David Damoison from Martinique, who lives in Paris. Each student was recorded telling a story about a family member, which plays over their photo. Thus Delilah Sagote, 10, talks about her Samoan grandmother growing up playing basketball and going to church with her brothers and sisters. Isaiah Tenes, 10, talks about his great-grandmother's struggles as a young person: "Her mom was born in Europe during the war. She had three other sisters. She said: 'They would be lucky if they made it to school. There were bombs falling and gunfire all the time. They would have to hide in bomb shelters. It was underground and very scary.'" Each student ended up taking more than 300 photos, though the website only displays a selection of them (Harmanci 2007).

All materials in *I've Known Rivers: The MoAD Stories Project* are grouped in four sections: "origins," "movement," "adaptation," and "transformation." This classification well captures the way that diasporic archives track changes in space and time, and how these changes may prompt transformational discourse. "Origin" stories are described on the website as "stories

that speak to our cultural and familial roots in Africa, whether from generation to genera-
tion or across continents, countries, islands and villages—these are stories that distinguish
the African experience." The stories vary in style and scope. Some are written quite formally,
others are more informal, like the following one written by Eileen in May 2007 called "My
Grandma Araceli":

> My grandma was born on April 10, 1956, in Acapulco, Mexico. She was the first and the oldest child.
> As a child, she enjoyed playing games like hopscotch.
>
> Her family is from Iguala Guerrero, but her mother was born in Chilpandingo, Mexico.
>
> After living in Mexico for a while, my grandma decided to move to San Francisco because she
> couldn't find work where she lived.
>
> One of my grandma's favorite family pictures was taken with her grandma and grandpa on the
> beach. She was only 12 years old. My grandma says that one of the special things about our family is
> that we love each other very much. Growing up, my grandma had a favorite auntie. She always used
> to play with her younger brother, even though sometimes they would fight.
>
> The special person in my grandma's life is her grandma. She taught her moral values.
>
> When my grandma was little, her dream was to become a doctor because she likes to help
> people.
>
> Now she has three sons. The oldest son is serious. The second son is happy. The last one is
> mad and sometimes happy and sometimes mad. They all work and work and work. She loves them
> so much. And I love her too.

Origin stories capture where diasporic families come from, how they adapted to new circum-
stances, and how their histories impacted on younger generations, evidencing the impor-
tance of the country and culture of origin among diasporic communities.

"Movement" stories are described on the website as "stories that document how indi-
viduals, families and communities move continuously, sometimes seeking fresh prospects,
sometimes forced by slavery, war, disaster, employment, or hope for a better life." One such
story, called "Segregation Blues," was told by Michal and William in September 2008. In it,
William Settles interviews his wife Michal about growing up during the segregation is a small
southern town:

> The dolls you got would always be white with blond hair. I never had a doll of color. Growing up
> in a small southern town there would always be looks of hatred. I always thought, "these people
> don't even know me, why are they so hostile?" But the plus was the African American community I
> grew up in always stressed the idea that "you do not let them define who you are." She says her life
> changed when she went to a white college in Kentucky. When she was 7 years old her parents, who
> were teachers, took her to Canada. On their way they had to stop at a restaurant near Washington,
> D.C. and were refused service. "I saw the hurt and pain in my father's face and it just did something
> to me. It hurts my heart because here was a man who was trying to do things right by his children
> and here was a society that [refused]."

While some authors offered statements, others contributed poems, as was the case of Gina Streaty who in August 2006, as part of the volume documenting the experience of Hurricane Katrina, wrote "Hurricane Coverage":

Ashen black faces
Tongues lap lips like waves
Bowed backs wish for wings
Tempers surge toward the camera
Voices jangle from jutted jaws
Bodies muddled on a stadium floor
Black hands rain on water bottles,
hastily made bologna sandwiches
A throng of men circle a body
hoisted from a cot? dead
Black woman seals her eyes in tears
Says, some died in the house.
Living room, kitchen like marshland
An opened wallet, wet dollar bills
Ain't got no money to buy a car!
Women, children? Refugees
Men wear necklaces of sweat
Dead body in a wheelchair, elderly woman
Black man hunkered down on his porch
yellow dog, shot gun at his knee
He speaks to the water, not the rescue team
I gonna stay right here. Leave me be.
Outside Mississippi, Louisiana,
eyes scan televised ruins
Tears pelt shoes on dry land.

Movement stories, such as the ones cited above, capture the often-traumatic lifestyle changes that communities experience as a consequence of an event.

"Adaptation" stories are described on the website as "stories that reflect the adjustments and struggles made by people of African descent as the traditions and memories we carry with us evolve amid new surroundings and other cultures." One such story is told by Rodger and Katie Allen in September 2008:

Rodger Allen, a native Californian, discusses growing up in both Marysville County, CA and San Francisco's Fillmore District in the early fifties. "When we lived in the country, we rented a farmhouse that had ten acres. We had animals and my brothers and I worked in orchards and drove tractors," he said. "We felt a lot of freedom there, being in the city we would have been restricted so we really enjoyed it." Rodger talks about his father, who was the first African American to graduate from UC Davis, his mother who, among other things, was a governess for a wealthy family and his rich

family history. "My mother's side of the family, there were four brothers who were the off-spring of a white slave-owner and an African mother." Of the four, three came to California and since they were trained in agriculture, they were able to start businesses. He joined the military during the Vietnam Era and served in Germany where he learned life lessons. "I've been pleasantly surprised by life." He says. "I have been extraordinarily blessed to do more things than many African American men had the opportunity to do."

Another example of an adaptation story was written by Margaret Nkechi Onwulka in February 2006:

"You are not one of them." Those were the words spoken to me by my father the first and last time to his knowledge that I said the word ain't. "You are not one of them." The "them" were the students at the predominantly African-American elementary school that I attended in Inglewood, California. It was the first time that I became aware that, although I looked like everyone else at school, I was different. I knew that my last name was different. I knew that my parents had accents. And I knew that my mother served fufu at least once a week. ...

Over the years I struggled trying to blend my Nigerian identity with the Black American culture that I knew far too well. In junior high, all of the kids said that I dressed too cool be an African. I would lie and tell them that only my father was from Africa. In high school, I became a "Nigerian Malcolm X" of sorts. ... It was not until college, where I no longer was the only person representing the continent, that I found a balance.

I am proud to say that I am a Nigerian-American. I wear my Nigerian lappas with American tank tops. I LOVE Nigerian food, but I find a way to balance it with my vegetarian diet. I'll get down to highlife and soukous, but I like to mellow out to jazz and R&B. I date Nigerian, Nigerian-American, and Black American men. My Nigerian and American identities no longer tetter [sic] totter in my life. I embrace both identities warmly. I'm Nigerian. I'm American. I'm Black. And I ain't changing my self-identification for anyone.

Adaptation stories attempt to explain the hybrid status of the diasporic citizen, disclosing information, for example, as to whether adaptation was the result of a synthesis or a blending (Brinkerhoff 2009, 32).

Finally, "transformation" stories are described on the website as "stories that reflect how we transform ourselves mentally, physically and spiritually in dialogue with new places and create new traditions and new cultures." One such story was told by Kiilu and Tureeda in September 2008:

Tureeda Mikel interviews Kiilu Nyasha on "Black August" to learn about her journey to California and her activism in Black Power Movement. "I grew up during the forties in Pittsburgh, Pennsylvania in the Hill District," says Kiilu, who was a foster child. "My mother suffered mental illness and struggled very hard to raise four children." Kiilu discusses overcoming poverty as a child, breaking the color barrier in corporate America, her membership in the Black Panther Party for Self-Defense, and her commitment to socialism. "I will continue to be a freedom fighter until the day I die."

Another transformation story stems from the Images Speak Words workshop and was written by Aliyah in May 2007:

> I interviewed my mom, Dijaida Durden. She lives in San Francisco, California. She was born on December 10, 1971. She has one sister who is the first and she is the second, and the oldest. Her family is from Kansas. Her mother was from Kansas and her grandmother was from Missouri. My mother was born in California and her family moved here for better jobs.
>
> The special thing about our family is that we are descendants of [African] slaves and American Indians and we have come a long way in the United States today.
>
> My mom's favorite picture was taken of her in the 1970s. Her favorite person as a child was her cousin Jay. Her favorite sport to play as a child was basketball. My mom's mom taught her how to be independent and to take care of herself. She taught her to be the best at whatever she wanted to do.
>
> My mom's dream as a child was to be a mother, have three children, a dog and a cat. She accomplished that dream. My mom is fantastic because of who she is.

Transformation stories distinctively capture examples of past transformation and may indicate possibilities for future change.

I've Known Rivers (IKR): The MoAD Stories Project entails different kinds of stories bearing different types of testimonies. At one level, they constitute a stratigraphy. They provide layers tracing a chronology spanning from "origins" to "movement," "adaptation," and "transformation." At another level, they constitute a memory architecture consisting of personal memory claims, which, as we have seen, "take as their object one's life history" (Connerton 2007, 22), as well as cognitive memory claims, which often imply the remembrance of words or stories and stem from past cognitive or sensory memories of oneself (p. 23). But, uniquely, they map change, tracing the movement and adaptation undergone in departing one's point of origin to arrive at a transformation. So we saw in chapter 2 how archives operate stratigraphically and here we see how the strata can be used not only as a deep map, but as a testimony to change. We saw in chapter 3 that as the relationship between different types of memories pertaining to oneself remains somewhat fluid, and that cognitive memory is able to affect personal memory (p. 23), and individual memories are able to become social memories (Zerubavel 2003), particularly commemorative ceremonies (Connerton 2007, 71), namely ceremonies in which "a community is reminded of its identity as represented by and told in a master narrative" in a kind of "collective autobiography" (p. 70). What we witness here is how these different kinds of memory build on one another and ultimately result in the articulation of a transformative community autobiography, one hitherto unwritten, that operates at once as archive and map, cartography, and trail. This new hybrid stratigraphic memory archive, which facilitates the creation of multiple points of view, is, however, not only a laboratory for the production of memories, it is also, most important, a strategy for facilitating societal and political change. It is at once a past- and future-oriented mechanism for transformation.

We saw in chapter 3 that watching someone conduct an action activates the same cortical regions, which are usually activated when executing the same actions so that by means of

Embodied Simulation (ES) Theory we in effect have what has been described as "direct access to the world of others" (Gallese and Guerra 2012, 185). We also know that by looking at an action in a film, photograph, or painting, or their visual documentation, we literally re-enact that action in our brain. In this context the artwork, its visual documentation, the archive and the museums that hosts it, all become fundamental to the embodied simulation of these actions, allowing us, as we watch, for example, the videos in *I've Known Rivers (IKR): The MoAD Stories Project,* not only to learn about but have a direct mnemonic access to a diasporic history that could become part of our own memory, part of who we are.

It is perhaps this transformational power of the archive that Lord Acton sought when he hastily abandoned his dinner to set off toward the Vatican Archives (Ernst 1999, 6). Lord Acton and his king, Victor Emmanuel, might have known even then that the "dark margin" of the archive (Agamben 1999, 144) is where old powers may be legitimized, and new powers forged, but also and where "still unsuspected mechanisms that will allow us to multiply the transformations" could be invented (de Certeau 1984, 152). These mechanisms allow the apparatus of the archive not only to re-produce, but to multiply the "present" that was transformed. Within the apparatus of the archive, we re-form our coming into being and can remain as process.

5 The Art of Archiving

I, however, had something else in mind: Not to retain the new but to renew the old. And to renew the old—in such a way that I myself, the newcomer, would make what was old my own—was the task of the collection that filled my drawer.

(Benjamin 2002, 403)

In the 20th and 21st centuries, archival methodologies have often been adopted for the creation of artworks that could be described as archives. These works show how artists have used archival methodologies for exhibiting personal, often autobiographical, histories, sometimes inspired by everyday life, often to challenge and/or critique canonical epistemological models. These artworks have produced a fundamental shift in the way we nowadays build and use archives. The chapter starts by analyzing curiosity cabinets spanning from the 15th to the 21st centuries, showing how they operated as media between forms and processes, and highlighting how they acted as precursors for 20th- and 21st-century archival art. The chapter then moves on to analyze archival art, including time capsules, showing how artists worked as collectors, curators (Foster 2004; Groys in Spieker 1999), and archivists. Finally, the chapter analyzes how web 2.0 (e.g., Facebook, Storify, Lifelogging, Your Story, and Web-Biographies) can be described as 21st-century cabinets of curiosity. The case studies for this chapter include Marcel Duchamp's *La boîte-en-valise* (1941), a suitcase containing miniature replica and photos of his works organized and codified into an archival system; Robert Morris's *Card File: July 11–December 31, 1962,* described as "an industrially produced, hand-operated Cardex file with a layered, quasi-archeological arrangement" (Spieker 2008, 12); Andy Warhol's *Time Capsules* (1975), a serial work consisting of six-hundred-and-ten standard-size cardboard boxes, which the artist filled and sent off to storage; Ant Farm's *Citizen Time Capsule* (1975–2000), containing objects donated by people and chosen by Ant Farm from their earlier piece *Time Capsule* (1968); and sosolimited's *ReConstitution* (2004–12), an award-winning live remix of the US presidential debates in 2004, 2008, and 2012, which incorporated elements of dynamic typography, video manipulation, computer vision, sensor technologies, and sound design.

The Curiosity Cabinet

We saw in chapter 3 how, in the aftermath of the Holocaust, our obsession with the necessity to remember weakened the boundaries between museums, memorials, and monuments, rendering them somewhat "fluid" (Huyssen in Young 1994, 12). We also saw how the apparatus of the archive operates interchangeably between museums, libraries, and archives. In fact the boundaries between these forms were fluid at other points in time, especially during moments of economic, political, and cultural expansion. For example, during the Classical period and during the Renaissance a number of proto-museums were founded that could be considered as precursors to the *Wunderkammer*, or curiosity cabinet (MacGregor 2007, 1), which in turn is often hailed as a precursor to the modern museum. Here, I show how the curiosity cabinet was also a precursor to a number of contemporary art practices that can be described as archival.

Among the earliest examples of fluid and interchangeable forms are a number of influential systems of classification. One of the most famous ones was Pliny the Elder's *Historia naturalis* (AD 77–79) that started by describing the world in its entirety and then progressed to analyze nature's component parts "in a way that was capable of being directly translated to the physical collection" (MacGregor 2007, 1–2). As a consequence of this direct link between classification and exhibition, Pliny the Elder's work exerted a great and prolonged influence over the creation of cabinets of curiosity across Europe (p. 2). However, cabinet-makers drew their strategies from a plurality of practices, including religion, and often adapted these to suit their own objectives. For example, evil was often represented in churches in the form of a crocodile carcass hanging from the ceiling, as were the cases in Santa Maria delle Grazie near Mantova, the Cathedral in Seville, and numerous other churches in Spain. This practice, as we will see throughout this chapter, was often adopted by cabinet-makers in Europe (p. 7). Cabinet-makers also drew strategies from memory culture, the likely sources being Giulio Camillo's *teatrum mundi*, Giordano Bruno's hermeticism, and Robert Fludd's magical and religious theories (Hooper-Greenhil 1992, 105–26). Here we will see how these collection and display strategies, which evolved over the years to embrace distinct traditions spanning from science and philosophy, to religion and art, played a fundamental role in determining the function of the archive at first within the cabinet and then independently from it.

The first cabinets of curiosity in the strictest sense of the term appeared in Northern Italy in the late 15th century. Known as *studioli*, they consisted of chambers in princely palaces usually not exceeding six-and-a-half meters in length. Two of the earliest cabinets were Leonello d'Este's (1407–50), at Palazzo Belfiore near Ferrara, and Pietro de Medici's (1414–69) in Florence, a collection subsequently inherited by Lorenzo the Magnificent (1449–1492). By the mid-16th century the practice of forming cabinets had spread in Europe among aristocrats, ecclesiasts, the military, physicians, lawyers, poets, and artists (Goltz in MacGregor 2007, 12). There were cabinets associated with libraries, gardens, anatomical, medical, and pharmaceutical collections, universities, workshops, and laboratories, with common materials

featuring natural specimen as well as fabricated ones, especially, unicorns; stones of various kinds; paintings, including those of giants and dwarfs; fossils; "jokes of nature" (MacGregor 2007, 46); classical antiquities; engraved gems; arms and armor; primitive weapons; tools and machines.

Memorial culture had a particularly significant impact on the emergence of novel collection and curation strategies and, more recently, on the renewed popularity of archival art. For example, the curiosity cabinet, which was frequently referred to as *teatrum mundi*, theater of the world, and which had been adapted in the 16th century from the classical schemes proposed by Cicero and Quintilian, was essentially a memory tool. At this point in time, the most influential proposer of memory tools was probably Giulio Camillo, who, in the early 16th century, had invented a three-dimensional wooden structure in the form of a Vitruvian theater that was intended to act as a memory aid. This was said to, "in a single glance," disclose "the secret of the universe" which ought to be "be apprehended, understood, synthesized, and memorized" (Hooper-Greenhill 1992, 97–98). Architecturally, the theater itself was probably semi-circular, raising in seven steps that were divided by seven gangways that represented seven planets accessible through seven doors. Eileen Hooper-Greenhill notes how the mystical significance of the number seven may have been related to the seven petitions in the Lord's prayer. For her, "within this division a whole cosmology was inscribed in decorated images which were enriched by the addition of a great number of boxes and coffers" (p. 98). Text, objects, and explanations were thus brought together, creating a collection that was also an exhibition as well as its own map of interpretation. In fact the theater, which had been built in the court of Francis I, gave the sovereign "extraordinary powers," operating as "a privileged apparatus articulating knowledge and powers on many levels, including celestial/terrestrial, magical/material, sovereign/subject" (p. 100). His theater was therefore not just a building, but a "plan of the psyche," a "mental map" (p. 101), which allowed the Renaissance subject to adopt a privileged position in the universe (Foucault 1970, 22). These early memory systems played a crucial role in determining how, nowadays, we use archives relationally, for example, to bridge between present and the past, individual and collective histories.

Camillo's theater played a major role in the creation of a number of cabinets. One of them was that of the Bavarian Duke, Albrecht V. His Flemish advisor, Samuel Quiccheberg's *Inscriptions* (1565), often considered as the first published work on museology (Seelig in Impey and MacGregor 1985, 76–89), divided the known world into five classes of objects that could each be subdivided into ten or eleven inscriptions ranging from portraits to machines, clothing, and so on. This work was described as a "map of the macrocosm rendered in a microcosm, beginning with God and the ruler who will be magnified by his collection, proceeding through artifacts (those things made by man) to the natural world (those things useful to man), to human instruments (the means for measuring and controlling the world), to art (the means for re-creating and representing it), ending, in the very last inscription, with the packing crates" (Robertson in Sheehy 2006, 50). The cabinet, underpinned by Quiccheberg's

theoretical argumentation, sat at the center of a system of schools, factories, armories, which was testimony to Albrecht's aim to place the means of economically useful knowledge production under his control, showing also how, at the time, collecting and experimenting were considered to be "analogous activities" (p. 50).

Not only did Quiccheberg's system, like Pliny the Elder's beforehand, create a direct link between classification and exhibition, it also connected these to a knowledge economy grounded in memorial culture. Quiccheberg in fact also referred to this ideal cabinet as a "Theater of Wisdom" (p. 50) or "memory system" (Seelig in Impey and MacGregor 1985, 87) which, again, was inspired by the physical memory theater of Camillo (Kaufmann 1978, 25). Quiccheberg's writings also referred to a classification system, the Munich Kunstkammer, which was described as a *Theatrum Sapientiae* (p. 86). This consisted of a "formation of cloister-like ambulatories, which, with four wings comprising several floors, surround a courtyard" (p. 77). From the center of the courtyard the entire structure could be "apprehended" (Hooper-Greenhill 1992, 108). Here, Quiccheberg had juxtaposed original specimen with artifacts, possibly in response to Camillo's boxes and images with their explanatory texts, perhaps a "reference to the display of *naturalia* and *artificialia*" (p. 109). Thus, arguably, Quiccheberg had adapted Camillo's "Memory Theater" to "a written scheme with which he re-structured a comprehensive encyclopedic collection, or series of collections, into a coherent unity that represented the entirety of the world" (p. 110). This coherent unity was also at the heart of Albrecht's political strategy, aiming for the creation of an ordering system that allowed for the control and production of knowledge.

One of the greatest collectors of all times was Emperor Rudolf II of Hapsburg (1552–1612). Among the items in his collection were a Nile horse, drawings of plants and animals by Joris Hofnaegel, and eight hundred paintings. The cabinet was arranged over three great chambers in his Prague residence, which were considered as the antichamber (*vordere Kunstkammer*) to the cabinet proper (*Kunstkammer*). The latter was principally devolved to *naturalia* (history, botany, mineralogy, and zoology), *scientifica* (clocks, instruments, and watches), *artificialia* (weapons, textiles, coins, medals, prints, and furniture), and a library (Mauriès 2011, 171). The antichamber contained similar objects as well as antiquities. Emperor Rudolf II also employed agents to scout for items and surrounded himself with artists and craftsmen, technologists and scholars, to create works for the cabinet. Overall, the aim was not only to collect, but "to manipulate reality, to experiment and invent" (p. 175). As in the case of the de Medici chamber, the presence of a workshop populated by craftsmen points to the desire to fabricate worlds. Many artifacts in the collection represented the world "ruled in harmony" by the emperor (Hooper-Greenhill 1992, 118). Thus the fountain by Wenzel Jamnitzer, which stood ten feet high in the *Kunstkammer,* represented the cosmos in the form of an imperial crown, with four gods symbolizing the four seasons by the base, while above them further gods and creatures were positioned that represented the four elements. Even further above were angels and four eagles, with the symbol AT the very top alluding to Jupiter who stood for the Emperor of the House of Austria. Ambassadors were usually taken here (Kaufmann

1978, 22), which suggests that the emperor used the cabinets to showcase his power. This *Kunstkammer* also followed the principles of Camillo's Memory Theater and, possibly, acted as an inspiration to Giordano Bruno's philosophy (Hooper-Greenhill 1992, 116).

By the 16th and 17th centuries the curiosity cabinet had become a medium facilitating the collection and more or less public exhibition of seemingly disparate objects among, primarily, aristocrats and scholars. It often consisted of small and ornate cabinets such as the Uppsala *Kunstschrank*, or whole rooms, as can be seen by contemporary engravings such as those depicting the cabinets of Ole Worm, Ferrante Imperato, and Ferdinando Cospi. We have already seen that the cabinets usually included both *naturalia* and *artificialia*, namely natural and human-made objects, as well as fake monstrosities. Along with the Museum Wormianum engraving (1655), the illustration of Imperato's collection from his *Historia Naturalis* (1599), two of the earliest representations of a cabinet of curiosities, have come to symbolize the "archetype" cabinet of curiosities: in both the natural history specimens are disposed according to an aesthetic scheme, with the walls below lined with cabinets and the racks against the opposite wall holding books and portfolios of drawings (MacGregor 2007, 22). Imperato's Museum in Naples also contained books, botanical and zoological specimens, and jars, while shells and a stuffed crocodile were suspended from the ceiling. Interestingly, Imperato was an apothecary and used his collection for research in the manufacture of medicines. The cabinet of Francesco Calzolari, who like Imperato was an apothecary, from his *Museum Calceolarium,* also included animals, birds, and fishes hanging from the ceiling, with shelves and drawers crowded with human-made objects and some specimen presented in a kind of altar at one end of the room. Worm, who had visited Imperato, in Naples, had a cabinet that confined to *naturalia*. These cabinets, like Quiccheberg's, functioned as collections, archives, exhibitions, and workshops in which the displayed relationship between disparate things served to demonstrate the validity of a system of knowledge that aimed to underpin his political and economic program.

Cabinets of curiosity were often formed through hybrid collections and, over time, encyclopedic classification systems started to play an increasingly significant role for their interpretation. One such cabinet was created by Ferdinando Cospi, an agent of the Medici family who collected Roman and Etruscan antiquities and deities from Mexico and Egypt. In 1605 he acquired the collection of Ulisse Alrovandi, professor of Natural History at the University of Bologna, which entailed an extensive collection of plants and illustrations that he had facilitated free access to. His collection consisted principally of display cupboards in his cabinet that contained over 4,554 drawers, often entailing smaller drawers. Interestingly, Alrovandi was so focused on his visitors that he kept a *Catalogus virorum qui visitaverunt Museum nostrum* in which he categorized visitors according to their geographical origins and social standing: "obsessive and indefatigable," we learn, "he would write notes on scraps of paper and place them in bags, alphabetically arranged, before doggedly re-ordering them once again and gluing them on to sheets. At his death, he left 360 manuscript volumes, some of which remain unpublished to this day" (Mauriès 2011, 150). In fact, by the time of his

death, Alrovandi had amassed eight thousand panels bearing representations in tempera of the exotic or rare objects from nature of which he had been unable to obtain specimens, in addition to eleven thousand beasts, plants, and minerals and seven thousand pressed plants that he cataloged into fifteen volumes, as well as eighty-three manuscript volumes with wood engravings (p. 150).

By the 17th century, hundreds of collections could be counted in Europe. Often the death of their owners, as in the case of Alrovandi's collection cited above, meant that the collections were acquired by local magnates or subsumed into royal collections. By the 18th and 19th centuries, the cabinets begun to give way to scientific collections based on natural law. Thus slowly collections moved from private dwellings to public museums. *Naturalia* were relocated primarily to natural history museums, while *artificialia* were relocated to art galleries. Joseph Bonnier la Mosson was between the two worlds, as his house in rue Saint-Dominique in Paris was filled with objects in the tradition of the *Kunstkammer*, but, unlike in previous cabinets, the objects, as in Worm's case, were now segregated (p. 185). A good example of such a novel kind of collector was Sir John Soane, the neoclassical architect, who turned his own house in London, now a museum, into a cabinet of sorts. Soane did not, however, display many *naturalia*, and rather favored *artificialia,* such as fragments of classical buildings, statues, paintings, like William Hogarth's *A Rake's Progress* (1733) and *An Election* (1754–55), Canaletto's *Riva degli Schiavoni Looking West* (c. 1735), and the alabaster Egyptian sarcophagus of Seti, as well as 30,000 architectural drawings, 6,857 historical volumes, 252 historical architectural models, among others.

The modern re-inventor of cabinets of curiosity was Julius von Schlosser who, in a seminal study published in 1908, talked about them, as well as the chambers used to house the secret treasures of Greek temples and Christian churches, as having an aura that extended to all forms of culture of curiosity, including that of the Surrealists' found objects (p. 23). For von Schlosser, who viewed Northern collections as linked to the medieval and the Gothic, and Southern collections as aiming to "construct a coherent image of the world, inherited from antiquity and anticipating the modern world view," Jean de Berry (1340–1416), the third son of King John II and a leading patron of the arts, was the "paradigm of all collectors" (p. 23), possibly because he charged "gaps between the objects with aesthetic significance" (p. 25) so that, arguably, the materials of the exhibition could be inscribed with different kinds of meaning (Lugli 1990, 43). This strategy was subsequently utilized by Surrealist artists, such as André Breton who collected African, Oceanic, Surrealist, vernacular and magical artifacts of which two hundred were cataloged through lengthy descriptions. These included descriptions about natural objects, such as minerals and plants; "interpretations of natural objects"; "disrupted objects" (e.g., modified by storms); objects "incorporated into sculptures"; objects from Picasso's studios, including "ready-mades" as well as Duchamp's "assisted ready-mades"; and masks and fetishes from Oceania and the Americas (Mauriès 2011, 214). Other Surrealists were also avid collectors, like Paul Eluard and Joseph Cornell whose portable box sculptures could be described as miniaturizations of the cabinets synthesizing his "passion of enclosing

one thing inside another—from furniture to shelves and from drawers to boxes" (p. 225). Crucially, though, it was the identification of the role played by the attribution of meaning to the space in between objects that was to play a greater than ever significance for archival art, as I will show in the next section.

A number of artists still use curatorial practices related to the cabinet of curiosities. One such artist is Mark Dion, who often utilizes existing collections to create installations that "mimic museum exhibitions" (Sheehy 2007, xi), deliberately encouraging viewers to consider the provenance of artifacts and the ways that "collecting has served as a central base for knowledge in the West" (pp. xi–xii). Thus in 2001 Dion created an exhibit at the Weisman Museum at the University of Minnesota for which he positioned a giant stuffed walrus head, originating from the mammal collection of the Bell Museum of Natural History, opposite nine cabinets recreating the style of the Renaissance cabinets of curiosities, which included minerals, fossils, sculpture, paintings, decorative objects, books musical instruments, historical artifacts, and technical devices (p. 3). Operating "like an archeologist," Dion had dug into the underground of the university where its collections were stored in collection storage areas that were rarely open to the public (p. 4). This archeological approach had already been used in *The Tate Thames Dig* (1999) where Dion had organized two-week long digs, one near Tate Britain, the other near what is now the Tate Modern, working with twenty volunteers to bring to light objects from the riverbanks of the nearby River Thames, such as rusty keys, knives, teeth, and toys. These objects were then classified and categorized, and finally arranged in a large cabinet on display in Tate Modern. Dion, who has often used photography, film, performance, drawing, or writing, also adopted a similar approach in his earlier *A Tale of Two Seas* (1996), which was developed for a gallery in Cologne with Stephan Dillemuth. For this, the two artists made expeditions to the Baltic and the North Sea where they "scavenged along shorelines for natural and human-made objects" that were then installed in a cabinet in the gallery. These included water and soil samples, dead birds and fish, debris and ephemera (p. 8). In this work, Colleen Sheehy notes, the objects were arranged in such a way so as "to defy obvious categories and hierarchies" and "instead the display prompted questions about the logic of its order" (p. 8). At the Weisman Art Museum, as well as at the Wexner Centre for the Arts at Ohio State University in Columbus, where he again created a cabinet in 1997, Dion therefore deliberately adopted Renaissance cosmology in what has been described as an "effort to re-imagine the organization of knowledge" (p. 24). Here, the model of the cabinet was used explicitly as "medium of contamination, the *locus* of chance encounters, the revealer of hidden meanings" (Mauriès 2011, 236).

The functions of the cabinet of curiosities, as Hooper-Greenhill shows, were varied. At one level, they brought objects together both in terms of a display and in terms of the logic that related them to one another so as "to represent all the different parts of the existent" (1992, 82). In this sense, the cabinets were a subjective interpretation of the macrocosm. In the cabinets, the ordering of the materials "represented *and* demonstrated the knowing of the world," and "both the collecting together of the material things, and their ordering,

positioned the ordering subject within that system of order" (p. 82; emphasis added). The cabinets operated as technologies for ordering the world, which facilitated the positioning of the subject within that world. For Hooper-Greenhill, the picture of the world presented by the cabinets was "constituted through the articulations of the rules of the Renaissance *episteme*" (p. 84), the "systems of correspondences" that formed the basis for both the collection and the exposition of materials and for the "constitution of the ordering subject as both subject and object" (p. 84). This fundamental feature of the cabinets allowed for a duplication or multiplication of the subject as object. Interestingly, when talking about a Renaissance episteme, Hooper-Greenhill adopts Foucault's theorization that there are three major *epistemes*: Renaissance, Classical, and the Modern, each with distinctive characteristics. In Foucault's analysis, the Renaissance *episteme*'s main characteristics were said to be interpretation and similitude (1970, 30), while the Classical *episteme* was said to be grounded in verifiable knowledge, and the Modern *episteme* saw the acknowledgment of the failure of representation (pp. 250ff). Whereas for her, the Renaissance *episteme* was grounded in relational discourse, with the cabinets representing this as a system of display of the *episteme*, during the time of the Classical episteme, records, and filing systems became increasingly important. Catalogs, indexes, and inventories were drawn up that aimed to introduce "an order between all things" (Hooper-Greenhill 1992, 137). During this period, which Foucault named the "era of the catalog" (1970, 131), "relationships of resemblance, infinitely variable, and often personal" of the previous period were replaced "by a tabulated, documented, limited canon of order" (Hooper-Greenhill 1992, 141). However, while during the Renaissance, the archive was one of the many components of the cabinet, during the Classical period, as we saw in chapter 1, the archive became increasingly prominent, so that, for example, we know that in the aftermath of the French Revolution much of the work seized by the French troupes was transported to the Louvre, leading to the creation of an archive for the "requisition, selection, distribution, installation, removal, reinstallation, classification, restoration, inventories, exhibitions, catalogs, for thousands upon thousands of works" (Bazin 1959, 52). Finally, in the modern period, the fragmentation of knowledge, that also defines the postmodern "condition" (Lyotard 1985), started not so much to undermine but rather to underpin the archive, which, thereafter, became even more prominent precisely because of this distinctive feature.

In conclusion, the cabinet of curiosity's legacy over what can be described as archival art has been significant. One philosopher, Walter Benjamin, articulated the reasons that may explain the cause for this phenomenon. Benjamin was notoriously critical of the construction of history as a teleology, and, instead, suggested that the task of the historical materialist was to "blast open the continuum of history" (1992, 262) so that writing about history would not be conducted sequentially but rather through the creation of college-like processes in which past moments would operate as "shocks" to the present. For Benjamin, the social historian was a collector, choosing items among the detritus produced by the progress of modernity. Benjamin had been absolutely meticulous in archiving his papers, so that,

for example, he used thirty groups to generate an inventory of his correspondence. This, though, was framed by an ordering system that appeared "distorted, affected by subjective memories and meanings" (Marx et al. 2007, 8). Increasingly, in the aftermath of the Second World War, the archive had started to include not only the subject as both subject and object but also made space for challenges to its own systems of knowledge production. Thus doubt, distortion, uncertainty, started to be built within the archive's ordering system and what Derrida described as the *archiving* archive (1995, 16–17; original emphasis), the technological ability to order of the archive, begun to include reference to its own fallibility. The ability to accommodate this acknowledgment of the fragility of epistemological structures, and the adoption of the cabinet's capacity to prompt relational thinking, facilitating the contamination of seemingly unrelated fields, contributed in rendering the apparatus of the archive a formidable *topos* for a self-doubting creation, dissemination, and preservation of knowledge.

Archival Art: The Cases of Marcel Duchamp's *La boîte-en-valise*; Robert Morris's *Card File: July 11–December 31, 1962;* Andy Warhol's *Time Capsules;* and Ant Farm's *Citizen Time Capsule*

In 1921 Friedrich Kuntze published a book entitled *The Technique on Intellectual Labor,* calling for the end of the Principle of Provenance on the basis of a need to mechanize through card indexes and mathematical computation. As we saw in chapter 1, the Principle of Provenance was opposed to any arrangement that may be by subject matter, and instead focused on the archive's organization, drawing attention to the conditions under which records emerged, the media and technologies that helped produce them, the business of which they were once part of (Spieker 2008, 18): the point of origin or ἀρχή. It was for Spieker "these conditions— this place—rather than meaning (or history)" that the 19th-century archive meant to reconstruct, aiming therefore not simply to focus on "content, but [on] the formal (administrative) and technical conditions for its emergence" (p. 18). Here, I show how artists integrated these formal archival administrative conditions within their aesthetic practice to expose the fragility of canonical epistemological models by exposing the fallibility of archival systems.

Since the inception of modernism, artists started to rely on the *topos* of the archive to express their unease about canonic systems for the production of knowledge. It was during this period that the archive also started to be considered as a medium or even an apparatus. This change in the perception of the archive was a consequence of modernism's changing relationship to time, which was also, possibly, at the heart of its growing fascination with historiography. The latter played a crucial role in the renewed popularity of the archive. Historiography, we know, brings on the "transformation of the archive's space into the effect of a [temporal narrative]" (Ernst 2002, 49). This rendered the *topos* of the archive particularly attractive to "modernist efforts to make time productive, consumable and maximally profitable" (Spieker 2008, 27). For Spieker, this explains the popularity of the interpretation of 19th- and, subsequently, 20th-century archives as technologies remediating the past into the

present (p. 26). The archive, just as, earlier, the cabinet of curiosities, was used as a memory theater, and memory, in turn, was thought to be inextricably embedded within the architecture of the archive (Groys in Spieker 1999). This produced, as we have already seen in the previous section, an anxiety over the archive's effectiveness in cataloging everything, which generated a much more significant anxiety over the unreliability of knowledge. This also produced a mutual dependency between memory and the archive, which led to a renewed effort to render the apparatus of the archive more efficacious.

Gustave Flaubert's unfinished satirical work *Bouvart and Pècuchet* (1881) well captures the 20th century's growing anxiety over building epistemological and ontological models that rest on the archive. *Bouvart and Pècuchet* was probably conceived of in the 1850s, shortly after Flaubert read Barthélemy Maurice's *Les Deux Greffiers* (*The Two Court Clerks*, 1841), which showed the two homonymous protagonists compelled to collect and catalog everything for even the smallest omission could lead to the collapse of their world (Flaubert 1976, 133). Likewise Ilya Kabakov's "The Man Who Never Threw Anything Away" (1996) famously sees a character in a room full of garbage bearing witness to what seem to be eventually pointless efforts to classify and record all the links between the items. Kabakvov writes:

> A simple feeling speaks about the value, the importance of everything ... this is the memory associated with all the events connected to each of these papers. To deprive ourselves of these paper symbols and testimonies is to deprive ourselves somewhat of our memories. In our memory everything becomes equally valuable and significant. All points of our recollections are tied to one another. They form chains and connections in our memory which ultimately comprise the story of life (2006, 33).

In the works of Flaubert and Kabakov, the archive is still seen as the medium through which to construct and defend established systems of knowledge. However, Kabakov's earlier installation, *Sixteen Ropes* (1984), although also archival in nature, adopted a different and telling approach. The work consists of numerous pieces of garbage hanging at eye level from sixteen parallel ropes suspended at about a meter and a half from each other (see figure 5.1). Written labels attached to the garbage contain texts. For Spieker, this "stringing up" of objects was in reference to the archival practice of filing. So, Spieker points out, "the English word 'file,' which is derived from the French *fil* (string), originally meant 'to line something up on a piece of string'" (2008, xi). The viewer here appears to be prompted to construct a story, or history, from the "heterogeneity of the trash" purely on the ground of its ordering through a formal archival methodology (p. x). Whereas in Flaubert and Kabavov's earlier work Derrida's "*archiving* archive" (Derrida 1995, 16–77; original emphasis) is seen as the condition without which epistemology, and its associated memory processes, collapse, here, as in other artworks discussed in this section, the archive becomes the apparatus through which to look at and experience the everyday.

Since the time of the Second World War, an increasing number of artists have used a whole variety of archival methods to curate, store, exhibit, and even sell their work. These artists not only adopted collecting strategies, "drawing on informal archives," utilizing

Figure 5.1
Ilya Kabavov, *Sixteen Ropes* (1984 installation). Watercolor and pen on paper (1993). Courtesy Ilya and Emilia Kabakov. © DACS 2015.

various kinds of archival architecture of texts, objects, data, as well as platforms, kiosks, stations, but also have produced archives as part of their creative practice (Foster 2004, 5). Archives, for them, were a method, or practice, as well as a product, or artwork. Moreover archival strategies, for them, were often a form of curation or, quite literally, exhibition. For example, Marcel Duchamp's *La boîte-en-valise* (*The Box in a Valise*, 1941), famously consisted of a box containing a collection of sixty-nine reproductions of his past artwork sometimes enclosed in a valise, constituting both an archive and an artwork (see figure 5.2). The history of the work is significant in this context. Toward the middle of his career, Duchamp had in fact become interested in serializing all his works and so commissioned manufacturers throughout Paris to make three-hundred-and-twenty miniature copies of each of his past artworks, which would then be stored and displayed in customized boxes, some of which were transported in valises, of which twenty were in leather. *La boîte-en-valise* seemingly parodied museum practices by implicating that the artist had become "a traveling salesman whose concerns are as promotional as they are aesthetic" (McAllister and Weil in Schaffner and Winzen 1998, 11). However, there could have been other reasons for Duchamp to use the valise. In fact Duchamp had started planning this work in the mid-1930s, finally developing it after 1940 when, fleeing from the arrival of Nazi troupes in northern France, he escaped

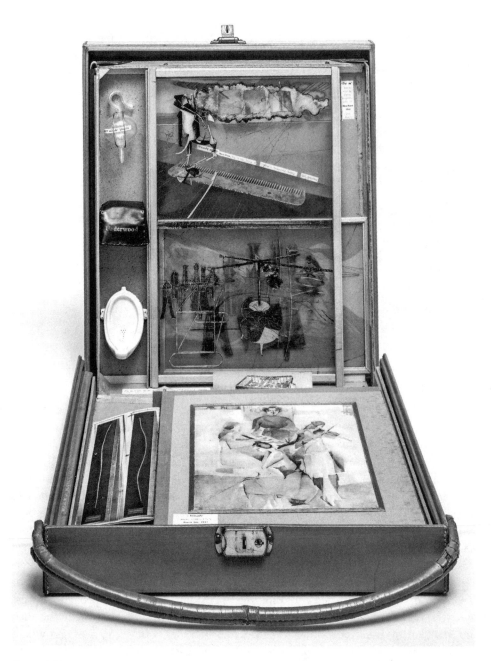

Figure 5.2
Marcel Duchamp's *La boîte-en-valise* (*The Box in a Valise,* 1941). © Succession Marcel Duchamp/ADAGP, Paris and DACS, London 2015. Digital Image © The Museum of Modern Art/Licensed by SCALA/Art Resource, NY.

Paris by traveling south to the town of Arcachon near Bordeaux. Duchamp then completed the work some time later in New York "after having smuggled the elements separately out of occupied France in the course of several trips which he, famously, had made armed with a cheese merchant's identity card" (Schwarz 1970, 512).

There were several editions of the work that were released in 1941 (two series, of which in the second series 10–15 of 60–75 also contained the valise); in 1958 (in natural color linen); in 1961 (in green linen); in 1963 (in dark green linen); in 1966 (in red leather) and in 1968 (in green leather) (Bonk 1989, 298–301), leading to a certain degree of variation among the different editions. Duchamp had compared the re-assemblage of his work to bodily reparation (in Demos 2002, 24), wishing for "the whole *body* of work to stay together" (in Cabanne 1971, 74; added emphasis). Thus he talked of *La boîte-en-valise* as "a box in which all my works would be collected and mounted like in a small museum, a portable museum" (in Schwarz 1970, 513). *La boîte-en-valise* epitomizes how the use of the archive as art was to become "an art in its own right" (Schaffner in Schaffner and Winzen 1998, 15). Both the paradigms of the museum and photography were said to be key to this work, providing "the twin engines of *decontextualisation*" and "*recontextualisation*" (Demos 2002, 10; original emphasis) that led to the constitution of "a new kind of complex artistic structure," or genre, which was "capable of addressing the complicated and interrelated developments of modernist, institutional, and geopolitical dislocation" (p. 10). This structure was the archive, which was subsequently identified as both a storage and an ordering system, but also as a critique and even opposition to prevailing forms of discourse, which the archive itself had hitherto represented.

La boîte-en-valise marks a turn in artistic practice. Addressing Andrè Malraux's own response to Walter Benjamin's seminal work on art and mechanical reproduction (1936) in which Malraux theorized a post-architectural "museum without walls" (1949), *La boîte-en-valise,* as we have seen, presented miniature copies of otherwise displaced works as an ordering system that ensured the artist's vision about their aesthetic relationship to each other, and related system of value, was to last over time. In fact, prior to developing *La boîte-en-valise,* Duchamp had created *La Mariée mise à nu par ses célibataires, Même (Boîte verte)* (*The Bride Stripped Bare by Her Bachelors, Even (The Green Box)*, 1934), which was also issued in editions. These consisted of three hundred boxes covered in green felt that contained ninety-four notes made between 1911 and 1923. The notes extended the meanings of Duchamp's artworks by providing additional concepts and so, to some extent, operating as finding tools. Together, *La boîte-en-valise* and *The Green Box* therefore constitute Duchamp's wider opus and its finding aid, the museum and its interpretation, which, however, unlike in the case of the cabinets of curiosity, remain displaced from one another, and do not coincide with each other, or with Duchamp's actual lifework. The artistic control Duchamp aimed to exert over his *opus* through *La boîte-en-valise* and *The Green Box* was therefore not over interpretation of one through the other but rather over the impossibility of juxtaposing one with the other. In a 1957 interview, Duchamp had in fact indicated that for him "[i]t is the *viewers* who make the pictures" (in Bonk 1989, 179; original emphasis), concluding also, in a talk held the same

year, that "the creative act is not performed by the artist alone; the spectator brings the work in contact with the external world by deciphering and interpreting its inner qualifications and thus adds his contribution to the creative act" (p. 179). Hence *La boîte-en-valise*, in its attempt to operate as a collection, an archive, but also as an artwork and as a museum, introduced a time-based, participatory, dimension to the work that brought the viewers into the orbit of object's aesthetics and empowered them with the responsibility of ownership and subsequent knowledge and value generation. With this work, the archive, however fallible, no longer reducible to catalog, became an instrument not only for preservation and exhibition, or storage and production, but also for framing the everyday as art, facilitating the (re-) enactment of the processes at stake in the emergence of knowledge through art, which, in this case, were rendered explicit through the figure evoked by the title of the work, that of an artwork made of a set of artworks that are located inside a box that is placed inside a valise.

Another artist who utilized an archival ordering system as part of his aesthetic was Robert Morris. His *Card File: July 11–December 31, 1962* (1962), consisted of an industrially produced, hand-operated Cardex file with a layered arrangement including headings such as "Categories," "Change," "Delays," "Future," "Interruptions," "Mistakes," "Possibilities," and "Time" (see figure 5.3). The work is mounted vertically through alphabetically indexed cards, which record the processes involved in the making of the work. For Sven Spieker, its individual pages "reflect the process of its own production" (2008, 12). What for Duchamp had remained distinct works (*La boîte-en-valise* and *The Green Box*) are here synthesized in one system. In this sense, Spieker points out, "*Card File* is as much an archive as it is a self-referential guide for the production of art" so that, for example, the pages marked "errors" list orthographic

Figure 5.3
Robert Morris. *Card File: July 11–December 31, 1962*. © ARS, NY and DACS, London 2015. Photo Philippe Migeat. Musee National d'Art Moderne. © CNAC/MNAM/Dist. RMN-Grand Palais /Art Resource, NY.

mistakes made on other pages (p. 13). In fact *Card File* adopts archival strategies to make visible processes of conception, creativity, and knowledge generation. For Spieker, this links the work to both the 18th-century efforts to establish archival order on the basis of language and the 19th-century critique of that attempt, with the work using archeological layering and preservation of process as well as language for formal classification (p. 13). Hence *Card File*, moving on from the *La boîte-en-valise*, operates as a tautological, "self-referential guide for the production of art" (p. 13), acting at once as an artwork, an archive, a system of (value) production, and its own critique. In other words, *Card File* creates its own language, space, and time, and as Marcia Tucker noted at the time of its exhibition at the Whitney, it is therefore "involved with its own act of becoming. Each entry, an exacting and specific reference to the making of the piece, is cross-referenced, and its own process becomes, finally, the whole" (1970). Even the archive's failure to archive everything, its "Delays" and "Mistakes," became part of the apparatus of the archive.

Card File was said to be "constitutive for the beginning of Conceptual Art in the American context" by anticipating three questions to do with the displacement of traditional forms of mark-making through recording and documentation; the transformation of the legacy of Duchamp, including, I would say, his position on archiving in *La boîte-en-valise*; and what has been described as "the radical dismantling of all traditional definitions of objects and categories" (Buchloh et al. 1994, 127). Crucially, as noted by Alexander Alberro, *Card File* created a "highly participatory model" (in Buchloh et al. 1994, 131), constituting a new type of artwork, which in its archival operation, functions both in terms of pre- and post-production (Foster 2004, 5), placing the user no longer just as a viewer, but as performer in the middle of this time-based process. Like *La boîte-en-valise, Card File* is as much about this process of persistence of the apparatus of the archive, and the epistemological confines created by its archival logic, as it is a work of art.

A number of artists experimented with the archive as a form of time-based art. For example, Andy Warhol's *Time Capsules* (1975) are a serial work consisting of six-hundred-and-ten standard-sized cardboard boxes, each containing around two hundred objects, that document the life of the artist, with the intent of "drowning the speculator in details of little or no importance" (Schaffner in Schaffner and Winzen 1998, 19). For Warhol these boxes, collected over twelve years but containing materials spanning between 1960 and 1987, were "an extension of the drawers in his desk," containing paperwork that included ephemera as diverse as dinner invitations, personal correspondence, toenail clippings, unused condoms, unseen artworks, dead bees, business records, photos, garbage, bills, and personal mementos such as Warhol's hospital bracelet from the 1968 shooting, fan letters, a pair of shoes that once belonged to the actor Clark Gable, silverware from an Air France flight, cans of soup, soiled clothing, raw pizza dough, some of his mother's clothes and a letter from Alfred Barr turning down his offer to donate one of his shoe drawings to the Museum of Modern Art in New York (see figure 5.4). Interestingly, as suggested by Ronald Jones, what is missing from the files is sometimes just as interesting as what is included, so, for example, Time Capsule

Figure 5.4
Andy Warhol's *Time Capsules* (1975). © 2015 The Andy Warhol Foundation for the Visual Arts, Inc. / Artists Rights Society (ARS), New York, and DACS, London.

21 contains a page from an issue of *Life Magazine* commemorating John Fitzgerald Kennedy's funeral from which the head of Jackie Kennedy was cut out (2014).

Warhol, who, interestingly, owned two copies of Duchamp's *Boite-en-valise*, a first edition from 1941 and a later edition from 1958, had become interested in using archival strategies for storage shortly after moving studios in 1974. Unlike Duchmap though, who included only his own opus in the *Boite-en-valise*, Warhol selected primarily objects from his daily life. These were chosen over time and placed in a cardboard box by his desk. There was seemingly no curatorial order to the placing of objects in specific boxes. Once each box was full, it entered the archive and became part of the work of art. Described as his "most extensive, complex and personal work" (Smith 2005), the *Time Capsules* were opened in 2011 as an act of performance, on a stage, in front of an audience, years after his death. Upon opening some of them, it was noted that the organic content of the capsules had become infested with at least three types of beetles (Morgan and Jacobs 2014). Warhol, of course, like the creator of the mummies of the "papyrus enriched" holy crocodiles in Egyptian Tebtunis, which included a "classification of papyri according to crocodiles" (Posner 1972, 5), may well have anticipated the possible deterioration of his work and so considered this contamination of its content as part of the artwork itself.

Throughout the 20th century, growing numbers of artists created artworks that adopted archival strategies, including time capsules, to exhibit found objects and media, and, in the process of it, generate hybrid works that can also be described as collections and archives. For Hal Foster, such artists often utilized archives as a form of "capitalist garbage bucket" (2004, 6) in the sense that they extracted value through the accumulation of found objects. These works often offer glimpses into the global economic processes that the archive in also part of. I have already mentioned Kabakov's *Sixteen Ropes*. Another such artist is Thomas Hirschhorn, who creates altar-like displays to exhibit images and texts commemorating cultural figures such as artists Otto Freundlich, Ingeborg Bachmann, and Raymond Carver. A memory artist, like Liebeskind, whose Jewish Museum in Berlin I discussed in chapter 3, Hirschhorn created, on the one hand, a number of monuments that reference the work of philosophers such as Spinoza, Bataille, Gramsci, and Deleuze. These, called by Hirschhorn pavilions, were frequently placed on "found" commemorative sites (in Buchloh 2001, 45) such as the U-Bahnhof Berlin Alexanderplatz (*Ingeborg Bachmann-Altar*, 2006) or a tower block in Glasgow (*Raymond Carver-Altar*, 2000). His *Very Derivative Products* (1999), on the other hand, consisted of a series of little red rags attached to the serial lineup of domestic fans whose propulsion gave motion to the exhibit. This particular form of stringing, for Benjamin Buchloh, constituted a grotesque dialectics that gave viewers "a sudden insight into the conditions and consequences of the present"; here, for him, "a totalising *atopia* flared up with even greater menace" (2001, 54; original emphasis). The filing system in this work therefore visualized the problematics raised by the collapse of various stages of production into one, showing phases of production that in all likelihood occurred in a third-world country and its distribution in the first, and so moving "from the production of exchange-value to a brief performance of use-value, and its imminent dismissal as detritus in ever decreasing temporal cycles" (p. 55).

Other artists who have created work as collectors include Nam June Paik and Karsten Bott. Paik, in his *Box for Zen (Serenade)* (1963), for example, brought together into an old suitcase artifacts that included electronic circuit diagrams, cords, diagrams, wires, a book with a Japanese title, some English magazines, a phonograph record, and the artist's signature on the inside of the suitcase lid. In contrast, Karsten Bott, in his *Von Jedem Eins* (*One Of Each*, 2011), exhibited his collection of 300,000 objects, one of each object encountered in everyday life, including surgical stockings, feathers, wage sheets, plastic bags, forming structures that are architectures, such as the kitchen, the bedroom, the garden shed, that audiences, maintaining, unusually, an almost cartographic view, were able to walk over (see figure 5.5). For Bott, archiving constitutes a life-long project, so his website, for example, under the heading "archive," draws attention to the fact that he intends, in "An Archive of the History of the Contemporary," to gather all the things people need in their everyday life that are usually neglected by museums and archives. Here, unlike in Warhol's *Time Capsules*, each object is cataloged according to different uses, so that, for example, an old pair of patched trousers can appear under texture/trousers, clothes/trousers, social class/worker/trousers, craft/knitting/trousers, and so forth, and find itself exhibited in other groups, each time in combination with different objects (Bott 2014).

Figure 5.5
Karsten Bott, in his *Von Jedem Eins* (*One of Each*, 2011). Photo Erik Staub. Courtesy Karsten Bott.

Like Warhol, Bay area art group Ant Farm also created a number of *Time Capsules* (see figure 5.6) primarily, but not exclusively, developed between 1969 and 1975. The first capsule consisted of a cardboard box, which the company sent to the Paris Biennial and which was filled with Texan souvenirs. Another capsule was a fridge-like box filled with objects bought in a supermarket, including, as in Warhol's case, perishable food and medicines. A *Texas Observer* article published at the time of the opening of the contemporary Art Museum in Houston in 1972, which commissioned the capsule, described the piece as follows: "video tapes of dignitaries and over-dressed guests, plus 'real images' of supermarkets, freeways and Laundromats, the 'real life' of Houston during opening week … edited, compiled and sealed in a refrigerated container" that, as in a cabinet of curiosity, was to be suspended from the gallery ceiling (in Scott 2008, 228). The opening had been planned for 1984, but the box was damaged following a flood at the museum. In their piece *Citizen Time Capsule* (1975), however, a 1968 Oldsmobile Vistacruiser, was packed with thirty suitcases filled with articles and images donated to the company by members of the Niagara Frontier community that were associated with the idea of a journey (p. 285), again, communicating values of the past to people in the year 2000. This capsule was buried in the Artpark in Lewinston, New York, to be subsequently unearthed. In this case the categories included again food, but also sport,

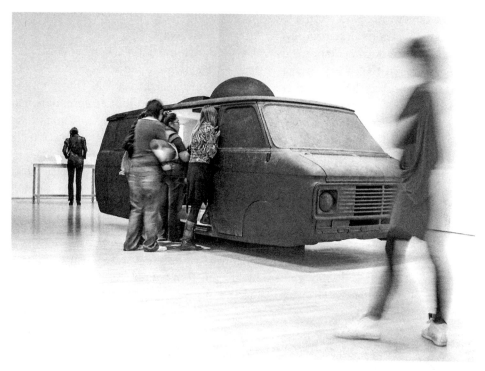

Figure 5.6

Ant Farm Media Van v. 08 (Time Capsule) installed at SFMOMA in the exhibition "The Art of Participation: 1950 to Now," 2008 Rudolf Frieling, Curator.

media, religion, politics, nature, weapons, tools, diaries, and scrapbooks (p. 287). *Media Van* (1971), a "documentation project" inspired in part by Robert Frank's *Americans* (Lord 2015), was a customized Chevy van with a bubble skylight used for videotaping the roads traversed by the company while on tour with the intention to "document everything" (Lord 2015). The artists had felt that "the roadside environment was changing fast and deserved practice documentation of the motels and cheap restaurants, road-side attractions, gas stations, and gift shops that made route 66 so junky and important in the fifties" (Frieling et al. 2009, 136).

Ant Farm's *Time Capsules* were part cabinets of curiosity, part archives, part artworks, part manifestos, part political programs, part surveillance tools. Their 1971 *Truckstop Network Tour,* for example, included the documentation of American roadside culture referred to as Vacancy M or Vacancy ooM through the modeling of an on-the-road pedagogical educational system that was to include the proposal for using Greyhound buses as an infrastructure, a Truckstop Tour across the country in the Media Van that included various stops for "information exchange," the production and playback of a number of Truckstop videos, the development of mobile hardware, the design of individual Truckstop nodes, and the articulation of

the nodes into a network spanning the United States (Scott 2008, 164). The Media Van was in this case not only a form of transportation, "it was an elaborate surveillance and feedback device, a tool of 'total documentation'" (p. 99), a self-sustaining mobile archival apparatus. The van, a customized 1972 Chevy, was described as "a closed life-support system" (p. 99), designed as the company's "own brand of nomadism" (Lord in Scott 2008, 224).

In 2008 San Francisco MOMA, as part of the *Art of Participation* exhibition, commissioned Lord and Schreier, alongside Bruce Tomb, to revisit this project by creating *Ant Farm Media Van. v. 08 (Time Capsule)*. The work was both an update and homage to the original Media Van and consisted of the conversion of a 1972 Chevy C10 van into a time capsule that combined analog and digital and whose interior consisted of a media hub showing Ant Farm videos and a slide show, including an interactive map, of the 1971 journey that was projected on both sides of the back window of the vehicle, thus allowing visitors outside the van to see the action as well. The console, which had been nicknamed "Media hookah," included an interface that allowed visitors to plug in their cell phones or equivalent to upload images, videos, and songs into the van's hard drive (see figure 5.7). The van was then sealed and was due to be reopened only in 2030 though because, the museum did not acquire the piece, it is not as yet clear whether there will be an actual reopening event. The piece was subsequently

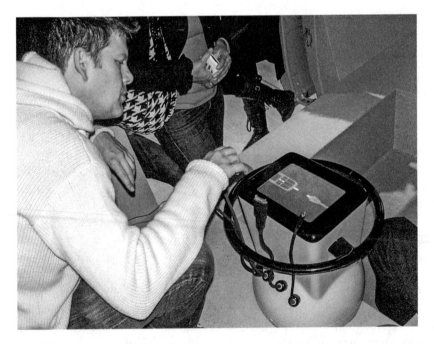

Figure 5.7
Ant Farm Media Van v. 08 (Time Capsule) installed at SFMOMA in the exhibition "The Art of Participation: 1950 to Now," 2008 Rudolf Frieling, Curator. Interior detail of the Media Huqquh showing the user interface and an active user connecting his iPhone (SFMOMA exhibition, 2008).

exhibited at three other locations (and capsules were produced for each of these locations) in Nantes, Frances, Lincoln, Massachusetts, and the ASU Museum, Tempe Arizona. Further editioned outputs of each capsule were also produced, with thumbnail images displayed between the two channels of video (Lord 2015). As in the case of Duchamp's *La boîte-en-valise*, the additional capsules, as well as these editioned outputs, constitute a multiplication, and yet a variation, of the work that exists as an apparatus with multiple outputs, showing its transformation at different moments in time and space.

We know that the potentiality of utterance the archive affords is a direct consequence as to whether the user takes on the role of witness. The archive is where we bear witness to our encounter with the remains of history. It is not a space of neutrality where the subject is put into parenthesis, rather it is where the subject takes on the act of remembering and acknowledges the problematics that their own subject positioning entails in the historicization of the present and its narration and documentation as part of a future history. Among the artists who have used archives as an act of politics is the "fictional" collective Atlas Group, which was established in 1999 to research, document, and archive the contemporary history of Lebanon, including notebooks, films, videotapes, photographs and other projects. To engage the public, installations, single channel screenings, lecture/performances, and literary essays were produced by Walid Raad. Among his works are a series of books and a fictional collection, allegedly, of Dr Fakhouri's found notebook reports on Lebanon's fourteen-year war. In 2009, *The Atlas Group (1989–2004)* exhibition, which opened at the Reina Sofia in Madrid, overtly aimed to research and document the contemporary history of Lebanon, specifically the years between 1975 and 1991. The exhibition, consisting of installations, videos, and photographs, intended to draw awareness to the various ways in which contemporary Lebanese history is told, organized, and possibly, frequently, manipulated. The materials were curated under three categories: documents with known sources, documents without known sources, and documents created by the Atlas Group. These are conventionally based on memories, but they also draw from "cultural fantasies constructed from collective memories," including, allegedly, "a series of photos showing the remains of car engines cast far and wide by explosives, a list of countries that sold weapons to the combatants, a video of townspeople watching bombs fall from the sky, notes from soldiers to their loved ones" (Gladstone 2009). Walid Ra'ad points out that "[t]he truth of the documents we archive/collect does not depend for us on their factual accuracy" for the "theoretical primacy of facts must be challenged," and so "facts have to be treated as processes" in that "what we have are objects and stories that should not be examined through the conventional but reductive binary, fiction and non-fiction." For the company therefore, "the Lebanese Civil War" should not be considered as "a settled chronology of events, dates, personalities, massacres, invasions," but rather "as an abstraction constituted by various discourses and, more importantly, by various modes of assimilating the data in the world" (in Merewether 2006, 179). For them, documents constitute "hysterical symptoms" based "not on any one person's actual memories but on cultural fantasies erected from the material of collective memories" (p. 179).

I have shown how artists have utilized archiving strategies for the creation, display, and preservation of their works. In the case of Duchamp's *La boîte-en-valise* his entire body of work was miniaturized, organized and codified into a portable archival system. *La boîte-en-valise* showed how archival art could act as mobile, portable museums. Morris's *Card File: July 11–December 31, 1962,* utilized archival methods to draw attention to processes involving the work's own becoming that included the viewer within the work of art. *Card File* showed how archival art problematizes temporality by shifting attention from the product to the process, and so the performativity, of art. Warhol's *Time Capsules* (1975) attempted to frame the everyday as art. The *Time Capsules* show how these particular kinds of archives can act as archeological sites. Ant Farm aimed to preserve roadside culture by combining politics and art in the *topos* of the archive. Finally, the work of the Atlas Group problematizes the claim to truthfulness of the archive. For the Atlas Group, documents become symptoms of the politics of contemporary society.

Foster famously described some of these works as "unarchival," since the artists in question are, as we have seen, more often than not drawn to "unfulfilled beginnings or incomplete projects" (2004, 5). For Ernst, these art forms in fact moved beyond the *topos* of the archive (2014). Here I hope to have shown that these works do use the apparatus of the archive as a way to frame found objects and environments and establish a relation, or present, between them and the viewer. Like the cabinets of curiosity, these works attempt to create knowledge maps that facilitate and at the same time exhibit epistemological as well as phenomenological orientation between subjects and objects. In turn, their influence on archives has been the recognition that aesthetics, gameful design and creativity, as we have seen in the case of ArtMaps (using the Tate archives), Placeify (using the archives of a number of museums and heritage organizations), and *Life Squared* (using Hershman Leeson's archives at Stanford University), for example, can constitute significant strategies not only for re-interpreting archival materials but also for engaging publics with the creation and co-curation of archival materials. This renewed understanding of archives as environments that are both past- and future-facing, where users can produce and reproduce knowledge, marked a fundamental shift in what we understand archives to be. This shift is evidenced by the fact that archives, increasingly, invite artists to work in the archive, and vice versa, ask of archivists to adopt processes of curation to share archival materials. This was, for example, the case of the Artists in the Archive conference organized by the National Archives in Wiltshire (2013), which developed an "Art in the Archives Toolkit," containing information on how to develop art out of archives, how to engage communities through archives, and how to produce new knowledge in the process of doing so.

Citizen Archivists and the Power of Replay: The Case of sosolimited's *ReConstitution*

In the early 2010s debates shifted from whether, in the context of archiving, organizations should use social media to how they should use social media. Thus David Ferrieiro, the

Archivist of the United States of America (AOTUS), in pointing out that "access to records this century means digital access" noted that "for many people if it's not online it does not exist." To prompt access to the National Archives and Records Administration, AOTUS therefore introduced the idea of a Citizen Archivist Dashboard that would encourage the public to pitch in via social media tools on a number of projects (in Howard 2011). It was in this context that Richard Cox (2008) and subsequently Ferriero himself spoke of the role of the "Citizen Archivist," in 2008 and 2009, respectively, to define a new form of user who would help identify, digitize, and archive a nation's history through the Internet (in Howard 2011). The Dashboard was set up to encourage tagging, transcription, the editing of articles, uploading, and sharing. One well-known project associated with the Dashboard is "Transcribe Old Weather," launched by the Zooniverse citizen science consortium in 2010, which aims to make available weather data from Arctic ship logs since the mid-19th century. The transcriptions contribute to climate model predictions and aim to improve knowledge about changes in the environment. The project was also taken up in Australia, under the heading Weather Detective, to uncover the logbooks of ships that sailed the seas around Australia in the 1890s and 1900s. All these utilize minimal forms of role-play to create game contexts so as to motivate users to provide new insights into a specific field of knowledge.

Tools like Twitter, Facebook, Delicious, Instagram, and Pinterest are known to engage their users in the "archivist-like behaviors of collecting, collating, describing, and disseminating" (Schlitz 2014). These activities are nowadays considered indispensible to establish users' online presence. This explains why, increasingly, social media facilitate the archival organization and replay of data as is the case in Facebook's Timeline, which distinctively attempts to make a feature of archiving through social media by generating a summary of one's Facebook "life" since birth by using photos, videos, status updates, and locations that were visited. Users are also encouraged to add events not captured by Facebook to their Timeline, thus producing a hybrid archive of their lives. Likewise the BBC's Your Story aims to pull together elements from its own news archive, pertaining, for example, to what happened on the day one was born or what significant moments in history occurred during one's lifetime, with personal Facebook data to create a curiosity cabinet of sorts and, as the corporation's website suggests, "turn the world's timeline into your timeline." The same is true for Storify, which pulls together Facebook posts and tweets, making it possible to add context to them. Interestingly, Storify is now often adopted in politics. For example, *The Herald* in Everett, Washington, on November 2, 2010, used Storify to pull together relevant election night content from its own site and other news sites. *The Washington Post* too on October 29, 2010, used Storify to compare the tweets of two local mayors in the aftermath of a storm. Finally, Lifelogging, or Lifeblogging, is an increasingly popular phenomenon defining users who wear computers to capture as much as possible of their lives, while WebBiographers defines users of WebBiographies, a Web 2.0 legacy journaling tool that helps users write up their own life stories as a blog that can be organized as a genealogy into customizable chapters.

All these platforms confirm the appetite users have for the social authoring, self-archiving, and replay of data pertaining to their personal lives often in juxtaposition to those depicting world history. Research has shown that the use of Facebook facilitates performance in that users leave behind traces that act as digital artifacts. Their collection, in Facebook's Timeline, for example, hence produces, literally, an exhibition of identity (Zhao et al. 2013, 1). Research also suggests that social media facilitate different types of sharing, with Twitter, for example, privileging performance, and Pinterest and Instagram, the latter through its Layout program which supports the creation of photo collages, facilitate exhibition, with all of them supporting archiving (Zhao et al. 2013). Thus, broadly speaking, social media facilitate exhibition and archiving by utilizing sets of photos, lists of status updates, and situational activities like chatting (Hogan 2010). The use of the Internet for archival purposes is becoming so popular that Yuk Hui suggests that we should talk of archivists rather than Internet users as users are increasingly managing their own digital objects and data so as to create what can be described as personal archives. For Hui, institutional archives should therefore be opened up to allow for self-archiving to so that users could "download, share and annotate their own collections, and then contribute their metadata to institutional archives" (2013). We have seen how some organizations have already been moving in this direction, and a consequence of this tendency is likely to be a decentralization of archives, something, we saw in chapter 1, that has often occurred historically at times of relative sociopolitical instability.

Studies about personal archives indicate that they have an impact on the collective memory of society, documenting "how individuals remember the past, characterize community relationships in the present, and memorialize activities over time" in so far as community memory is built upon "connections between individuals." This means, as we suggested in chapter 3, that personal archives are "integral" to documenting how individuals are connected to communities (Acker and Brubaker 2014, 6) and that such archives facilitate a flow between different kinds of memories. We know, however, that social media tend to frame our ability to self-document, with Facebook, for example, not necessarily liberating personal memory, but rather "enslaving it within a corporate collective" (Garde-Hansen 2009, 136). We also know that encryption has always been associated with power, and are aware that social media shape and control their users' experiences and possibly even frame how these may be encountered in the future. As Joanne Garde-Hansen notes, nowadays, social networking sites determine how our private thoughts become memories, and define how these memories may come into public existence (2009, 137). While allegedly ensuring the security of what is posted, these sites in fact often reserve rights over the materials we post (p. 137), possibly limiting future accessibility and interaction. While it has been said that Facebook is a "database of users and for users" with "each user's page" being "a database of their life, making this social network site a collection of collections and collectives" (p. 141), it is clear that Facebook is also, and primarily so, a formidable vehicle for the propagation of the digital economy, aiming, above all, at creating capital out of knowledge about how we live. Thus data-mining is a burgeoning part in the digital economy, and social media provide a

rich territory for it. So, for example, there has been much interest in Flickr, particularly from the computer science community in determining how the growing corpus of images can be automatically searched for reuse (Kennedy et al. 2007); how people are using Flickr and its digital images to interact socially, to document their lives, to build communities (Maia, Almeida, and Almeida 2008), and how and why individuals build up their own image-based collections (Stvilia and Jörgensen 2007, 2009).

Interestingly, the affordances of social media platforms often result in what has been called "context collapse," which indicates that social media "flatten multiple audiences into one" (Marwick and Boyd 2011, 122). This is often associated with the necessity to identify categories of users so as to facilitate targeting commercial information to what may be perceived to be their needs. Facebook itself, among other such social media platforms, offers advice to businesses about how to use the platform to make their business discoverable, connected, timely and insightful, whereby the latter they mean that the Facebook analytics can offer a deeper understanding of potential customers for marketing purposes. So we learn that friendships act as adverting campaigns in that users are more likely to purchase something if their friends do, and that the Timeline, which includes formats for administrators of brand pages, can be particularly significant for building a strong visual impression on visitors, something, again, that is perceived to have a positive impact on sales. The Queensland government, for example, has a page offering tips for successful marketing through Facebook, suggesting that Facebook should not be used for "hard sell," and because users regard Facebook "as a fun social space where they chat to friends, check out photos and videos, and relax," businesses should attempt to join conversations and become part of a community (Queensland government 2014).

An art company that has been experimenting with the potential of data mining and their replay in a political context is sosolimited, an art and technology studio founded in 2003 by Justin Manor, John Rothenberg, and Eric Gunther based in Boston and San Diego, operating at the boundary of art, design, experience, and information. Since its inception, the company has been utilizing data visualization and information design as an artistic medium, focusing on the live transformation of broadcast media. One well-known example is *ReConstitution* (2004–12), which comprises three award-winning live remixes of the US Presidential Debates that took place in 2004, 2008, and 2012, incorporating elements of dynamic typography, video manipulation, computer vision, sensor technologies, and sound design. For *ReConstitution*, sosolimited teamed up with The Creators Project, with Vice and Intel, Tim Branyen, and Bocoup, and for the language analysis, Cindy Chung and James Pennebaker from the Department of Psychology at the University of Texas at Austin.

ReConstitution 2004 was a three-part live audiovisual remix of the 2004 presidential debates, which was described on sosolimited's website as a hybrid of video art and public service, aiming to represent "a shift away from the polarized manner in which people approach political artwork." For the remix, the company designed a piece of software that allowed them to sample the television broadcast of the presidential debates in real time, extract the

Figure 5.8
ReConstitution 2008. Courtesy sosolimited.

video, audio, and closed captioned text, which was then be transformed, analyzed, and reassembled for a projection onto a large screen. Though parts of the broadcast were obscured, others were highlighted and analyzed, and in all cases the information contained in the television signal was augmented through this process though a "clean version of the candidate's voices was always present in the audio mix, so as to maintain the 'legibility of the debates'" (2015).

ReConstitution 2008 was a live remix of the 2008 US presidential debates, performed in Boston, New York, and Washington, DC, by the company wearing black suits and sunglasses, looking "like Kraftwerks, omniscient news anchors, or FBI agents (Mancuso)," to an audience of over 1500 people (see figure 5.8). For this work the company used software that could analyze the spoken words, gesticulation, and cadence of the candidates throughout the debates, so that statistics on their language, movements, and emotional state could be presented alongside the live broadcast. Ben Sisario described how "as the candidates spoke, brightly colored columns of type floated across the screen, zipped from side to side and broke apart to form complex shapes, like molecular models" (2008). The software picked up, for example, how many times the candidates used the word "finance" or their favorite pronouns. While in sport commentators often use playback, where such statistics are flashed up on the screen,

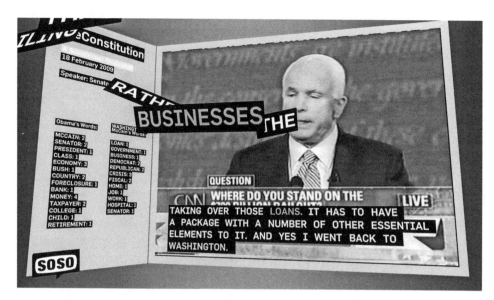

Figure 5.9
ReConstitution 2008. Courtesy sosolimited.

Gunther notes, "[w]e do a similar thing here, but more along the lines of language. You're watching these words getting cataloged as they're coming out of their mouths' (in Sisario 2008).

What is on show here is the operation of what Derrida called the *"archiving* archive" (1996, 16–17; original emphasis), and its creation of a spectacle of the making of order out of chaos. sosolimited's work exposes the layers, stratigraphies, even of the mediations that take place between the viewer and the candidates. By using broadcast's closed caption feed to draw words that are then sorted and rearranged, they spectacularize the creation of meaning that is at the heart of the apparatus of the digital archive: "We have a list of topics and key-words that we expect the candidates to talk about that was culled from their Web sites, said company member Rothenberg, [t]hen we look at all the instances of a keyword, like health care, jobs, weapons. And spending—spending was a big one in the first debate" (in Sisario 2008) (see figure 5.9).

ReConstitution 2012, described as "part data visualization, part experimental typography," was a live web app that linked to the 2012 US presidential debates. During and after the debates, language used by the candidates generated a live graphical map of the events, with algorithms tracking the psychological states of the two candidates Mitt Romney and Barack Obama. These were then compared to those of past candidates in US presidential elections. For the company, the app allowed users "to get beyond the punditry and discover the hidden meaning in the words chosen by the candidates" (2015) (see figure 5.10). Technically, the

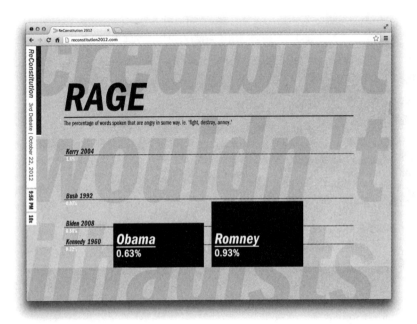

Figure 5.10
ReConstitution 2012. Courtesy sosolimited.

app received the text of the debate from the server, and constructed "an animated layout" of the transcript in users' browser windows. The server used several language processing libraries to analyze and tag the captioned text, which was sent to it by an application connected to a live cable feed, running in the sosolimited studio. For the company "much of the 'liveness of [their] performances' originates 'in the immediacy of the source material.'" Through a "real-time appropriation" (in Mancuso). In this piece they aimed to introduce "memory and meaningful analysis into the signal" and add "some layers of history and logical rules as to how the signal was 'transformed' to generate new meaning that was previously hidden" (in Mancuso). *ReConstitution,* sosolimited note, can be viewed as a data-rich companion of the televised debates, or as a stand-alone experience. During the debates, the live transcript is streamed to the app and drives a number of graphical modes. Key moments trigger graphical annotations on top of the transcript pointing out the mood of the candidate. Repeated phrases and buzzwords are also called out. Users can then analyze the transcript and investigate the various analytical layers that form the work. By touching the name of either candidate, users can also switch to a comparison view, where they can track the candidates in head-to-head metrics so that "language processing algorithms expose the psychological state of each candidate, showing for example, how deceptively each one is speaking, and how

they compare to past candidates." This live analysis of data shows how the apparatus of the archive can become a spectacle in its own right.

In 2010 sosolimited created *The Long Conversation,* the replay of a nine-hour event that took place during the Transmediale Festival in Berlin at the Haus der Kulteren der Welt. The performance by sosolimited occurred in parallel with the "Futurity Long Conversation," which was a nine-hour debate involving 21 speakers in an auditorium. There were two speakers on stage at any given time, with one of them being replaced by another every 20 minutes. On a separate stage located at the opposite end of the venue, the team had typists transcribing in real time the words of all the artists, designers, academics and authors who were speaking, and sending the text streams to the analysis software. The visualizations of the conversations, which were projected on the screen behind the typists, soon proved to be more popular than the Futurity Long Conversation itself. The words of all the participants were in fact matched to lexical databases, and sorted by topic, tense, and certitude, providing analyses of each contribution as well as meta-analyses of all the speakers' contributions in relation to each other on the go. Yet again the spectacle offered by making visible the operation of the apparatus of the archive proved to be an insightful and aesthetically powerful spectacle.

In conclusion, we saw how cabinets of curiosity operated as media between forms and processes, acting as precursors for 20th- and 21st-century archival art. In this context, we saw how artists started to work as collectors, curators, and archivists, creating an appetite for the exhibition of autobiographical data that then affected how we choose to gather and present data about ourselves, for example, through social media. We looked at a number of artists whose practices could be described as archival. We saw how Duchamp crated miniature replicas of his entire opus, which he then framed within a mobile exhibition "space" in *La boîte-en-valise* (1941). We also saw how Morris utilized a "quasi-archeological arrangement" in *Card File: July 11–December 31, 1962,* that included the possibility of its own becoming (Spieker 2008, 12). We looked at Warhol's archivization of his everyday life in *Time Capsules* (1975) and Ant Farm's endeavors to preserve a vanishing landscape, inclusive of its social history, in *Truckstop Network Dossier* (1970) and *Citizen Time Capsule* (1975–2000). Finally, we looked at sosolimited's live performance and exhibition of constantly shifting meaning-making processes in *ReConstitution* (2004–12).

We know that in the aftermath of the Holocaust, our obsession with the necessity to remember weakened the boundaries between museums, memorials, and monuments, rendering them somewhat "fluid"(Huyssen in Young 1994, 12) and, possibly, interchangeable. Here, I have shown how this fluidity and interchangeability affected the way we document our everyday lives through social media and how these in turn curate the data we capture into stories often connecting objects, practices, and subjects with diverse epistemological and phenomenological discourses. Just as the curiosity cabinet was a precursor to a number of contemporary art practices that can be described as archival, it was also a precursor to our obsession with self-archiving through social media. Our average Facebook profiles disclose our preferences for art, nature, technological innovation, politics, friends, families,

and loved ones, while also connecting us to the broader knowledge system of the apparatus of the archive. Archival art, in turn, affected our appetite for viewing or even participating in meaning-making processes, from the ones available through social media, to crowdsourcing, and even, as we will see in the next chapter, those operating at the level of biopolitics. We have seen that archives are persistent, pervasive, and transformative; that they operate as stratigraphies and memory theaters; and that they are apparatuses with a potential for transformation. Now we have also established that they do not only frame, preserve, and disseminate but also, increasingly, aestheticize our lives. Archives are what we use to perform our relationships with everything as we continue to search for the yet unlived in and around us. What enters the archive becomes part of the process of our becoming.

6 (A)live Archives

Historically, we have seen, archives tended to be ordered according to the principle of provenance, which was introduced at the Privy State Archive in Berlin in 1881. The principle of provenance stipulated that archival files had to be arranged "in strict accordance with the order in which they had accumulated in the place where they had originated *before* being transferred to the archive" (Spieker 2008, 17; original emphasis). According to the principle of provenance filed materials should be "oriented topographically rather than semantically," so that a given archive would collect "not what exists in an extra-archival outside but what has already been collected, arranged, and organized *in another place*" (17; original emphasis). Records kept in this kind of archive thus referred users "back to the conditions under which they emerged (in the other place)." In this sense, we learn from Spieker, the 19th-century archive was akin to a body, built through a precise "anatomy" (p. 20), and aimed to reconstruct "the formal (administrative) and technical conditions for its emergence" (p. 18). Because of this, "every single administrative registry [became] an *organism* in and of itself, with its own vital principle" (Meineke in Spieker 2008, 20; added emphasis). Artists have often explored, as we saw in chapters 1 and 5, the use of the archive as an object or site, or even as an ordering system through which to frame the every day. In this chapter we look at how artists used the body as an archive. We also explore how, in what has been described as the Internet of Things, both bodies and objects became smart through the acquisition of knowledge that turns them into (a)live archives. The premise on which these (a)live archives are built is based on a performative and post-human model of the body, that is a body which is networked, distributed, augmented, hybrid and under constant surveillance (Giannachi 2007). Theoretical points of influence in this chapter are studies in performance documentation (Taylor 2003; Lepecki 2010; Jones 2012), database aesthetics (Vesna 2007), the digital economy (Negroponte 1995; Rifkin 2000), and archiving and genomics (Senior 2011). Examples of (a)live archives included in this chapter are the Musée de la Danse's *If Tate Modern was Musée de la Danse?* (2015); George Legrady's *An Anecdoted Archive from the Cold War* (1993), *Pockets Full of Memories* (2001), and *Pockets Full of Memories II* (2003–2006); Natalie Bookchin's *Databank of the Everyday* (1996); Eduardo Kac's *Time Capsule* (1997); Christine Borland's *HeLa* (2000) and *HeLa, Hot* (2004); and Lynn Hershman Leeson's hybrid installation *The Infinity*

Engine (2014), which problematizes the very notion of what constitutes *life* in art and society today.

Embodying the Archive: Musée de la Danse *If Tate Modern was Musée de la Danse?*

As we saw in chapter 4, oral histories, rituals, and gestures are all strategic for the transmission of knowledge among communities that do not traditionally have archives or those privileging physical forms of transmission. We also saw how scholars in performance and dance studies such as Diana Taylor distinguish between the archive and the repertoire, where by the former she means "supposedly enduring materials (i.e., texts, documents, buildings, bones)," whereas by the latter she refers to the "so-called ephemeral repertoire of embodied practice/ knowledge (i.e., spoken language, dance, sports, ritual)" (2003, 19). While for Taylor the archive "sustains power" and "archival memory works across distance, over time and space" (2003, 19), the repertoire, she states, "requires presence" because "people participate in the production and reproduction of knowledge by 'being there,' being part of the transmission" (p. 20). We further saw how Amelia Jones notes that the "living body is just as mediated as the 'body' of the archive, itself never fixed in meaning or static," which means that we should avoid the creation of a binary opposition between an "authentic" live body and the "secondary" archive, and instead note that the body becomes "archival" and the archive should be thought of as "embodied" (2012, p. 118).

An example of an embodied archive seen in performance was Musée de la Danse's *If Tate Modern was Musée de la Danse?* (2015) in which Tate Modern, for a period of 48 hours became the Musée de la Danse with the help of 90 dancers. In this work, "[t]he medium that occupies the thinnest boundary between art and life" (Wood 2010, 1) was literally embedded within the Tate infrastructure. For Musée de la Danse's lead choreographer, Boris Charmatz, dance is in fact akin to "wearing 'glasses'" with a "corrective function," making it possible for one kind of institution to overlap with another—the museum acting as a form of "readymade" (Wood 2014), or "framing device for dance" (Wood and Perrot 2014). With the intention of changing "the viewing behavior of visitors," the Musée de la Danse inhabited Tate so that its visitors would be able "to reconsider the museum as a space filled with potential" (2015).

If Tate Modern was Musée de la Danse? comprised the setting up of different areas of activity or stages within the museum that included what was described as a "permanent theater" in the Turbine Hall forming a centerpiece to showcase choreographic work by Charmatz; "permanent dissemination," the space of transmission, also featuring the Turbine Hall as a teaching environment to familiarize visitors with movement; "permanent collection," the Tate gallery spaces used for performed interventions by dancers, often teaching what could be described as a choreographic perspective; and a "permanent dance floor," using again the Turbine Hall as a nightclub with dance being led by choreographers with the public (Wood and Perrot 2014). An appetite for the piece was created by a question spread through social

media asking of audiences to imagine what a dancing museum would look like and where it might take place.

In his practice, Charmatz seeks to create "a living museum of dance" in which "the dead will have their place, but among the living" (2009, 3). For him the bodies of the dancers are where the history of dance comes back to life. They are the site of the collection (2014). The spectators, by participating, can then carry the work into their own lives (Charmatz speaking at BMW Tate Live: Museums: Artists' Creations, May 12, 2015). The history of dance that the Musée deals with is therefore not fixed, but fluid, not situated in artifacts and documents of works, but within the bodies of dancers, participants, and spectators. In this sense the Dancing Museum is "built by the bodies moving through it" (Charmatz 2009).

In the Turbine Hall the sequence, which lasted ten hours, was as follows: À bras-le-corps (1993), an investigation into personal space and proximity choreographed and performed by Charmatz and Dimitri Chamblas (see figure 6.1); Levée des conflits (2010), consisting of 25 movements performed by 24 dancers; Adrénaline, in which the Turbine Hall became a dance floor for everyone; Roman Photo performed by London-based volunteers; Adrénaline again; and finally manger (2014), exploring the action of eating. 20 Dancers for the XX Century, in which 20 dancers performed the Musée's collection, and expo zéro, in which a number of invited theorists and performers discussed, performed, or enacted their ideas of what a museum of dance could be, lasted five hours and took place throughout the collection galleries at levels 2, 3, and 4.

Levée des conflits was described as "a sculpture that one can view from all sides" (Charmatz in interview with Gilles Amalvi, dossier on the work prepared by Musée de la Danse). Each dancer appeared to be caught in a movement inherited both from the dancer that preceded him or her, and transmitted to the one that followed him or her, so as to create a live archive in which every part could be seen simultaneously. Here, bodies replaced one another continuously, so that if the structure swiveled without end, the shape itself remained precariously stable (Charmatz in interview with Gilles Amalvi, dossier on the work prepared by Musée de la Danse).

In 20 Dancers for the XX Century, each of the twenty invited dancers chose an historic solo, or group of solos, from the previous century as a starting point for their work. They were then able to explore this solo through their own relationship with the work and its choreographer, combining the historic dance with their own experience. The process of creating the performances was in some ways "archeological." Thus the dancers were invited "to dig into their own corporality in order to unveil the gestures that made them," their bodies becoming multiple sites, at once "containers of works of art, exhibition and curatorial spaces" (Charmatz in Wood 2015). This "living archive" (2013) then was overlaid with the Tate collection (see figure 6.2).

Adrénaline was the space where movement was transmitted to the audience though there was also a noticeable fluidity between 20 Dancers for the XX Century, À bras-le-corps, and Levée des conflits. Participants picked up on this fluidity by commenting on twitter: "public warm

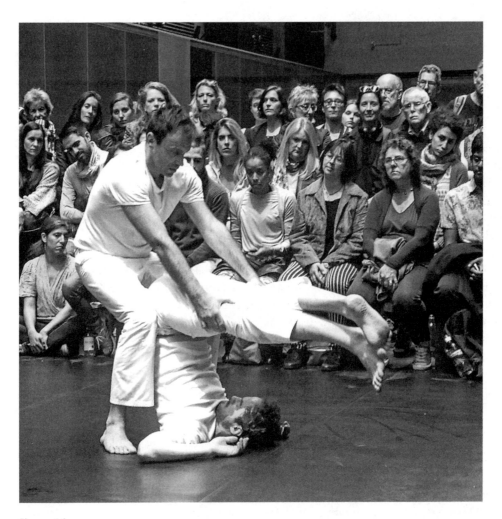

Figure 6.1
Musée de la Danse. *If Tate Modern was Musée de la Danse?* (2015). Photo Gabriella Giannachi.

Figure 6.2
Musée de la Danse. *If Tate Modern was Musée de la Danse?* (2015). Photo Gabriella Giannachi.

up with Boris Charmatz—dance class or installation"; "so interesting to see quotes from *A bras-le-corps* which came up in *Levee des conflits*" (see figure 6.3). Interestingly participants had been encouraged to take their own documentation of the work via social media or twitter, thus continuing the tradition of transmitting the work, as documentation, through different channels and media.

We saw in chapter 5 that Eileen Hooper-Greenhill suggested that the picture of the world represented by the cabinets of curiosity articulated the Renaissance episteme (1992, 84) privileging "systems of correspondences" that formed the basis for both the collection and the exposition of materials and for the "constitution of the ordering subject as both subject and object" (p. 84). We also saw that Foucault, the Renaissance *episteme*'s main characteristics were said to be interpretation and similitude (1970, 30), while the Classical *episteme* was said to be grounded in verifiable knowledge, and the Modern *episteme* saw the acknowledgment of the failure of representation (250ff). Whereas for Hooper-Greenhill the Renaissance *episteme* was grounded in relational discourse, with the cabinets representing this as a system of display of the *episteme,* during the time of the Classical episteme, records and filing systems

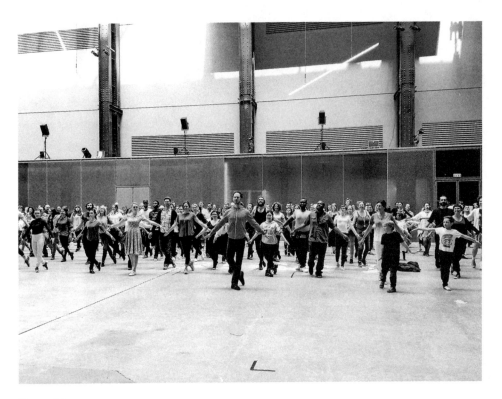

Figure 6.3
Musée de la Danse. *If Tate Modern was Musée de la Danse?* (2015). Photo Gabriella Giannachi.

became increasingly important (Hooper-Greenhill 1992, 137). Taylor suggests that perfor-mance too operates as an *episteme* (2003, 16). For her, performance is not just something that is done, but something that is known, and in being done is itself a way of knowing. As a result performers are left with a *"repertoire* of embodied practice/knowledge" (p. 19), they become the site of a history of performance, which "exceeds the archive's ability to capture it" (p. 20) because it remains live. We know, however, that the apparatus of the archive is more fluid and hybrid that Taylor's definition implies, and one could probably postulate, given also performance's raising popularity over the last fifty years, that in itself performance has also become an apparatus, therefore no longer being reducible to presence or liveness, but rather consisting of a network of intra-documents of which the live performer is only one among many others.

In response to Hal Foster's description of archives as a "pervasive concern" (2004, 3), André Lepecki introduces what he describes as a "specifically choreographic 'will to archive'" (2010, 29). Critical of Foster's suggestion that the "archival impulse" is born out of a desire to connect to "misplaced pasts" (2004, 22–23), Lepecki suggests that the archive, whether as

Figure 6.4
Musée de la Danse. *If Tate Modern was Musée de la Danse?* (2015). Photo Gabriella Giannachi.

memory or bureaucracy, "predicates, from the start, its own onto-political performance as one of endless memory 'failures'—thanks to its constitutive (and unavoidable) acts of exclusions and misplacements" (2010, 30). Jessica Santone is equally critical of Foster. For her re-enactments are performative modes of theorizing performance's relationship to the document. This echoes Rebecca Schneider's idea that re-enactments are forms of re-documentation (2001) as part of a "drive to documentation" (Santone 2008, 147). Santone also draws attention to the fact that is it not, as Foster suggests, the past that is incomplete but rather history itself (p. 147). In line with Santone, Lepecki suggests that the "will to archive" refers to "a capacity to identify in a past work still non-exhausted creative fields of 'impalpable possibilities' to use an expression from Brain Massumi" (2002, 93) so that there are "no distinctions between archive and body" precisely because the "body is archive and archive a body" (p. 31). This position is, of course, in line with Jones's comment at the beginning of this section. In conclusion then, the archive here, more than ever, is what is not as yet exhausted, what entails an as yet unlived present that can and should be embodied, so that the archive can stay alive. It is this as yet unlived present that Charmatz performs, and transmits, which

allows us to position ourselves within a choreographic history that, like Walter Benjamin's angel and Libeskind's building, stares into the accumulation of our past while being invariably projected toward an unknown future.

The Smartness of Things

We know that the archive played a critical role in the development of the scriptural economy (de Certeau 1984, x). It also played a fundamental role in each of the industrial revolutions. The first industrial revolution consisted of the introduction of mechanical production at the end of the 18th century when archives started to expand, archival practices became increasingly scientific and Lord Acton, as we saw in chapter 4, was prompted to abandon his dinner to set off at once in a carriage so as to plunder the Vatican Secret Archives. The second one led to mass production through the help of electrification in the 20th century, while the third industrial revolution, or digital revolution, started in the 1970s with the introduction of electronics and IT, leading to the automaticization of the processes of production and the introduction of mechanization and digitization of archival databases, lading to fast, easy, and open access. The fourth industrial revolution was announced in 2011 as "Industrie 4.0" by representatives from business, politics, and academe with the aim of strengthening the competitiveness of German manufacturing (Kagermann, Lukas, and Wahlster 2011). In Industry 4.0 smart products become uniquely identifiable so that they could be located at all times, know their own history, status and alternative routes to achieving their target state (p. 5). Industry 4.0 is dependent on the use of archival strategies of knowledge production for the augmentation of such objects.

Since the German federal government announced "Industrie 4.0," or Industry 4.0, as one of the key initiatives of its high-tech strategy in 2011 (Kagermann, Wahlster, and Helbig 2013, 77), numerous academic publications, practical articles, and conferences have analyzed the consequences of this phenomenon on the broader economy (Bauernhansl, Hompel, and Vogel-Heuser 2014, v). Unlike its predecessors, Industry 4.0 was in fact predicted a priori (Drath 2014, 625), which has made it possible for companies to prepare for it. The impact of Industry 4.0 promises to be revolutionary, leading to the development of new "smart" business models, services, and products (Kagermann et al. 2013, 16; Kagermann 2014, 603; Kempf 2014, 5). The apparatus of the archive is strategic for the facilitation of this new smart world.

It is well known that we have been moving from a goods-producing society to a service-performing and experience-generating economy. In this context, access to services has become increasingly significant, with technology playing a particularly important role in this respect. One distinctive feature of this process has been the reinvention of services "as long-term multifaceted relationships between servers and clients" (Rifkin 2000, 85). Whereas in the old economy the information flow of cash, checks, reports, and bills was physical, in the digital economy the information flow of data is primarily digital (Negroponte 1995). This

flow must nevertheless be integrated with the physical world. The control over the access to digital databanks and platforms and the facilitation of their interaction with the physical world is significant in this context.

The Internet of Things allows objects, such as RFID, sensors, actuators, mobile phones to interact with each other and cooperate with the smart components in their neighborhood "to reach common goals" (Giusto et al. 2010, v). One of the primary consequences of this phenomenon is an integration of knowledge with the physical world. Thus Nicholas Negroponte famously predicted that by the end of the last millennium information would be regulating most products used in everyday life:

> Your right and left cufflinks or earrings may communicate with each other by low-orbiting satellites and have more computer power than your present PC. Your telephone won't ring indiscriminately; it will receive, sort, and perhaps respond to your incoming calls like a well trained English butler. Schools will change to become more like museums and playgrounds for children to assemble ideas and socialise with children all over the world. (1995, 6)

Negroponte also predicted that products and organizations would radically change in function, that objects would become increasingly "animate" and, as we have already seen, organizations even more fluid. The archive plays a key role in this development, as it is part of the apparatus that underpins the smartness of things and so makes it possible for an object to know about its provenance and, for example, be able to tell us about its own (his)story.

We know that the digital economy is a form of knowledge economy based on "the application of human know-how to everything we produce and how we produce it" (Tapscott 1996, 7). Products, such as clothes, vehicles, fridges, maps, houses, phones, are likely to carry a knowledge content, which not only renders them "smart" (1996, 7) but has the potential to render them capable of remembering past use and modifying themselves to facilitate future use. We know that in this Internet of Things there are "knowledge workers and consumers" (1996, 44) that gear their work toward users' particular purchasing needs. The physical world has become an information system formed by networks of sensors and actuators embedded in objects that have an increasingly active role in shaping the processes of their own production and are capable of creating memory architectures pertinent to their own use. In this sense, objects will become their own archive.

The digital economy is in some ways a departure from other concepts such as Daniel Bell's information economy (1974), which describes the codification of information, and Manuel Castells's idea of a network economy (1996) that ties information and people. In fact the three main components of the digital economy are a supporting infrastructure, and e-business, and an e-commerce (Mesenbourg 2001), though social media are already proving that the digital economy is broader than this. So the digital economy is at once still a knowledge economy grounded in the production and transmission of knowledge, an information economy based on data, and a networked economy that generates an Internet of Things. For Tapscott crucial ingredients of the digital economy are virtualization and networking,

convergence and prosumption (1995). Markets have long been behaving as processes (Agnew 1986, 41) facilitating immaterial labor that is the world of information, communication, ideas, and emotional responses. This often has biopolitical repercussions in that it produces not only goods or services but life itself (Hardt and Negri 2004, 109). The digital economy rests on the apparatus of the archive not only for the embedding of intelligence or smartness into both its products and agents but also for the production of life itself.

It has been shown that to be of use in this context, archives need to facilitate access to the economy and the physical world while also continuing to provide access to archival memory (Menne-Haritz 2001, 59). To establish and maintain relationships between servers and clients it is therefore necessary "to reinvent how to connect archives with a mind, how to connect the memories in our archives with the memories in people's minds, how to make archives into people's archives" (Ketelaar 2003, 3). In this sense, as Margaret Hedstrom wrote, it is important to create archives and smart objects that facilitate an understanding of what "memory means in different contexts," building, as we have seen, a "sensitivity to the differences between individual and social memory" (Headstrom 2002, 31–32). In the next section we will see how artists have variously utilized the archive as a strategy to create environments that are at once archeological, memorial, transformational, aesthetic, and (a)live.

Database Art: George Legrady's *An Anecdoted Archive from the Cold War*, *Pockets Full of Memories* **and** *Pockets Full of Memories II*; **Natalie Bookchin's** *Databank of the Everyday*; **Eduardo Kac's** *Time Capsule*; **Christine Borland's** *HeLa* **and** *HeLa, Hot*

At the heart of the development of the apparatus of the archive in the 21st century is the database, which we know to be a "structured collection of data" organized for fast search and retrieval (Manovich in Vesna 2007, 39). As Lev Manovich has shown, creating a work in new media often consists of the production of an interface for a database, which means that the same database can produce different works through different interfaces (p. 45). Databases are therefore at the heart of the fluidity and interchangeability of the apparatus of the archive with other elements of the digital economy.

Natalie Bookchin's *Databank of the Everyday* (1996), which was originally published through CD-ROM, is a reflection on everyday uses of computers for storage, transmission, dissemination, and ordering. The loop here was said to replace photography's frozen moment and cinema's linear narrative (Manovich in Bookchin 2014). The screen is divided into two frames, one showing a video loop of a woman shaving her leg and the other a loop of a computer program in execution (see figure 6.5). As in other archival artworks seen in chapter 5, the screens document and memorialize moments in the artist's everyday life and are organized into different categories. For Bookchin, the work "reflects on what media—from photography to computers—have always attempted to do: represent, organize and catalog life into well-defined lists and categories" (in Quaranta 2011, 82). For Domenico Quaranta, works like these show that platforms like Flickr and YouTube have translated the concept of

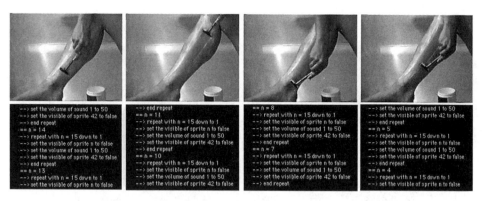

Figure 6.5
Natalie Bookchin, *Databank of the Everyday* (1996). Courtesy Natalie Bookchin.

the "*Databank of the Everyday* into powerful businesses, endless archives in which the same banal gesture, the same insignificant detail, is replicated countless time by countless users" (2011, 82). The work, described as a "conceptually infinite database of life itself in all its mundane activities" (Paul in Vesna 2007, 106), shows the potential values, including the economic values, of databases.

We have said that in the digital economy it is not only objects but also humans who are augmented. An early artwork exploring the possibilities of human databases was Eduardo Kac's *Time Capsule* (1997) where the artist implanted a bio-panoptic surveillance device in his ankle. This consisted of a microchip containing a programmed identification number integrated with a coil and a capacitator sealed in biocompatible glass. When the implant was scanned, a low energy radio signal was released that energized the microchip (see figure 6.6.). This, in turn, released a code. At some level, *Time Capsule* continues the tradition of the time capsules discussed in chapter 5, Andy Warhol's *Time Capsules* (1975) and Ant Farm's *Citizen Time Capsule* (1975–2000). But here the time capsule, the database, was the artist himself. In fact Kac had registered himself as a database for finding lost animals and classified himself as both an animal and it owner (Dietz in Vesna 2007, 114) in the area of the body tradition-ally associated with chaining or branding (Machado 1998). Typically for Kac, the work con-sisted also of the creation of a context in which the work was received. So Arlindo Machado draws attention to a number of factors that informed *Time Capsule* and yet are frequently overlooked in studies of the work, such as the conversion of the physical space at Casa das Rosas into a hospital room with surgical instruments, with an emergency ambulance parked outside in case of complications, and the use of seven original photos on the wall that con-stituted the only memories of his grandmother's family who had been exterminated during the Second World War in Poland.

Figure 6.6
Eduardo Kac, *Time Capsule* (detail), 1997. Collection BEEP, Spain. Curtesy Eduardo Kac.

At the time, a number of television companies broadcast the work which had been pro-
duced by Canal 21. The piece was seen as a warning about the dangers of surveillance and
the microchip implanted in a human body was interpreted as something that could reveal
"who we are, what we do, what kinds of products we consume, if we are in debt with the
Internal Review Service, if we are facing criminal charges, or if we are hiding from the judicial
system" (Machado 1998). The work also seemed to suggest that memories might one day be
implanted within human beings. So we are reminded that the "images, which strangely con-
textualize the event, allude to deceased individuals whom the artist never had the chance to
meet, but who were responsible for the 'implantation' in his body of the genetic traces he has
carried from childhood and that he will carry until his death" (Machado 1998).

For Kac himself *Time Capsule* "lies somewhere between a local event-installation," "a site-
specific work in which the site itself is both my body and a remote database, and a simulcast
on TV and the Web" (1997). The body, for Kac, "is traditionally seen as the sacred repository
of human-only memories, acquired as the result of genetic inheritance or personal experi-
ences." In *Time Capsule*, he notes, "the presence of the chip (with its recorded retrievable
data) inside the body forces us to consider the co-presence of lived memories and artificial
memories within us" (1997). For Christiane Paul *Time Capsules* draws attention to "the way

our data bodies become subject to the classification and ultimately the control of innumerable databases that are beyond our corporeal reach" (in Vesna 2007, 115). Here not only do "[e]xternal memories become implants in the body" (Kac in Vesna 2007, 257) but also the body becomes interconnected to the Internet of Things, at once artist and artwork, input and output, subjective and communal memory. As Kac suggests, the presence of the chip forces us to consider *all* artificial memories that are as yet unlived, unrecognized, within us.

Kac famously experimented with transgenetic art in his subsequent piece *GFP Bunny* (2000):

> My trangenetic artwork "GFP Bunny" comprises the creation of a green fluorescent rabbit (named *Alba*), its social integration, and its ensuing public debate. GFP stands for green fluorescent protein. (in Kostic and Dobrila 2000, 101)

The piece entailed the creation and exhibition of a fluorescent rabbit. Thus *GFP Bunny* consisted of both the rabbit and the public debate. The piece in fact, Kac suggests, was meant to stimulate a debate on the notions of "normalcy, heterogeneity, purity, hybridity and otherness" (in Kostic and Dobrila 2000, 102) while also showing "consideration for a non-semiotic notion of communication as the sharing of genetic material across cognitive life of transgenetic animals" (102). This intended to generate "public respect and appreciation for the emotional and cognitive life of transgenetic animals" while also offering an "expansion of the present practical and conceptual boundaries of artmaking to incorporate life invention" (102).

GFP Bunny is a complex and multi-layered piece. The GFP is a green fluorescent protein isolated from Pacific Northwest jellyfish that emits a bright green light when exposed to UV or blue light (Kac in Stocker and Schöpf 1999, 289). The rabbit, Alba, constitutes a new species in that she was inserted with the jellyfish gene, and so although she is completely white, she glows when illuminated in a certain light (Kac in Kostic and Dobrila 2000, 102). Lori Andrews explains that Kac had transformed the exhibition space in Avignon, where the piece was meant to take place, into a "cosy living room" that included a couch where Kac could live with Alba for a week in order to convey the idea "that biotechnologies are on their way to entering our lives at the most basic level: in our private homes." At the last minute however, the director of the institute that had created Alba refused to release her for the exhibition (Andrews in Kac, 2002) and the piece has mainly consisted of Kac's appeals to the institute for Alba's discharge. Whatever the ethical judgment on *GFP Bunny,* the piece is clearly a pioneering work. Not only does the "performance" of *GFP Bunny* entail the conventional gallery installation, consisting of the showing of the rabbit, as well as of the human subject looking after it, namely Kac himself, bus also it includes the very making of the rabbit, or "bunny" even, as well as the heated public debate following its creation and, more unexpectedly, the director's refusal to release her. With the creation of Alba, life itself was turned into artwork and its making and existence became, respectively, an example of an economic and social performance.

Kac's artwork entailed "a new ecology where organic and technological systems cross-pollinate" (Bureaud in Kostic and Dobrila 2000, 8). At the time, he wrote:

> In the future we will have foreign genetic material in us as today we have mechanical and electronic implants. In other words, we will be transgenetic. As the concept of species based on breeding barriers is undone through genetic engineering, the very notion of what it means to be human is at stake. However, this does not constitute an ontological crisis. To be human will mean that the human genome is not a limitation, but our starting point. (Kac in Stocker and Schöpf 1999, 293)

By experimenting with the intersections of the physical and the digital, Kac has been showing that the viewer is continually enmeshed in both and that actions carried out in the digital may affect the physical, and vice versa. Kac's viewer is in fact dispersed and often even existing only in a condition of mediation. In his work individuality gives way to multiplicity and the physical is always available only as an unstable and "flickering" (Hayles in Druckrey 1996, 259–79) overlay of physical and digital, organic and machinic, human and animal. In his transgenetic art, Kac has also been showing that not only is the human already a cyborg but also that it is already post-human and that in fact the very notion of the human is already a hybrid, not only by means of evolution but also medically, via genetic engineering. In Kac's work this hybrid post-human viewer, residing at the point of intersection between species, is the archive of its own genetic history, continuously re-enacting the uncomfortable, and ethically charged performance of life.

In George Legrady's *An Anecdoted Archive from the Cold War* (1993), an interactive CD-ROM installation project featuring Central European personal and official communist material from the 1950s, the visitor was met with orientation devices such an index and a floor plan (of the Worker's Movement Museum in Budapest, which no longer exists) with thematically ordered rooms that were meant to help integrating the visitors' personal stories within the history of the museum (Legrady in Lovink 1995). Official memories were here mixed with personal memories and the visitor participated in the "structuring and restructuring of the archive" (Gibbons 2009, 138). There were a number of intertextual references. The first one was to Fluxus artist Daniel Spoerri's *An Anecdoted Topography of Chance* (1962), which was created out of the chaotic leftovers he saw on his kitchen table in his room at the Hotel Carcassonne in Paris one morning after a party. This resulted in an archive of the things Spoerri found researching the history of each of the leftover objects that were subsequently also cross-referenced with each other (Legrady in Lovink 1995). Each object was assigned a number. A description of the object and memories associated with it was also written. Through the objects, it was possible to trace Spoerri's life at the time he created the collection. Here we have become what we consume. The second and third intertextual references were to Foucault's *The Order of Things* (1970), in which the notion of the episteme, tracing the conditions of discourse over time, is discussed, and *The Archaeology of Knowledge* (1969), a text already cited in chapters 2 and 5, in which Foucault shows that epistemes and discursive formations are governed by rules operating beneath consciousness that define the boundaries of thought

Figure 6.7
George Legrady, *An Anecdoted Archive from the Cold War.* Courtesy George Legrady.

and language. Visitors had personalized experiences of this archive according to their background. Here, memory was "not a quest for the authenticity of the past or an excavation of the past so much as a backward-looking exercise which is more about creating mutable and multiple perspectives through which the past can be experienced" (Gibbons 2009,138). The visitor formed a remembrance from a secondary source because they had no primary memory and so created a memory from the data that were collected through the experience of the work (see figure 6.7).

Legrady's subsequent works *Pockets Full of Memories* (2001) and *Pockets Full of Memories II* (2003–2006) can also be described as "exercises in archiving" (Gibbons 2009, 139). The first work was an installation on the topic of the archive and memory. During its installation at the Centre Pompidou in Paris, between April 10 and September 3, 2001, 20,0000

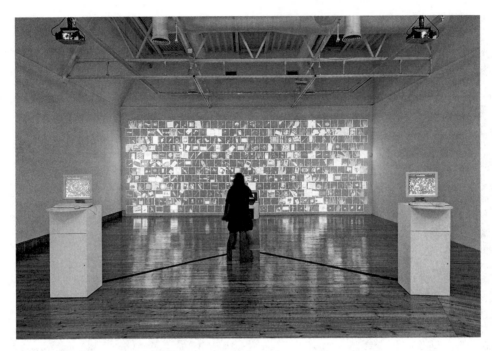

Figure 6.8
George Legrady, *Pockets full of Memories*. Courtesy George Legrady.

visitors contributed over 3,300 objects in their possession, including phones, keys, toys, fragments of clothing, personal documents, currency, reading material, through scanning and descriptions. This information about these objects was stored in a database organized by the Kohonen self-organizing map algorithm that groups objects of similar kinds together in a two-dimensional map. This was made available as a projection in the gallery space ad online, so as to allow users to review what they had added and add more comments (Legrady and Honkela 2002). The project was developed with funding from the Daniel Langlois Foundation for Art, Science and Technology and in collaboration with teams from UIAH Media Lab, the C3 Center for Culture and Communication, Projekttriangle, the CREATE lab from University of California Santa Barbara, and Fraunhofer Institute for Industrial Engineering. Visitors could scan objects in their possession at the entrance of the exhibition and describe their attributes online. The images of the objects and their related data were then stored in a database that grew throughout the duration of the exhibition (see figure 6.8). Presentation and access to the database occurred online and in a large-scale projection in the gallery space of the museum (Legrady and Honkela 2002). Interestingly, visitors scanned body extensions (heads, hands and feet) (Legrady in Vesna 2007, 243), and so the overall quality of the archive was a consequence of "the dialogue that occurred between the audience's perception of the

archive's holdings, followed by a contribution that functions as a statement of participation and the desire to leave a trace of themselves behind" (Legrady in Vesna 2007, 243).

Finally, Christine Borland's installation *HeLa* first exhibited at the Exit Gallery in New York in 2000 and then renamed *HeLa, Hot* in 2004 is an example of bioart, a form of art that includes live materials such as cells, bacteria, tissue, and viruses. The installation was a comment on genomic exploitation. On October 4, 1951, an African American woman from Virginia had died of cervical cancer at the age of 31. The cells from her cancer were placed in petri dishes, freezers, and flasks in laboratories all over the world. Among scientific communities these cells are known as HeLa (Hee-Lah). Adele Senior points out, separated from Lacks's body, these cells gave rise to what is now considered a "workhorse" of the cellular biology lab: the HeLa cell line. Unusually, under the right conditions, HeLa cells can grow indefinitely and are scientifically and commercially useful because they are in endless supply, so much so that they have been deemed "immortal" (Landecker 2000). Among a number of uses, HeLa cells have been launched into space to study the effects of space travel on humans, exposed to huge amounts of radiation in order to examine the damage done to human cells by nuclear weapons, and injected into rats to study cancer growth. For Senior, "HeLa" became a "linguistic signifier for both the material cells that exist in laboratories all over the world and the immaterial discursive economies which constitute these cells within scientific practice and, more recently, in our cultural imaginary" (2011, 513).

The installation consists of a microscope that allows visitors to observe the HeLa cells in a nutrient solution in a flask. At the latter exhibition the installation was accompanied by a statement by David Barrett:

> The text informs us that we are looking at HeLa cells, which are tumour cells with an unusually fast growth rate, and hence ideal for scientific study. They are used in labs around the world and can be purchased from scientific supply companies. However, Borland's text goes on to state that HeLa cells are so called because they originate from the tumour that killed the 31-yearold African-American woman Henrietta Lacks back in the 50s. Each HeLa cell contains Lacks's DNA, and it is supposed that there are more of her cells in existence now than there were when she was alive. Furthermore, Lacks's surviving children only discovered that their mother's cells had become a staple of the life sciences when they themselves were asked to provide DNA samples for comparative study some 20 years after her death. (2004)

Senior points out that what exactly is owned by Henrietta, namely "Henrietta's image, Henrietta's cell line or Henrietta's story," is for the spectator to decide and, "in that act of decision, the spectator arguably becomes a participant in the act of archiving as productive of immaterial and perhaps even flesh remains" (2011, 526). For her, in current archival writing, and particularly within performance studies, the document is seen, in opposition to anything to do with physical presence, as a remain (Schneider 2001, 12), and she proposes that HeLa challenges this view by asking "what exactly is 'archived' in, or by, HeLa as *material remains* begs clarification, particularly in view of the fact that there are now many different HeLa strains in use which are said to have derived from Lacks's cancer cells" (Senior

2011, 514; original emphasis). For Senior, the use of these cells in bioart has meant that the cells in the work do at once "archive the life and death of Henrietta Lacks" and also "participate materially in both life and death" so that the "have the potential to be encountered through the body of the artist and/or the body of the spectator" (p. 514). This archival work, grounded in experimentation with life itself, challenges conventional notions of the archive while forcing us to rethink the archive's symbiotic relationship to the body. The genomic archive not only participates in the preservation of our pasts and production of our futures, but also it literally informs exactly what life we will be having. We are our own archive.

The Infinity Engine by Lynn Hershman Leeson

Lynn Hershman Leeson's *The Infinity Engine* (2014–) is an installation that, along with a film of the same name, makes up a hybrid media artwork exploring "possibilities for evolution now that DNA can be programmed" (Hershman Leeson 2013a). The work utilizes emerging ideas in communication technology, medicine, and biological technology, and draws from cultural studies of identity, including history of science, cyborg theory, feminism, performance, art, and fiction. *The Infinity Engine* is at once a time-based installation, a film, an experiment, medical evidence, and (a)live archive.

Hershman Leeson has long been investigating the malleability of the body and the fabrication of identity through technology. Thus, for example, we already saw in chapter 2 how her well-known work *Roberta Breitmore* (1974–78), which combines photo, video, and performance, sees her enact, by wearing a wig, a costume, and make up, the signs of a "physical embodiment" through "a set of individual gestures, needs and fears" (Rötzer in Schwarz and Shaw 1996, 136). Roberta was met only as mediated "evidence" or document of past "archived" activity over whose veracity, significance, and connection the viewer or reader was invited to speculate.

The Infinity Engine (2014-), as well as being an installation, also constitutes the concluding part of a film trilogy that includes *Conceiving Ada* (1997) and *Teknolust* (2002). All three feature Tilda Swinton and explore "the implications—ethical as well as social—of the impact on the human species in an era of genetic manipulation" (Hershman Leeson 2013a). The trilogy is centered on the theme of the cyborg, the "self-regulating human machine system[s]" (Featherstone and Burrows 1995, 2) that have been challenging traditional binaries between natural and human-made entities, leading to the often disputed theorization of the posthuman (Gray 2002). Thus *Conceiving Ada,* using a virtual set composed of 375 photos of bed and breakfast hotels in San Francisco that had a "Victorian feel" (in Tromble and Hershman Leeson 2005, 97), features the computer scientist Emmy Coer who, obsessed with Countess Ada Lovelace, the author of the first computer algorithm written for Charles Babbage's *Difference Engine,* attempts to bring her into the present. While the two women succeed in communicating, they find that gender is a major concern, since, unlike Babbage, Lovelace's name is largely forgotten.

The second film in the sequel, *Teknolust,* features the biogeneticist Rosetta Stone inject-
ing her own DNA into a computer program that generates three self-replicating automata
(SRAs), named Ruby, Marine, and Olive, after the red, green, and blue pixels used to create
color on the computer monitors, that grow on her computer. These need to adventure into
the real world to receive the Y chromosome that keeps them alive. To achieve this, Ruby is
programmed to absorb images from films so she can re-enact love scenes in real life, meet
partners, collect their semen, and share it with the other two automata, though the men
she meets appear to develop a strange disease. Subsequently, the three pursue their own
adventures: Ruby develops an encrypted language that allows her to talk to her sisters in
secret; Olive reads psychology, philosophy, and history texts; and Marine hacks into Rosetta's
computer to steal her code for the cloning. In the end, Ruby falls in love with Sandy, a print
shop employee, and has a child with him. For Jackie Stacey, the three digital clones embody
a tension between sameness and difference. As cyborgs, she suggests, they are a combination
of genetic and computational material, both human and nonhuman, single and multiple,
and emerge from a culture of copy that is digital and genetic (Stacey 2010), technological
and medical.

The third film in the trilogy, *The Infinity Engine,* still in production at the point of writing,
features Iris, who is seen as a nineteen-year-old coming to terms with being "the first human
to have received a bio printed heart and the tenuous nature of her life" (Hershman Leeson
2014d). In this case, Tilda Swinton takes on the role of a glowing rebel cat—glowing because,
like Eduardo Kac's Alba, she carries the genetic code of a jellyfish, the fluorescent protein
GFP. Her character searches for freedom, enlightenment, and the company of humans in a
biotechnology company. The choice of the cat was inspired by the glowing cat that had been
injected with the fluorescent protein GFP. The latter was designed to study the feline immu-
nodeficiency virus, which played a crucial role in building an understanding of HIV/AIDS.

We have seen how Hershman Leeson's artworks are interrelated and could be described
as emerging from one another. Thus *Roberta Breitmore,* on the one hand, bred out from *The
Dante Hotel* (1993), which in turn, as we saw in chapter 1, produced *Life Squared.* Roberta
Breitmore, one year after *The Dante Hotel,* started her "life" at this location after stepping
out of a Greyhound bus with only $1,800. *Agent Ruby* (2002), on the other hand, bred out of
Teknolust. In *Agent Ruby,* users log into "Ruby's E-Dream Portal," also featured in *Teknolust,*
from which Ruby can invite them to ask her anything so that she may teach them to dream.
If visitors type a question, Ruby then types a response and the conversation begins. Ruby
can remember users' questions and names, and she has moods that depend as to whether
she enjoyed their company. In a more recent version (2004) Ruby can also respond ver-
bally and can be downloaded to Palm handheld computers from the website. For Hershman
Leeson, "this Tamagotchi-like creature is an Internet-bred construction of identity that
develops through cumulative virtual use, reflecting the global choices of Internet users."
The piece thus, for Hershman Leeson, "evokes questions about the potential of networked

consciousness, identity, corruption, redemption, and interaction" (in Tromble and Hersh-
man Leeson 2005, 98).

We know that the post-human body is defined by "symbiotic interdependence," which
means that, like the apparatus of the archive, it is defined by the "co-presence of different
elements, from different stages of evolution: like inhabiting different time-zones simultane-
ously" (Braidotti 2002, 226). One of the ways in which this manifests itself in Hershman Lee-
son's work is the co-presence of works that are related, but interdependent from one another,
whose "liveness" therefore is not a consequence of the time of the execution of the work, but
rather of its "procreational" potential and capacity, as in the case of her *Roberta Breitmore*, to
persist. We also know that the post-human body tends to be "viral" or "parasitic" (Shaviro
1995). In Hershman Leeson's work, the post-human body is frequently represented through
the meeting of the signs drawn from a number of disciplines, which, intertextually, also draw
from the aesthetics of works spanning different periods in time. In other words, these post-
human bodies are not only in a viral relationship with each other, they are also in a parasitic
relationship with other "bodies" of work. They literally are the result of a copy-cut-paste pro-
cess. This is, increasingly, a distinctive feature of archives created through social media that
not only cite one another but are formed by each other.

This ability of the work to replicate (*The Infinity Engine* itself is a replica of a laboratory of
science) is not unconnected to what Jean Baudrillard described in relation to the simulacrum,
which, for him, duplicates without any pretension of originality (1983). Caught in a cycle of
"successive phases of the image" (p. 11), for Baudrillard, the post-human body is always also
"capital" or "consumer object" (1998, 129). Except in Hershman Leeson's work post-human
replicas maintain an identity, presence even, that makes them distinct from one another.
Here, the post-human body, while being in a symbiotic relationship with other bodies and
possibly replicating aspects of them, remains a subject. This ability to establish their pres-
ence, and so also define their present, is also what makes them persistent. Furthermore the
"body" of work, namely Hershman Leeson's opus, largely consisting of archival documents,
primary, secondary, as well as inter-documents, mimics this behavior of the post-human
body, including its capacity to act as and be understood as archive. It is a consumer object
(product) as well as a producing mechanism (process), growing from the inside out, whose
capital consists mainly of its generative power (primarily, but not exclusively, established
through replication occurring via documentation). Every replica, every copy, can become
again an original, with a distinct aesthetic, political, and economic value. Additionally, in
The Infinity Engine, addressing advances in regenerative medicine through 3D printing, cop-
ies are in effect the live prints of our cells, organisms without a body, potentially part of us,
the archive that is left of our physical existence.

The Infinity Engine installation consists of the eight-room replica of a genetics lab that
is shown in museums and science laboratories. Constructed from modular units utilized
in current genetic research, the lab, turned into an exhibition space, includes video inter-
views with leading experts in genomics, medicine, and history of science; photography and

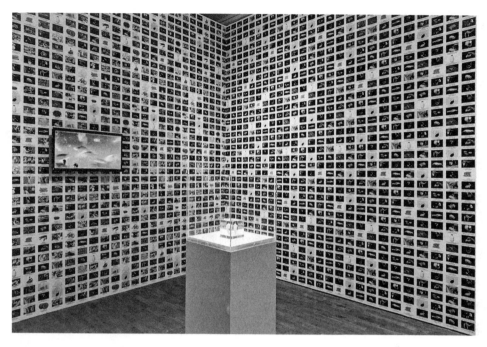

Figure 6.9

Lynn Hershman Leeson, *The Infinity Engine*, 2005–2015. Courtesy of the artist and ZKM | Center for Art and Media, Karlsruhe, Germany, Paule Anglim Gallery, San Francisco, Bridget Donahue Gallery, New York and Waldburger Wouters, Brussels. Photo Andy Stagg © Modern Art Oxford, 2015.

experimentation about regenerative medicine, bio-printing, genetically modified organisms and DNA re-programming. Visitors enter the installation via a replica of a genetics lab door. To the right of this, they can enter a room where the scaffolding of a nose is exhibited (see Figure 6.9). The latter was donated by Wake Forest Center for Regenerative Medicine, specialized at engineering laboratory-grown organs that are successfully implanted in humans. Music playing in this room consists of "DNA components." Here is the first 3D printer, which was donated by Organovo, a company designing functional human tissue (Hershman Leeson 2014a).

In the "anti-chamber," video interviews show Dr. Antony Atala, Professor in Regenerative Medicine at Wake Forest, describing 3D bio-printing techniques, and a recipient, Luke Masala, talking about what it means to have one of the first bio-printed organs. In the "hybridity room," visitors can see wallpaper of genetically modified plants and animals, which are juxtaposed against pictures of labs conducting scientific experiments. A number of iPads are available here so that visitors can see "the consequences of actions by experts, such as Dr. Drew Endy, Professor of Microbiology at Stanford University (see figure 6.10), Dr. Elizabeth

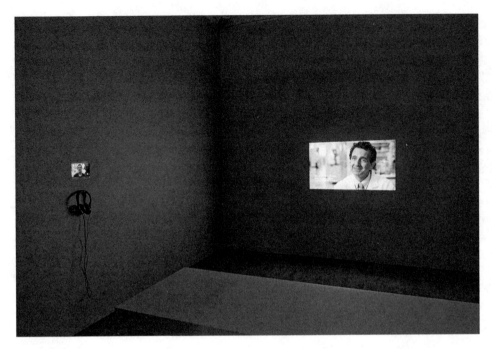

Figure 6.10
Lynn Hershman Leeson, *The Infinity Engine*, 2005–2015. Courtesy of the artist and ZKM | Center for Art and Media, Karlsruhe, Germany, Paule Anglim Gallery, San Francisco, Bridget Donahue Gallery, New York and Waldburger Wouters, Brussels. Photo Andy Stagg © Modern Art Oxford, 2015.

Blackburn, and Dr. Anthony Atala (Hershman Leeson 2014). In the "ethics room," file boxes of court cases relating to gene patents are available and cases are discussed by experts such as Dr. Myles Jackson, Chair, History of Science, New York University; Dr. Troy Duster, Professor Emeritus in Sociology, University of New York; and Andrew Hessel, a futurist and catalyst in biological technologies. At the "biometric soul catcher installation," visitors can enter data into a visualization that will result in a downloadable live archive. Visitors are captured by a scan that then "reverse-engenders their facial structure to reveal origins. This becomes part of a mutating but individually retrievable image that can converse about genetics" (Hershman Leeson, 2014d).

Finally, in the hallways, formed by mirrors reflecting the different lab surroundings seen in *The Infinity Engine*, visitors encounter replicas of lab paraphernalia (see figure 6.11). The prototype for the work was first seen by the public at the Yerba Buena Center for the Arts in San Francisco in 2013 and the full exhibition opened at the ZKM | Center in Karlsruhe in December 2014. When the work opened at Modern Art Oxford, an activity guide for families and school was produced to accompany the exhibition. This guide, which could be

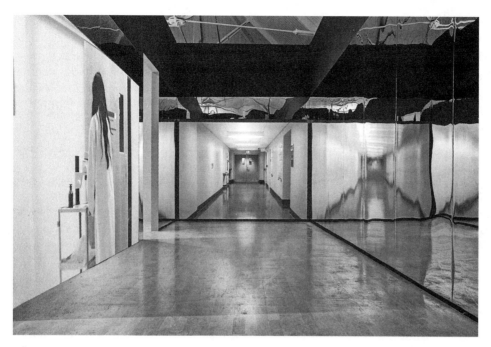

Figure 6.11
Lynn Hershman Leeson, *The Infinity Engine*, 2005–2015. Courtesy of the artist and ZKM | Center for Art and Media, Karlsruhe, Germany, Paule Anglim Gallery, San Francisco, Bridget Donahue Gallery, New York and Waldburger Wouters, Brussels. Photo Andy Stagg © Modern Art Oxford, 2015.

used in the gallery, at home, or in the classroom, encouraged children to draw a picture of a cyborg; reflect about what kinds of questions one might ask a cyborg; think about what one might put in desktop-like folders called "memories," "emotions," "hopes," and "fears"; reflect about genetic engineering by imagining how they would modify a food or even a family member. Finally, children were encouraged to make themselves into a cyborg, create a film, and curate an exhibition.

For Hershman Leeson, the lab "enacts narratives of a not-too-distant future." Here, "organs can be manufactured and banked, lost limbs can be regenerated from the inside out, skin can be printed on an ink jet printer and human life can be extended to 130 years" (2013b). Visitors to the lab, whose images are reflected "to infinity" in the disorienting wall of mirrors (Hershman Leeson, interviewed in San Francisco, August 2014), can directly participate in the work, which results in an online cumulative "intelligent being," an (a)live "constantly mutated archive for all participants who will become an expert on genetic information" (Hershman Leeson 2014d).

Through interviews to scientists conducted by Hershman Leeson, we learn about the latest advances in reproductive medicine. Thus, for example, in the interview with Dr. Elizabeth Blackburn, Professor at University of California, we learn about her work in telomere isolation, a DNA protecting structure at the end of chromosomes, for which Blackburn won the Nobel Prize in 2009. In analyzing the role of telomerase in aging, cancer, and the onset of cardiovascular disease, she draws attention to the links between ongoing stress and illness produced by the wearing down of telomeres:

> ... what we're finding is that if you don't have good telomerase activity and proper maintenance of telomeres—that actually puts people at risk of cardiovascular disease. The two groups we've got the most immediate data on are caregiver groups—one of which is mothers whose biological child is chronically ill with autism, bowel disease, etc. The mother is the caregiver and she's under stress for not just a short time but years. We found that the worse the stress was and the worse the person perceived it by quantitative measures, (and you can do that), and the longer she had been in situation, the worse was the wearing down of her telomeres and her risks for developing cardiovascular disease. ... so there was this possibility that they were literally aging faster. (Blackbourn in Hershman Leeson 2014b)

Dr. Blackburn's pioneering work in this field has led to observations that telomerase is active in rapidly dividing cells and is almost universally elevated in cancer patients. A deficiency in telomerase is associated with a set of bone marrow failure syndromes, while shortened telomeres have been linked to elevated incidences of age-related illnesses, including heart disease. The status of telomeres therefore appears to reflect the health status and risk for chronic diseases in humans, which makes telomere DNA research crucial in a number of fields.

In the interview with Dr. Atala, Professor in Regenerative Medicine at Wake Forest, we hear how terminally ill patients can benefit from 3D printed organs. In his work, he notes, children are implanted with the 3D organs that then "grow and get larger as the children grow." "These organs," he continues, "get identified by the body, as being their own. And they act as if the organs were just the patients' own organ" (Atala in Hershman Leeson 2014c). In answer to Hershman Leeson's question as to whether he was able to transfer or download cells' memories, Atala says:

> You know, cells themselves have a memory, so every single cell in your body has all the genetic information to create a whole new you. The idea is you're going to have readymade organs for the patient by using the patient's own cells. The question is, will we be able to have them just on the shelf, ready to put in. In fact, you really could. If you had a bank of organs, which was large enough, you could actually do that. But it's not practical at this point to do so, maybe someday in the future as science evolves. That will become something that will be financially feasible. I may not see it in my lifetime but it's certainly a possibility. (Atala in Hershman Leeson 2014c)

At the heart of Atala's practice is the desire to "induce the body's own ability to regenerate inside the organ." Thus he continues, "a lot of our efforts right now are aimed toward using

the body's own ability to regenerate and to improve that ability." This can be achieved by programming DNA. Hence he notes: "We can change the cells" pathway. We can change the cells' fate. We can direct cells from any different directions. The things that we can do with cells today were thought to be entirely science fiction just a few decades ago" (Atala in Leeson 2014c). It is evident from these interviews that the "organ" that is presented in *The Infinity Engine* is one that is intervened with or even produced by biotechnology, and yet it is also an organ that is interfered with while it grows inside us, or that is generated outside of us but is then placed inside of us to become part of us. In the case of Atala's research, the future may even entail a new kind of "readymade," that is, organs that can be bought off the shelf, commercial products, developed to aid our ability to perform as humans, forming a part of us that may help us stay alive.

We have seen that Hershman Leeson frequently uses replication as well as the multiplication of viewpoint in her work. For her in fact, "the number three constitutes the proof of validity of an assumption. I am told that in science you have to prove something three times. Hence we have three rooms, three Roberta's, three cyborgs, and three critics" (interviewed in San Francisco, November 2008). Furthermore Hershman Leeson often utilizes different disciplinary perspectives, "whether as a psychologist, sociologist, anthropologist, painter," and her practice consists of "taking elements and collaging them through remixing, creating something that morphs into something beyond itself" (in Giannachi 2010, 233). *The Infinity Engine*, like other works by her, is primarily about surveillance and biopolitics, only that here we see "surveillance from the inside out" (Hershman Leeson 2014d). The body here is at once alive (operating biologically) and live (operating as a mediation).

We know from Michel Foucault that "the control of society over individuals is not conducted only through consciousness or ideology, but also in the body" through biopolitics, the politics that control "the biological, the somatic, the corporeal" (1994, 210), for it, in the words of Michael Hardt and Antonio Negri, is about the "production and reproduction of *life itself*" (2004, 24; added emphasis). We also know from Donna Haraway that between the First World War and the early 1990s, biology was transformed from "a science centered on organisms, understood in functionalist terms, to a science studying automated technological devices, understood in terms of cybernetic systems" and that this meant that biology was transformed from a "science of sexual organisms to one of reproducing genetic assemblages" (1991, 45). Finally, we know from Sarah Franklin that this has had the implication that nature has become biology and then genetics, "through which *life itself* becomes reprogrammable information" (2000; added emphasis). For her, our DNA results in marketable brand names so that our genes become our capital. The re-definition of life itself, which is at the heart of Hershman Leeson's *The Infinity Engine,* means that the archive is now the site where (a)live readymades can be located that could one day become part of us, become us. The present in this archive, the as yet unlived, is literally waiting to be us.

Hershman Leeson's *The Infinity Engine* is a complex work. It is at once a time-based installation, as well as a film, an experiment, a school assignment, evidence, and a live archive. It

offers multiple disciplinary viewpoints, and it entails multiple aesthetic viewpoints, or ways of entering, engaging with, and even remembering the work (or being remembered in the work). Not unlike Charles Babbage's *The Difference Engine* (1821), an automatic mechanical calculator designed to tabulate polynomial functions based on the method of finite differences, this engine is also about labor, the very labor of life.

Historian of science Myles Jackson pointed out, while talking about *The Difference Engine,* that Babbage's work should challenge us to think about: "What was the status of manual labor *vis à vis* intellectual labor? Could intellectual skill be mechanized as an ever-increasing set of manual skills could?" For him, questions concerning the management of such labor are in fact dependent on whether that labor was communicable and, if so, how we communicate knowledge to future scientists, engineers, and commercial firms, is crucial. For Jackson, "[t]he politics of labor can offer insights into how these issues were solved then and into how those solutions affect decisions being made today" (2013). Hershman Leeson's work too raises questions about labor and its communication. For example, it asks: what is the labor of life now that our organs can be regenerated and bought as "readymades" from some kind of live archival shelf? who will be benefit from this labor? how can this archival labor of life be communicated? As Jackson notes, "humans are evolving very rapidly, more rapidly than in any other period in history, precisely because of molecular biology and biomedical research" (in Hershman Leeson 2013c). Hershman Leeson's work presents us with a complex and experimental analysis of what these processes of regeneration and evolution may entail for us and what the role of the *live* archive may be. Here, the human being has become its own *alive* archive, one that, through regenerative medicine, can now be modified inside out. The apparatus of the archive here is not only a site, a content, a technology, and a communication system, or a plurality of platforms, it is also the ability of life to regenerate itself.

We know that the archive played a fundamental role in each of the industrial revolutions, leading to mechanical production, mass production, digitization, and the development of an Internet of Things, in which objects, integrated with the physical world, operate as their own archives. We have seen that in the Internet of Things, the relationship between the archive, the physical world, the digital economy, is increasingly intertwined. We have also seen that 3D printed organs are now able to grow in their host bodies, and become identified with them. These 3D printed organs, which have been produced by working with the archive of life itself, our genetic patrimony, empower us to re-generate ourselves inside out. Bodies, objects, archives, now all form part of the Internet of Things, which renders all of them capable of affecting, and be affected by, what we can, broadly speaking, call our economy.

The archive, whose term, we know, comes from the Greek *arkheion,* indicating, as Derrida pointed out, "a house, a domicile, an address, the residence of the superior magistrates, the *archons,* those who commended" (1995, 2), has become a fundamental motor in driving our economy. This term too comes from the Greek, *oikos,* indicating a house, and *nemein,*

suggesting an operation of management. The administration of the economy, of our house, on the one hand, requires the use of the archive not only because of the authority brought on by the *arkheion*, the address of that which is in command, but also, and perhaps, as we have seen in the previous chapters, because of this address' implication of a network of possible routes or trails that constitute forms of orientation or ordering systems within the everyday. The archive, on the other hand, as we have seen in this chapter, requires the management of our house to affect things other than itself so as to control the (re-)ordering of life itself.

Afterword

Sven Spieker concludes *The Big Archive* (2008) with an epilogue discussing Thomas Demand's artwork *Archive* (1995, 16–17). For Spieker, Demand's work is "empty, stripped of its contents and its ability to reflect anther place and time" (2008, 192). Consisting of empty boxes of identical size, stacked up on the floor, for there is no room left on the shelves, also packed with boxes, this archive has seemingly no content and no finding tools (192). Here, no "*archiving* archive" (Derrida 1995, 16–17; original emphasis) appears to be in operation. This work may be read as a comment on the apparent failure of the 20th-century archive, and the epistemological system it had attempted to underpin, to produce new meanings and generate new meta-narratives. And yet, while there is no content, other than what is there, and, seemingly, there are no strata, no memories, no deep maps, no transformational potential, *Archive* remains a powerful work, capable, like Lucio Fontana's *Slashes* from the 1950s, and much of the memory art discussed in chapter 3, of disturbing the viewer's comfortable position within history by making them confront, precisely, what is indeed not there. This archive is a symptom of last century's "*mal*" (Derrida 1995). In true postmodern fashion, it points to our condition but shows no sign of a possible diagnosis or treatment.

Nearly twenty years after Demand's *Archive*, in 2014 comes a possible diagnosis, a work that may also be described as an "archive" created by computer scientist Steve Benford and his team at the University of Nottingham with the aim to produce an exclusive guitar, one that had been created with the unique purpose to capture and tell its own life history. The guitar uses a QR-like technology called Aestheticodes and enables people to draw their own interactive acoustic guitar to hide digital codes within the Celtic inspired decorative patterns adorning it (Benford et al. 2015). The instrument, named Carolan after the Celtic composer Turlough O'Carolan of the 18th century, is said to be, like the artist it is named after, "a roving bard; a performer that passes from place to place, learning tune, songs and stories as it goes and sharing them with the people it encounters along the way" (2014). Unlike Demand's *Archive*, this guitar is a driving agent within the knowledge economy. It accumulates information, including knowledge about its maker, its players, its performance (in video-documentation), as well as an instrument's user guide and full technical specifications. Like other augmented objects within Industry 4.0 discussed throughout this book, which are

trackable, leave a life-long digital footprint, and generate their own documentation, the Carolan Guitar is also an archival apparatus, forming its own autobiographical memory (Hoven and Eggen 2008), its autotopography, or, in other words, its object's physical map of memory that provides us with knowledge about its history (Petrelli et al. 2010). As in the case of the "tales of things," a tagging service that enables people to record multimedia stories about objects (Barthel et al. 2013), we can conduct an archaeography of this object, contribute to its operation as a memory laboratory, and even use it as an art object within the broader economy of the Internet of Things. The Carolan Guitar is an example of an Archive 4.0, where the archive is embedded in the artifact, rendering it part of a wider network of things, comprising people, objects, organizations and markets. The Carolan Guitar offers a possible diagnosis to our condition because it engages us with its, and, possibly, our own history.

The archive has become a fundamental part of our lives. Not only is information about us located, at any one point, in a plurality of archives, we also incessantly archive our lives, primarily, but not exclusively, through social media, and use a plurality of archival materials to orient ourselves within our everyday lives. While there has always been a fluidity and even interchangeability between cultural institutions such as museums, archives, and libraries, but also cabinets of curiosity, installations, artworks, databases, and, nowadays, games and mixed reality architectures, over time, the archive has absorbed features from these other forms so that it can now be, appropriately, described as an apparatus, capable of producing its own subjects and inserting them within a broader economy. Archives are in fact increasingly operating as a combination or network of materials, tools, machines, structures, labor, facilitating the transmission of the knowledge economy within the Internet of Things. Other cultural forms and other kinds of apparatuses, in turn, have integrated elements of the archive within their own systems and started to operate archivally.

I have discussed the evolution of methods and technologies through which these processes have occurred historically by looking at a whole variety of archives, from primitive, Medieval, Renaissance, and Victorian archives, to digital and mixed reality archives, including archives that contain "nothing" as well as those that attempt to contain "everything." I have shown how archives played a fundamental role in how individuals and social groups administer themselves though and within a broader social memory apparatus. I have shown why archives have been at the heart of every industrial revolution thus far. Archives have in fact been contributing not only to the way we store, preserve, and generate knowledge but also, increasingly, to the way we share knowledge and use this sharing of knowledge as an instrument to propagate transformation and effect change, at all levels of production, including that of life itself. Archives act as catalysts for transformation, and their operation as an apparatus means that the transformation can be propagated and disseminated across seemingly unrelated fields.

I have said that it is only possible to talk about the archive from within its apparatus, and chosen to use a series of disciplines as perspectival viewpoints through which to observe its operation. I have established not only that the archive is "valid for our diagnosis" (Foucault

2001, 147), for it tells us about our provenance, re-establishes our memories, re-writes our histories, marks how we changed over time, aestheticizes our lives, facilitates orientation, but also that it literally re-forms us inside out. In looking at the ἀρχή, or origin, we do not only look into the past but also into the "unlived element" (Agamben 2009, 52) implicit in the present's acts of historical becoming. Precisely because of the archive's ability to facilitate our gaze into another time or space, and their implicit chronologies, geographies, and associated epistemologies and ordering systems, we use the archive to revisit the past in the present, and so rewrite our presence, as other, getting closer to the as yet unlived in the present, to subvert our past and, at the same time, design possible new futures.

Archives, even digital archives, must always be looked at as material contents and sites. We must become archeologists to unpack the strata formed by these archival remains, generate surveys, create possible chronologies, produce deep maps that may reveal the stratigraphy of our *puncta*, those details with "power of expansion" (2000, 45), as Barthes put it, that conceal a "perverse confusion between the Real and the Live" (2000, 79). We must not forget to be Foucauldian, though, to comprehend the operation of the archive in relation to discourse and herewith be able to excavate the complex layers that tie the Real, the Live, Life, and what Agamben has described as the as yet "Unlived" (2009, 52). Through this sensibility, we dig up the value of traces, the remains of the past, in an as yet undefined present, treat the present as a future past, document it, preserve it, share it, to expand its temporality and our presence within that, beyond the ephemeral "now." At the level of materiality, the archive is also a palimpsest, a set of erasures. At the level of discourse, the archive is a set of relationship between discursive and nondiscursive domains. The archive entails a stratigraphy of materials and an archeology of discourses.

In the archive memory, inextricably grounded in the flow life itself, and history, invariably seen as a series of plots that can be reformed and replayed time and again, prompt and produce each other. Through the re-writing of memories, whether episodic, autobiographical, subjective, collective, primary, or secondary, and so forth, we access to the worlds of others. The persistence of elements of a medieval culture within a modern culture explains why aspects of the former, which have been described as memorial, now co-habit with elements of the latter, otherwise described as documentary. This explains our obsession with the archive as creative memory architecture, repository for documents and system for the replay of documentation. The parasitic relationship between the scriptural and digital economy explains how the former's spirit of accumulation and conformism affects the operation of the latter. This is especially visible in our use of social media. The accumulation of documents is still, and increasingly so, a mechanism through which power is generated. Future battles for power will unquestionably be about the control not only of archives but also of the apparatus of the archive.

For most of us the point of origin is elsewhere. Our histories are not linear. Our backgrounds are complex. Archives can help us understand the generation, consolidation, and dismantling of configurations of power and facilitate our orientation in constantly

changing cultural, societal, and political territories. Archives, historically, have always operated as instruments of colonization. Here, we see how archives can be used as strategies for the rewriting of our pasts. While some archives have been propagated, and others were destroyed, new ones are still constantly being produced, leading to the generation of new contents, sites, legacies, and histories, and the creation of new ordering systems, capable of affecting different aspects of the social, political, and economic orders we use to define who we are. We always make politics in the archive because we increase our power, individually or collectively, through the control of what is in the archive. The archive is, now more than ever, our polis precisely because, increasingly so, it is where our citizenship in the world is recorded and re-written.

One only needs to look at how we have been using cabinets of curiosity, as well as, nowadays, social media, to see how we are all collectors and curators, using archives as sites for exhibition, performance, and replay of who we are in relation to everything we know. Archives allow us to re-present what we capture throughout our lives in the context of broader epistemological models and phenomenological contexts. Just as we are all archeologists, historians, politicians, we are also all collectors and curators not only of things but of strategies for orientation so as to create collage-like exhibitions in which the past operates as "shocks" to the present (Benjamin 1992, 262). These shocks to our present allow us to continuously re-write ourselves through the archive, something that, in turn, allows us to curate our relationship with what is other from us.

We embody the archive only in the present. But by embodying the archive, we inhabit our past and adventure into our future. The archive is inextricably linked to our economy. This is not only because the archive, especially, nowadays, the genomic archive, forms part of our economy but also because the archive will in all likelihood be the all-embracing apparatus through which the economy of the future will be managed. Objects, people, sites, contents, ordering systems, histories, including medical histories but also values, whether cultural, social, political, or medical, are dependent on the archive for interpretation, production, transformation, and propagation. We saw in the previous chapters how we constantly redesign the archive as the apparatus we want to be interpreted and produced by. To really advance our economy, our house, we need to become economists so as to regain control over the management (not just the use) of the archive for the letter entails the set of addresses that facilitate the production of and orientation within life itself.

References

Acker, A., and J. R. Brubaker. Death, memorialiation, and social media: A platform perspective for personal archives. *Archivaria* 77 (2014): 1–23.

Adams, M., M. Flintham, L. Oppermann, and S. Benford. 2007. Workpackage WP17 CCG Rider Spoke. http://iperg.sics.se/Deliverables/D17.2-Game-design-document-CCG-Rider-Spoke.pdf. Verified 19/6/2009.

Agamben, A. *Remnants of Auschwitz*, trans. D. Heller-Roazen. New York: Zone Books, 1999.

Agamben, G. *What Is an Apparatus and Other Essays*, trans. D. Kishik and S. Pedatella. Stanford: Stanford University Press, 2009 [2006].

Agnew, J. C. *Words Apart: The Market and the Theatre in Anglo-American Thought, 1550–1750*. New York: Cambridge University Press, 1986.

Alpers, K. P. It's not an archive: Christian Boltanski's *Les Archives de C.B., 1965–1988*. *Visual Resources: An International Journal of Documentation* 27 (3) (2011): 249–66.

Aporta, C. Routes, trails and tracks: Trail breaking among the Inuit of Igloolik. *Études/Inuit/Studies* 28 (2) (2004): 9–38.

Appadurai, A. *Modernity at Large*. Minneapolis: University of Minnesota Press, 1996.

Appadurai, A. Archive and aspiration. Eds J. Brouwer and A. Mulder. *Information Is Alive*. Rotterdam: V2, Publishing/NAI Publishers, 2003, pp. 14–25.

Archivi Segreti Vaticani. http://web.archive.org/web/20110505090210/http://asv.vatican.va/en/arch/1_past.htm. Verified April 3, 2014.

Axel, B. K. The context of diaspora. *Cultural Anthropology: Journal of the Society for Cultural Anthropology* 19 (1) (2004): 20–60.

Barthel, R., K. L. Mackley, A. Hudson Smith, A. Karpovich, M. de Jode, and C. Speed. An Internet of old things as an augmented memory system. *Personal and Ubiquitous Computing* 17 (2) (2013): 321–33.

Barthes, R. *Camera Lucida*, trans. R. Howard. London: Vintage Classics, 2000. [1981].

Bartlett, F. C. *Remembering: A Study in Experimental and Social Psychology*. Cambridge: Cambridge University Press, 1932.

Batchen, G. The art of archiving. In *Deep Storage: Collecting, Storing, and Archiving in Art*. Munich: Prestel, 1998, pp. 46–49.

Baudrillard, J. *Simulations*, trans. P. Foss, P. Patton, and P. Beittchman. New York: Semiotex, 1983. [e]

Baudrillard, J. *The Consumer Society*, trans. C. T. London: Sage, 1998 [1970].

Bauernhansl, T., M. ten Hompel, and B. Vogel-Heuser. *Industrie 4.0 in Produktion, Automatisierung und Logistik: Anwendung*. Berlin: Springer Verlag, 2014.

Bazin, G. *The Louvre*. New York: Abrams, 1959.

Bell, D. *The Coming of Post-Industrial Society: A Venture in Social Forecasting. London: Heinemann. Originally published*. New York: Basic Books, 1974.

Benford, S., and G. Giannachi. *Performing Mixed Reality*. Cambridge: MIT Press, 2011.

Benford, S., A. Hazzard, and L. Xu. The Carolan Guitar. *Interactions of the ACM* 22 (3) (2015): 64.

Benjamin, W. The work of art in the age of mechanical reproduction. Ed. H. Arendt. *Illuminations*, trans. H. Zohn. London: Fontana, pp. 214–18, 1992 [1940].

Benjamin, W. Theses on the philosophy of history. Ed. H. Arendt. *Illuminations*, trans. H. Zohn. London: Fontana Press, pp. 245–55, 1992 [1940].

Benjamin, W. *Selected Writings*, vol. 3: 1935–1938. Eds. H. Eiland and M.W. Jennings. Cambridge: Belknap Press of Harvard, 2002.

Bhabha, H. K. *The Location of Culture*. London: Routledge, 1994.

Blouin, F. X., E. Yakel, and E. Coombs. Vatican Archives: An inventory and guide to historical documents of the Holy See. *American Archivist* 71 (2) (2008): 410–32.

Boast, R., and P. Biehl. Archaeological knowledge production and dissemination in the digital age. Eds. E. Kansa, S. Whitcher Kansa, and E. Watrall E. 2012. *Archaeology 2.0: New Approaches to Communication and Collaboration*. Los Angeles: Cotsen Digital Archaeology, 2012, pp. 119–56.

Boast, R., M. Bravo, and R. Srinivasan. Return to Babel: Emergent diversity, digital resources, and local knowledge. *Information Society* 23 (5) (2007): 395–403.

Bolter, J. D., and R. Grusin. *Remediation: Understanding New Media*. Cambridge: MIT Press, 2000.

Bonfiglio-Dosio, G. Padua Municipal Archives from the 13th to the 20th centuries: A case of a record-keeping system in Italy. *Archivaria* 60 (2005): 91–144.

Bonk, E. *Marcel Duchamp: the Portable Museum*, trans. D. Britt. London: Thames and Hudson, 1989.

Bookchin, N. 2014. Databank of the Everyday. http://bookchin.net/projects/databank-of-the-everyday/. Verified January 29, 2015.

Bott, K. 2014. Archiv. http://www.karstenbott.de. Verified December 30, 2014.

Bourriaud, N. 2009. Altermodern. http://www.tate.org.uk/whats-on/tate-britain/exhibition/altermodern. Verified August 5, 2014.

Bowker, G. C. *Memory Practices in the Sciences*. Cambridge: MIT Press, 2005.

Braidotti, R. *Metamorphoses: Towards a Materialist Theory of Becoming*. Cambridge: Polity Press, 2002.

Brecht, B. *Brecht on Theatre: The Development of an Aesthetic*, ed. and trans. J. Willett. London: Methuen, 1964 [1950].

Brenneke, A. *Archivkunde*. Leipzig: Koehler und Amelang, 1953.

Briet, S. *What Is Documentation?*, trans. E. Day, L. Martinet, and H. G. B. Anghelescu. Lanham, MD: Scarecrow Press, 2006 [1951].

Brinkerhoff, J. M. *Digital Diasporas: Identity and Transnational Engagement*. New York: Cambridge University Press, 2009.

Brown, R. Death of a Renaissance record-keeper: The murder of Tomasso da Tortona in Ferrara, 1385. *Archivaria* 44 (1997): 1–43.

Brundell, P., P. Tennent, C. Greenhalgh, D. Knight, A. Crabtree, C. O'Malley, S. Ainsworth, D. Clarke, R. Carter, and S. Adolphs. 2008. Digital Replay System (DRS)—A tool for interaction analysis. *Proceedings of the 2008 International Conference on Learning Sciences*, June 23–24. Utrecht: ICSL Information Systems. E77–D12, 449–455.

Buchloh, B., Krauss, R., Alberro, A., de Duve, T., Buskirk, M., Bois, Y.-A. Conceptual art and the reception of Duchamp. *October* 70 (1994): 126–46.

Buchloh, B. H. D. Detritus and decrepitude: The sculpture of Thomas Hirschhorn. *Oxford Art Journal* 24 (2) (2001): 41–56.

Burr, G. L. European archives. *American Historical Review* 7: (4) (1902): 653–62.

Cabanne, P. *Dialogues with Marcel Duchamp*, trans. R. Padgett. New York: Da Capo, 1971.

Guitar, Carolan. 2014. http://carolanguitar.com/2014/07/25/concept/. Verified July 24, 2015.

Carruthers, M. *The Book of Memory: A Study of Memory in Medieval Culture*. Cambridge, UK: Cambridge University Press, 2008 [1990].

Casanova, E. *Archivistica. Seconda Edizione*. Siena: Stabilimento Art Grafiche Lazzeri, 1928.

Castells, M. *The Rise of the Network Society. The Information Age: Economy, Society and Culture*. Oxford: Blackwell, 1996.

Chamberlain, A., D. Rowland, J. Foster, and G. Giannachi. Riders have spoken: Replaying and archiving pervasive performances. *Leonardo Transactions* 43 (1) (2010): 90–91.

Charmatz, B. 2009. Manifesto for a Dancing Museum, p. 4. http://www.borischarmatz.org/sites/borischarmatz.org/files/images/manifesto_dancing_museum100401.pdf. Verified August 9, 2015.

Charmatz, B. Interview with Boris Charmatz. *Dance Research Journal* 46 (3) (2014): 49–52.

City Weekly. Lynn Hershman Leeson: RAW/WAR. January 24, 2011. http://e.cityweekly.net/cityweekly/ 2011/01/20/?g=print#?article=1141879. Verified September 19, 2011.

Clanchy, M. T. Tenacious letters: Archives and memory in the Middle Ages. *Archivaria* 11 (1981): 115–25.

Clifford, J. *Routes: Travel and Translation in the Late Twentieth Century*. Cambridge: Harvard University Press, 1997.

Cockle, W. E. H. State archives in Graeco-Roman Egypt from 30 BC to the reign of Septimius Severus. *Journal of Egyptian Archaeology* 70 (1984): 106–22.

Collignon, B. 1996. *Les Inuit: Ce qu'ils savent du territoire*. Paris: L'Hartmattan.

Connerton, P. *How Societies Remember*. Cambridge, UK: Cambridge University Press, 2007 [1989].

Cook, T. What is past is prologue: A history of archival idea since 1898, and the future paradigm shift. *Archivaria* 43 (1997): 17–63.

Cook, T. Archival science and postmodernism: New formulations for old concepts. *Archival Science* 1 (2001): 3–24.

Cox, R. *Personal Archives and a New Archival Calling: Readings, Reflections and Ruminations*. Duluth, MN: Litwin Books, 2008.

Crabtree, A. Ethnography in participatory design. *Proceedings of the 1998 Participatory Design Conference*. Seattle: Computer Professionals for Social Responsibility, 1998, pp. 83–105.

Crabtree, A., D. M. Nichols, J. O'Brien, M. Rouncefield, and M. B. Twidale. Ethnomethodologically informed ethnography and IS design. *Journal of the American Society for Information Science* 51 (7) (2000): 666–82.

Crabtree, A. Taking technomethodology seriously: Hybrid change in the ethnomethodology—design relationship. *European Journal of Information Systems* 13 (3) (2004): 195–209.

Damasio, A. *Descartes's Error: Emotion, Reason and the Human Brain*. New York: Grosset/Putnam, 1994.

Damasio, A. *The Feeling of What Happens: Body and Emotion in the Making of Consciousness*. Orlando, FL: Harcourt, 1999.

Damasio, A. *Looking for Spinoza: Joy, Sorrow and the Feeling Brain*. Orlando, FL: Harcourt, 2003.

DDFR. 2014. http://1world1family.me/ddfr-roadshows/. Verified July 2, 2014.

de Certeau, M. *The Practice of Everyday Life*, trans. S. Rendall. Berkeley: University of California Press, 1984.

de Certeau, M. The historiographic operation. *The Writing of History, trans. T. Conley*. New York: Columbia University Press, 1988 [1974].

DeFlorimonte, M. 2011. Art/object: Re-contextualising African art. http://www.moadsf.org/media/documents/MoADPressReleaseArtObjectfinal.pdf. Verified July 7, 2014.

Dekker, A., ed. *Archive 2020: Sustainable Archiving of Born-Digital Cultural Content.* Amsterdam: Virtueel Platform, 2010.

Dekker, A. *Virtueel Platform Research: Born-Digital Kunswerken in Nederlands.* Amsterdam: Virtueel Platform, 2012.

Demos, T. J. Duchamp's *La boîte-en-valise*: Between institutional acculturation and geopolitical displacement. *Grey Room* 8 (2002): 6–37.

Dening, G. *The Death of William Gooch: A History's Anthropology.* Honolulu: Hawaii University Press, 1995.

Depocas, A., J. Ippolito, and C. Jones. *Permanence through Change: The Variable Media Approach.* New York: Guggenheim Museum Publications, 2003.

Derrida, J. *Archive Fever*, trans. E. Prenowitz. Chicago: University of Chicago Press, 1995.

Derrida, J. Economimesis. *Diacritics II* 3 (9) (1981): 3–25.

Diamond, E. The archivist as a forensic scientist: Seeing ourselves in a different way. *Archivaria* 38 (1994): 139–54.

Diminescu, D., M. Jacomy, and M. Renault . Study on social computing and immigrants and ethnic minorities: Usage trends and implications. Technical Note JRC55033. Joint Research Center, Ispra, Italy, 2010.

DiNucci, D. Fragmented future. *Printmagazine* (1999). http://www.darcyd.com/fragmented_future.pdf. Verified June 4, 2015.

Dirks, N., G. Eley, and S. Ortner, eds. *Culture, Power, History: A Reader in Contemporary Social Theory.* Princeton: Princeton University Press, 1993.

Dollar, C. Archivists and records managers in the Information Age. *Archivaria* 36 (1993): 37–52.

Drath, R. Industrie 4.0—eine Einführung. 2014. http://www.openautomation.de/fileadmin/user_upload/Stories/Bilder/oa_2014/oa_3/oa_3_14_ABB.pdf. Verified December 2, 2014.

Druckrey, T., ed. *Electronic Culture: Technology and Visual Representation.* New York: Aperture, 1996.

Duchein, M. The history of European archives and the development of the archival profession in Europe. *American Archivist* 55 (1992): 14–25.

Duranti, L. From digital diplomatics to digital records forensics. *Archivaria* 68 (2009): 39–66.

Enwezor, O. *Archive Fever: Uses of the Document in Contemporary Art.* New York: International Center of Photography, 2008.

Ernst, W. Archival action: The archive as ROM and its political instrumentalization under National Socialism. *History of the Human Sciences* 12 (2) (1999): 13–34.

190

References

Ernst, W. *Das Rumoren der Archive: Ordnung aus Unordnung*. Berlin: Merve, 2002.

Ernst, W. *Digital Memory and the Archive*. Ed. J. Parikka. Minneapolis: University of Minnesota Press, 2013.

Everett, A. *Digital diaspora: A race for cyberspace*. Albany: SUNY Press, 2009.

Faraguna, M., ed. *Archives and Archival Documents in Ancient Societies*. Trieste: Edizioni Università Trieste, 2013.

Featherstone, M., and R. Burrows. *Cyberspace, Cyberbodies, Cyberpunk*. London: Sage, 1995.

Fissore, G. G. Conceptual development and techniques of organizing documents and archives in some early civilizations. Eds. P. Ferioli, E. Fiandra, and G. G. Fissore. *Archives before Writing: Proceedings of the International Colloquium*. October 23–25, 1991. Turin: Scriptorium, 1994, pp. 339–61.

Flaubert, G. *Bouvard and Pécuchet*, trans. A. J. Krailsheimer. Harmondsworh: Penguin, 1976.

Fogassi, L., and V. Gallese. The neural correlates of action understanding in non-human primates. Eds. M. Stamenov and V. Gallese. *Mirror Neurons and the Evolution of Brain and Language*. Amsterdam: John Benjamns Publishing, 2002, pp. 13–31.

Foster, H. An Archival Impulse. *October* 110 (2004): 3–22.

Foucault, M. *The Order of Things*. London: Tavistock, 1970.

Foucault, M. *The Archaeology of Knowledge and the Discourse on Language*, trans. A. M. Sheridan Smith. New York: Pantheon, 2011 [1969].

Franklin, S. Life itself: Global nature and the genetic imaginary. Eds. S. Franklin, C. Lury, and J. Stacey. *Global Nature, Global Culture*. London: Sage, 2000, pp. 188–227.

Freedberg, D., and V. Gallese. Motion, emotion and empathy in aesthetic experience. *Trends in Cognitive Sciences* 11 (5) (2007): 197–203.

Frieling, R., B. Groys, R. Atkins, and L. Manovich. *The Art of Participaton: 1950 to Now*. San Francisco: San Francisco Museum of Modern Art, Thames and Hudson, 2009.

Frost, H. 2011. Interview with G. Giannachi. Palo Alto, October 26, 2011.

Furner, J., M. Kellogg Smith, and M. Winget. 2006. Collaborative indexing of cultural resources: Some outstanding issues. *Digital Humanities, Proceedings of the 1st ADHO International Conference*, Paris, France, July 5–9, 2006. Eds. C. Sun, S. Menasri, and J. Ventura. Paris: Centre de Recherche Cultures Anglophones et Technologies de l'Information, Université Paris-Sorbonne, pp. 69–71.

Gallese, V., L. Fadiga, L. Fogassi, and G. Rizzolatti. Action recognition in the premotor cortex. *Brain* 119 (1996): 593–609.

Gallese, V., and M. Guerra. Embodying movies: Embodied simulation and film studies. *Cinema: Journal of Philosophy and the Moving Image* 3 (2012): 183–210.

Garde-Hansen, J. My Memories?: Personal digital archive fever and Facebook. Eds. J. Garde-Hansen A. Hoskins, and A. Reading. *Save As… Digital Memories*. London: Palgrave, 2009, pp. 135–50.

Garfinkel, H. *Studies in Ethnomethodology*. Englewood Cliffs, NJ: Prentice Hall, 1967.

Giannachi, G. *The Politics of New Media Theatre: Life*. London: Routledge, 2007.

Giannachi, G., ed. Lynn Hershman Leeson in Conversation with Gabriella Giannachi. *Leonardo* 43 (3) (2010): 232–33.

Giannachi, G., D. Rowland, S. Benford, J. Foster, M. Adams, and A. Chamberlain. Blast Theory's *Rider Spoke*, its documentation and the making of its replay archive. *Contemporary Theatre Review* 3 (20) (2010): 353–67.

Giannachi, G., and N. Kaye. *Performing Presence: Between the Live and the Simulated*. Manchester: Manchester University Press, 2011.

Giannachi, G., N. Kaye, and M. Shanks. *Archaeologies of Presence*. London: Routledge, 2012.

Giannachi, G., W. Barrett, R. Lawrence, T. Cadbury, H. Burbage, A. Chapman, and P. Farman. Time trails. Ed. H. Gottlieb. *Beyond Control: the Collaborative Museum and Its Challenges* International Conference on Design and Digital Heritage. Stockholm: Interactive Institute, Swedish ICT, 2013, pp. 195–200. Also available at http://repo.nodem.org/?objectId=115. Verified February 28, 2014.

Gibbons, J. *Contemporary Art and Memory: Images of Recollection and Remembrance*. London: I.B. Tauris, 2009 [2007].

Gibson, J. *The Ecological Approach to Visual Perception*. Boston: Houghton Mifflin, 1979.

Giles, G. J. Archives and historians: An introduction. Ed. G. J. Giles. *Archivists and Historians*. Washington, DC: German Historical Institute, 1996, pp. 5–14.

Giusto, D., A. Iera, G. Morabito, and L. Atzori, eds. *The Internet of Things*. Heidelberg: Springer-Verlag, 2010.

Gladstone, V. Walid Raad, *Blouin Artinfo*. 2009. http://www.blouinartinfo.com/news/story/32967/walid-raad/. Verified October 23, 2014.

Gray, C. H. *Cyborg Citizen: Politics in the Posthuman Age*. London: Routledge, 2002.

Guha, R. The proses of counter-insurgency. Eds. N. B. Dirks, G. Eley, and S. B. Ortner. *Culture, Power, History: A Reader in Contemporary Social Theory*. Princeton: Princeton University Press, 1994 [1983], pp. 336–71.

Habermas, J. *Eine Art Schadensabwicklung*. Kleine Politische Schriften VI. Frankfurt-am-Main: Suhrkamp, 1987.

Hall, S. *Minimal Selves: Identity Documents*. Birmingham: Birmingham Center for Cultural Studies, 1987.

Hamilton, C., V. Harris, J. Taylor, M. Pickover, G. Reid, and R. Saleh. Eds *Refiguring the Archive*. Dordrecht: Springer, 2002.

Haraway, D. *Simians, Cyborgs, and Women: The Reinvention of Nature*. London: Free Association Books, 1991.

Hardt, M., and A. Negri. *Empire*. Cambridge: Harvard University Press, 2004.

Harley, J. B., and D. Woodward, eds. *The History of Geography*, vol. 1. Chicago: Chicago University Press, 1987.

Harmanci, R. One year after Hurricane Katrina, performers and survivors give a rousing wake and a wake-up call. *San Francisco Chronicle*, August 23, 2006.

Harmanci, R. Telling it as they see it. *San Francisco Chronicle*, August 29, 2007.

Harris, T. A. Email communication with G. Giannachi. July 15, 2015.

Harris, V. Redefining archives in South Africa: Public archives and society in transition, 1990–1996. *Archivaria* 42 (1996): 6–27.

Haskins, C. H. The Vatican Archives. *American Historical Review* 2 (1) (1896): 40–58.

Hedstrom, M. Archives, memory, and interfaces with the past. *Archival Science* 2 (2002): 21–43.

Hershman Leeson, L., ed. Clicking. *Hot Links to a Digital Culture*. Seattle, WA: Bay Press, 1996.

Hershman Leeson, L. *Lifen*. San Francisco: Hotwire Productions, 2009.

Hershman Leeson, L. 2010. About RWA/WAR. http://rawwar.org/about. Verified June 8, 2015.

Hershman Leeson, L., A. Chowaniec, and R. Spain. 2010. *! W.A.R.*, Women Art Revolution LLC.! WAR: videotape interviews by Lynn Hershman-Leeson for film, 1990–2008 (M1639). http://lib.stanford.edu/women-art-revolution. Verified November 22, 2011.

Hershman Leeson, L. Interview with G. Giannachi. San Francisco, October 28, 2011.

Hershman Leeson, L. *The Infinity Engine: A Live Cinematic Installation*. Production brochure, private archive, 2013a.

Hershman Leeson, L. *The Infinity Engine* , 2013b. http://www.theinfinityengine.com/lynn.html. Verified January 2014.

Hershman Leeson, L. *The Infinity Engine* , 2013c. https://www.kickstarter.com/projects/theinfinityengine/the-infinity-engine-lab. Verified August 10, 2014.

Hershman Leeson, L. *The Infinity Engine* installation footprint. Hershman Leeson private archive, 2014a.

Hershman Leeson, L. Lynn Hershman Leeson's interview to Elizabeth Blackburn, Hershman Leeson private archive, 2014b.

Hershman Leeson, L. Lynn Hershman Leeson's interview to Antony Atala. Hershman Leeson private archive, 2014c.

Hershman Leeson, L. Interview with G. Giannachi, San Francisco, August 17, 2014d.

Hochmuth, M. Invitation to Martin Hargraeves: Expo zéro in the framework of *If Tate Modern was Musée de la danse?* May 15, 16, 2015. Email exchange. Tate archive, 2014.

Hodder, I. *Reading the Past.* Cambridge: Cambridge University Press, 1986.

Hogan, B. The presentation of self in the age of social media: Distinguishing performances and exhibitions online. *Bulletin of Science, Technology & Society* 30 (6) (2010): 377–86.

Hooper-Greenhill, E. *Museums and the Shaping of Knowledge.* London: Routledge, 1992.

Hoven, E. V. D., and B. Eggen. Informing augmented memory system design through autobiographical memory theory. *Personal and Ubiquitous Computing* 12 (6) (2008): 433–43.

Howard, A. The future of social media at the National Archives. *Radar.* 2011. http://radar.oreilly.com/2011/11/national-archives-social-media.html. Verified March 25, 2015.

Huhtamo, E., and J. Parikka, eds. *Media Archaeology: Approaches, Applications and Implications.* Berkeley: University of California Press, 2011.

Hui, Y. Archivist Manifesto. *Mute*, 2013. http://www.metamute.org/editorial/lab/archivist-manifesto. Verified March 25, 2015.

Husserl, E. *On the Phenomenology of the Consciousness of Internal Time*, trans. J. B. Brough. Dordrecht: Kluwer, 1990 [1928].

Huyssen, A. *Twilight Memories: Making Time in a Culture of Amnesia.* London: Routledge, 1995.

IKR. 2014. http://moadsf.org/ikr/. Verified July10, 2014.

Impey, O., and A. Macgregor. *The Origins of Museums.* Oxford: Clarendon Press, 1985.

Ingold, T. *The Perception of the Environment.* London: Routledge, 2000.

Ingold, T. *Lines: A Brief History.* London: Routledge, 2007.

Isaac, G. Mediating knowledges: Zuni negotiations for a culturally relevant museum. *Museum Anthropology* 28 (2005): 3–18.

Jackson, M. Charles Babbage on intellectual and manual skill. *Huffington Post ,* 2013. http://www.huffingtonpost.com/myles-jackson/charles-babbage-on-intell_b_2760780.html. Verified August 10, 2014.

Jameson, F. Nostalgia for the Present. *South Atlantic Quarterly* 88 (1989): 517–37.

Jenkinson, H. Reflections of an Archivist. *Contemporary Review (London, England)* 165 (1944): 355–61.

Jenkinson, H. *The English Archivist: A New Profession. The Selected Writings of Sir Hilary Jenkinson.* Eds. R. H. Ellis and P. Walne. Gloucester: Alan Sutton, 2003 [1980].

Jones, A. *Sexual Politics: Judy Chicago's Dinner Party in Feminist Art History.* Los Angeles: Armand Hammer Museum of Art and Cultural Center in association with University of California Press, Berkeley, 1996.

Jones, A. Lost bodies: Early 1970s Los Angeles performance art in art history. Ed. P. Phelan. *Live Art in LA: Performance in Southern California (1970–1983).* London: Routledge, 2012, pp.115–84.

Jones, J., and L. Muller. Between real and ideal: Documenting media art. *Leonardo* 41 (4) (2008): 418–41.

Jones, R. Living in a Box. *Frieze* 82 (2014). http://www.frieze.com/issue/article/living_in_a_box/. Verified December 19, 2014.

Kabakov, I. *The Man Who Never Threw Anything Away: The Archive.* Ed. C. Merewether. Cambridge: MIT Press, 2006 [1977], pp. 32–37.

Kac, E. *Time Capsule.* 1997. file:///Users/gabriella/Desktop/Time%20Capsule.webarchive. Verified April 16, 2015.

Kac, E. 2002. KAC. http://www.ekac.org. Verified February 2, 2015.

Kagermann, H., W. Wahlster, and J. Helbig, eds. Recommendations for implementing the strategic initiative Industrie 4.0. Final report of the Industrie 4.0 Working Group, 2013.

Kagermann, H. Chancen von Industrie 4.0 nutzen. Eds. T. Bauernhansl, M. ten Hompel, and B. Vogel-Heuser. Industrie 4.0 in Produktion, Automatisierung und Logistik. Anwendung, Technologien und Migration, 2014, pp. 603–14.

Kaufmann, T. da C. Remarks on the collection of Rudolph II: The *Kunstkammer* as a form of *Representatio. Art Journal* 38 (1978): 22–28.

Keen, S. *Romances of the Archive in Contemporary British Fiction.* Toronto: University of Toronto Press, 2001.

Kennedy, L., M. Naaman, S. Ahern, R. Nair, and T. Rattenbury. How Flickr helps us make sense of the world: Context and content in community-contributed media collections. 2007. http://infolab.stanford.edu/~mor/research/kennedyMM07.pdf. Verified June 6, 2015.

Kempf, D. Vorwort. Ed. F. I. BITKOM. *Industrie 4.0—Volkswirtschaftliches Potenzial für Deutschland, 5* (2014) .

Ketelaar, E. Archival temples, archival prisons: Modes of power and protection. *Archival Science* 2 (3–4) (2002): 221–38. http://dl.acm.org/citation.cfm?doid=1291233.1291384. Verified June 4, 2015.

Ketelaar, E. Being digital in people's archives. *Archives and Manuscripts* 31 (2) (2003): 8–22. fketelaa.home.xs4all.nl/BeingDigital.doc. Verified June 11, 2015.

Kobialka, M. Of the memory of a human unhoused in being: *On Memory. Performance Research* 5 (3) (2000): 41–55.

Kostic, A., and P. T. Dobrila eds. *Eduardo Kac: Telepresence, Biotelematics, Transgenetic Art.* Ljubljana: Publication of the Association for Culture and Education, 2000.

Krinsky, T. Digital diaspora family reunion: A new kind of geneology, 2009. http://www.documentary.org/content/digital-diaspora-family-reunion-new-kind-geneology. Verified July 2, 2014.

LaCapra, D. *History and Memory after Auschwitz.* Ithaca: Cornell University Press, 1998.

Landecker, H. Immortality, in vitro: A history of the HeLa cell line. Ed. P. E. Brodwin. *Biotechnology and Culture: Bodies, Anxieties, Ethics.* Bloomington: Indiana University Press, 2000, pp. 53–72.

Leavitt, A. What are archives? *American Archivist* 24 (2) (1961): 175–78.

Lee, F. 2011. Mining memories to preserve the past. *New York Times,* December 2, 2011. http://www. nytimes.com/2011/02/22/arts/22diaspora.html. Verified July 1, 2014.

Legrady, G., and T. Honkela. Pockets full of memories: An interactive museum installation. *Visual Communication* 1 (2) (2002): 163–69. http://www.mat.ucsb.edu/~g.legrady/glWeb/publications/publ_art/ textpfom.html. Verified November 9, 2013.

Lepecki, A. The body as archive: Will to re-enact and the afterlives of dances. *Dance Research Journal* 42 (2) (2010): 28–48.

Libeskind, D. *Between the Lines: Extension to the Berlin Museum with the Jewish Museum.* Amsterdam: Joods Historisch Museum, 1991.

Libeskind, D. *Extension to the Berlin Museum with Jewish Museum Departments.* Berlin: Ernst and Sohn, 1992.

Libeskind, D. *Radix-Metrix.* Münich: Prestel, 1997.

Libeskind, D. *Jewish Museum Berlin.* Münich: Prestel, 1999.

Linenthal, E. T. *Preserving Memory: The Struggle to Create America's Holocaust Museum.* New York: Columbia University Press, 2001 [1995].

Lodolini, E. *Archivistica: Principi e Problemi.* Milano: Franco Angeli, 1984.

Lord, C. Email communication with G. Giannachi, July 17, 2015.

Lovink, G. 1995. An anecdoted archive: Interview with George Legrady. *Mediamatic* | Special 8: 2, 3, http://www.mediamatic.net/article-200.5953.html. Verified June 11, 2015.

Lowood, H. Interview with G. Giannachi, Palo Alto. October 26, 2011.

Lugli, A. *Naturalia et Mirabilia: Il collezionismo enciclopedico nelle Wunderkammern d'Europa.* Milano: Mazzotta, 1990.

Lyotard, J.-F. *The Postmodern Condition,* trans. G. Bennington and B. Massumi. Manchester: Manchester University Press, 1985 [1979].

Macdonald, S., ed. *A Companion to Museum Studies.* Malden, MA: Blackwell, 2006.

MacDonald, C. Scoring the work: Documenting practice and performance in variable media art. *Leonardo* 42 (1) (2009): 59–63.

MacGregor, A. *Curiosity and Enlightenment: Collectors and Collections from the Sixteenth to the Nineteenth Century.* New Haven: Yale University Press, 2007.

Machado, A. 1998. A michrochip inside the body. *Nettime.* file:///Users/gabriella/Desktop/A%20MICRO CHIP%20INSIDE%20THE%20BODY.webarchive. Verified April 16, 2015.

Maciariello, C. 2014. Cultural innovation in action. http://artsfwd.org/digital-diaspora-family-reunion/. Verified July 1, 2014.

Maia, M., J. Almeida, and V. Almeida. 2008. Identifying user behavior in online social networks. *Proceedings, SocialNets 08 Proceedings of the first Workshop on Social Networks Systems*. New York: ACM, 1–6.

Malinowski, B. *Argonauts of the Western Pacific: An Account of Native Enterprise and Adventure in the Archipelagoes of Melanesian New Guinea*. New York: Dutton, 1932.

Malraux, A. The museum without walls, trans. S. Gilbet. *Psychologie de l'art*. Geneva: Skira, 1949.

Mancuso, R. (no date). sosolimited: Deconstruction time again. http://www.digicult.it/digimag/issue-049/sosolimited-deconstruction-time-again/. Verified July 9, 2015.

Marx, U., G. Schwarz, M. Schwartz, and E. Wizisla. *Walter Benjamin's Archive: Images, Texts, Signs*. London: Verso, 2007.

Marwick, A., and D. Boyd. I tweet honestly, I tweet passionately: Twitter users, context collapse, and the imagined audience. *New Media and Society* (2011) 13 (1): 122.

Mauriès, P. *Cabinet of Curiosities*. London: Thames and Hudson, 2011 [2002].

Menne-Haritz, A. Access—The reformulation of an archival paradigm. *Archival Science* 1 (2001): 57–82.

Merewether, C., ed. *The Archive*. Cambridge: MIT Press, 2006.

Mesenbourg, T. L. *Measuring the Digital Economy*. Washington, DC: US Bureau of the Census, 2001.

Meyer, L. 2009. A studio of their own: The legacy of the Fresno feminist art experiment. http://www.astudiooftheirown.org/legacy.html. Verified November 12, 2011.

Milgram, P. and Kishino F. 1994. A taxonomy of mixed reality displays. *IEICE Transactions on Information Systems*. E77–D12: 449–55.

Mitra, A. Marginal voices in cyberspace. *New Media and Society* 3 (1) (2001): 29–48.

MOAD. 2014. Permanent exhibitions. http://www.moadsf.org. Verified July 2, 2014.

Morgan, A. E., and J. S. Jacobs. (no date). The accidental IPM program: A case study of contemporary art and archives at the Andy Warhol Museum. http://museumpests.net/wp-content/uploads/2014/04/1-2-Morgan-and-Jacobs-paper.pdf. Verified December 19, 2014.

Muller, S., J. A. Feith, and R. Fruin. 2002 [1898]. *Manual for the Arrangement and Description of Archives*, trans. (1940) of the 2nd ed. A. H. Leavitt. New York. Reissued 1968, with a foreword by P. Horsman, E. Ketelaar, and T. Thomassen. Chicago: Society of American Archivists.

Murray, G. 2005. Asynchronous JavaScript technology and XML (Ajax) with the Java platform. http://www.oracle.com/technetwork/articles/java/ajax-135201.html. Verified June 4, 2015.

Musée de la Danse: Three Collective Gestures. MoMA program, 2013.

Nalbantian, S., P. M. Matthews, and J. L. McClelland, eds. *The Memory Process*. Cambridge: MIT Press, 2011.

Negroponte, N. *Being Digital*. New York: Knopf, 1995.

Newmedia, F. I. X. US premiere of Lynn Hershman Leeson's! W.A.R. at Sundance/NYC theatrical premiere on June 3, January 11, 2011. http://newmediafix.net/daily/?p=3510. Verified September 19, 2011.

Nora, P. Between memory and history: *Les lieux de mémoire*, trans. M. Roundebush. *Representations (Berkeley, CA)* 26 (26) (1989): 7–24.

Nora, P. 1996. The reasons for the current upsurge in memory, trans. M. Roudebush. *Eurozine*. http://www.eurozine.com/articles/2002-04-19-nora-en.html. Verified December 13, 2011.

Osthoff, S. *Performing the Archive*. New York: Atropos Press, 2009.

Parry, R. *Recoding the Museum: Digital Heritage and the Technologies of Change*. Oxford: Routledge, 2007.

Pearson, M., and M. Shanks. *Theatre Archaeology*. London: Routledge, 2001.

Peers, L., and A. Brown, eds. *Museums and Source Communities*. London: Routledge, 2003.

Petrelli, D., and S. Whittaker. Family memories in the home: Contrasting physical and digital mementos. *Personal and Ubiquitous Computing* 14 (2) (2010): 153–69.

Posner, E. *Archives in the Ancient World. Harvard*. Canbridge: Harvard University Press, 1972.

Pratt, M. L. Arts of the Contact Zone. *Profession* 91 (1991): 33–40.

Quaranta, D. *Collect the WWWorld: The Artist as Archivist in the Internet Age*. Brescia: Link Editions, 2011.

Queensland Government. (no date) Tips for successful marketing through Facebook. https://www.business.qld.gov.au/business/running/marketing/online-marketing/using-facebook-to-market-your-business/tips-for-successful-marketing-through-facebook, verified April 3, 2015.

Rabe Barritt, M. Coming to America: Dutch *Archivistiek* and American archival practice. *Archival Issues* 18 (1993): 43–54.

RAW/WAR. (2010–) http://rawwar.org/. Verified November 22, 2011.

RAW/WAR. (2010) http://lynnhershman.com/livingblog/tag/rawwar/. Verified March 3, 2011.

Richards, T. *The Imperial Archive: Knowledge and the Fantasy of Empires*. London: Verso, 1993.

Rifkin, J. *The Age of Access: The New Culture of Hypercapitalism Where All of Life Is a Paid-for Experience*. New York: Tarcher/Putnam, 2000.

Rinehart, R. and Ippolito, J. *Re-collection: Art, New Media, and Social Memory*. Cambridge: MIT Press, 2014.

Rizzolatti, G., L. Fadiga, V. Gallese, and L. Fogassi. Premotor cortex and the recognition of motor actions. *Brain Research. Cognitive Brain Research* 3 (1996): 131–41.

Safran, W. Comparing diasporas: A review essay. *Diaspora: A Journal of Transnational Studies* 8 (3) (1991): 255–91.

Sandri, L. La storia degli archivi. *Archivium* 18 (1968): 101–13.

Santone, J. Marina Abramovic's Seven Easy Pieces: Critical documentation strategies for preserving art's history. *Leonardo* 41 (2) (2008): 147–52.

Sassen, S. Electronic space and power. *Journal of Urban Technology* 4 (1) (1997): 1–17.

Savage, S. 2011. Exclusive interview: Lynn Hershman Leeson Talks! Women art revolution, feminism, outtakes of history. *indieWIRE*. http://blogs.indiewire.com/thompsononhollywood/2011/06/01/exclusive_lynn_hershman_leeson_talks_women_art_revolution_feminism_outtakes/. Verified September 19, 2011.

Schaffner, I. and Winzen, M., eds. *Deep Storage: Collecting, Storing, and Archiving in Art*. Munich: Prestell, 1998.

Schellenberg, T. R. Archival principles of arrangement. *American Archivist* 24 (1961): 11–24.

Schiffer, D. *Io sono la mia memoria*. Torino: Centro Scientifico Editore, 2008.

Schlitz, S. 2014. Participatory culture, participatory editing and the emergent archival hybrid. *Archive Journal* 4. http://www.archivejournal.net/issue/4/archives-remixed/participatory-culture-participatory-editing-and-the-emergent-archival-hybrid. Verified March 25, 2015.

Schwarz, A. *The Complete Works of Marcel Duchamp*. New York: Abrams, 1970 [1969].

Schneider, R. Archive performance remains. *Performance Research* 6 (2) (2001): 100–108.

Schwartz, J. Lessons from photographs for the practice, politics, and poetics of diplomatics. *Archivaria* 40 (1995): 40–74.

Schwartz, J., and T. Cook. Archives, records, and power: The making of modern memory. *Archival Science* 2 (2002): 1–19.

Schwartz, H-P., and Shaw, J. 1996. *Perspektive der Medienkunst*. Karlsruhe ZKM: Cantz Verlag.

Scott, F. *Living Archive 7: Ant Farm*. Barcelona: Actar, 2008.

Senior, A. Haunted by Henrietta: The archive, immortality and the biological arts. *Contemporary Theatre Review* 21 (4) (2011): 511–29.

Shanks, M. *Social Theory and Archaeology*. Cambridge: Polity Press, 1987.

Shanks, M. *ReConstructing Archaeology*, 2nd ed. Cambridge, UK: Cambridge University Press, 1992 [1987].

Shanks, M. *Classical Archaeology of Greece*. London: Routledge, 1996.

Shanks, M. 2004. Digital media, agile design and the politics of archaeological authorship. http://documents.stanford.edu/michaelshanks/75. Verified March 30, 2011.

Shanks, M. 2004a. Media Archaeology Meets Theatre Archaeology. http://www.mshanks.com/2004/12/media-archaeology-meets-theatrearchaeology/. Verified November 18, 2011.

Shanks, M. 2005. Archaeography. http://www.mshanks.com/2005/01/archaeographycom/. Verified July 28, 2011.

Shanks, M. 2007. Media Archaeology. http://archaeography.stanford.edu/michaelshanks/54. Verified November 22, 2011.

Shanks, M. 2008. Archive and memory in virtual worlds. http://documents.stanford.edu/michaelshanks/302. Verified March 30, 2011.

Shanks, M. 2009. The archaeological imagination. http://documents.stanford.edu/michaelshanks/57. Verified March 30, 2011.

Shanks, M. 2010. Deep mapping. http://documents.stanford.edu/MichaelShanks/51. Verified July 5, 2011.

Shaviro, S. Two lessons from Borroughs. Eds. J. Halbertstam and I. Livingston. *Post-Human Bodies*. Bloomington: Indiana University Press, 1995, pp. 38–56.

Sheehy, C. J., ed. *Cabinet of Curiosities: Mark Dion and the University as Installation*. Minneapolis: University of Minnesota Press, 2006.

Sheffer, G. A new field of study: Modern diasporas in international politics. Ed. G. Sheffer. *Modern Diasporas in International Politics*. Sydney: Croom Helm, 1986, pp. 1–15.

Sherwin-White, S. M. Ancient archives: The edict of Alexander to Priene, a reappraisal. *Journal of Hellenic Studies* 105 (1985): 69–89.

Shilton, K., and R. Srinivasan. Counterpoint: Participatory appraisal and arrangement for multicultural archival collections. *Archivaria* 63 (2007): 87–101.

Simon, N. *The Participatory Museum*. Santa Cruz: Museum, 2010.

Smith, J. W. 2005. The Warhol: Time Capsule 21. http://www.warhol.org/tc21/. Verified December 19, 2014.

Sontag, S. *On Photography*. New York: Farrar, Straus and Giroux, 1977.

Sisario, B. With software artists put yet another spin on the presidential debates. *New York Times*, October 7, 2008, http://www.nytimes.com/2008/10/07/arts/design/07deba.html. Verified 28/2/2015.

Spieker, S. Boris Groys: The logic of collecting. *Art Margins Online*, January 15, 1999. file:///Users/gabriella/Desktop/archiving%20book/Chapter%205/Boris%20Groys:%20The%20Logic%20of%20Collecting.webarchive. Verified December 19, 2014.

Spieker, S. *The Big Archive: Art from Bureaucracy*. Cambridge: MIT Press, 2008.

Spivak, G. *In Other Worlds: Essays in Cultural Politics*. New York: Routledge, 1988.

Srinivasan, R., and J. Huang. Fluid ontologies for digital museums. *International Journal on Digital Libraries* 5 (3) (2005): 193–204.

Srinivasan, R., and A. Pyati. Diasporic information environments: Reframing immigrant-focused information research. *Journal of the American Society for Information Science and Technology* 58 (12) (2007): 1734–44.

Srinivasan, R. Ethnomethodological architectures: Information systems driven by cultural and community visions. *Journal of the American Society for Information Science and Technology* 58 (5) (2007): 723–33.

Srinivasan, R., R. Boast, J. Furner, and M. Becvar. Digital museums and diverse cultural knowledges: Moving past the traditional catalog. *Information Society* 25 (4) (2008): 265–78.

Srinivasan, R., J. Enote, K. Becvar, and R. Boast. Critical and reflective uses of new media technologies in tribal museums. *Museum Management and Curatorship* 24 (2) (2009): 161–81.

Stacey, J. *The Cinematic Life of a Gene*. Durham, NC: Duke University Press, 2010.

Stapleton, R. Jenkins and Schellenberg: A Comparison. *Archivaria* 17 (1983–84): 75–85.

Stocker, G., and C. Schöpf, eds. *Life Science: Ars Electronica 1999*. New York: Springer Verlag, 1999.

Stoler, A. L. Colonial archives and the arts of governance. *Archival Science* 2 (2002): 87–109.

Stoler, A. L. *Along the Archival Grain*. Princeton: Princeton University Press, 2010.

Stvilia, B., and C. Jörgensen. End-user collection building behavior in Flickr. Ed. A. Grove. *Proceedings of the 70th ASIS&T Annual Meeting,* vol. 44. Hoboken, NJ: Wiley, 2007, 1–20.

Stvilia, B., and C. Jörgensen. User-generated collection level metadata in an online photo-sharing system. *Library and Information Science Research* 31 (1) (2009): 54–65.

Tapscott, D. *The Digital Economy*. New York: McGraw-Hill, 1996.

Tapscott, D., and A. D. Williams. *Wikinomics: How Mass Collaboration Changes Everything*. New York: Portfolio, 2007.

Taylor, D. *The Archive and the Repertoire: Performing Cultural Memories in the Americas*. Durham, NC: Duke University Press, 2003.

Taylor, T. 2013. Press release for *I've known Rivers*. http://bayviewhunterspoint.tumblr.com/post/63684436599/the-museum-of-the-african-diaspora-moad-receives. Verified June 8, 2015.

Tromble, M., and L. Hershman Leeson, eds. *The Art and Films of Lynn Hershman Leeson: Secret Agents, Private I*. Berkeley: University of California Press, 2005.

Tucker, M. *Robert Morris*. New York: Whitney Museum of American Art, 1970. http://archive.org/stream/robertmorris00tuck/robertmorris00tuck_djvu.txt. Verified 5/12/2014.

Turnbull, D. *Masons, Tricksters and Cartographers*. Cambridge, UK: Polity Press, 2000.

Turner, S. The secret war: QA with Lynn Hershman Leeson. *Art in America*, 2011. http://www.artinamericamagazine.com/news-features/previews/lynn-hershman-neeson-raw-war/. Verified June 18, 2011.

Valatspu, D. History, our own stories and emotions online. *Historien* 8 (2008): 108–16.

Vergo, P., ed. *The New Museology*. London: Reaktion, 1989.

Vesna, V., ed. *Database Aesthetics: Art in the Age of Information Overflow*. Minneapolis: University of Minnesota Press, 2007.

Villamil, G. P. RAW/WAR at Sundance Film Festival, 2011. http://villamil.org/?p=1147. Verified October 19, 2011.

Villamil, G. P. Interview with G. Giannachi, 2011a. San Francisco, October 28, 2011.

Wareham, E. From explorers to evangelists: Archivists, recordkeeping, and remembering in the Pacific Islands. *Archival Science* 2 (2002): 187–207.

Webmoor, C. 2007. Between media archaeology and memory practices: Two recent excavations. http://traumwerk.stanford.edu/archaeolog/2007/12/between_media_archaeology_and.html. Verified November 18, 2011.

Wood, C. 2010. The art of writing with people. *Tate Paper* 20: 1–8. http://www.tate.org.uk/context-comment/articles/art-writing-people. Verified December 15, 2014.

Wood, C. Personal email to Catherine Wood from Boris Charmatz. 2014.

Wood, C., and C. Perrot. Tate Modern as the Musée de la Danse. Unpublished paper, 2014.

Wood, C. *If Tate Modern was the Musée de la Danse?* Tate Programme, London, 2015.

Wood, D. The fine line between mapping and mapmaking. *Cartographica* 30 (4) (1993): 50–60.

Yates, F. A. *The Art of Memory*. London: Routledge and Kegan, 1972 [1966].

Young, J. E., ed. *The Art of Memory: Holocaust Memorials in History*. Munich: Prestel, 1994.

Young, J. E. *At Memory's Edge: After-Images of the Holocaust in Contemporary Art and Architecture*. New Haven: Yale University Press, 2000.

Zerubavel, E. *Time Maps, Collective Memory and the Social Shape of the Past*. Chicago: University of Chicago Press, 2003.

Zhao, X., N. Salehi, S. Alwaalan, S. Voida, and D. Cosley. The many faces of Facebook: Experiencing social media as performance, exhibition, and personal archive. *Proceedings of the SIGCHI Conference on Human Factors in Computing Systems (CHI 2013)*. Paris, France, April 27 to May 2, 2013. SIGCHI, 2013, pp. 1–10.

Zielinski, S. *Deep Time of the Media*, trans. G. Custance. Cambridge: MIT Press, 2006.

Index